中国出土壁画全集

徐光冀／主编

科学出版社

北京

版权声明

图书在版编目（CIP）数据

中国出土壁画全集／徐光冀主编.—北京：科学出版社，2011
ISBN 978-7-03-030720-0

Ⅰ．①中... Ⅱ．①徐... Ⅲ．①墓室壁画－美术考古－中国　图集
Ⅳ．①K879.412

中国版本图书馆CIP数据核字（2011）第058079号

审图号：GS（2011）76号

责任编辑：闫向东／封面设计：黄华斌　陈　敬
责任印制：赵德静

科学出版社出版
北京东黄城根北街16号
邮政编码：100717
http://www.sciencep.com

北京天时彩色印刷有限公司印刷
科学出版社发行　各地新华书店经销

*

2012年1月第　一　版　开本：889×1194　1/16
2012年1月第一次印刷　印张：160
印数：1-2 000　字数：1280 000

定价：3980.00元
（如有印装质量问题，我社负责调换）

THE COMPLETE COLLECTION OF
MURALS UNEARTHED IN CHINA

Xu Guangji

Science Press

Beijing

Science Press

16 Donghuangchenggen North Street, Beijing,

P.R.China, 100717

Copyright 2011, Science Press and Beijing Institute of Jade Culture

ISBN 978–7–03–030720–0

《中国出土壁画全集》编委会

凡　例

1. 《中国出土壁画全集》为"中国出土文物大系"之组成部分。

2. 全书共10册。出土壁画资料丰富的省区单独成册，或为上、下册；其余省、自治区、直辖市根据地域相近或所收数量多寡，编为3册。

3. 本书所选资料，均由各省、自治区、直辖市的文博、考古机构提供。选入的资料兼顾了壁画所属时代、壁画内容及分布区域。所收资料截至2009年。

4. 全书设前言、中国出土壁画分布示意图、中国出土壁画分布地点及时代一览表。每册有概述。

5. 关于图像的编辑排序、定名、时代、尺寸、图像说明：

编辑排序： 图像排序时，以朝代先后为序；同一朝代中纪年明确的资料置于前面，无纪年的资料置于后面。

定　　名： 每幅图像除有明确榜题外，均根据内容定名。如是局部图像，则在原图名后加"（局部）"；如是同一图像的不同部分，则在图名后加"（一）（二）（三）……"；临摹图像均注明"摹本"。

时　　代： 先写朝代名称，再写公元纪年。

尺　　寸： 单位为厘米。大部分表述壁画尺寸，少数表述具体物像尺寸，个别资料缺失的标明"尺寸不详"。

图像说明： 包括墓向、位置、内容描述。个别未介绍墓向、位置者，因原始资料缺乏。

6. 本全集按照《中华人民共和国行政区划简册·2008》的排序编排卷册。卷册顺序优先排列单独成册的，多省市区合卷的图像资料亦按照地图排序编排。编委会的排序也按照图像排序编定。

《中国出土壁画全集》编委会

中国出土壁画全集

◆ 6 ◆

| 陕西 上 |
SHAANXI I

主 编：尹申平
副主编：张 蕴 成建正 程林泉 岳 起
Edited by Yin Shenping, Zhang Yun, Cheng Jianzheng, Cheng Linquan, Yue Qi

科学出版社
Science Press

陕西卷编委会名单

编委

王炜林　张建林　尹申平　张　蕴　成建正　申秦雁　程林泉　王自力　岳　起
张志攀　李浪涛　刘军社　王　沛

参编人员（以姓氏笔画为序）

马永赢　马志军　马明志　王　沛　王　敏　王　磊　王　颢　王力军　王小蒙
王自力　王建荣　王保平　王望生　尹申平　申秦雁　邢福来　吕智荣　刘军社
刘呆运　孙秉君　李　明　李光宗　李志桢　李举纲　李浪涛　杨军凯　邱子渝
汪大刚　汪幼军　张　蕴　张小丽　张东轩　张明惠　张建林　张展望　张翔宇
张鹏程　岳　起　岳连建　骆福荣　秦造垣　魏　军

陕西卷参编单位

陕西省考古研究院　　　　　　　宝鸡市考古研究所
陕西省历史博物馆　　　　　　　延安市文物研究所
西安文物保护考古研究所　　　　昭陵博物馆
咸阳市文物考古研究所

陕西地区出土壁画概述

张 蕴

本卷包括了建国以来陕西省境内发现出土的所有壁画，时间上限始于战国时期之秦国；下限至元，历时近两千年、跨越14个王朝与历史阶段。本卷收录陕西境内63余处出土的600余幅壁画，真实反映了当时社会生活、礼制观念、意识形态、理想追求、绘画艺术等方面。它是一部由古人描绘的彩墨丹青大书，也是一部比文字记载更确切、更客观、更形象的珍贵史书。

用壁画装饰墙面、表达意境是古人智慧与艺术结合的体现，其表现途径可分为两大类：第一类是宫处建筑、寺院庙宇壁画。此类壁画存在于地面，难以长期保存，故而极为罕见珍贵。本书仅收录该类壁画3幅，皆出土于咸阳战国秦3号宫殿遗址宫门门廊壁面的废墟中[1]，现分别藏于咸阳市博物馆与陕西省考古研究院，是目前发现最早的宫殿壁画，代表了战国秦绘画最高艺术水平。画师以浓墨淡彩之手法、准确逼真之造型，透过骏马、奔车、御手的勇猛动态表现了粗犷强劲之美以及秦人所崇尚的必胜精神。向世人展示了两千多年前这个崛起于渭水流域的、以强悍著称的王国在艺术领域的骄人成就。第二类属墓葬壁画，长期埋藏于地下，保存状况好于地面建筑壁画，是我国传统绘画中具有悠久历史和特殊风格的、极其珍贵的艺术宝藏。它较传世画卷及宫殿庙宇壁画更具有特殊意义和独到内容。自秦帝国以来，陕西即以特殊的地理位置、良好的自然环境、深厚的文化底蕴而成为封建王朝定都之首选，因此也成为当时文化艺术最高境界的代表。汉之前的大型墓葬中已发现壁画雏形。汉代墓葬壁画以色彩绚丽、惟妙惟肖的图像表达方式向人们讲述着汉人对死亡的认识和对另一个世界的神奇构思。而气势非凡、表述现实的隋唐墓葬壁画，则是达官显贵真实生活景的再现。那些手笔细腻、技法娴熟的宋元墓葬壁画却更多地描绘了精致安闲的家居生活和人们在现实中对福、禄、寿的追求。

本卷中除战国秦咸阳宫出土壁画为宫殿建筑壁画外，余者皆属阴宅装饰壁画。在此即以墓葬壁画为重点，从以下四个方面做一简单概述。

1.墓葬壁画

作为阴宅装饰壁画，20世纪70年代发掘的扶风杨家堡4号西周墓[2]，其墓圹四壁以白色绘简单菱形两方连续装饰带一周；宝鸡秦家沟村东周墓内壁面发现墨绘痕迹，应属最早见于陕西境内的墓葬壁画遗迹[3]，此时仅有几何线条纹饰，无思想内涵。80年代末，出土于西安交通大学基建工地的一座西汉晚期砖室墓[4]，其壁面绘制色彩浓艳、构图神秘的各式翻卷云气、星象、祥瑞禽兽、车马出行图，布局繁缛、用色斑斓、技艺较熟练。近年，西安南郊理工大学基建工地又清理一座西汉晚期砖券壁画墓[5]，其壁画内容与前者迥然不同，重彩浓墨绘出的骑马出行、狩猎、乐舞、斗鸡等场面，极富动感、手笔简洁、气势不凡，画艺属该时期上乘之作。2008年西安南郊曲江新区工地出土的西汉壁画墓则以众多侍从人物、高大卫士为画面主体，虽显呆板却体形高大，别具一格[6]。就上述三座墓葬壁画设计、构图、运笔、施色等诸方技艺分析来看，已非原始稚拙之作。汉代之前，壁画内容已完成自单纯几何图案向有基本构思的实物实景描绘之进化过程。

东汉墓葬壁画较西汉大量增加，目前陕西省西、北部均有壁画墓发现。但壁画制作工艺、绘画技巧、人物形体塑造、表现手法等方面均显示出早期绘画的平朴单调、略呈幼稚、比例失调等特点，此或与墓葬位置大多偏远有关，绘画技艺并不能代表当时的较高水准。壁画民间色彩浓郁，充分表现了大地主庄园经济的各种生活娱乐场景。由此亦可推断，墓葬主人应是当地豪强。壁画作者无疑为民间画匠。该时期陕西各地出土的壁画墓数量说明，阴宅装饰已流行

至偏远地区并呈渐趋增多之势，而工艺技法仍处于较早的发展阶段。

南北朝时期，陕西境内发现的壁画墓屈指可数。北周的宇文通墓[7]、安伽墓[8]是两座官吏墓葬。墓中壁画所占面积较小，制作略显粗糙，地仗单薄或未见明显层面，人物、花卉较东汉壁画描绘细致准确、技艺提高，但人物神情姿态仍较呆滞。

短暂的隋王朝未能留下丰厚的地下文化遗产，可准确判断纪年的壁画墓仅2座，就现存状况而言，可归纳出以下特点：①壁画墓使用者身份高贵；②壁画占有范围扩大，基本遍布墓葬所有壁面；③画面内容格局初步确定，并成为唐代墓葬壁画布局之基本模式；④制作工艺、绘画技巧有长足进展，画面着重细部刻画，力求真实传神；⑤布局风格严谨但缺少动感；⑥地仗层构制步骤确定，层面加厚。总之，隋代是墓葬装饰壁画水平迅速提高并走向成熟，内容逐步模式化的重要发展阶段。

唐帝国是中国封建文化艺术走向灿烂辉煌的阶段，国力民生皆属富足。该时期皇族、官吏墓葬较多使用装饰壁画，政府设置专职机构与官员负责特殊人群的丧葬办理，其中就包括墓葬修筑与壁面装饰。在唐代近三百年的统治中，墓葬壁画经历了兴盛辉煌至简化萧条的过程，其发展演化规律与唐帝国之兴衰意韵相合。初唐与盛唐早期，丧葬制度严格，华丽壁画的拥有者只限于皇族成员与高官，此特点承袭于隋。进入唐代鼎盛阶段，厚葬成为普遍现象。皇族成员与高级官吏墓中壁画更为华美绚丽，人物鲜活、构思生动、内容更富生活化。严格的等级使用制度似有松动，少数中级以上官吏与富绅悄然僭越，如贝国夫人墓乃单室、1天井、竖穴墓道，形制简单，推测品秩不高；冯君衡墓[9]属卒后赠正四品下秩，两墓皆有壁画装饰，仅地仗层较薄、画幅规格较小而已。通过对初、盛唐墓葬壁画的比较，明确看到不同等级墓葬壁画人物尺寸有别：亲王、公主与高官墓壁画人物高度约为正常人体身高之半，而准皇帝级墓葬壁画人物大小与真人相当，推测帝陵中壁画人物亦为仿真体规格。

中、晚唐壁画墓发现较少，这与战乱及经济衰退直接相关。壁画的质地、画幅、内容均较前期差别甚大，墓主身份上至帝王下到小吏，等级跨度悬殊。主要特征为：①使用壁画之墓主数量大减，身份等级界限模糊，经济能力成为主要或决定因素；②画面质地较简陋，内容趋向简略化，绘画工艺出现墨笔勾勒的白描手法；③初盛唐时期场面宏大、气派壮观、庄重华丽、极具宫廷色彩的装饰画面已不再盛行，壁画在描绘内容上发生较大转折。

宋、金、元代墓葬壁画反映了阴宅装饰的一个全新阶段，其布局、技法、主题内容方面完全有别于隋唐时期。首先表现为地仗层较薄或简化，往往仅涂白灰壁面即可。其次，画幅内容以表现墓主家居生活、戏曲娱乐、夫妇肖像、男主人生平阅历为主。宋墓壁画精致细腻的绘画技法，金墓壁画表达的浓厚的生活趣味，元墓壁画准确逼真、技巧娴熟的表达，是上述各阶段墓葬壁画的主要特点。该时期壁画墓使用者身份尚不确定，推测为官宦或富绅一类。

2.壁画内容

西汉墓葬壁画内容有纯粹神幻内容及现实生活结合神幻内容两种倾向。从现有资料看，二者各自独立存在。所谓以神幻内容为主的壁画，重点表现了星象、四神、云气、瑞禽、异兽等神仙世界之情景，是神仙家思想在丧葬领域的体现。作者通过超现实的神幻构思、浓烈的色彩渲染、令观者强烈感受到脱离世俗的一个肃穆、安宁、和谐、非人类主宰空间的奇异美丽世界。西安交大西汉墓壁画可为此类型之范例。而表现现实生活的画面，主要取材于墓主生前狩猎、出行、赏乐、斗鸡、被奴仆侍奉等生活娱乐场景，同时以墓顶为天界，绘日月、四神、羽人图案。西安理工大学出土墓葬壁画和西安南郊曲江新区出土墓葬壁画皆属此类。作者创作思想是以人为主，天人结合，这是道家思想更深一层的体现。

东汉墓葬壁画内容主要承袭了西汉天人合一之思

想精髓，在偏远地区，中央集权力量薄弱，大地主庄园经济发达，百姓思想束约较少，作者可以放开思路尽情想象，故而造就了一批带有浓郁神话传说色彩及乡土气息的艺术作品。根据该时期墓葬壁画构图特征大致可将其内容划分为二至三个区域。拱形顶为第一区域，上皆绘天象图，包括日、月、星座、银河等，并以彩色云气填充环绕。顶壁相交处为第二区域，多分布神话故事图、仙人图或圣人故事图。它们应该是天、人之间沟通的媒介。此类画面常见于陕北，关中西部则较少出现。所以第二区域内容不具有普遍性。第三区域主要分布于墓室壁面，主画人物出行图、宴饮图、娱乐图、农耕图、采摘图、仓储图、庭院图、侍从图等，重在表现墓主生前主要活动片段及庄园日常生活场景，是对墓主生平的记录。人物侧旁常设榜题，更富真实性。第二、三区域间有时无明确位置划分，相互交融，仅在每幅画题材上反映了不同的内容。所以，东汉墓葬壁画之灵魂应是道家天人合一思想在丧葬领域的体现。内容的最大特点为创作者不受束缚，用画笔自由地表现出内心深处对幸福生活的向往，对另一个未知世界充满神奇的想象，揭示了东汉人对死亡的认识与表白。而画面浓艳斑斓的色彩更增加了它超乎自然的美丽与神秘。

南北朝时期，墓室壁画主要内容仍是天上、人间两类题材，但壁画内容布置渐趋于统一化、规范化。星辰、日月、云气、代表上天，皆绘于墓室顶部。详细具体的星座图简化，不再标注名称，个别墓葬于顶壁相交处绘十二生肖图，十二时兽乃主管人间岁月的时光之神，将其画于天地之交处仍有沟通天人之喻意。四神图多绘于墓道，既标志方位又有镇摄鬼魅之意。其余壁面则全部表现人间生活场景，幅面宽阔。此时壁画所表达的内容发生了重大转变，反映农业生产和庄园经济的画面趋于缩减淡化，描绘墓主生前仪卫队伍、车马出行、标志身份的列戟、侍从、门吏、墓主肖像、瑞禽异兽等成为壁画之主题。从壁画内容、布局的转变明确看到，自由的庄园经济衰退，追求权势、地位、身份，显示墓主不但生活富足、而且社会地位较高、具备相当官职已成为壁画需要表达

的重要信息。而墓葬壁画的使用者身份此时亦提升至中、上等级，包括皇族、高官等上流社会人物。所以南北朝墓葬壁画内容的重大转折实际与社会发展紧密相连，其决定因素在于皇权统治的加强，人们对现实生活产生了与前不同的追求理念和价值观。壁画内容的初步统一化、规范化，直接影响了隋唐墓葬壁画的基本构成模式。而使用者身份等级的提高，成为决定隋及初、盛唐可使用墓葬壁画人群的早期依据。所以南北朝时期是中国墓葬壁画发展史上的重要阶段，起着承前启后、继往开来的巨大作用。

唐代墓葬壁画在继承前朝部分题材后，又不断增加了新的表现内容，形成了一条清晰的、具有不同时间段特征的发展演变脉络。隋与初唐墓葬壁画题材有诸多共同点，此时，属隋唐时期墓葬壁画格局初步统一、内容模式化形成之际。首先，壁画作者将整个墓葬壁面按位置、用途划分区域；其次，确定各区域内绘画基本题材；再次，凡官给之皇族显贵大型墓葬壁画内容可能有规定范围，即所谓宫廷模式；最后，因使用壁画的墓葬有严格等级划分，所以在宫廷模式之外尚未发现该时段之民间模式。壁画内容分布特点为：墓道自南向北依次画云纹、瑞禽、青龙、白虎及车马出行、仪仗出行等表现墓主远行的宏大场面。墓道北壁画城楼图，城楼之北应属墓主生活范围，多绘侍从、列戟等显示墓主身份等级的画面。甬道是通向主人寝室的途径，往往绘有众多司职各异的侍女人物排列两侧侍奉的画面。墓室乃主人内堂，壁画内容以反映主人休闲生活、音乐歌舞、侍女仪态为主。墓顶绘日月星象图。汉与魏晋南北朝流行的、富于民俗乡情的饮宴图、农耕图、宅园图、仓储图完全消失。从而在壁画内容上完成了脱离民间走向宫廷化、高雅化的进程。盛唐墓葬壁画内容在初唐基础上增添了更加活泼生动、贴近生活，带有趣味性的画面。如前期簇拥而立或肃穆排列的侍女此时变得姿态婀娜、捻花、扑蝉、携婴、饲鸟、仪态万方，充分表现了少女的青春活泼；而节愍太子墓[10]、嗣虢王李邕墓[11]所绘打马球图、狩猎图就是墓主生前极为喜爱的运动项目，它们的出现打破了原墓葬壁画庄严沉重的气氛，

注入了活力与轻松。墓道北壁的城楼图也在不经意间悄然变化，以前门窗紧闭、与世隔绝，至开元末让皇帝李宪墓[12]时城楼则设计为三开间亭式，完全无封闭，仅垂挂竹帘为隔段。似乎欲将大唐盛世的明媚春光引入这阴森幽暗的地下宫殿。这些细节的改变同样说明，盛唐墓葬壁画的宫廷模式中更多地吸取了现实生活素材。与此同时，由于壁画使用者范围有所扩展，含有民间气息的绘画内容开始重新步入大雅之堂。如韦慎名墓[13]少女骑马出行图，均不在庄重的宫廷模式内容之列。这些生动、饱含民间生活情趣的画面给观者带来了耳目一新的视觉效果，它是日常生活的真实描绘。在画面格局上，隋与初唐以影作仿木结构隔断长廊将壁面划分为多个独立画幅的构图方式因创作意念受到框制、不能自如发挥而被逐步淘汰。连续的、长卷式的系列画面能够更真实、更有序、更丰富、更故事化地表达作者意图，成为墓道、过洞、天井壁画的主要流行趋势。李邕墓壁画设计即使用了此类构思。中唐壁画墓数量骤减，壁画内容基本如前，是盛唐的延续。在制作工艺、绘画技法方面有所改动，但主导思想一如既往。书中收录的陕棉十厂壁画墓[14]在内容上似乎透露出更多的自由浪漫色彩。特别是乐舞图，乐师纵情吟唱弹奏、舞人随意踏步相随，气氛和谐轻松。构图上再次出现红色框栏分隔的独立画幅。晚唐壁画墓数量少于中唐，而且在壁画内容方面发生重大转变。传统的出行、仪仗、车马、列戟、狩猎、马球等场面浩大、气势壮观的大幅画面基本不见，仪卫队伍减化为卫士图，侍从、伎乐虽有保存，数量规模则大不如前。四神、天象等道教神化图案仍继续使用并有增加，如唐僖宗靖陵[15]中绘人身兽首十二生肖像，与北朝时期壁画墓绘制内容有类同之处。从而反映出晚唐末年丧葬领域之主导思想发生变化——更倾向于宗教信仰，并掺杂复古情绪。

金、元墓葬壁画创作思想完全区别于隋唐，以表现墓主夫妇肖像、墓主家庭日常生活、室内摆设、家私布置及墓主个人阅历等题材为主，惟妙惟肖地反映了墓主的形象体貌特征、真实体现了堂内布置陈列。

综上所述，陕西省墓葬壁画内容自汉至元历经一千多年发展演变，其规律可概括为如下若干阶段：

（1）西汉至东汉，壁画内容由完全神化逐步转入神人结合、以人为主，以庄园生活为主之题材，表现了道家思想特别是天人合一观对当时丧葬理念的深刻影响，而这种影响始终贯穿存在，直至近现代。

（2）魏晋南北朝时期墓葬壁画内容处于承前启后、留旧出新的改革探索阶段。汉以来流行的庄园生活画面仍有保留，道家影响力依然如前，而更多的表现墓主权势、身份、地位之内容成为新的时尚题材，反映了该时期人们从追求死后升仙到重视今生享乐这一生活观的改变。

（3）隋与初唐是唐代墓葬壁画内容基本形成固定模式之阶段，日月星辰代表天，四神瑞禽代表仙，主体内容描绘人；表现墓主奢华生活、高贵门第的画面一直延用至晚唐。

（4）盛唐与中唐是唐代墓葬壁画内容模式巩固、补充、丰富、完善的阶段，墓葬各区域壁画内容已成定局。

（5）晚唐墓葬壁画内容有重大转变，重新突出了有关道教题材，带有复古倾向。该时期石刻图案也同样存在类似规律。

（6）唐末至元初墓葬壁画受宋人精致生活方式影响很大，更重视表现仕途的追求和安逸悠闲的家居生活。墓主肖像继魏晋南北朝之后又一次成为壁画主题之一。而元代墓葬壁画基本延续了这些内容，更加突出表现了墓主夫妇在家庭中不可取代的重要地位。所以宋、金、元墓葬壁画内容自唐末的道教题材转而走入通俗化、生活化的崭新创作领域。

3.壁画制作

发掘资料显示，完善的壁画制作过程主要分为三个步骤：首先修平壁面；其次于壁上涂抹草拌泥地仗层，其厚薄程度多与墓葬规格匹配；再次在地仗层之上施加白灰层面。一般墓葬壁画绘制前基础工作主要为上述三步。待其晾至半干后，根据规划以尖状物或树枝、赭石起稿，勾描轮廓、精画细部、填充色彩。但早期的壁画制作程序、技术尚不完善，从目前已揭取的壁画观察：西汉壁画无草拌泥地仗，仅于砖壁上

刷胶类物质一层，上抹白粉；东汉壁画制作之最大特点是就地取材，无统一用料规定。草拌泥地仗层薄而不甚均匀，其上薄施当地所产淡青色细泥或淡青色矿粉一层，与后期所用白灰面比较，显得粗糙晦暗。画面上留有树枝或尖状物起稿划痕，说明此时图案布局已预先做过计划安排。西安周边发掘的西汉墓壁画，多以墨色勾勒轮廓；陕北东汉墓壁画外廓亦同上；而旬邑东汉墓则不勾外廓、直接涂抹色彩。这从一个方面反映了汉代墓葬壁画制作的不统一性。

南北朝时期墓葬壁画的制作工艺有显著改进，草拌泥地仗依然较薄，淡青色表层被白灰面或白灰水替代。虽然白灰面极薄但是壁画制作工艺中的重要改革，开隋唐墓葬壁画制作技艺之先河。从此，墓葬壁画的制作用料、工艺流程基本固定，后代墓葬壁画即在此基础上逐步修整完善成为固定模式。画面起稿除使用传统树枝、尖状物外，还出现了浅咖色赭石线条痕迹。所绘人物、禽鸟、动物、花卉等均以墨色勾出轮廓、衣理褶纹、毛羽走向、叶脉茎络，表明此时期绘画技艺亦逐渐成熟。

隋唐墓葬壁画制作工艺已经成熟完善，其方法按层次自下向上归纳为以下几点：

（1）修或做平土、砖质壁面。

（2）壁面上可能薄施动物血或其他黏合剂。

（3）草拌泥地仗涂抹较均匀，土圹壁上略厚，砖壁面为减少重量、保证与砖壁的亲合力而施用较薄。

（4）白灰面细腻坚硬，厚薄程度与墓主身份地位有直接关系。

（5）白灰面上往往刷涂明矾水以防墨迹洇散。

（6）壁画布局设置已有规划，起稿工具使用树枝或赭石，程序如前述，墨线勾勒轮廓后细画填彩。

（7）从墓葬不同区域壁画技艺、风格差异分析，同一墓葬中各区域分别由若干工匠小组按计划承担该段绘画工作，所以整座墓葬壁画是分工合作的结果。

唐代之后的墓葬壁画主要绘制于砖券墓室壁面，地仗层渐趋单薄，仅涂超薄白灰层面或完全不施地仗，砖面上只刷白灰水，其上作画，使画面与墓壁更利于结合。

迄今为止，陕西出土的宋、金、元代墓葬壁画资料较少，与隋唐相比，该时期壁画研究还是一个涉足甚少的领域，其中与前所不同的素材为研究者提供了广阔空间。希望通过本卷的出版，唤起更多学者对该时期墓葬壁画的兴趣。

本卷的问世是陕西省所有考古工作者几十年来辛勤工作的硕果，它为所有研究、爱好和关心考古事业及绘画艺术的人们提供了真实可靠的研究、观赏资料——中华民族艺术宝库中鲜为人知的壁上丹青。

注　释

［1］陕西省考古研究所：《秦都咸阳考古报告》，科学出版社，2004年。

［2］罗西章：《陕西扶风杨家堡西周墓清理简报》，《考古与文物》1980年第2期。

［3］陕西省文物管理委员会：《陕西宝鸡阳平镇秦家沟村秦墓发掘记》，《考古》1965年第7期。国家文物局：《中国文物地图集·陕西分卷·下》，西安地图出版社，1998年。

［4］陕西省考古研究所、西安交通大学：《西安交通大学西汉壁画墓》，西安交通大学出版社，1991年。

［5］西安市文物保护考古所发掘清理，现资料尚未发表。

［6］2008年西安市文物保护考古所抢救性发掘，资料未发表。

［7］2000年4月出土于陕西省咸阳市渭城区西安咸阳国际机场，陕西省考古研究所发掘，资料未发表。

［8］陕西省考古研究所：《西安北周安伽墓》，文物出版社，2003年。

［9］贺梓城：《唐墓壁画》，《文物》1959年第8期。

［10］陕西省考古研究所：《唐节愍太子墓发掘报告》，科学出版社，2004年。

［11］2004年出土于陕西省富平县北吕村，陕西省考古研究所发掘，资料未发表。

［12］陕西省考古研究所：《唐李宪墓发掘报告》，科学出版社，2005年。

［13］2002年出土于陕西师范大学长安校区，陕西省考古研究所发掘，资料未发表。

［14］陕西省考古研究所：《西安西郊陕棉十厂唐壁画墓清理简报》，《考古与文物》2002年第1期。

［15］1995年出土于陕西省乾县铁佛乡南陵村东，陕西省考古研究所发掘，资料未发表。

Murals Unearthed From Shaanxi Province

Zhang Yun

This volume collects all of the ancient murals unearthed in Shaanxi Province since the founding of the People's Republic. The dates of the murals covered 14 dynasties spanning about 2000 years since the Qin State of the Warring-States Period to the Yuan Dynasty. The over 600 murals collected in this volume truly reflected the social lives, ritual concepts, ideologies, ideals and painting arts of their respective periods. They are a huge volume written by the ancient people with color inks and an invaluable history work much more precise, more objective and more vivid than textual historic works.

Decorating walls and expressing moods with murals is the embodiment of the integration of ancient people's wisdom and artisanship. The murals can be classified into two types: the first is the architectural murals in palaces, monasteries and temples, which are created in the architectures above the ground and seldom preserved for long time and therefore very rare and valuable. Only three pieces of this kind of murals are collected in this volume, all of which are unearthed from the ruins of the porch walls of the front gate of Palace Site No. 3 of the Qin State in the Warring-States Period, and collected in Xianyang Museum and Shaanxi Provincial Institute of Archaeology, respectively.[1] They are the earliest court murals found to date representing the top level of the painting art of the Qin State in the Warring-States Period. The artists recreated the toughness of the Qin people and their pursuit of triumphs by the swift and powerful poses of the steeds, chariots and drivers painted with thick and dark outlines and light colors and accurate and true-to-life imaging. These murals displayed the striking artistic achievements of this state originated in the Wei River Valley and known by its strength and braveness more than twenty centuries ago. The second type is the tomb murals which are created in the underground environments and preserved much more and better than the architectural murals: these tomb murals are the invaluable treasures of Chinese traditional painting art with long history and uninterrupted developing sequence. Compared to the handed down paintings in traditional collections and the murals in palaces and religious architectures, the tomb murals have special significance and unique motifs. Since the unification of the Qin Empire, the present-day Shaanxi Province became the first candidate of the capitals of the dynasties in the following more than one thousand years, and of course became the center of the cultures and arts of the highest levels. The prototyped murals have been found in the tombs earlier than the Han Dynasty. In the Han Dynasty, the tomb murals were interpreting the understandings to the death and the fanciful imagination to the afterworld of the people at that time with vivid figures and brilliant colors. On the other hand, the tomb murals of the Sui and Tang Dynasties are the true reappearance of the lavish lives of the prominent nobles and elites. As for the tomb murals of the Song and Yuan Dynasties, which are painted with subtle touches and dexterous skills, they are mostly the depictions of the sedative daily lives and the pursuits of happiness, high social statuses and longevity in the present world.

Except for the ones unearthed from the palace ruins of the Qin State in Xianyang, all of the murals collected in this volume are that from tombs of the dynasties and periods since the Western Han Dynasty. Now let us have an outlined introduction to these tomb murals from the following four aspects.

1. The Emergence, Development and Maturity of Tomb Murals

As the decorations of the afterworld residences, the earliest tomb murals found so far in Shaanxi would be the rhombus pattern painted with white color on the four walls of the grave of Tomb No. 4 in Yangjiapu Cemetery of the Western Zhou Dynasty in Fufeng County[2] and the unidentifiable designs painted with dark ink on the walls of a tomb in the Qinjiagou Cemetery of the Eastern Zhou Period in Baoji County.[3] However, the tomb wall decorations of this period were only simple geometric patterns without any concrete meanings. A brick-chamber tomb of the late Western Han Dynasty excavated in the campus of Xi'an Jiaotong University[4] at the end of 1980s had murals with motifs of curling clouds, celestial bodies, auspicious animals and procession of cavalry and chariots painted with garish colors, mysterious shapes and compositions and complex arrangements and masterly techniques. In recent years, another brick-chamber mural tomb of the late Western

Han Dynasty with vault ceiling was recovered in the campus of Xi'an University of Technology in the southern suburb of Xi'an City[5] had rather different motifs, which are cavalry processions, hunting, music and dancing performances, cockfight and so on, painted animatedly and vividly with simple but strong strokes. These murals could be seen as the topflight masterpieces of this period. In 2008, a Western Han mural tomb excavated on the construction site of Qujiang New District in the southern suburb of Xi'an City had figures of numerous attendants and strong guardians, the modeling of which are somewhat stiff but the images are all painted very large, showing a special feature in the tomb murals of the Western Han Dynasty.[6] The designing, compositions, drawing skills and coloring techniques of the murals of these three tombs show high maturity, hinting that they were not the primitive artworks but the results of a long-time evolution from the simple geometric patterns to the depictions of realities with beforehand conception before then Han Dynasty.

In the Eastern Han Dynasty, the amount of tomb murals increased in a large way; to date, mural tombs of this period are found in western and northern parts of Shaanxi Province. However, the tomb murals found in these regions usually show some immature features, such as tedious motifs, inept skills and inconsistent scales, which might be because they were not located in the central regions of culture and art and therefore these murals could not represent the top level of the painting art of that period. Nevertheless, the contents of these murals had rich folkloric flavors, the motifs of which are mainly the daily lives, amusements and other scenes of the manorial economy of the powerful landlords. The contents of these murals hinted that the tomb occupants would be the local magnates and the painters would be the folk craftsmen. The amount and distribution areas of the tomb murals in the Eastern Han Dynasty both showed that this type of decoration of the afterworld residences had been introduced to the remote areas and become more and more popular, albeit the painting techniques were not fully developed.

Very few mural tombs of the Southern and Northern Dynasties Period have been found so far in Shaanxi Province. Of these tombs, those of Yuwen Tong[7] and An Jia[8] are the tombs of two officials. The murals in their tombs took very small proportions of the walls and all of them were painted sketchily on very thin and coarse base or without any base at all. Compared to the murals of the Eastern Han Dynasty, the human figures and floral designs were painted more accurately, elaborately and to more proper scales with rather experienced skills but the poses and airs of the human figures were still somewhat stiff and dull.

The short-lived Sui Dynasty did not leave us plenty of underground cultural heritage; only two precisely dated mural tombs of this period have been found in Shaanxi Province to date. The preserved murals in these tombs demonstrated the following characteristics: ① the occupants of these mural tombs were in very high statuses; ② the murals occupied much larger areas in the tombs; almost all of the walls were decorated with murals; ③ the arrangement of the motifs in the different parts of the tomb was generally defined and became the basic mode of the layouts of the tomb murals of the Tang Dynasty; ④ the processing techniques and painting skills were substantially developed, the details of the murals were carefully depicted and the efforts were mainly made to recreate the true-to-life images; ⑤ the layout styles were strictly followed but the vigor was insufficient; ⑥ the base of the murals was applied in somehow given procedure and much thicker than that of the earlier murals. In short, the Sui Dynasty was an important stage for the tomb mural art to rise into a higher level and become more mature and for the themes and compositions of the tomb murals to become modularized.

The Tang Empire was the climax of the cultures and arts of the feudalism period of China, and the social economy was also developed to the highest level. During this time, the tombs of imperial family members and officials were mostly decorated with murals, and the governments had specialized agencies and personnel in charge of the funeral affairs of these people with high rank or special statuses, including the tomb construction and mural designing and painting.

In the almost three centuries of the sovereignty of the Tang Dynasty, the tomb murals experienced the flourishing, declining and depressing stages, which closely corresponded to that of the Tang Empire. In the Early Tang and the early stage of the High Tang Periods, the funeral systems were executed strictly and the grandiose and elaborate murals could only be used in the tombs of the imperial family members and high-ranked officials, which was succeeded from that of the Sui Dynasty. In the High Tang Period, lavish and wasteful burial custom became more and more popular. The murals

of the tombs of the imperial family members and high-ranked officials were more gorgeous and vivid, the arrangements were more flexible and the motifs were more lifelike. The strict mural using system seemed not that stiff: the motifs for the imperial family and high-ranked bureaucrats were seen in the tombs of mid-ranked officials and rich civilians. For example, the shape of the tomb of the Consort of Bei State was very simple, which had only one chamber, one ventilating shaft and vertical passageway, showing that the tomb occupant's rank was not high; Feng Junheng[9] was promoted to senior fourth rank minor after his death (which means he was a mid-ranked official when living). However, their tombs were both decorated with murals, although the bases were relatively thin and the sizes of the murals were somewhat small. By comparing the murals in the tombs of the people with different ranks, we can see clearly that the human figures in them were painted to different scales: in the murals of the tombs of the imperial princes, princesses and high-ranked officials, the human figures were painted as about a half of the size of the real people, but that in the tombs constructed in the standard of imperial mausoleums were painted as large as real people, therefore it is reasonable to conjecture that the human figures in the murals of the imperial mausoleums would be also painted as large as the real people.

Very few tomb murals of the Mid Tang and Late Tang Periods have been found so far, and their qualities were much lower than that of the Early and High Tang Periods. The sizes and contents of the discovered murals of this period were rather different from that of the previous periods, which were unquestionably related to the warfare, turmoil and the economic depression. The class statuses of the occupants of the mural tombs became even much lower, even some clerks not listed in the official ranks also had murals in their tombs. The features of the tomb murals of this periods were mainly the following: ① the tombs bearing murals reduced sharply and the occupants of them had large disparity in social statuses: some high officials did not enjoy mural tombs but some common people did, because in this period the economic abilities were the main or decisive factor of enjoying tomb murals or not rather than official ranks or social statuses; ② the qualities of the murals were much more coarse and the contents were simplified, and the ink line drawing technique was applied in the murals without colors filled; the spectacular scenes and the palatial atmospheres almost disappeared and the motifs of the murals were absolutely changed.

In the Song, Jin and Yuan Dynasties, the tomb murals reflected a brand-new stage of the afterworld residence decoration. Their layouts, techniques and themes were completely different from those of the Sui and Tang Dynasties. Firstly, the processing of the mural bases was simplified, sometimes only a thin layer of lime plaster was applied on the wall as the base of the tomb murals. Secondly, the themes were mainly the daily lives, drama, music or dancing performance, the portraits of the couple of the tomb occupants and the experiences of the male occupant, and so on. The exquisite painting skills of the tomb murals of the Song Dynasty, the strong daily life flavor shown by the tomb murals of the Jin Dynasty and the accurate, true-to-life and masterly reappearance of the reality of the tomb murals of the Yuan Dynasty were the main features of the mural art of this stage. The statuses of the occupants of the mural tombs have not been clearly identified but most of them would be officials or rich common people.

2. The Contents of the Tomb Murals

The tomb murals of the Western Han Dynasty had both pure mythical and supernatural contents and the integration of the mythical and supernatural contents and realistic contents. The materials we have got to date show that these two types were existing mutual independently in the Western Han Dynasty. The mythical and supernatural contents were mostly the stylized celestial bodies, the Four Supernatural Beings, auspicious clouds, exotic birds and beasts, and so on, which were the embodiment of the immortal pursuit in the funeral affairs. The artists made the viewers have a feeling of a spectacular world with solemn, tranquil and harmonious atmosphere beyond the human controlling through the surrealistic conceiving and composition and thick and heavy colors of their works. A typical case of this kind of themes is the murals of that brick-chamber tomb of the Western Han Dynasty in Xi'an Jiaotong University. As for the murals with the themes of daily lives, the main contents were the scenes of hunting, procession, enjoying music and dancing performances and cockfighting, being attended by servants or maids, and so on, which were usually the records of the lives of the tomb occupant when

he was alive. Meanwhile, the ceilings of the tombs decorated with this kind of murals were also decorated with figures of celestial bodies, the Four Supernatural Beings and winged immortals. The typical cases of this kind of themes are the tombs in Xi'an University of Technology and Qujiang New District in the southern suburb of Xi'an City. These artworks were created under the direction of the Taoist theory of "Heaven and Man are Integration" and the deeper expression of the Taoist thought.

The themes of the tomb murals of the Eastern Han Dynasty were mainly succeeded from that of the Western Han, especially the essence of the "Heaven and Man are Integration" theory; in the remote and isolated regions, the political and thought control of the central government was weak but the manorial economy of the powerful landlords was developed, so the local artists did not have too much restrict preventing them from freely imagining; therefore, lots of artworks bringing legendary and folk flavors were created and preserved to the present in these regions. Generally, the murals in each tomb of this period could be divided into two to three zones by their contents and composition features: Zone One is on the vault- or dome-shaped ceiling, which were the celestial bodies including the sun, the moon, the constellations and the Milky Way, the blank area among which were usually filled with curling clouds in various colors. The zone along the springing line of the tomb chamber walls was Zone Two, which was occupied by the scenes of legends, myths or the story of sages. This zone would be the intermediate of the heaven and the earth. However, motifs of this type have been mainly found in the northern Shaanxi but seldom in the Guanzhong Plain, so it is not a universal rule to contain this zone in the tomb murals. The Zone Three was on the walls of the tomb chambers, the motifs of which were usually the scenes of processions, feasting, performing, sowing and cultivating, gathering and storing, and the courtyards, attendants, and so on, which were displaying the activities of the tomb occupants when they were alive and the manorial lives, which were usually accompanied with captions describing the contents and making these murals more true-to-life. The Zones Two and Three sometimes did not have exact boundary but were mutually overlapped, and they could only be identified by the motifs.

Therefore, the soul of the tomb murals of the Eastern Han Dynasty was the Taoist thought of "Heaven and Man are Integration". Their unique characteristics were that the artists were not restrained by any given schemes or rules but could freely express their desire to the happy life, the fantastic imagination to the other unknown world and the understanding and description to the death of the people in the Eastern Han Dynasty. Meanwhile, the bright and gorgeous colors increased the murals' superb beautifulness and mysteriousness.

In the Southern and Northern Dynasties Period, the motifs of the tomb murals were still that of the Heaven and the Earth, but their contents and arrangements were gradually unified and regularized. The constellations, the sun, the moon and the curling clouds symbolizing the Heaven were painted on the ceilings of the tomb chambers; the constellations were not real star maps but stylized ones, and the captions were omitted. In some tombs, the Twelve Zodiac Animals were painted at the springing line of the tomb chamber; these animals were the deities in charge of the years, months and days of this world, so painting them between the Heaven and the Earth also hinted that they were the guides leading the people into the Paradise. The Four Supernatural Beings were usually painted in the passageways to mark the directions and to exorcise the evil spirits. The rest spaces, which were almost all of the walls, were the scenes of the daily lives of the living people. In this period, the contents of the tomb murals significantly changed: the scenes of farming activities and manorial lives were reduced and simplified, and the main motifs changed into the lines of guards of honor, carriages, cavalry and infantry processions, halberd displays marking the ranks and statuses of the tomb occupants, the attendants, door guards, the portraits of the tomb occupants and the auspicious birds and the exotic beasts, and so on. These changes clearly showed that the manorial economy had declined and the functions of the tomb murals were changed into reflecting the rich lives, high social statuses and official ranks of the tomb occupants. Meanwhile, the statuses of the users of tomb murals were concentrated to the higher ones, including the imperial family members and high-ranked officials. Therefore, the significant changes of the motifs of the tomb murals in the Southern and Northern Dynasties were tightly related to the social developments, the decisive reasons were that the imperial power was strengthened and the people had new pursuits and values to the lives. The contents of the tomb murals were preliminarily standardized and unified and directly influenced the

basic modes of the tomb murals of the Sui and Tang Dynasties. Moreover, the rising of the statuses of the users of the tomb murals also became the background of the defining the authorities of the people using murals in their tombs in the Sui and early Tang Dynasties. Because of these, the Southern and Northern Dynasties Period, which succeeded the past and opened the path for the future, was an important stage in the history of the tomb mural development of China.

In addition to the motifs succeeded from the former periods, the tomb murals of the Tang Dynasty had many more new motifs, forming an uninterrupted developing and evolving sequence. The tomb murals of the Sui and the early Tang Dynasties had many features in common, both of which were in the time of the regularization and standardization. Firstly, the entire internal space of the tomb was divided into zones by their locations and planned usages; secondly, the basic motifs of each zone were decided; thirdly, the motifs of the tomb murals of the imperial family members and high-ranked officials, whose tombs were designed and sponsored by the government, might have defined contents, or "Courtly Model"; fourthly, because of the strict hierarchies of the mural tombs by the social statuses of the occupants, the folk styles other than the "Courtly Model" had not emerged yet. Generally, the arrangement of the murals in a tomb was: curling clouds, auspicious birds, the Green Dragon and White Tiger, the processions and guards of honor, and other scenes showing the outgoing of the tomb occupant(s) were painted successively from the south end of the ramp passageway of the tomb; atop the tomb entrance, a gate tower was painted, flanked by attendants and halberd displays showing the status of the tomb occupant. The corridor approaching the tomb chamber(s) was the imitation of the hall leading to the inner room of the tomb occupants, so its walls were usually filled by the lines of attending maids and servants. The tomb chamber, which was the imitation of the inner rooms of the residence of the tomb occupants, was decorated with the scenes of leisure times, music and dancing performances, and the figures of maids in various postures. The ceiling of the tomb chamber was still the stylized star map with the sun and the moon. The scenes of feasting, plowing and sowing, storing, and courtyards and gardens, which were popular in the tomb murals of the Han through the Southern and Northern Dynasties, completely disappeared; the themes of the tomb murals have finished its evolution from the folk art to the court and elite art. In the High Tang Period, more interesting, vigorous and vivid scenes close to life emerged in the tomb murals. For example, the maids used to stand rigidly in lines or gather tightly together in the early Tang Period became lithe and graceful in gestures of picking flowers, catching cicadas, holding babies, feeding birds, and so on, showing the beautifulness and youthfulness of the girls; the scenes of polo playing and hunting in the murals of tombs of Prince Jiemin [10] and Li Yong, the heir of Prince Guo[11], were that of the favorite games of the tomb occupants when they were alive; the appearances of these motifs broke the solemn and grave atmosphere in the burials and brought in animation and easiness. Meanwhile, the gate tower atop the tomb entrance was also silently changed its style: in the past, the doors and windows were all tightly closed and separating the internal space from the external world; at the end of Kaiyuan Era, the gate tower image of the tomb of Li Xian, the Emperor Rang (the should-be emperor yielded his throne to his brother) of the Tang Dynasty,[12] was painted in the style of a three-bayed pavilion without walls, doors and windows, the only partitions of which were the bamboo curtains hanging in it: it seems that this gate tower was guiding the spring scenery of the High Tang flourishing time into the dark and gloomy underground palace. The changes of these details also evidenced that the tomb murals painted according to courtly model also absorbed some themes from the realistic lives. Also in this period, because the tomb murals were applied in a wider scope, some contents with folk flavors came back. For example, the girls riding horses in Wei Shenming's tomb[13] were all absent in the themes of the solemn courtly model. These interesting and dynamic scenes with strong folk taste were all the accurate depictions of the daily lives bringing fresh visual experiences to the viewers. As for the compositions of the tomb murals, the method of partitioning the walls into many bays with simulated wooden galleries to arrange isolated scenes was gradually abandoned because the bays or frames manacled the creative ideas. The continuous long scroll-shaped composition could demonstrate the artists' ideas more truly, orderly, richly and anecdotally, so it became the main style of the murals in the passageways, tunnels and ventilating shafts. This method was applied in the designing of the murals in Li Yong's tomb. In the Middle Tang Period, the amount of mural tombs decreased sharply but their themes were still those of the High Tang, the only changes of which were on the techniques and skills, but the central

motifs were the same. The murals of a Tang tomb found in Shaanxi Tenth Cotton Plant[14] seemed showing more liberal and romantic flavors, especially the music and dancing performance scene in which the musicians and the dancers were painted enthusiastically and harmonically in a relaxed atmosphere, and the isolated scenes separated by the red strips simulating the columns and beams of wooden architecture. In the Late Tang Period, the amount of murals was more reduced and the themes were also sharply changed. The processions, lines of guards of honor, cavalry and carriages, halberd displays, the scenes of hunting, polo playing and other activities almost disappeared; the lines of guards of honor were reduced into single guards; the attendants, music bands and dancers were still kept as groups but the numbers of each were also reduced noticeably. The Taoist deities and symbols such as the Four Supernatural Beings and the celestial bodies were still seen in the tomb murals and the use of them was increased: for example, the Twelve Zodiac Animals painted as standing figures with human bodies and animal heads were seen in the Jingling Mausoleum of Emperor Xizong[15], which was similar to those in the tomb murals of the Southern and Northern Dynasties. These themes reflected that in the Late Tang Period, the guiding ideas in the funeral affairs were changed: religious trend was strengthened and mixed with antiquity worship.

During the Jin and Yuan Dynasties, the guidelines of the tomb mural creating were completely deviated from that of the Sui and Tang Dynasties; their themes of this period were the portraits and the daily lives of the couple of the tomb occupants, the internal settings of the living rooms, the furniture displays and the personal experiences of the tomb occupants, and so on, all of which were vividly and accurately reappeared the bearings of the tomb occupants and the internal settings and decorations of the houses of that time.

In short, the evolution of the tomb murals in the over ten centuries from the Han to the Yuan Dynasties might be synthesized into the following stages:

(1) The Western and Eastern Han Dynasties. In this stage, the themes of the tomb murals changed from complete mythical images to the combination of secular and mythical images in which the secular lives took the main roles, and then the manorial lives became the central theme. This type of themes reflected the deep influence of Taoist worldview especially the thought of "Heaven and Man are Integration" to the funeral ideas, which has been handed down even to the present.

(2) The Three-Kingdoms to the Southern and Northern Dynasties Periods. In this stage, the themes of the tomb murals were still in the reform exploring period of inheriting the old traditions and inventing the new types. The scenes of manorial lives popular since the Han Dynasty were still kept and the influence of Taoist thoughts were still prevailing; however, new themes showing the powerfulness and loftiness of the tomb occupants emerged and became more and more fashionable. This situation reflected the change of the worldview of the people from pursuing the ascending to the paradise after the death to seeking pleasure in this life.

(3) The Sui and early Tang Dynasties were the period for the tomb murals to basically form the stereotyped formats: the images of the sun, the moon and other celestial bodies represented the heaven, the Four Supernatural Beings and the auspicious birds and beasts represented the immortal world and the main bodies of the murals were given to the human figures: the scenes showing the luxurious life and high statuses of the tomb occupants were applied as long as to the late Tang Period.

(4) The High and Middle Tang Periods were the stages for the tomb murals to complete the formats and to enrich and perfect the contents; in this period, the contents of the murals in a tomb were all defined.

(5) In the Late Tang Period, the contents of the tomb murals had significant changes and the Taoist motifs emerged again; the stone sculptures in this time also had similar trends.

(6) From the end of the Tang Dynasty to the early Yuan Dynasty, the tomb murals were greatly influenced by the delicate lifestyle of the people of the Song Dynasty, which was strongly emphasizing the pursuit of high official ranks and relaxed home lives. The portraits of the tomb occupants became one of the motifs again since the Southern and Northern Dynasties. In the Yuan Dynasty, the tomb murals were roughly still succeeding the motifs of that of the Song Dynasty, while the irreplaceable positions of the tomb occupant couple were more stressed. Therefore, in the Song, Jin and Yuan Dynasties, the tomb murals entered a brand-new field of secularization and realization from the religious and mysterious flavor in the Late

Tang Period.

3. The Painting of the Tomb Murals

The archaeological excavation materials reflected that a complete procedure of the tomb mural base preparing consisted of three steps: firstly, the wall surface was leveled; secondly, a layer of straw-tempered daub was applied to the wall, the thickness of which usually matched the rank of the tomb; finally, a layer of lime stucco was applied to the top of the daub layer and finished. When the mural base was half-dried, the sketch was made with pointed tools or twigs or ocher pieces, then the contours were traced, the details were added and the colors were filled. However, the bases of early tomb murals were mostly not prepared with the full procedure. From the shucked-off murals, we observed that the tomb murals of the Western Han Dynasty did not have the daub base, instead of which was a layer of something like glue; over this glue layer, the thin lime stucco layer was plastered. The most obvious feature of the bases of the tomb murals of the Eastern Han Dynasty was that they were made with the handy local materials without any given rules. The daub base were usually applied thin and uneven, over which a thin layer of bluish fine clay or ore powder was applied; compared to the lime stucco layer of the other periods, the tints of the tomb murals painted on this kind of bases looked coarse and dim. The traces scratched with twigs or thin wooden sticks on the lime stucco layer hinted that the overall layout of the murals in a tomb was designed and arranged before the painting began. The murals in the Western Han tombs nearby Xi'an City usually had ink-drawn outlines, and those in the Eastern Han tombs in northern Shaanxi were also done like that; on the contrary, the murals in the Eastern Han tombs in Xunyi County did not have ink-drawn outlines but were directly painted with various colors on the walls. These different painting skills reflected the diversity of the tomb murals in the Eastern Han Dynasty.

In the Southern and Northern Dynasties, the processing technique of the tomb mural base was improved, but the daub layer was still thin and the bluish coating was replaced by white lime stucco coating. This lime stucco layer was very thin but it was a significant progress in tomb mural making technique, which started the new epoch of the tomb mural painting technique of the Sui and Tang Dynasties. Since this period, the materials and workflows of tomb mural painting were regulated and that of the later periods were refined and perfected based on them. The sketches were done with brownish ocher lines in addition to the incised lines made by twig or pointed tools. The human figures and images of birds, beasts, flowers and plants were all outlined with dark ink and the details of the dress pleats, the hairs and feathers, the veins of the leaves and the stems were all vividly depicted, showing the maturity of the painting skills in this period.

In the Sui and Tang Dynasties, the tomb mural painting techniques were perfected; the whole procedure could be concluded into the following main steps:

(1) The earthen or brick walls were trimmed and finished.

(2) Animal blood or other adhesives were applied to the smoothened wall.

(3) The daub mortar was evenly plastered on the walls; that on the earthen walls were thicker, while that on the brick walls were thinner for reducing the weight and guaranteeing the adhering between the mortar and the walls.

(4) The lime stucco layer was fine and strong, the thickness of which matched the statuses and ranks of the tomb occupants.

(5) Alum solution was brushed on the lime stucco finished wall surface to prevent the ink and color from blurring.

(6) The overall arrangement of the murals in a tomb was predesigned; the sketches were done with twigs or ocher as mentioned above, then the outlines and details were drawn with ink and the colors were filled to finish.

(7) From the different technique features and styles of the murals in different areas of the same tomb, we can see that the painting of the murals in a tomb was separately carried out by some artist groups by area, so the murals in a tomb was the result of cooperation.

After the Tang Dynasty, the tomb murals were mostly seen in the brick-chamber tombs, and the mortar bases were getting thinner, only a very thin lime stucco layer was applied or no base processing at all; the murals were painted on the brick wall brushed with lime solution and the murals could be stronger stuck to the walls.

To date, the materials about the tomb murals of the Song, Jin and Yuan Dynasties were still scarce; compared to that on the Sui and Tang Dynasties, the researches on the murals of this period were rather insufficient. However, the new-emerged motifs of this period provided wide space for researchers dedicated to this field. We hope the publishing of this volume can raise the interests of more scholars to the tomb murals of this period.

The publishing of this volume is the fruit of the hard work of all of the archaeologists in Shaanxi Province for several decades; it presents reliable materials for the academic researchers and amateurs as well as all of the people interested in archaeological cause and painting art to study and enjoy, and displays the rare mural art in the treasure of Chinese traditional art.

References

[1] Shaanxi Provincial Institute of Archaeology. 2004. Archaeological Report on the Investigations and Excavations at the Ancient Qin Capital Xianyang. Beijing: Science Press.

[2] Luo Xizhang. 1980. The Recovering of the Western Zhou Tombs in Yangjiapu Village, Fufeng County, Shaanxi. Kaogu yu Wenwu (Archaeology and Cultural Relics), 2: 21-27.

[3] CPAM, Shensi Province. 1965. Excavation of the Ch'in Tombs at Ch'in Chia Kou Village in Yang Ping Chen, Paochi, Shensi Province. Kaogu(Archaeology), 7: 339-46. State Administration of Cultural Heritage. Shaanxi Volume (II) of Atlas of Chinese Cultural Relics. Xi'an: Xi'an Ditu Chubanshe. 222.

[4] Shaanxi Provincial Institute of Archaeology. 1991. Xi'an Jiaotong University West Han Dynasty Mural Tomb. Xi'an: Xi'an Jiaotong Daxue Chubanshe.

[5] Excavated by Xi'an Institute of Cultural Heritage Conservation and Archaeology, report not published.

[6] Excavated by Xi'an Institute of Cultural Heritage Conservation and Archaeology in 2008, report not published.

[7] Excavated by Shaanxi Provincial Institute of Archaeology at Xi'an Xianyang International Airport in April 2000, report not published.

[8] Shaanxi Provincial Institute of Archaeology. 2003. Anjia Tomb of Northern Zhou at Xi'an. Beijing: Cultural Relics Press .

[9] He Zicheng. 1959. The Tang Tomb Murals. Wenwu(Cultural Relics), 8: 31-33.

[10] Shaanxi Provincial Institute of Archaeology, et al. 2004. Tomb of Prince Jiemin of Tang Dynasty. Beijing: Science Press .

[11] Excavated by Shaanxi Provincial Institute of Archaeology in 2004 at Beilü Village in Fuping County, report not published.

[12] Shaanxi Provincial Institute of Archaeology. 2005. The Tomb of Li Xian of Tang Dynasty. Beijing: Science Press .

[13] Excavated by Shaanxi Provincial Institute of Archaeology in 2002 at New Campus of Shaanxi Normal University in Chang'an County, report not published.

[14] Shaanxi Provincial Institute of Archaeology. 2002. A Tang Tomb with Wall Paintings at Shaanxi Tenth Cotton Plant. Kaogu yu Wenwu (Archaeology and Cultural Relics), 1: 16-37.

[15] Excavated by Shaanxi Provincial Institute of Archaeology in 1995 at Nanling Village in Tiefo Township, Qianxian County, report not published.

目 录 CONTENTS

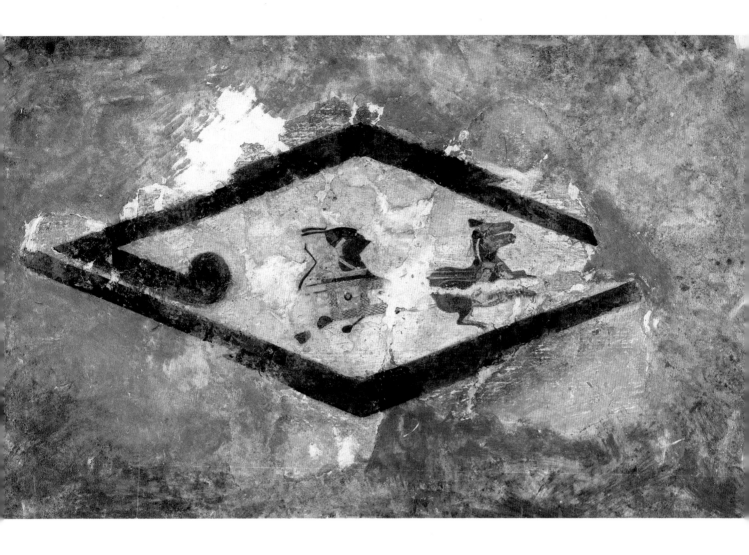

1. 车马出行图（一）

秦（前221～前206年）

长73、宽465厘米

1980年陕西省秦咸阳宫遗址出土。现存于陕西省考古研究院。

位于三号宫殿倒塌堆积层中。为车马出行图，画面略残。

（撰文：汪幼军　摄影：张明惠）

Procession Scene (1)

Qin (221-206 BCE)

Length 73 cm; Width 465 cm

Unearthed from the Qin Palace Site in Xianyang in 1980. Preserved in Shaanxi Provincial Institute of Archaeology.

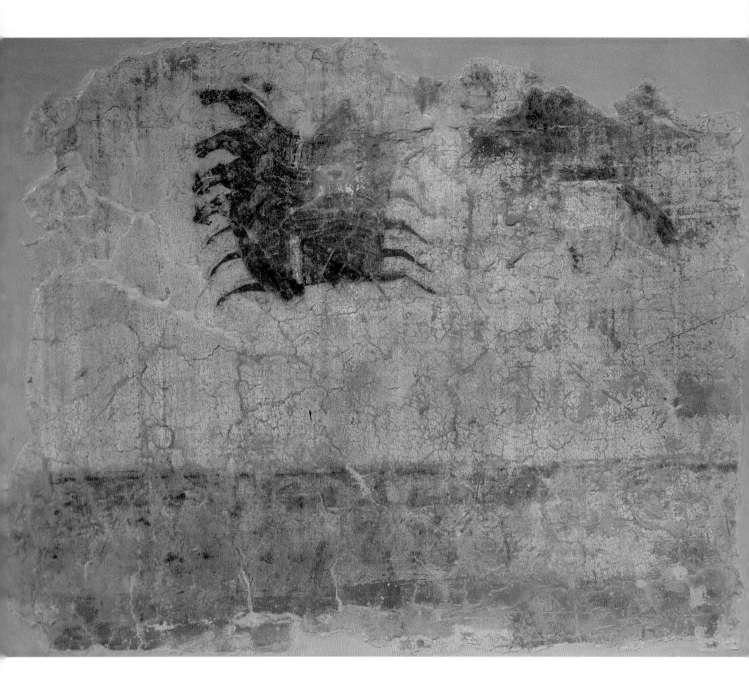

2. 车马出行图（二）

秦（前221～前206年）

长73、宽465厘米

1980年陕西省秦咸阳宫遗址出土。现存于陕西省考古研究院。

位于三号宫殿倒塌堆积层中。为车马出行图，画面略残。

（撰文：汪幼军　摄影：张明惠）

Procession Scene (2)

Qin (221-206 BCE)

Length 73 cm; Width 465 cm

Unearthed from the Qin Palace Site in Xianyang in 1980. Preserved in Shaanxi Provincial Institute of Archaeology.

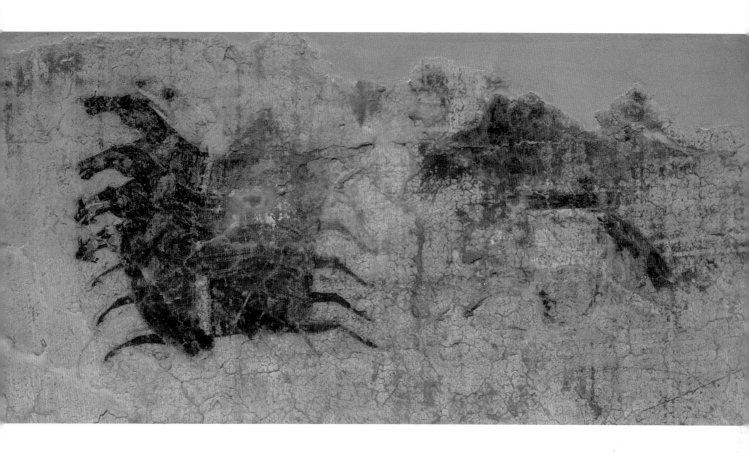

3. 车马出行图（二）（局部）

秦（前221～前206年）

1980年陕西省秦咸阳宫遗址出土。现存于陕西省考古研究院。

位于三号宫殿倒塌堆积层中。为车马出行图，画面略残。

（撰文：汪幼军　摄影：张明惠）

Procession Scene (2)(Detail)

Qin (221-206 BCE)

Unearthed from the Qin Palace Site in Xianyang in 1980. Preserved in Shaanxi Provincial Institute of Archaeology.

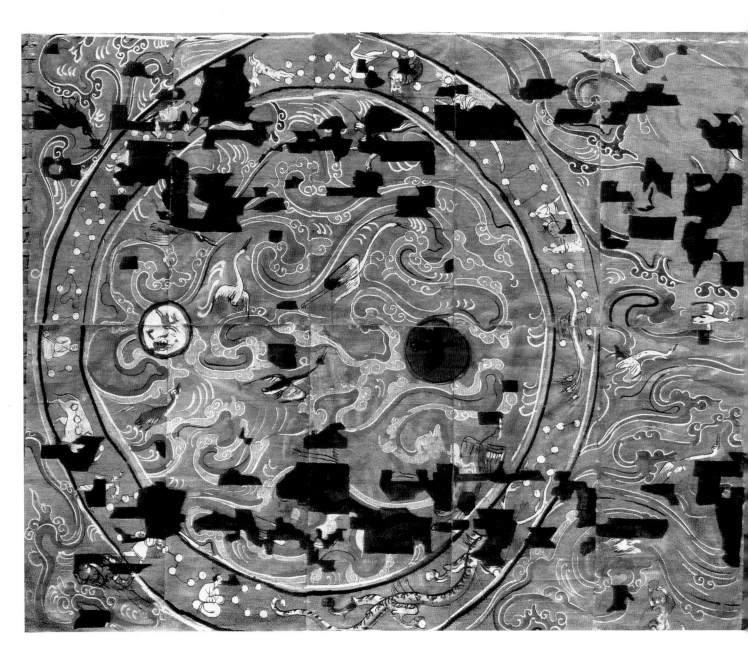

4. 主墓室顶部壁画全景图（摹本）

西汉（前206～25年）

长约450、展开约270厘米

1987年陕西省西安交通大学西汉晚期墓出土。原址保存。

墓向南。位于主墓室拱形顶部。全图偏北绘有直径分别约为270、228厘米的同心圆圈，小圆圈内绘有太阳、月亮、彩云、仙鹤、凤凰等，两圆圈中间绘有星辰及四神，大圆圈外绘有彩云、仙鹤、三足乌等。

（临摹：段卫　撰文、摄影：张明惠）

Full-view of the Vaulted Ceiling of the Main Chamber (Replica)

Western Han (206 BCE - 25 CE)

Length ca. 450 cm; Unfolded Width ca. 270 cm

Unearthed from a Later Western Han Tomb in the Campus of Xi'an Jiaotong University in 1987. Preserved on the original site.

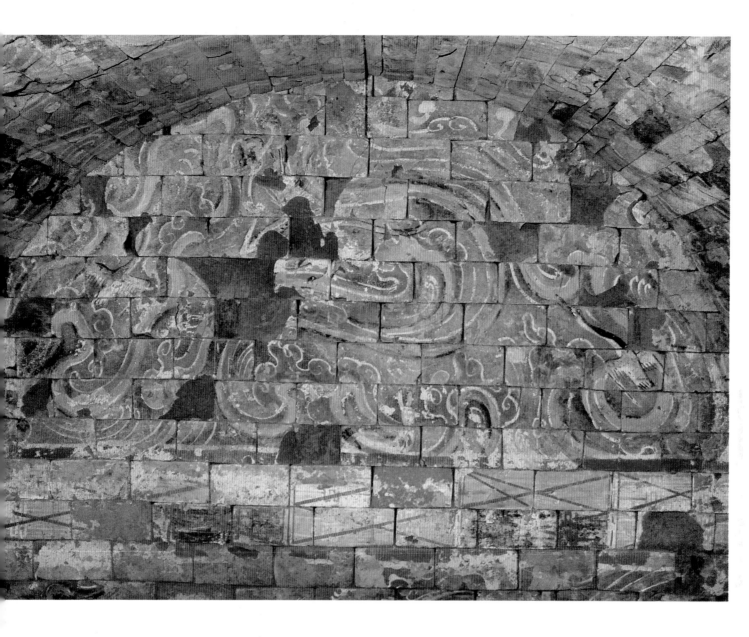

5. 主墓室后壁上部全景图

西汉（前206~25年）

高约100、宽180厘米

1987年陕西省西安交通大学西汉晚期墓出土。原址保存。

墓向南。位于主墓室后壁上部。在彩云缭绕中左右各有一只白色仙鹤向上飞翔，中间下部绘一卧鹿，鹿上方绘一白色物，四足、长卷尾，右前爪举一三叶状物。

（撰文：张明惠 摄影：张明惠）

Full-view of the Upper Part of the Rear Wall of the Main Chamber

Western Han (206 BCE - 25 CE)

Height ca. 100 cm; Width 180 cm

Unearthed from a Later Western Han Tomb in the Campus of Xi'an Jiaotong University in 1987. Preserved on the original site.

6.日轮图

西汉（前206～25年）

直径约30厘米

1987年陕西省西安交通大学西汉晚期墓出土。原址保存。

墓向南。位于主墓室顶部同心圆圈内偏南。日轮饰一圈黑色轮廓线，中间一只向右飞翔状黑色金乌。

（撰文、摄影：张明惠）

The Sun

Western Han (206 BCE - 25 CE)

Diameter ca. 30 cm

Unearthed from a Later Western Han Tomb in the Campus of Xi'an Jiaotong University in 1987. Preserved on the original site.

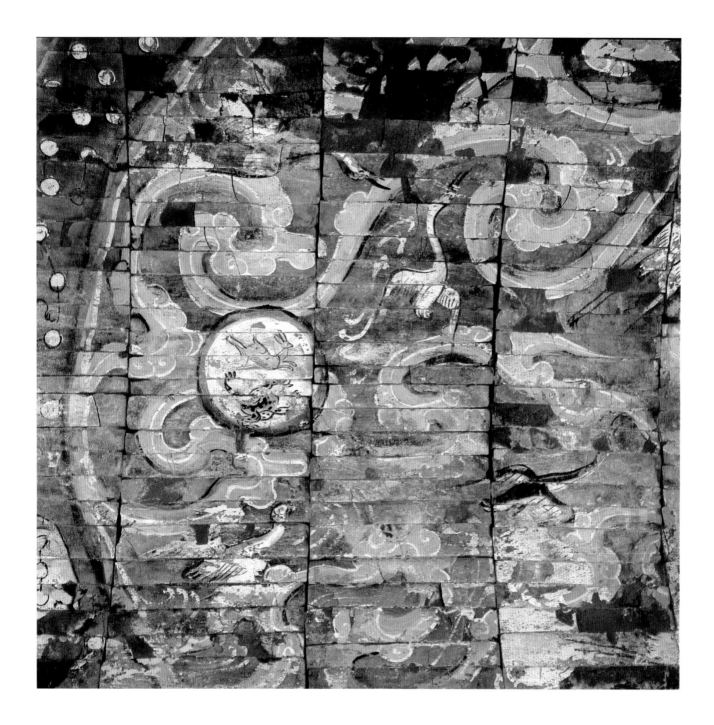

7. 月轮图

西汉（前206～25年）

直径约27厘米

1987年陕西省西安交通大学西汉晚期墓出土。原址保存。

墓向南。位于主墓顶部偏北与太阳相对应位置。月轮饰黑、红两圈轮廓，中间东西分别绘蟾蜍、玉兔，头均向右，玉兔作奔跑状。

<div align="right">（撰文、摄影：张明惠）</div>

The Moon

Western Han (206 BCE - 25 CE)

Diameter ca. 27 cm

Unearthed from a Later Western Han Tomb in the Campus of Xi'an Jiaotong University in 1987. Preserved on the original site.

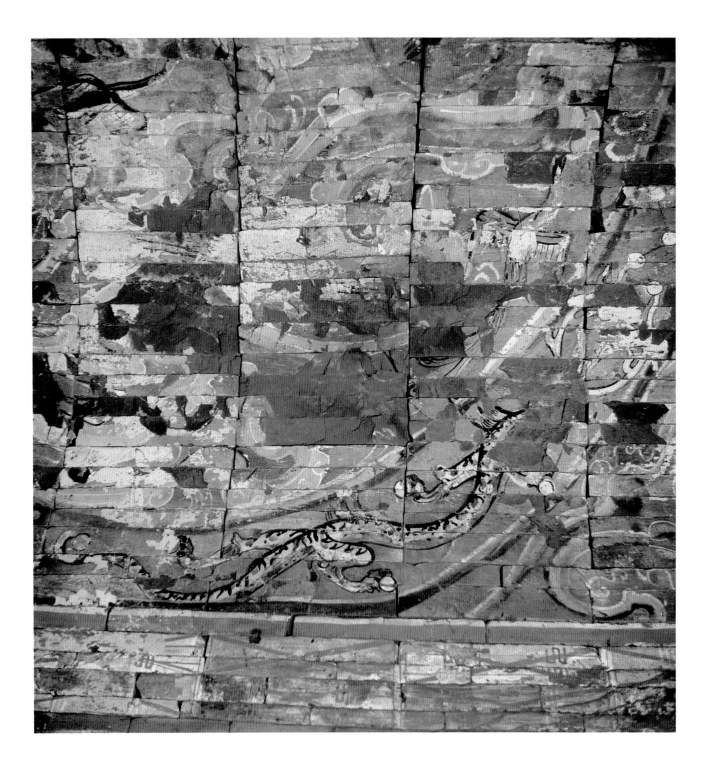

8. 青龙图

西汉（前206～25年）

长约220厘米

1987年陕西省西安交通大学西汉晚期墓出土。原址保存。
墓向南。位于主墓室顶部壁画两同心圆之间东南方向。龙头
向东，头上绘有八颗星，四足及尾巴各有一颗星，仅左后足
下一只星为红色。

（撰文、摄影：张明惠）

Green Dragon

Western Han (206 BCE - 25 CE)

Length ca. 220 cm

Unearthed from a Later Western Han Tomb in the Campus of
Xi'an Jiaotong University in 1987. Preserved on the original site.

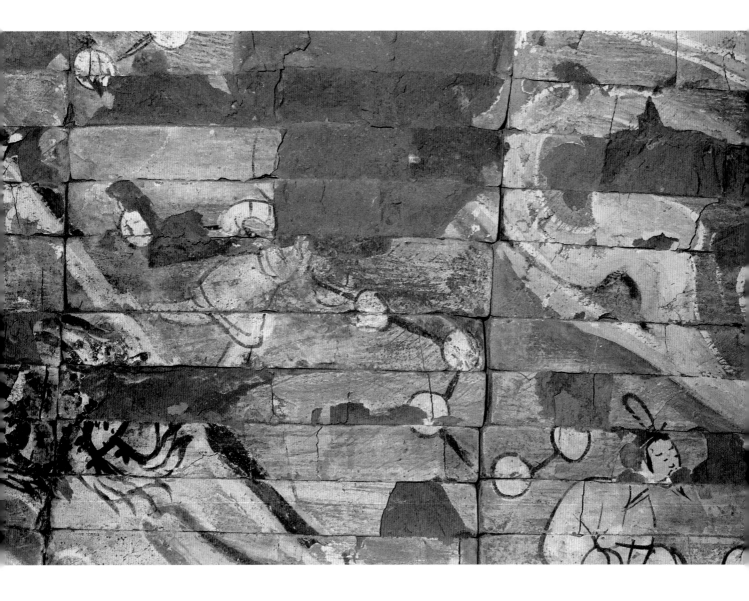

9. 斗宿图

西汉（前206～25年）

长约80、宽50厘米

1987年陕西省西安交通大学西汉晚期墓出土。原址保存。

墓向南。位于主墓室顶部壁画两同心圆之间东北方向。紧接箕宿，由一人与手中持有的七颗星连成的斗组成。

<div align="right">（撰文、摄影：张明惠）</div>

Dou (Dipper) of the 28 Lunar Mansions

Western Han (206 BCE - 25 CE)

Length ca. 80 cm; Width 50 cm

Unearthed from a Later Western Han Tomb in the Campus of Xi'an Jiaotong University in 1987. Preserved on the original site.

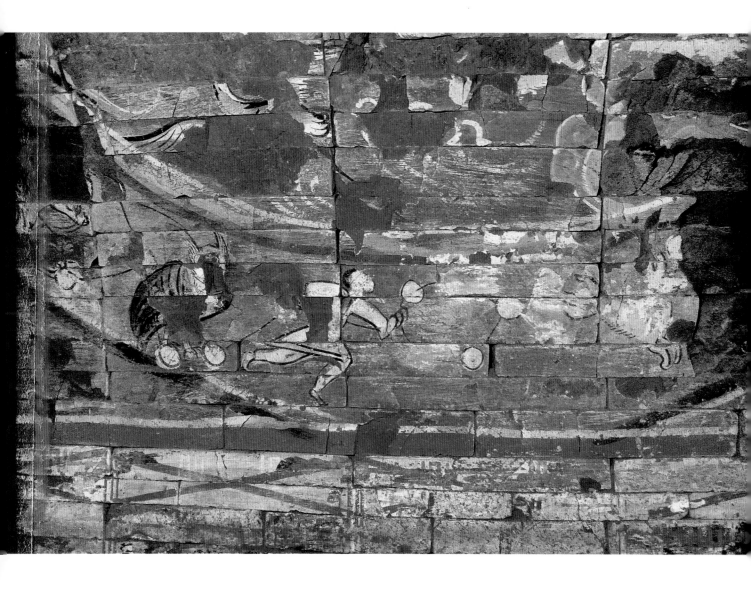

10.毕宿图

西汉（前206～25年）

长约110、宽75厘米

1987年陕西省西安交通大学西汉晚期墓出土。原址保存。

墓向南。位于主墓室顶部壁画两同心圆之间正西方向。一个奔跑的人左手持由七颗星连成的毕，右手另连接一颗星，正在追捕一只拼命逃跑的兔子。

（撰文、摄影：张明惠）

Bi (Net) of the 28 Lunar Mansions

Western Han (206 BCE - 25 CE)

Length ca. 110 cm; Width 75 cm

Unearthed from a Later Western Han Tomb in the Campus of Xi'an Jiaotong University in 1987. Preserved on the original site.

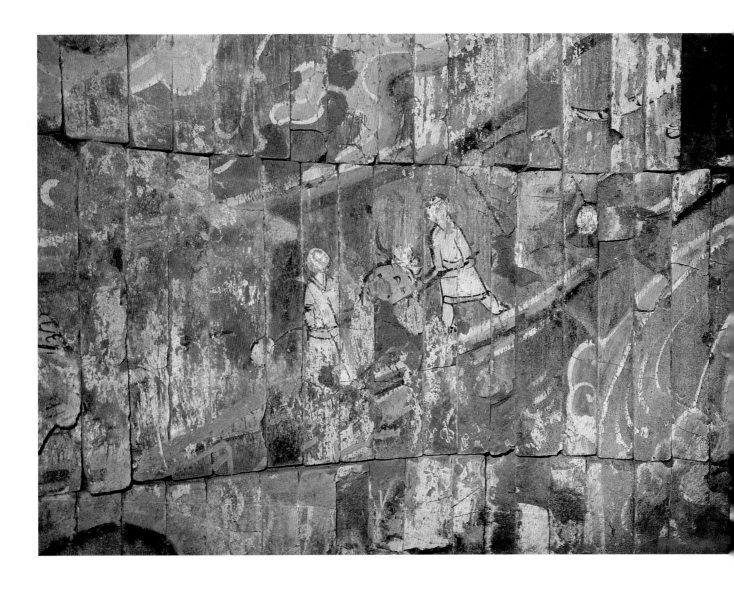

11.井宿、鬼宿图

西汉（前206～25年）

长约75、宽50厘米

1987年陕西省西安交通大学西汉晚期墓出土。原址保存。

墓向南。位于主墓顶部壁画两同心圆之间西南方向。西方白虎参宿之后，四颗星用线连成长方形，随后是双人"舆鬼"图。

（撰文、摄影：张明惠）

Jing (Well) and Gui (Ghost) of the 28 Lunar Mansions

Western Han (206 BCE - 25 CE)

Length ca. 75 cm; Width 50 cm

Unearthed from a Later Western Han Tomb in the Campus of Xi'an Jiaotong University in 1987. Preserved on the original site.

12.三足乌

西汉（前206～25年）

高约34、宽50厘米

1987年陕西省西安交通大学西汉晚期墓出土。原址保存。

墓向南。位于主墓室顶部壁画大圆环西北角。朱红色菱形格栏之上，一只黑色三足乌面南，仰头立于祥云之上。

<div align="right">（撰文、摄影：张明惠）</div>

Three-legged Crow

Western Han (206 BCE - 25 CE)

Height ca. 34 cm; Width 50 cm

Unearthed from a Later Western Han Tomb in the Campus of Xi'an Jiaotong University in 1987. Preserved on the original site.

13.骑马狩猎图（一）

西汉（前206～25年）

高约10、宽15厘米

2004年陕西省西安市南郊西安理工大学西汉壁画墓出土。原址保存。

墓向185°。位于墓室东壁南部。马上人物作拉弓射箭状。

<div align="right">（撰文：张翔宇　摄影：王保平）</div>

Riding and Hunting (1)

Western Han (206 BCE - 25 CE)

Height ca. 10 cm; Width 15 cm

Unearthed from a Western Han Tomb in the Campus of Xi'an University of Technology in 2004. Preserved on the original site.

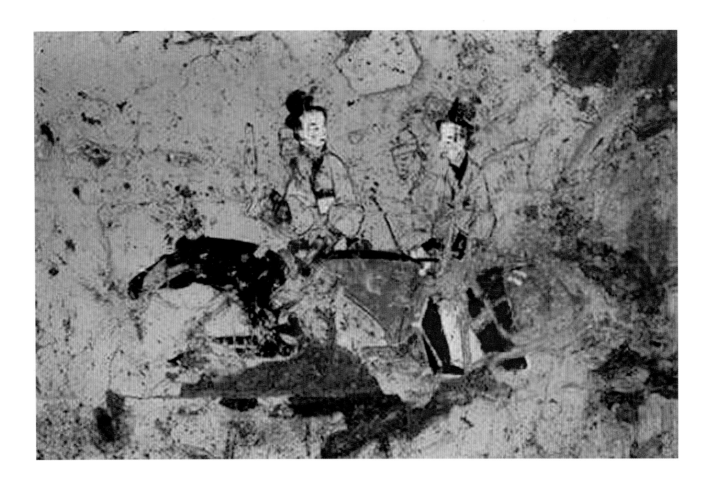

14.骑马狩猎图（二）

西汉（前206～25年）

高约10、宽18厘米

2004年陕西省西安市南郊西安理工大学西汉壁画墓出土。原址保存。

墓向185°。位于墓室东壁南部中部偏上。二人骑马作交谈状。

<div style="text-align: right;">（撰文：张翔宇　摄影：王保平）</div>

Riding and Hunting (2)

Western Han (206 BCE - 25 CE)

Height ca. 10 cm; Width 18 cm

Unearthed from a Western Han Tomb in the Campus of Xi'an University of Technology in 2004. Preserved on the original site.

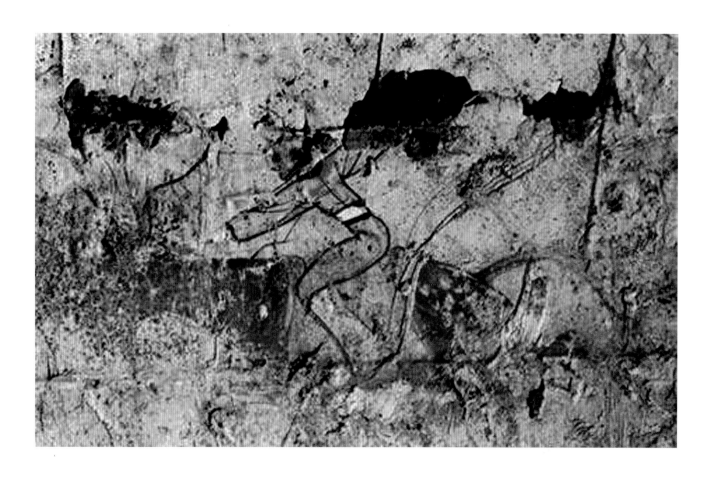

15.骑马狩猎图（三）

西汉（前206～25年）

高约12、宽14厘米

2004年陕西省西安市南郊西安理工大学西汉壁画墓出土。原址保存。

墓向185°。位于墓室东壁中南部偏下。马上人物作拉弓射箭状。

（撰文：张翔宇　摄影：王保平）

Riding and Hunting (3)

Western Han (206 BCE - 25 CE)

Height ca. 12 cm; Width 14 cm

Unearthed from a Western Han Tomb in the Campus of Xi'an University of Technology in 2004. Preserved on the original site.

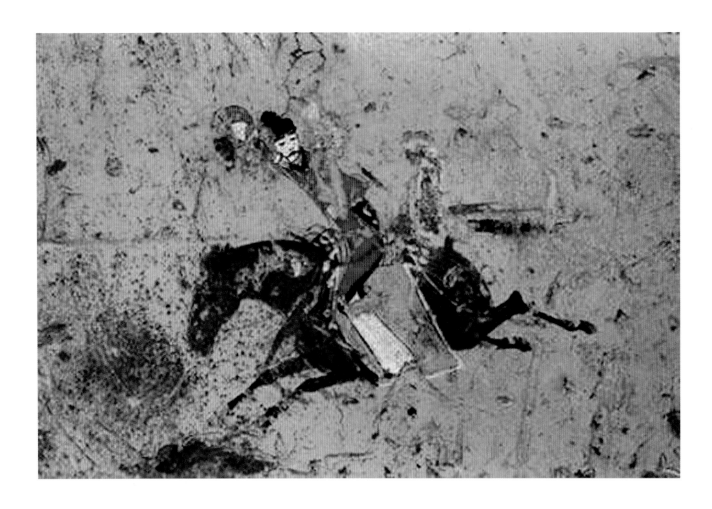

16.骑马狩猎图（四）

西汉（前206～25年）

高约15.5、宽20厘米

2004年陕西省西安市南郊西安理工大学西汉壁画墓出土。原址保存。

墓向185°。位于墓室东壁中偏下部。马上人物作拉弓射箭状。

<div align="right">（撰文：张翔宇　摄影：王保平）</div>

Riding and Hunting (4)

Western Han (206 BCE - 25 CE)

Height ca. 15.5 cm; Width 20 cm

Unearthed from a Western Han Tomb in the Campus of Xi'an University of Technology in 2004. Preserved on the original site.

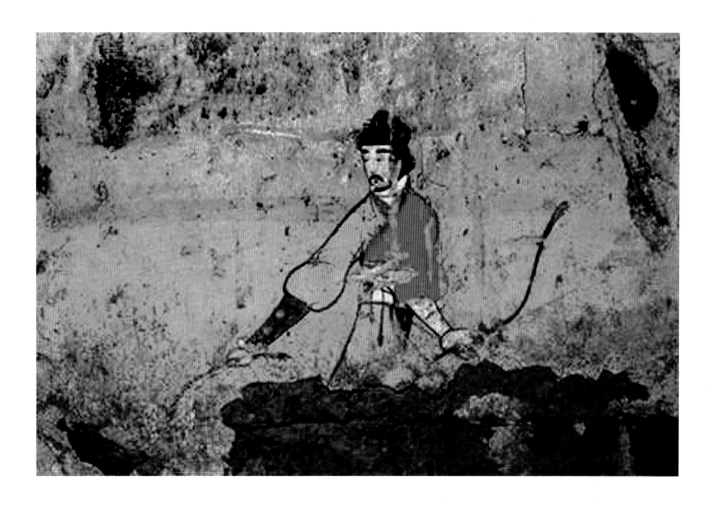

17.骑马狩猎图（五）

西汉（前206～25年）

高约16、宽20厘米

2004年陕西省西安市南郊西安理工大学西汉壁画墓出土。原址保存。

墓向185°。位于墓室东壁中下偏北部。马上人物左手持弓，侧身，作下马捡取猎物状。

（撰文：张翔宇　摄影：王保平）

Riding and Hunting (5)

Western Han (206 BCE - 25 CE)

Height ca. 16 cm; Width 20 cm

Unearthed from a Western Han Tomb in the Campus of Xi'an University of Technology in 2004. Preserved on the original site.

18. 狩猎人物图

西汉（前206～25年）

高约12、宽18厘米

2004年陕西省西安市南郊西安理工大学西汉壁画墓出土。原址保存。

墓向185°。位于墓室东壁中偏北部。狩猎者作徒步追逐野猪状。

（撰文：张翔宇　摄影：王保平）

Hunting on Foot

Western Han (206 BCE - 25 CE)

Height ca. 12 cm; Width 18 cm

Unearthed from a Western Han Tomb in the Campus of Xi'an University of Technology in 2004. Preserved on the original site.

19.骑马狩猎图（六）

西汉（前206～25年）

高约16、宽22厘米

2004年陕西省西安市南郊西安理工大学西汉壁画墓出土。原址保存。

墓向185°。位于墓室东壁北部偏上。马上人物作回射状。

（撰文：张翔宇　摄影：王保平）

Riding and Hunting (6)

Western Han (206 BCE - 25 CE)

Height ca. 16 cm; Width 22 cm

Unearthed from a Western Han Tomb in the Campus of Xi'an University of Technology in 2004. Preserved on the original site.

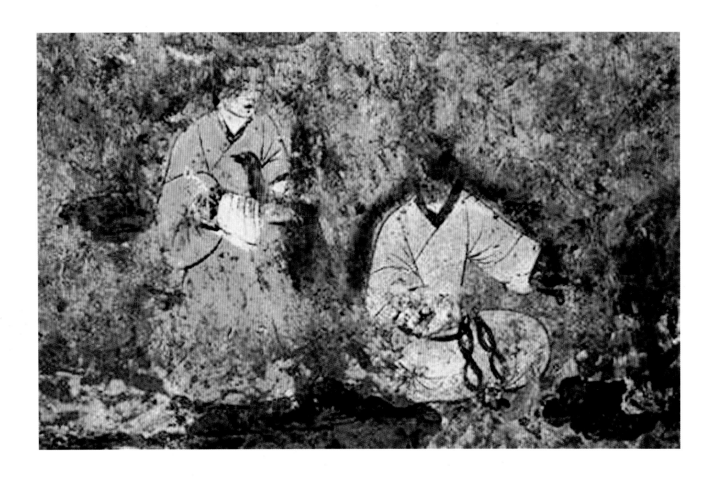

20.欣赏斗鸡人物图（一）

西汉（前206～25年）

高约15、宽20厘米

2004年陕西省西安市南郊西安理工大学西汉壁画墓出土。原址保存。

墓向185°。位于墓室西壁中部偏上。主仆二人作欣赏斗鸡状。

（撰文：张翔宇　摄影：王保平）

Cockfight Watchers (1)

Western Han (206 BCE - 25 CE)

Height ca. 15 cm; Width 20 cm

Unearthed from a Western Han Tomb in the Campus of Xi'an University of Technology in 2004. Preserved on the original site.

21.欣赏斗鸡人物图（二）

西汉（前206～25年）

高约14、宽18厘米

2004年陕西省西安市南郊西安理工大学西汉壁画墓出土。原址保存。

墓向185°。位于墓室西壁中部偏上。作欣赏斗鸡状。

（撰文：张翔宇　摄影：王保平）

Cockfight Watchers (2)

Western Han (206 BCE - 25 CE)

Height ca. 14 cm; Width 18 cm

Unearthed from a Western Han Tomb in the Campus of Xi'an University of Technology in 2004. Preserved on the original site.

22.欣赏乐舞场景图

西汉（前206～25年）

高约40、宽60厘米

2004年陕西省西安市南郊西安理工大学西汉壁画墓出土。原址保存。

墓向185°。位于墓室西壁南部。中间为舞人，四面为欣赏者。

（撰文：张翔宇　摄影：王保平）

Performance Viewing

Western Han (206 BCE - 25 CE)

Height ca. 40 cm; Width 60 cm

Unearthed from a Western Han Tomb in the Campus of Xi'an University of Technology in 2004. Preserved on the original site.

23. 舞人

西汉（前206～25年）

高约15、宽8厘米

2004年陕西省西安市南郊西安理工大学西汉壁画墓出土。原址保存。

墓向185°。位于墓室西壁南部。人物作舞蹈状。

（撰文：张翔宇　摄影：王保平）

Dancing Dancer

Western Han (206 BCE - 25 CE)

Height ca. 15 cm; Width 8 cm

Unearthed from a Western Han Tomb in the Campus of Xi'an University of Technology in 2004. Preserved on the original site.

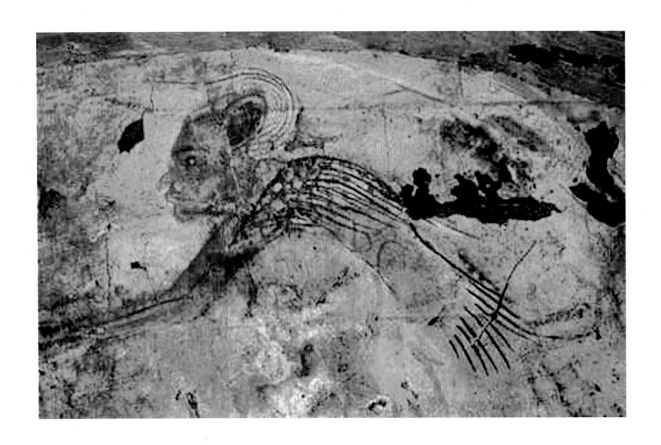

24. 羽人

西汉（前206~25年）

高约60、宽70厘米

2004年陕西省西安市南郊西安理工大学西汉壁画墓出土。原址保存。

墓向185°。位于墓室北壁上部。仙人作乘龙状。

<div align="right">（撰文：张翔宇　摄影：王保平）</div>

Winged Immortal

Western Han (206 BCE - 25 CE)

Height ca. 60 cm; Width 70 cm

Unearthed from a Western Han Tomb in the Campus of Xi'an University of Technology in 2004. Preserved on the original site.

25.墓壁画全景图

西汉（前206～25年）

高约350、宽约140厘米

2008年陕西省西安市曲江翠竹园一号墓出土。原址保存。

墓向10°。位于墓室四壁及券顶之上。四壁之上为贵族家庭生活场景，券顶之上为四神、星宿等天象。

（撰文：张翔宇　摄影：王保平）

Full-view of the Murals of Chamber Shaanxi

Western Han (206 BCE - 25 CE)

Height ca. 350 cm; Width ca. 140 cm

Unearthed from Cuizhuyuan Tomb No. 1 in Qujiang New District of Xi'an, Shaanxi, in 2008. Preserved on the original site.

26.门吏图

西汉（前206～25年）

高约200、宽约70厘米

2008年陕西省西安市曲江翠竹园一号墓出土。原址保存。墓向10°。位于北壁墓门西侧。门吏头梳圆髻，面容丰满，弯眉修长，二目凝视，鼻阔唇红，八字须，络腮胡，身着褐色短襦，下穿白色长裤，足踏黑履，腰间配剑，拢手立于门侧。

（撰文：张翔宇　摄影：王保平）

Petty Official

Western Han (206 BCE - 25 CE)
Height ca. 200 cm; Width ca. 70 cm
Unearthed from Cuizhuyuan Tomb No. 1 in Qujiang New District of Xi'an, Shaanxi, in 2008. Preserved on the original site.

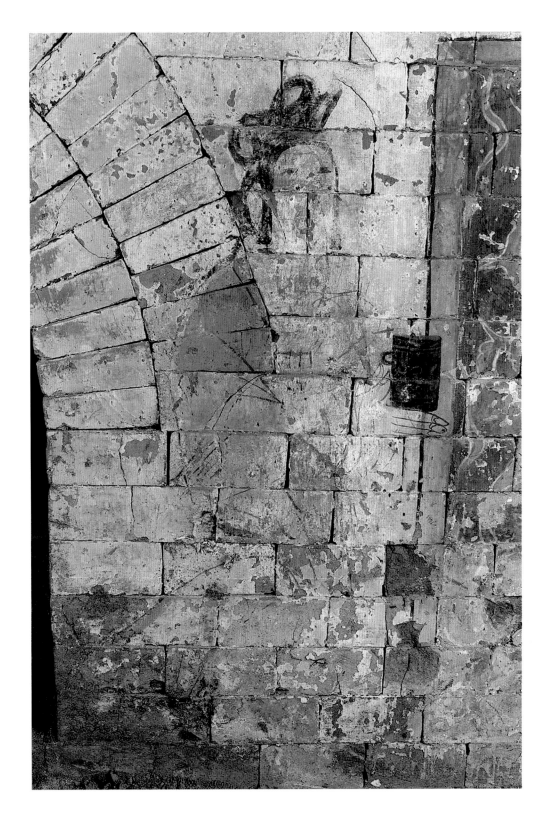

27.捧杯侍女图

西汉（前206～25年）

高约110、宽约70厘米

2008年陕西省西安市曲江翠竹园一号墓出土。原址保存。墓向10°。位于东耳室南侧。捧杯侍女作跪坐状，面向方屏，头挽三环髻，面部圆润，小口红唇，身着绿色袍服，双手捧漆绘卮杯。

（撰文：张翔宇　摄影：王保平）

Maid Holding a Cup

Western Han (206 BCE - 25 CE)
Height ca. 110 cm; Width ca. 70 cm
Unearthed from Cuizhuyuan Tomb
No. 1 in Qujiang New District of
Xi'an, Shaanxi, in 2008. Preserved
on the original site.

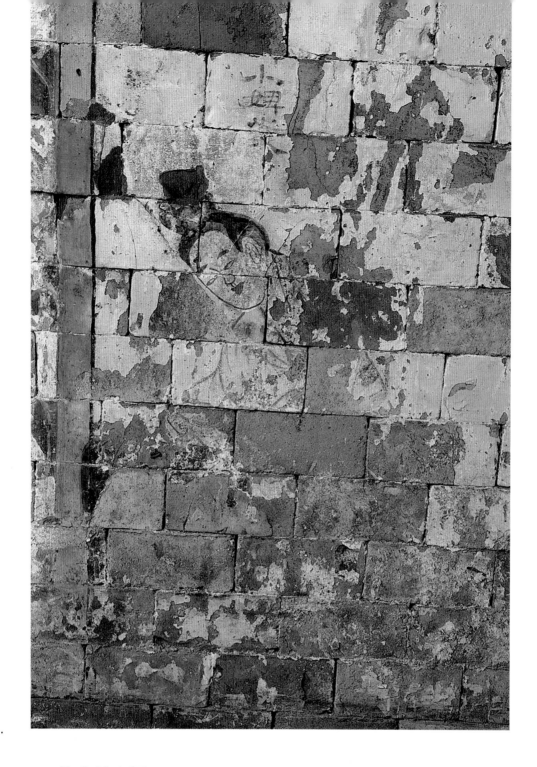

28.捧盒婢女图

西汉（前206～25年）

高约85、宽约50厘米

2008年陕西省西安市曲江翠竹园一号墓出土。原址保存。

墓向10°。位于东壁耳室南侧。内容为一手捧漆盒婢女。婢女头束高髻，面部丰满圆润，柳叶细眉，圆鼻红唇，眼睛斜视。身穿红色襦裙，人物右上方书写"小婢□"三字。

<div align="right">（撰文：张翔宇　摄影：王保平）</div>

Maid Holding a Case

Western Han (206 BCE - 25 CE)

Height ca. 85 cm; Width ca. 50 cm

Unearthed from Cuizhuyuan Tomb No. 1 in Qujiang New District of Xi'an, Shaanxi, in 2008. Preserved on the original site.

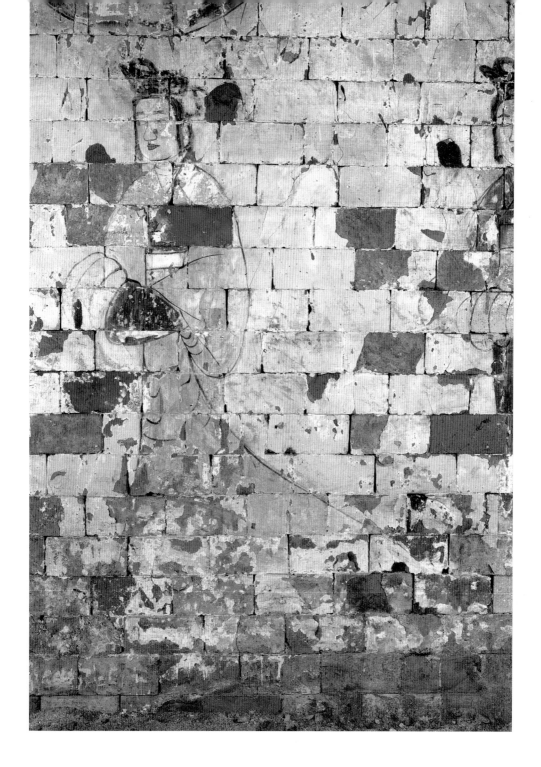

29. 贵妇图

西汉（前206~25年）

高约130、宽约65厘米

2008年陕西省西安市曲江翠竹园一号墓出土。原址保存。

墓向10°。位于墓室东壁中南部。贵妇作站立状，双手拱于袖内，头梳三环髻，面容饱满，粗眉大眼，阔鼻小口，双唇红润。身着青色襦裙，襦袖下垂，裙摆宽大。

（撰文：张翔宇　摄影：王保平）

Noble Lady

Western Han (206 BCE - 25 CE)

Height ca. 130 cm; Width ca. 65 cm

Unearthed from Cuizhuyuan Tomb No. 1 in Qujiang New District of Xi'an, Shaanxi, in 2008.
Preserved on the original site.

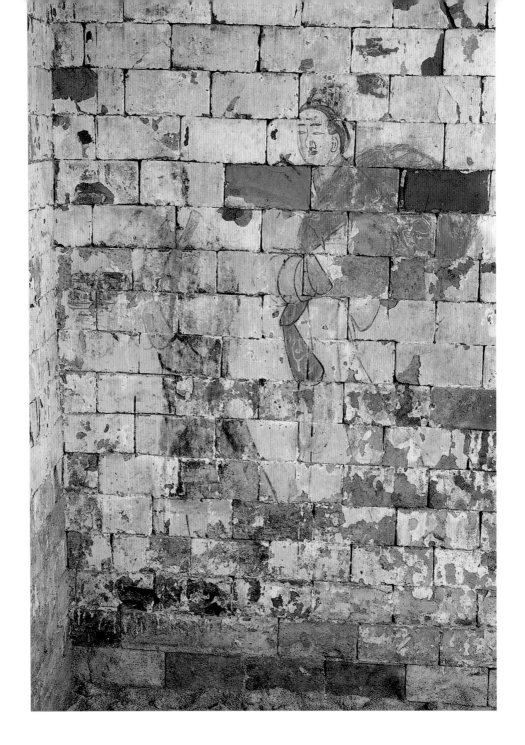

30. 婢女侍奉图

西汉（前206～25年）

高约120、宽约90厘米

2008年陕西省西安市曲江翠竹园一号墓出土。原址保存。

墓向10°。位于南壁东部。内容为两位侍女，一前一后站立。前者，束发圆脸，粗眉大眼，小口红唇，身着褐色襦衣，足踏黑履，手捧漆盒。后者，头梳高髻，鬓角分明，面部丰润，柳叶眉，丹凤眼，平视前方，勾鼻红唇，身着襦裙，裙摆及地，身背红色包袱。

（撰文：张翔宇　摄影：王保平）

Attending Maids

Western Han (206 BCE - 25 CE)

Height ca. 120 cm; Width ca. 90 cm

Unearthed from Cuizhuyuan Tomb No. 1 in Qujiang New District of Xi'an, Shaanxi, in 2008. Preserved on the original site.

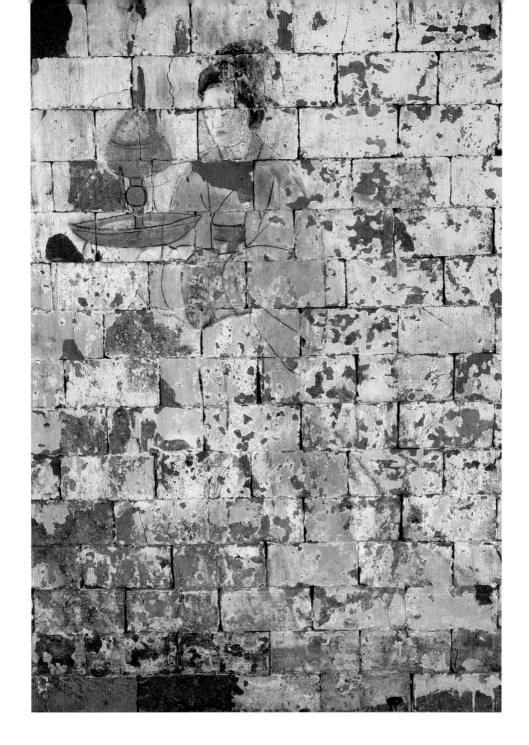

31. 捧熏炉侍女图

西汉（前206～25年）

高约125、宽约50厘米

2008年陕西省西安市曲江翠竹园一号墓出土。原址保存。

墓向10°。位于墓室南壁中部。侍女，头梳高髻，面容丰满，二目下视，阔鼻小口，身着浅黄宽博长衣，手捧熏炉，毕恭毕敬。

（撰文：张翔宇　摄影：王保平）

Maid Holding Censer

Western Han (206 BCE - 25 CE)

Height ca. 125 cm; Width ca. 50 cm

Unearthed from Cuizhuyuan Tomb No. 1 in Qujiang New District of Xi'an, Shaanxi, in 2008. Preserved on the original site.

32.抱婴婢女图

西汉（前206～25年）

高约150、宽约100厘米

2008年陕西省西安市曲江翠竹园一号墓出土。原址保存。

墓向10°。位于西壁南部。内容为婢女看护贵族婴幼儿。婢女，头梳圆髻，面容丰满，短粗眉，丹凤眼，大口红唇，身着绿色襦裙，右臂怀抱婴儿，左手牵一儿童。

（撰文：张翔宇　摄影：王保平）

Maid Holding Baby

Western Han (206 BCE - 25 CE)

Height ca. 150 cm; Width ca. 100 cm

Unearthed from Cuizhuyuan Tomb No. 1 in Qujiang New District of Xi'an, Shaanxi, in 2008. Preserved on the original site.

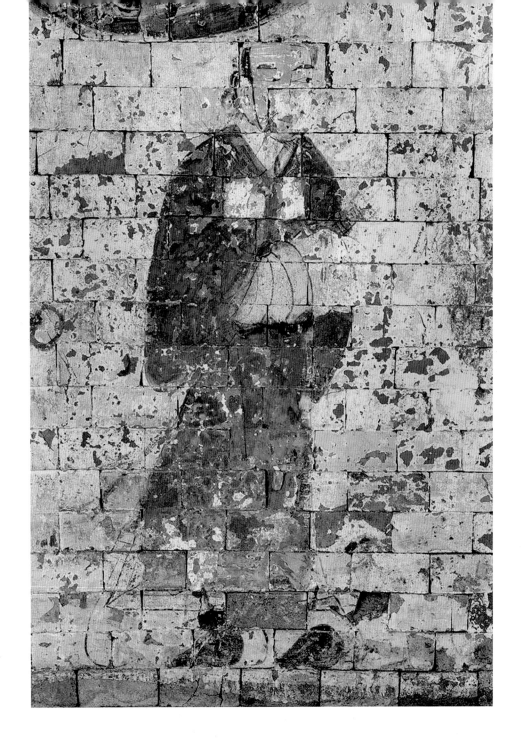

33. 佩剑武士图

西汉（前206~25年）

高约150、宽约70厘米

2008年陕西省西安市曲江翠竹园一号墓出土。原址保存。

墓向10°。位于西壁北部。武士头梳小圆髻，颌下细缨，面部圆润，粗眉大眼，阔口红唇，八字须，上着褐色短襦，下穿宽大长裤，足踏黑履，腰系长剑，威武雄壮。

（撰文：张翔宇　摄影：王保平）

Warrior Wearing Sword

Western Han (206 BCE - 25 CE)

Height ca. 150 cm; Width ca. 70 cm

Unearthed from Cuizhuyuan Tomb No. 1 in Qujiang New District of Xi'an, Shaanxi, in 2008. Preserved on the original site.

34. 佩刀武士图

西汉（前206～25年）

高约140、宽约90厘米

2008年陕西省西安市曲江翠竹园一号墓出土。原址保存。

墓向10°。位于西壁北部。武士作站立状，怀抱长刀，面容丰满，粗眉大眼，阔鼻大口，八字须。身着褐色襦衣，下穿白色长裤，足踏黑履。

（撰文：张翔宇　摄影：王保平）

Warrior Holding Sword

Western Han (206 BCE - 25 CE)

Height ca. 140 cm; Width ca. 90 cm

Unearthed from Cuizhuyuan Tomb No. 1 in Qujiang New District of Xi'an, Shaanxi, in 2008. Preserved on the original site.

35. 天象图

西汉（前206～25年）

高约420、宽约190厘米

2008年陕西省西安市曲江翠竹园一号墓出土。原址保存。

墓向10°。位于券顶南部。内容为太阳、星宿与云气，太阳涂红，内有金乌，星宿六组计二十颗，其中三组完整，三组残缺。

（撰文：张翔宇　摄影：王保平）

Celestial Bodies

Western Han (206 BCE - 25 CE)

Height ca. 420 cm; Width ca. 190 cm

Unearthed from Cuizhuyuan Tomb No. 1 in Qujiang New District of Xi'an, Shaanxi, in 2008. Preserved on the original site.

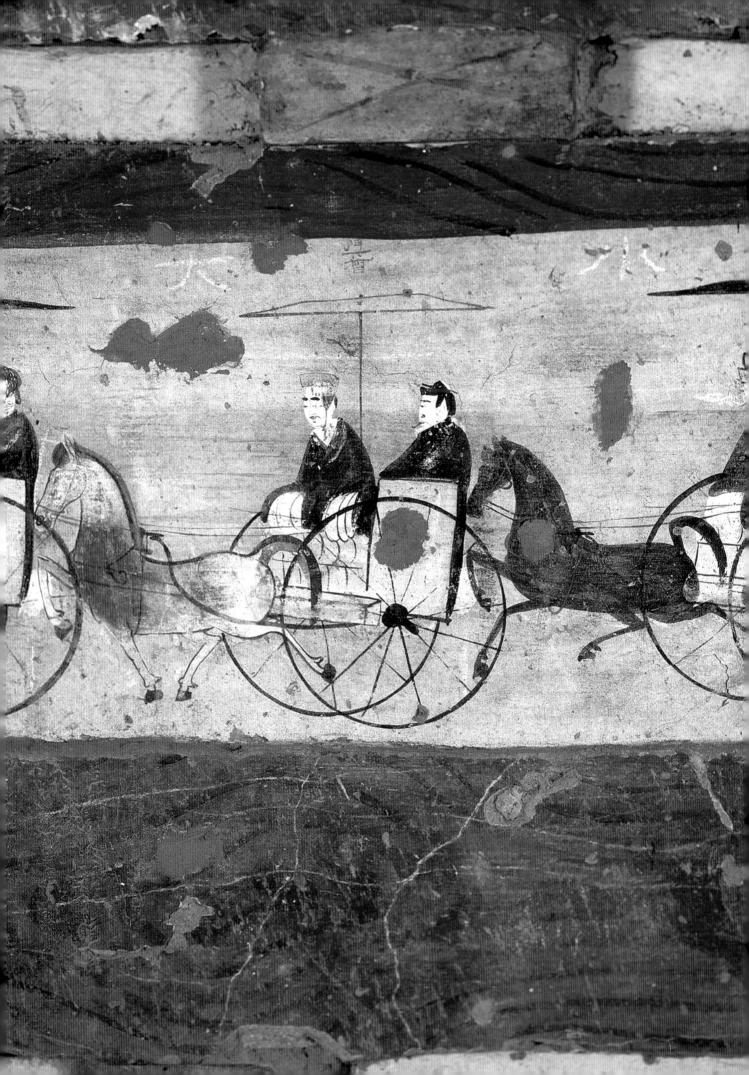

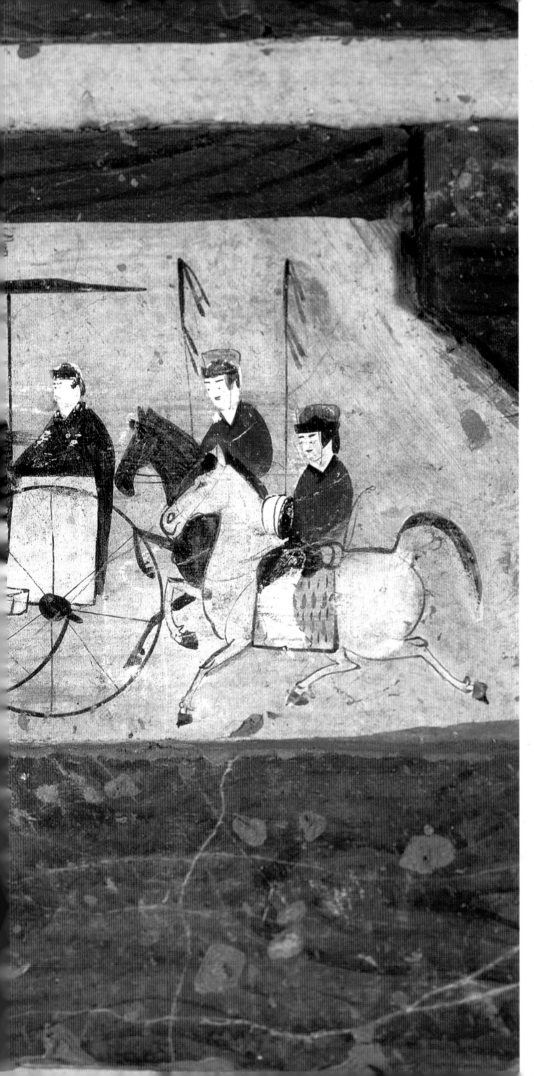

36. 车马骑从仪仗出行图（局部一）

新（9~23年）

整体高26、宽115厘米

2009年陕西省靖边县杨桥畔镇杨桥畔二村南侧渠树壕汉墓出土。现存于陕西省考古研究院。

墓向205°。位于墓室前室东壁上栏的斗拱间，为车马出行图。画面先以红绿等色打出底稿，再以黑色颜料勾勒轮廓，以各种色彩填充轮廓内各部位。车骑顶端有"戌曹"、"门下曹"等墨书榜题。

（撰文：马明志　摄影：张明惠、
张庆波）

Procession Scene (Detail 1)

Xin (9-23 CE)

Height 26 cm (total); Width 115 cm

Unearthed from a Tomb to the South of Village No. 2 of Yangqiaopan in Jingbian, Shaanxi, in 2009. Preserved in Shaanxi Provincial Institute of Archaeology.

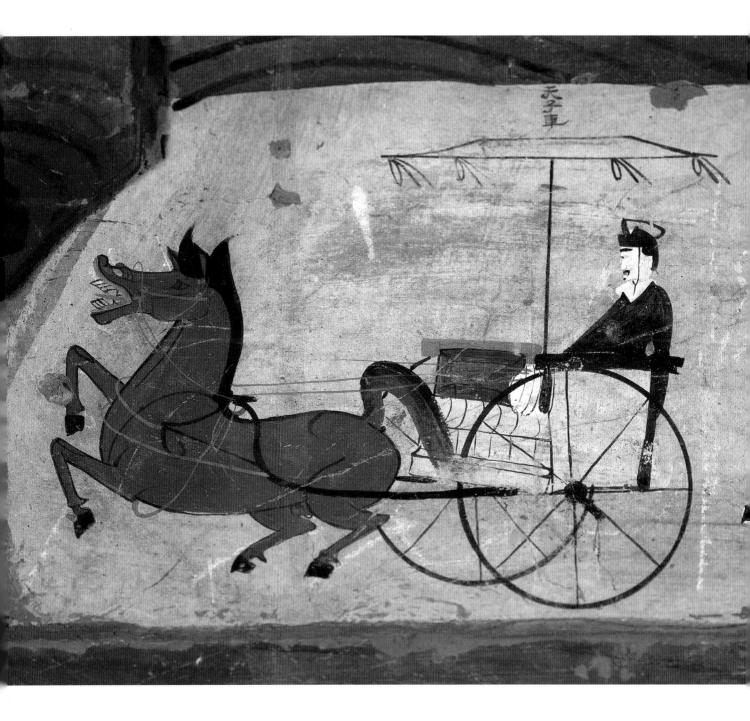

37. 车马骑从仪仗出行图（局部二）

新（9~23年）

整体高26、宽115厘米

2009年陕西省靖边县杨桥畔镇杨桥畔二村南侧渠树壕汉墓出土。现存于陕西省考古研究院。

墓向205°。位于墓室前室东壁上栏的斗拱间，为车马出行图。画面先以红绿等色打出底稿，再以黑色颜料勾勒轮廓，以各种色彩填充轮廓内各部位。车骑顶端有"天子车"墨书榜题。

<div align="right">（撰文：马明志　摄影：张明惠、张庆波）</div>

Procession Scene (Detail 2)

Xin (9-23 CE)

Height 26 cm (total); Width 115 cm

Unearthed from a Tomb to the South of Village No. 2 of Yangqiaopan in Jingbian, Shaanxi, in 2009. Preserved in Shaanxi Provincial Institute of Archaeology.

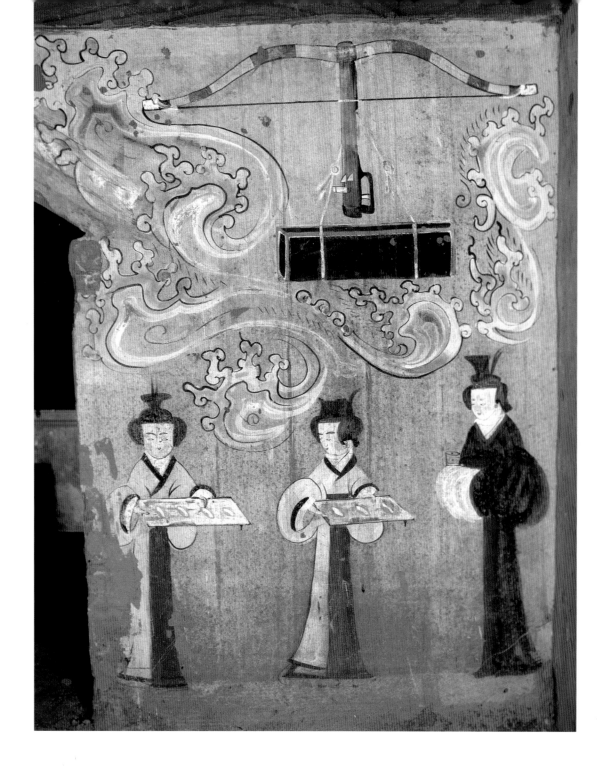

38.悬弩、侍女图

新（9~23年）

高158、宽88厘米

2009年陕西省靖边县杨桥畔镇杨桥畔二村南侧渠树壕汉墓出土。现存于陕西省考古研究院。

墓向205°。位于墓室前室东壁下栏的耳室门南侧。画面上部为一架弩和矢匣，下方为三位侍女，其中两位双手托案，案内置盛酒的耳杯，并以祥云纹环绕填白。

（撰文：马明志　摄影：张明惠、张庆波）

Hanging Crossbow and Attending Maids

Xin (9-23 CE)

Height 158 cm; Width 88 cm

Unearthed from a Tomb to the South of Village No. 2 of Yangqiaopan in Jingbian, Shaanxi, in 2009. Preserved in Shaanxi Provincial Institute of Archaeology.

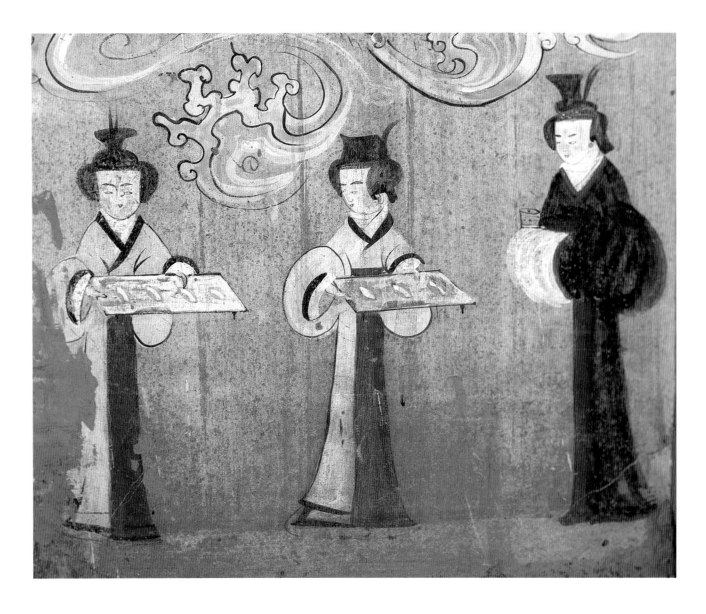

39.悬弩、侍女图（局部）

新（9~23年）

2009年陕西省靖边县杨桥畔镇杨桥畔二村南侧渠树壕汉墓出土。现存于陕西省考古研究院。

墓向205°。位于墓室前室东壁下栏的耳室门南侧。画面上部为一架弩和矢匣，下方为三位侍女，其中两位双手托案，案内置盛酒的耳杯，并以祥云纹环绕填白。

<div align="right">（撰文：马明志　摄影：张明惠、张庆波）</div>

Hanging Crossbow and Attending Maids (Detail)

Xin (9-23 CE)

Unearthed from a Tomb to the South of Village No. 2 of Yangqiaopan in Jingbian, Shaanxi, in 2009. Preserved in Shaanxi Provincial Institute of Archaeology.

40. 鹰、弩、拜谒图

新（9~23年）

高110、宽190厘米

2009年陕西省靖边县杨桥畔镇杨桥畔二村南侧渠树壕汉墓出土。现存于陕西省考古研究院。

墓向205°。位于墓室前室西耳室南壁。画面上部右侧为二架弩，左侧为一只站立状的鹰，下方为一长跪拜谒的男子。画面底色为预先涂抹的青绿色涂料。

<div style="text-align: right">（撰文：马明志　摄影：张明惠、张庆波）</div>

Eagle, Hanging Crossbows and Submitting Official

Xin (9-23 CE)

Height 110 cm; Width 190 cm

Unearthed from a Tomb to the South of Village No. 2 of Yangqiaopan in Jingbian, Shaanxi, in 2009. Preserved in Shaanxi Provincial Institute of Archaeology.

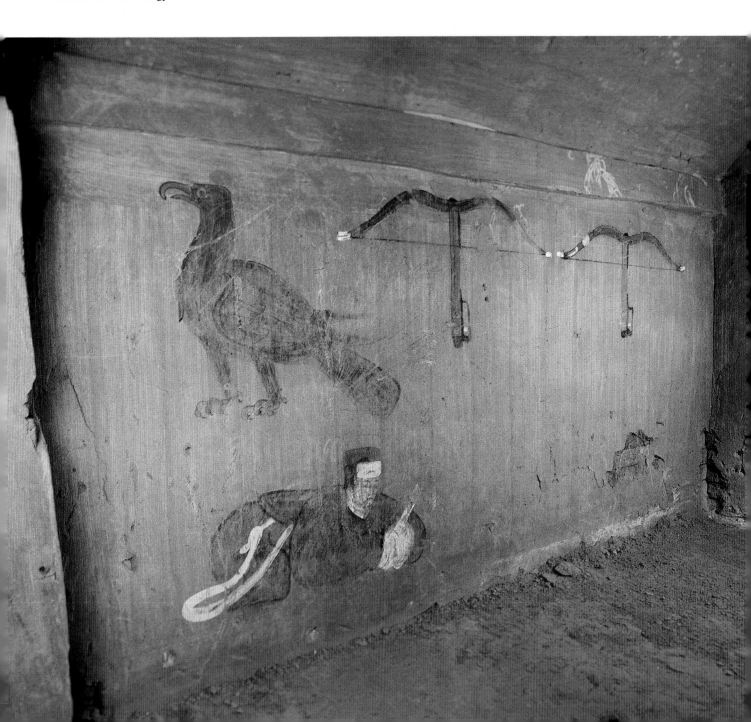

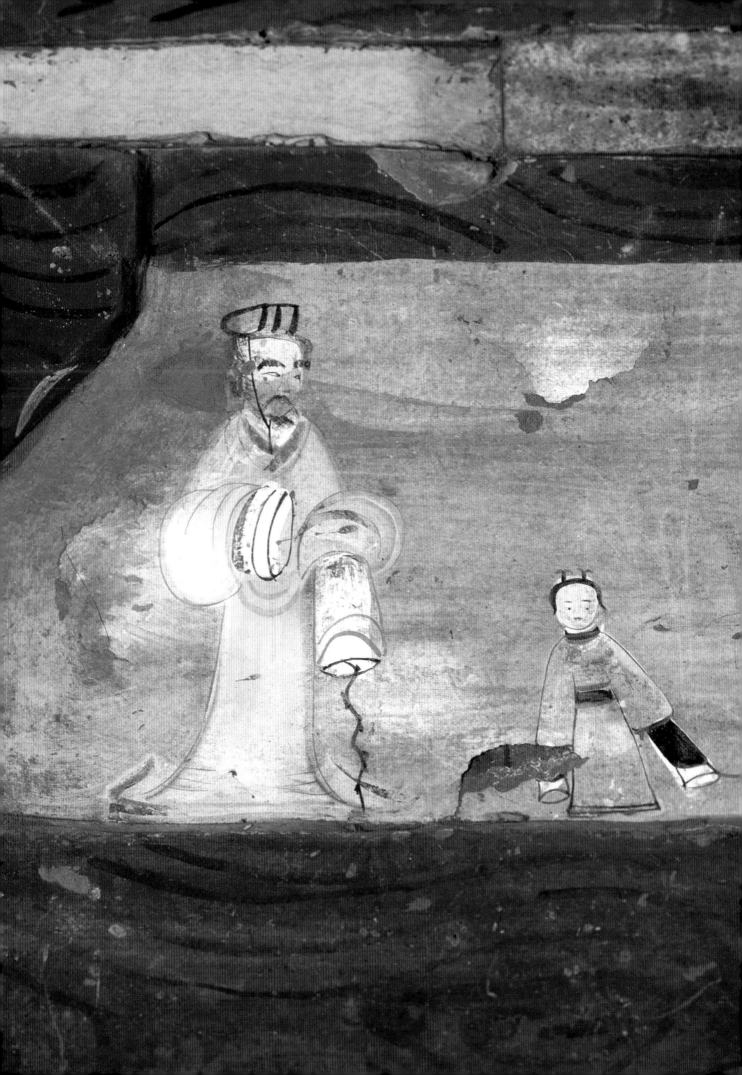

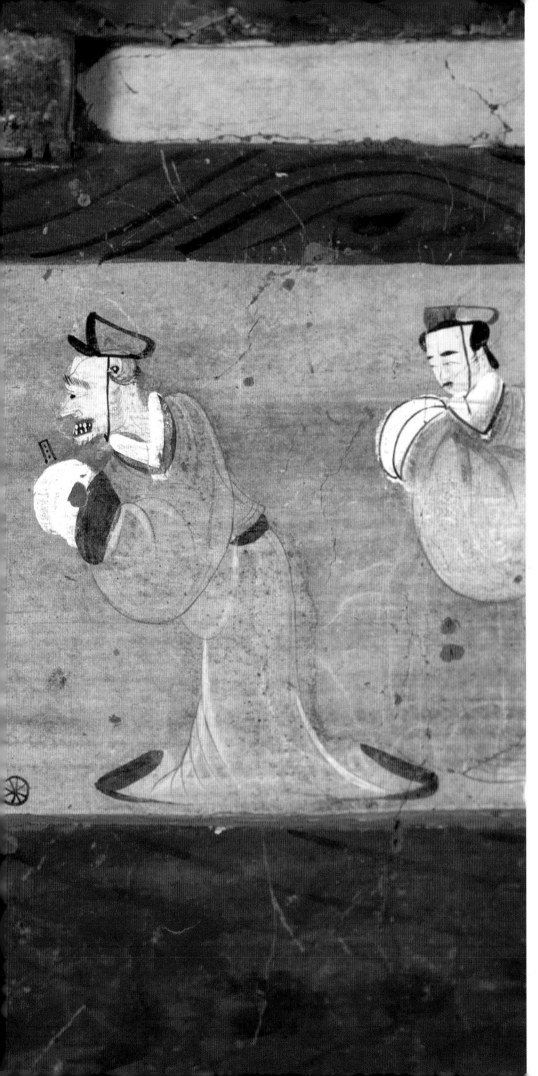

41. 孔子见老子图（局部）

新（9~23年）

整体高27、宽117厘米

2009年陕西省靖边县杨桥畔镇杨桥畔二村南侧渠树壕汉墓出土。现存于陕西省考古研究院。墓向205°。位于墓室前室西壁上栏南侧。画面由左至右依次为老子、童子、孔子及其随从门徒。老子身着紫色长袍，左手拄着一支弯曲的树枝作为拐杖，面庞丰满红润，自然站立，神态自若，侧视孔子。孔子面庞消瘦憔悴，身体前躬，双手持笏作拜谒状，弟子亦作拜谒状。老子身边的童子左手以线绳牵玩具车，车体为鸟身形。画面充分表现出道家的恬淡和儒家的恭谨风范。

（撰文：马明志　摄影：张明惠、张庆波）

Confucius Meeting Laozi (Detail)

Xin (9-23 CE)

Height 27 cm (total); Width 117 cm

Unearthed from a Tomb to the South of Village No. 2 of Yangqiaopan in Jingbian, Shaanxi, in 2009. Preserved in Shaanxi Provincial Institute of Archaeology.

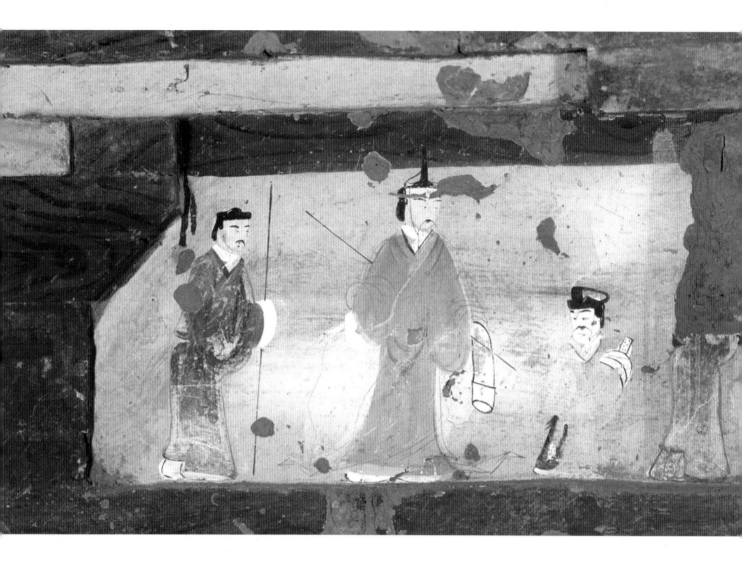

42.二桃杀三士图

新（9~23年）

高27、宽118厘米

2009年陕西省靖边县杨桥畔镇杨桥畔二村南侧渠树壕汉墓出土。现存于陕西省考古研究院。

墓向205°。位于墓室前室西壁上栏北侧。画面正中置案几，几上放置二桃，案几右侧为三士形象（公孙接、田开疆和古冶子），案几左侧第一人上身画面残损，面向三士弓身站立，拄杖，可能为齐相晏子。左侧第二人呈踞坐状，双手持笏，可能为晏子之随从。左侧第三人身着绿色长袍作站立状，应为齐景公，侧视三士，右手向后面的持戟卫士伸出二个手指，可能意指二桃杀三士。画面寓意和人物神态极为逼真传神。

（撰文：马明志　摄影：张明惠、张庆波）

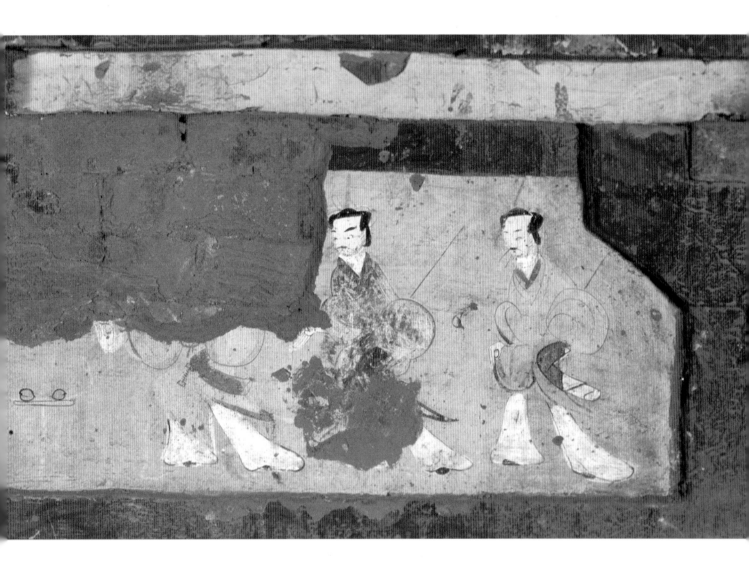

Killing Three Brave Men by Serving Them Two Peaches

Xin (9-23 CE)

Height 27 cm (total); Width 118 cm

Unearthed from a Tomb to the South of Village No. 2 of Yangqiaopan in Jingbian, Shaanxi, in 2009. Preserved in Shaanxi Provincial Institute of Archaeology.

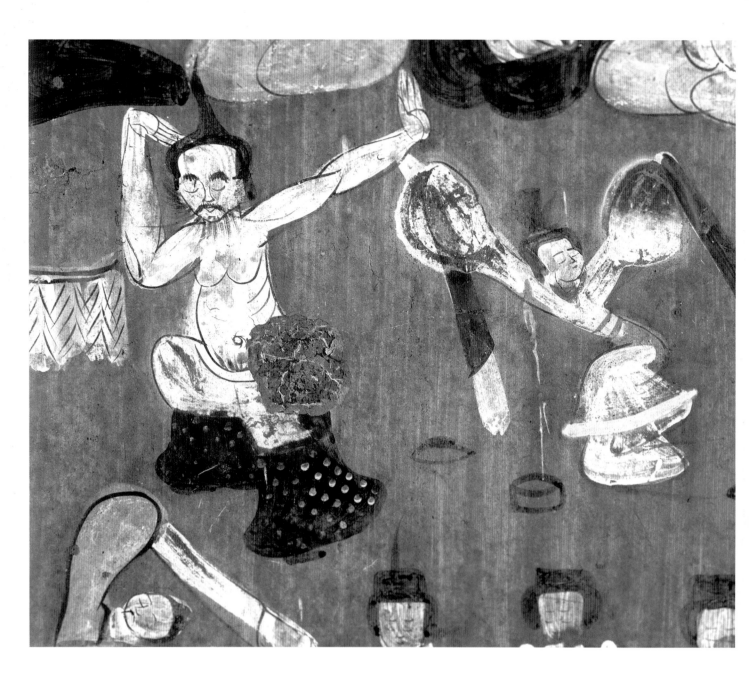

43. 乐舞图（局部）

新（9~23年）

高105、宽145厘米

2009年陕西省靖边县杨桥畔镇杨桥畔二村南侧渠树壕汉墓出土。现存于陕西省考古研究院。

墓向205°。位于墓室后室东壁下栏北侧。画面由吹弹各种乐器的女子、击打建鼓者以及男女舞者组成。其中男子上身赤裸，肌肉强健，可能正在进行武术表演；而女子挥舞长袖，双脚舞动于覆置在地面的碗碟之上；阳刚与柔媚相映，动静相衬，气氛欢愉。

（撰文：马明志　摄影：张明惠、张庆波）

Music and Dancing Performance (Detail)

Xin (9-23 CE)

Height 105 cm; Width 145 cm

Unearthed from a Tomb to the South of Village No. 2 of Yangqiaopan in Jingbian, Shaanxi, in 2009. Preserved in Shaanxi Provincial Institute of Archaeology.

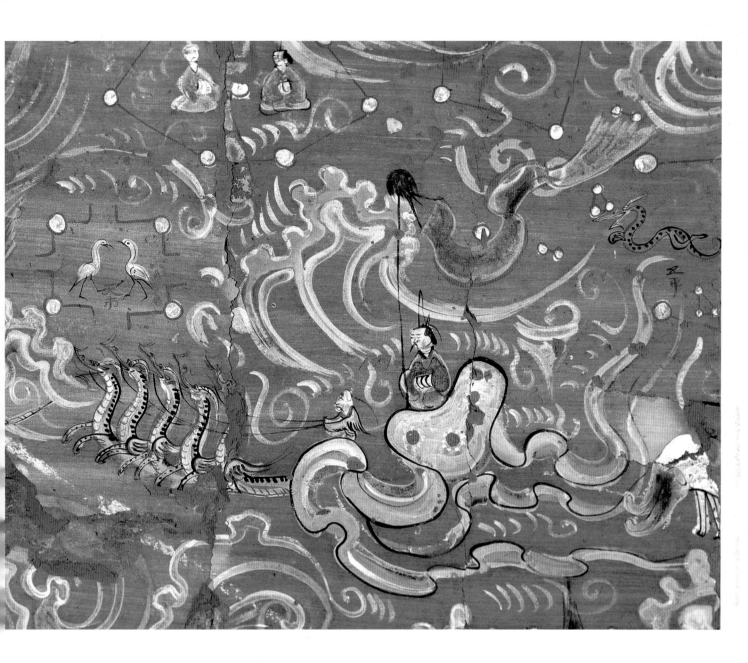

44.天象图（局部一）

新（9~23年）

高68、宽105厘米

2009年出于陕西省靖边县杨桥畔镇杨桥畔二村南侧渠树壕汉墓出土。现存于陕西省考古研究院。

墓向205°。位于墓室前室顶部。由多组星宿和具象的神仙、动物组成，每个星宿对应不同的具象题材，星宿旁题星宿名，有五车、天市、史角、毕星等。星宿间以祥云填白，画面极其繁缛，表现出程式化的布局和题材特征。

（撰文：马明志　摄影：张明惠、张庆波）

Celestial Bodies (Detail 1)

Xin (9-23 CE)

Height 68 cm; Width 105 cm

Unearthed from a Tomb to the South of Village No. 2 of Yangqiaopan in Jingbian, Shaanxi, in 2009. Preserved in Shaanxi Provincial Institute of Archaeology.

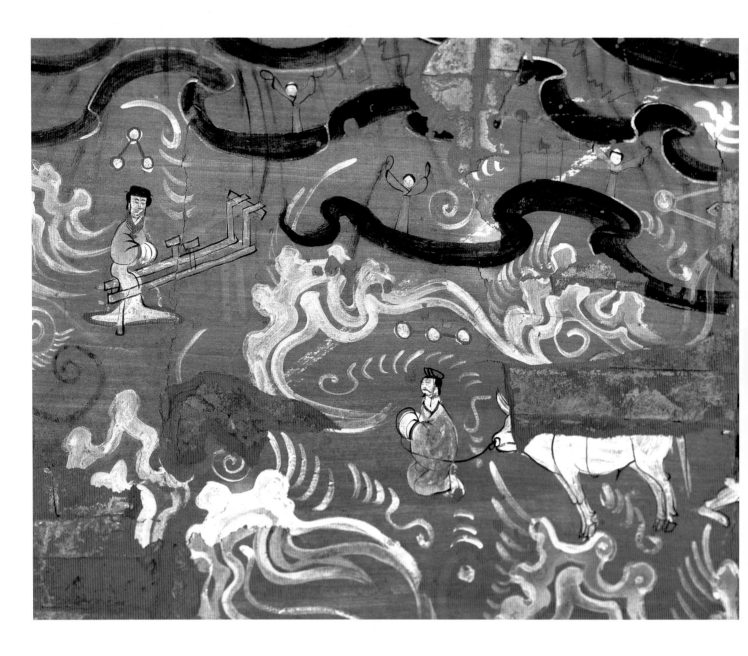

45.天象图（局部二）

新（9~23年）

高68、宽105厘米

2009年陕西省靖边县杨桥畔镇杨桥畔二村南侧渠树壕汉墓出土。现存于陕西省考古研究院。

墓向205°。位于墓室前室顶部。由多组星宿和具象的神仙、动物组成，每个星宿对应不同的具象题材。本画面局部反映的是织女和牵牛两个星宿及其对应的具象人物。织女端坐于织布机之上，牵牛作踞坐状，手牵一头白色的公牛。织女与牵牛星宿之上为雷公、电母、风伯及众小神击鼓、降雨、放电、扇风的场面，众神周边为重重乌云。星宿间以祥云填白。

（撰文：马明志　摄影：张明惠、张庆波）

Celestial Bodies (Detail 2)

Xin (9-23 CE)

Height 68 cm; Width 105 cm

Unearthed from a Tomb to the South of Village No. 2 of Yangqiaopan in Jingbian, Shaanxi, in 2009. Preserved in Shaanxi Provincial Institute of Archaeology.

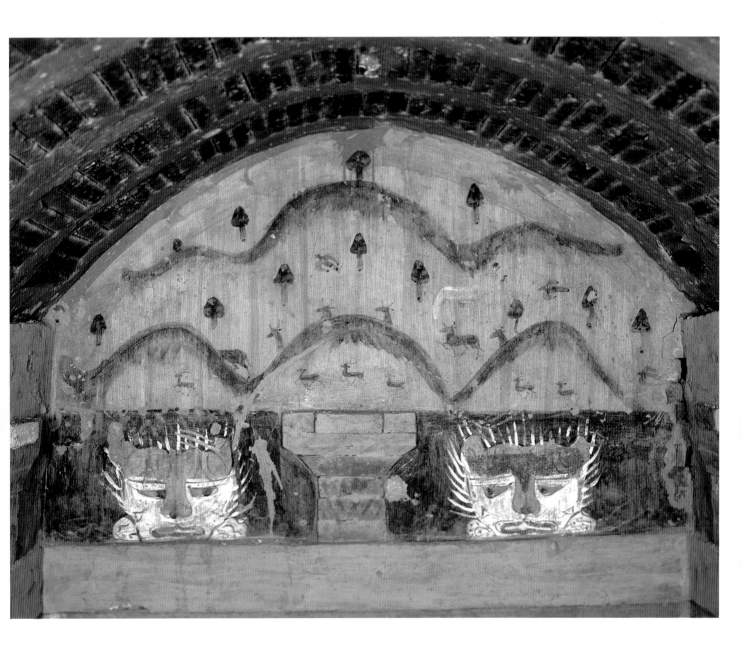

46. 镇墓神及山野图

新（9~23年）

高152、宽172厘米

2009年陕西省靖边县杨桥畔镇杨桥畔二村南侧渠树壕汉墓出土。现存于陕西省考古研究院。

墓向205°。位于墓室后壁中上部。中段以斗拱隔离为左右两半，对称绘制两个硕大而又面目狰狞的神怪头像，神秘而怪诞，应是镇守墓宅的神物，可能与后世的镇墓兽有源流上的承袭关系。后壁上部的半圆形范围内绘制写意性极强的山峦、野鹿、飞鸟和树木，这种风格在我国古代山水画的起源和发展史上占有极为重要的地位。

（撰文：马明志　摄影：张明惠、张庆波）

Tomb-guardian Beasts and Landscape

Xin (9-23 CE)

Height 152 cm; Width 172 cm

Unearthed from a Tomb to the South of Village No. 2 of Yangqiaopan in Jingbian, Shaanxi, in 2009. Preserved in Shaanxi Provincial Institute of Archaeology.

47.箕宿图

新－东汉（9～220年）

高约35、宽525厘米

2003年陕西省定边县郝滩乡汉墓出土。现存于陕西省考古研究院。

墓向北。位于墓室拱顶西南部。为二十八宿中的箕宿，由箕宿四星与一着绿衣女子构成。

（撰文：吕智荣、张鹏程　摄影：张明惠）

Ji (Basket) of the 28 Lunar Mansions

Xin to Eastern Han (9-220 CE)

Height ca. 35 cm; Width 525 cm

Unearthed from a Han Tomb in Haotan Township of Dingbian, Shaanxi, in 2003. Preserved in Shaanxi Provincial Institute of Archaeology.

48.虚宿、危宿图

新—东汉（9～220年）

高约39、宽59厘米

2003年陕西省定边县郝滩乡汉墓出土。现存于陕西省考古研究院。

墓向北。位于墓室拱顶南部。为二十八宿中的虚宿和危宿，在四星连成的四角形内绘有两只奔鹿。

（撰文：吕智荣、张鹏程　摄影：张明惠）

Xu (Emptiness) and *Wei* (Rooftop) of the 28 Lunar Mansions

Xin to Eastern Han (9-220 CE)

Height ca. 39 cm; Width 59 cm

Unearthed from a Han Tomb in Haotan Township of Dingbian, Shaanxi in 2003. Preserved in Shaanxi Provincial Institute of Archaeology.

49. 室宿、壁宿图

新–东汉（9～220年）

高约80、宽54厘米

2003年陕西省定边县郝滩乡汉墓出土。现存于陕西省考古研究院。

墓向北。位于墓室拱顶南部。为二十八宿中的室宿、壁宿，在四星连成的菱形内绘一龟，菱形相对的两边各有一蛇缠绕成S状，该图即为主北方的玄武之像。

（撰文：吕智荣、张鹏程　摄影：张明惠）

Shi (Encampment) and Bi (Wall) of the 28 Lunar Mansions

Xin to Eastern Han (9-220 CE)

Height ca. 80 cm; Width 54 cm

Unearthed from a Han Tomb in Haotan Township of Dingbian, Shaanxi, in 2003. Preserved in Shaanxi Provincial Institute of Archaeology.

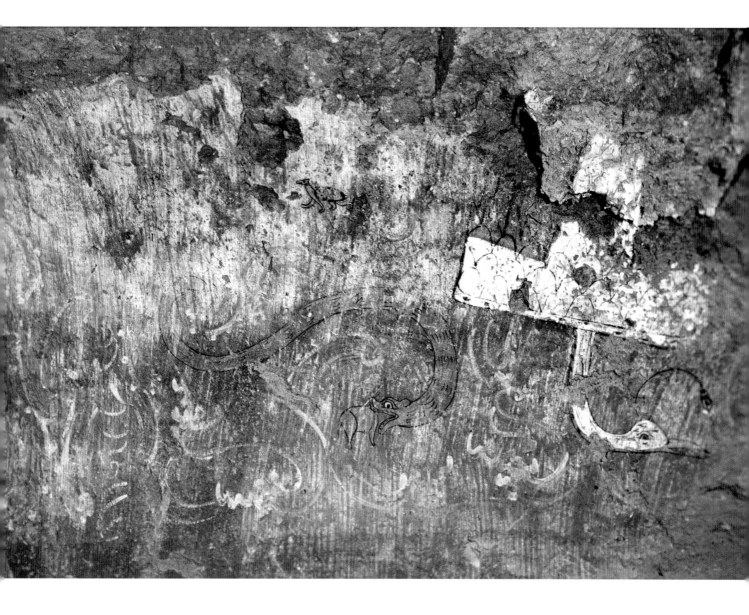

50.朱雀图

新–东汉（9～220年）

高约122、宽180厘米

2003年陕西省定边县郝滩乡汉墓出土。现存于陕西省考古研究院。

墓向北。位于墓室拱顶东北部。为二十八宿中的柳、星、张、翼、轸五宿，因图像残损，可辨认星数有十五颗，分布于白色的朱雀的各个部位，图中朱雀为南方主神。在朱雀的南侧有"巴蛇吞象"图，并有与星相结合的骑红象者一人、骑龟者一人。

（撰文：吕智荣、张鹏程　摄影：张明惠）

Scarlet Bird in the Celestial Bodies

Xin to Eastern Han (9-220 CE)

Height ca. 122 cm; Width 180 cm

Unearthed from a Han Tomb in Haotan Township of Dingbian, Shaanxi, in 2003. Preserved in Shaanxi Provincial Institute of Archaeology.

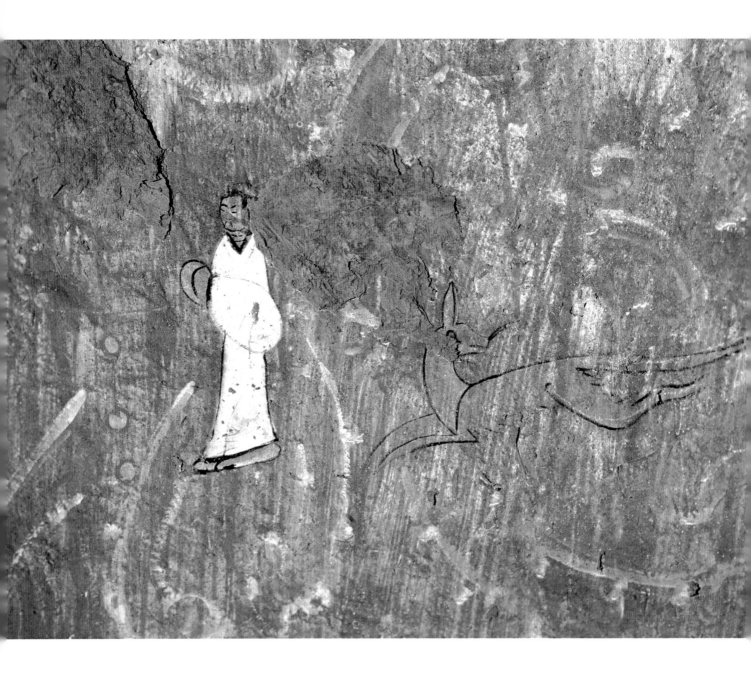

51.毕宿图

新-东汉（9~220年）

高约53、宽36厘米

2003年陕西省定边县郝滩乡汉墓出土。现存于陕西省考古研究院。

墓向北。位于墓室拱顶东部中段。为二十八宿中的毕宿，七颗星连成叉子状，其侧立有一白衣男子。

（撰文：吕智荣、张鹏程　摄影：张明惠）

Bi (Net) of the 28 Lunar Mansions

Xin to Eastern Han (9-220 CE)

Height ca. 53 cm; Width 36 cm

Unearthed from a Han Tomb in Haotan Township of Dingbian, Shaanxi, in 2003. Preserved in Shaanxi Provincial Institute of Archaeology.

52.弧矢图

新–东汉（9～220年）

高约56、宽38厘米

2003年陕西省定边县郝滩乡汉墓出土。现存于陕西省考古研究院。

墓向北。位于墓室拱顶东部中段。为二十八宿中的弧矢，图像残损，可辨有八星围绕一红衣男子分布，红衣男子作张弓欲射状，其前面为狼宿中慌张奔逃之动物。

（撰文：吕智荣、张鹏程　摄影：张明惠）

The Constellation of Drawn Bow and Arrow in the Celestial Bodies

Xin to Eastern Han (9-220 CE)

Height ca. 56 cm; Width 38 cm

Unearthed from a Han Tomb in Haotan Township of Dingbian, Shaanxi, in 2003. Preserved in Shaanxi Provincial Institute of Archaeology.

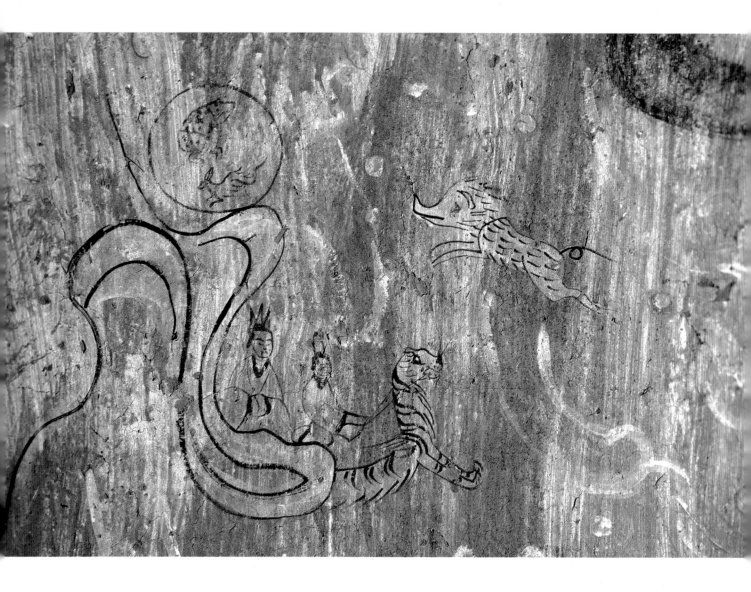

53. 月亮、娄宿与仙人图

新–东汉（9～220年）

高约16、宽25厘米

2003年陕西省定边县郝滩乡汉墓出土。现存于陕西省考古研究院。

墓向北。位于墓室拱顶东南部。月亮中绘蟾蜍、玉兔，月亮下为一头戴三齿冠乘白虎的仙人，月亮与仙人北侧为娄宿，娄宿由三星与一猪组成。

（撰文：吕智荣、张鹏程　摄影：张明惠）

The Moon, the Lou (Bond) of the 28 Lunar Mansions and the Immortal in the Celestial Bodies

Xin to Eastern Han (9-220 CE)

Height ca. 16 cm; Width 25 cm

Unearthed from a Han Tomb in Haotan Township of Dingbian, Shaanxi, in 2003. Preserved in Shaanxi Provincial Institute of Archaeology.

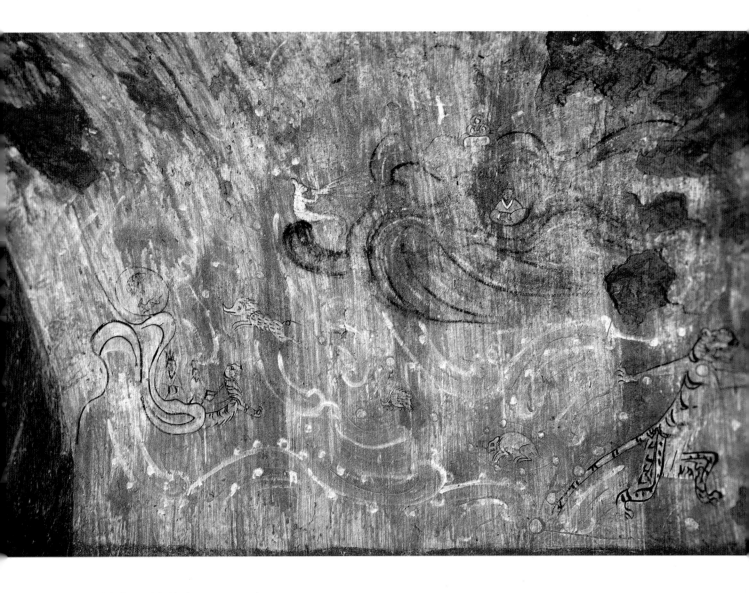

54. 风伯与雨师图

新–东汉（9～220年）

高约68、宽102厘米

2003年陕西省定边县郝滩乡汉墓出土。现存于陕西省考古研究院。

墓向北。位于墓室拱顶东南部。图中白色兽首仙人为风伯，手持风袋，风从中涌出，风伯北侧云中着绿衣的雨师端坐其中。

（撰文：吕智荣、张鹏程　摄影：张明惠）

Fengbo (the Wind God) and Yushi (the Rain Master) in the Celestial Bodies

Xin to Eastern Han (9-220 CE)

Height ca. 68 cm; Width 102 cm

Unearthed from a Han Tomb in Haotan Township of Dingbian, Shaanxi, in 2003. Preserved in Shaanxi Provincial Institute of Archaeology.

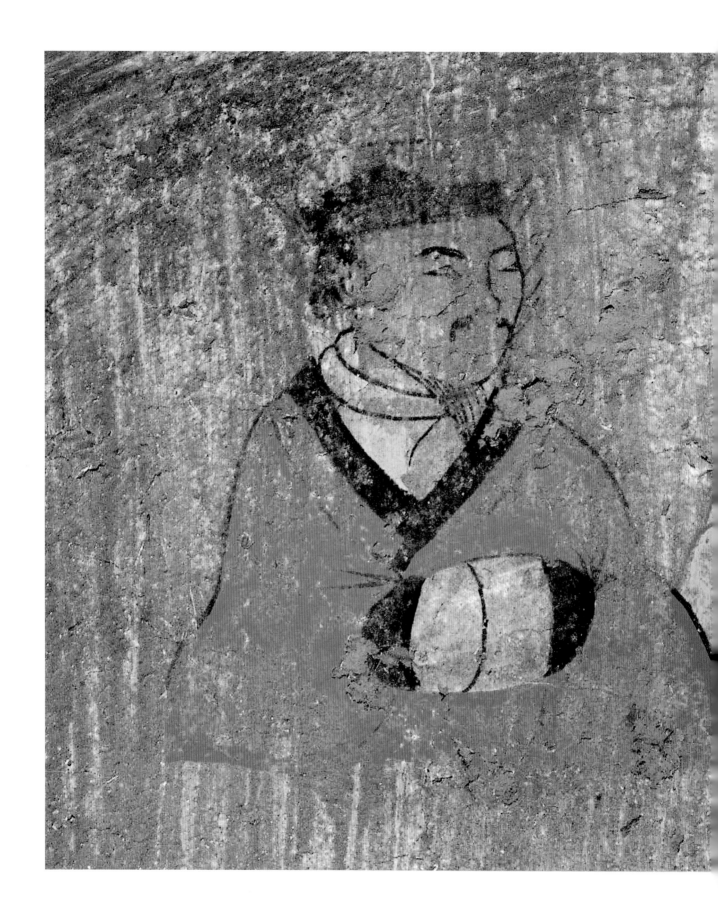

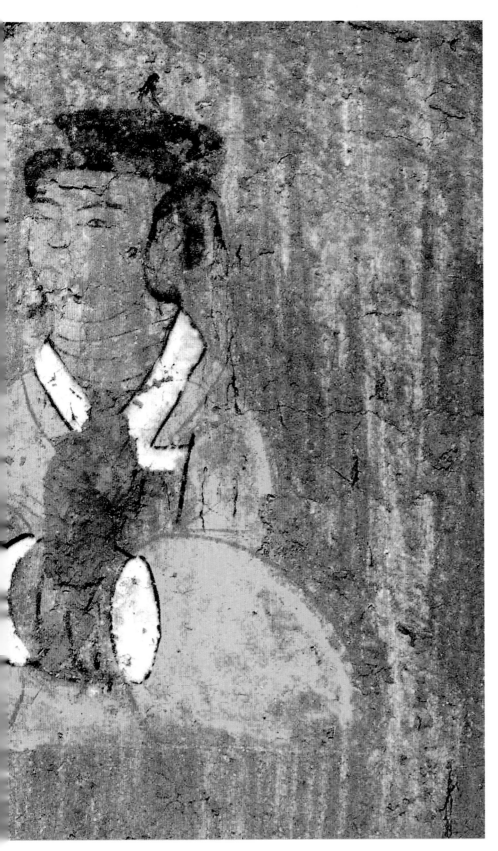

55.墓主夫妇图

新-东汉（9～220年）

高约48、宽71厘米

2003年陕西省定边县郝滩乡汉墓出土。
现存于陕西省考古研究院。

墓向北。位于墓室南壁。男主人着红衣
右衽，女主人着绿衣左衽。

（撰文：吕智荣、张鹏程　摄影：张明惠）

The Portraits of the Tomb Occupant Couple

Xin to Eastern Han (9-220 CE)
Height ca. 48 cm; Width 71 cm
Unearthed from a Han Tomb in Haotan
Township of Dingbian, Shanxi, in 2003.
Preserved in Shaanxi Provincial Institute
of Archaeology.

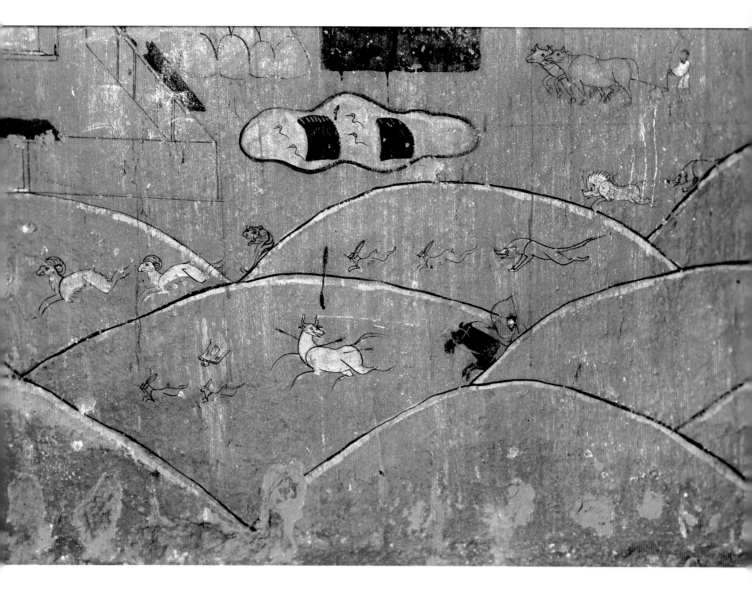

56.狩猎图

新–东汉（9～220年）

高约64、宽177厘米

2003年陕西省定边县郝滩乡汉墓出土。现存于陕西省考古研究院。

墓向北。位于墓室南壁。为一红衣黑冠男子在山间射猎，飞禽走兽惊觉奔走。

（撰文：吕智荣、张鹏程　摄影：张明惠）

Hunting

Xin to Eastern Han (9-220 CE)

Height ca. 64 cm; Width 177 cm

Unearthed from a Han Tomb in Haotan Township of Dingbian, Shaanxi, in 2003. Preserved in Shaanxi Provincial Institute of Archaeology.

57.庭院图

新–东汉（9～220年）

高约52、宽78厘米

2003年陕西省定边县郝滩乡汉墓出土。现存于陕西省考古研究院。

墓向北。位于墓室南壁。图中有一庭院，其旁为堆积的粮食与粮仓，分别有"禾积"、"高禾积"榜题。

<div align="right">（撰文：吕智荣、张鹏程　摄影：张明惠）</div>

Courtyard

Xin to Eastern Han (9-220 CE)

Height ca. 52 cm; Width 78 cm

Unearthed from a Han Tomb in Haotan Township of Dingbian, Shaanxi, in 2003. Preserved in Shaanxi Provincial Institute of Archaeology.

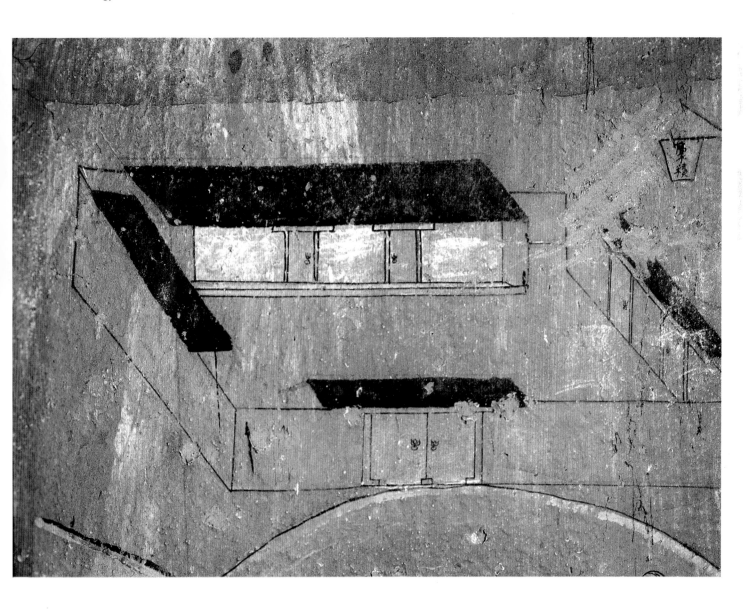

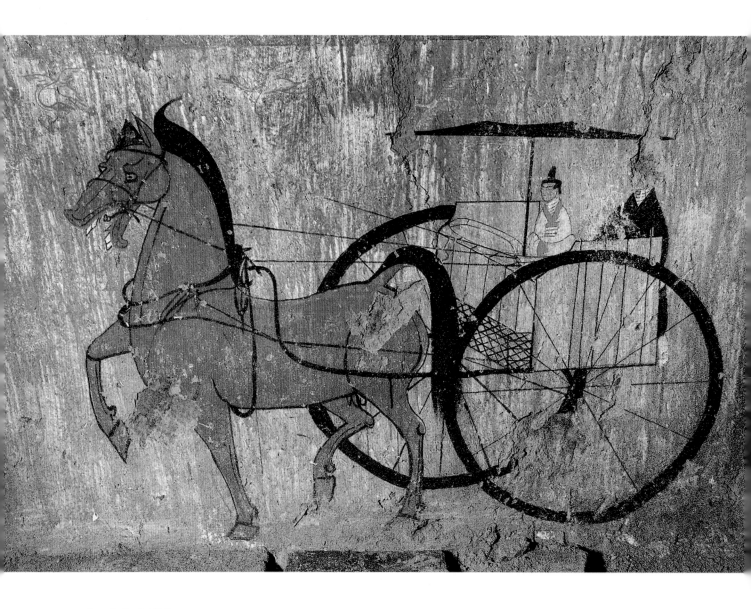

58. 车马出行图

新–东汉（9～220年）

高约118、宽176厘米

2003年陕西省定边县郝滩乡汉墓出土。现存于陕西省考古研究院。

墓向北。位于墓室西壁南部。图为绿衣女主人安坐车中，黑衣男子御车前行，天空有三只鸿雁一字飞行。

<div align="right">（撰文：吕智荣、张鹏程　摄影：张明惠）</div>

Procession Scene

Xin to Eastern Han (9-220 CE)

Height ca. 118 cm; Width 176 cm

Unearthed from a Han Tomb in Haotan Township of Dingbian, Shaanxi, in 2003. Preserved in Shaanxi Provincial Institute of Archaeology.

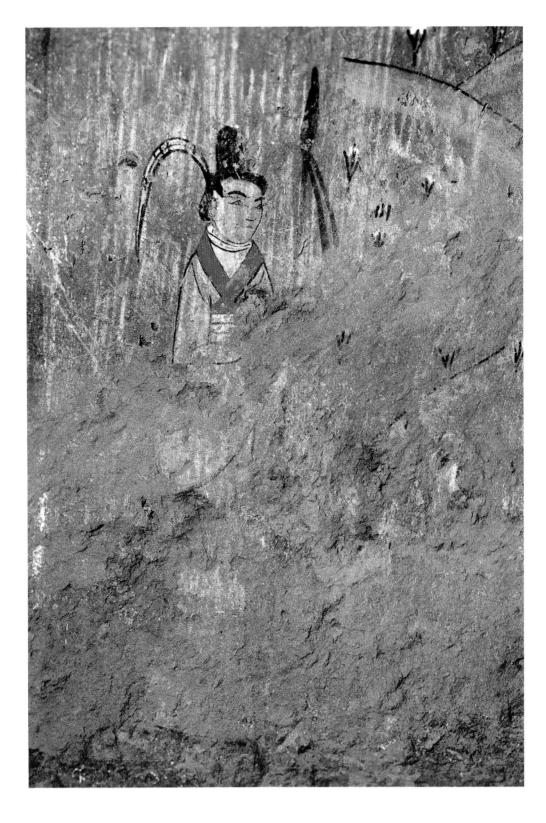

59.放牧图（局部）

新－东汉（9～220年）

高约88、宽59厘米

2003年陕西省定边县郝滩乡汉墓出土。现存于陕西省考古研究院。

墓向北。位于墓室东壁北部。为一牧者立于山旁。

（撰文：吕智荣、张鹏程　摄影：张明惠）

Herding Scene (Detail)

Xin to Eastern Han (9-220 CE)

Height ca. 88 cm; Width 59 cm

Unearthed from a Han Tomb in Haotan Township of Dingbian, Shaanxi, in 2003. Preserved in Shaanxi Provincial Institute of Archaeology.

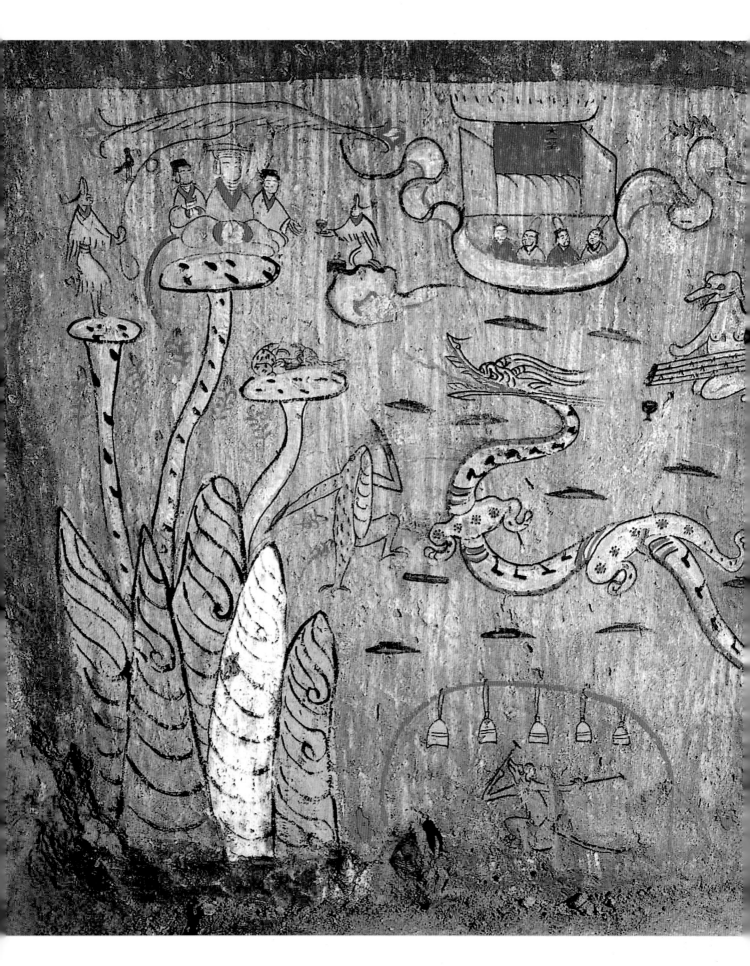

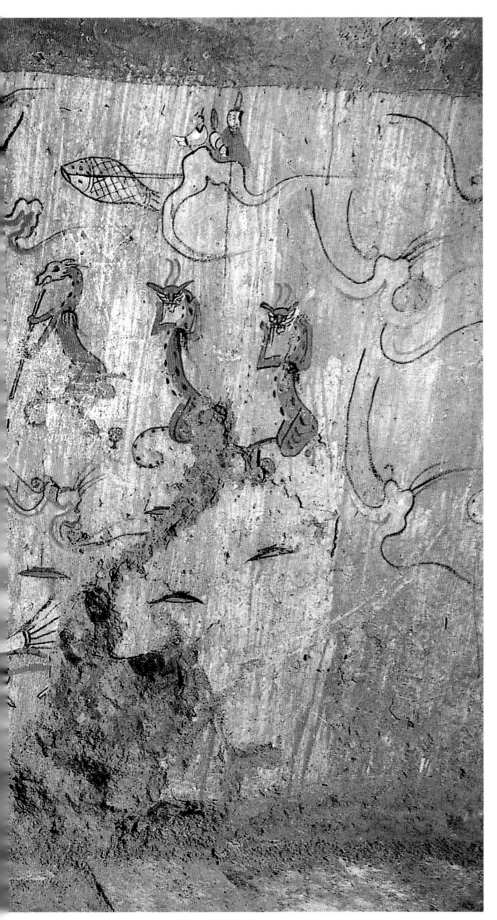

60．西王母宴乐图

新-东汉（9～220年）

高约103、宽286厘米

2003年陕西省定边县郝滩乡汉墓出土。现存于陕西省考古研究院。

墓向北。位于墓室东壁南部。图中西王母端坐昆仑山，蟾蜍及九尾狐在捣不死药，青鸟立于其侧，其前方有前来参加宴会的仙人，下方有舞动的龙及奏乐的众多瑞兽。

（撰文：吕智荣、张鹏程　摄影：张明惠）

Feasting of Xiwangmu (Queen Mother of the West)

Xin to Eastern Han (9-220 CE)
Height ca. 103 cm; Width 286 cm
Unearthed from a Han Tomb in Haotan
Township of Dingbian, Shaanxi, in 2003.
Preserved in Shaanxi Provincial Institute
of Archaeology.

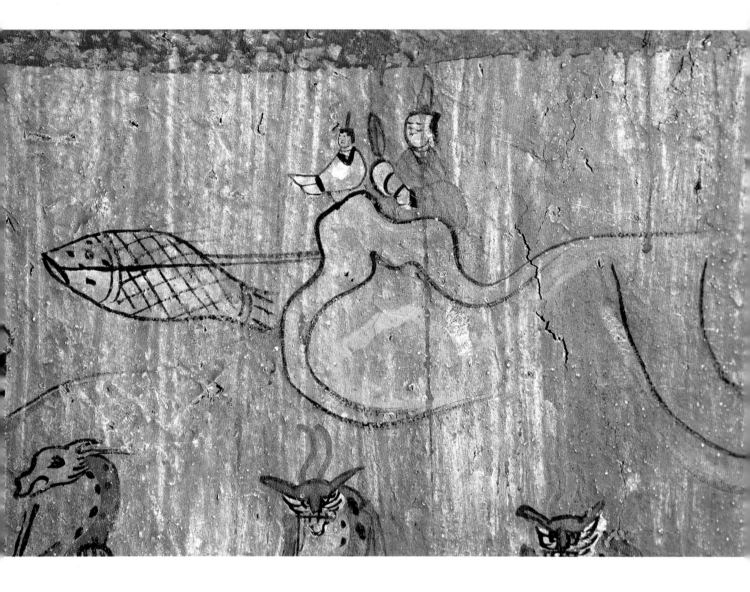

61.西王母宴乐图（局部一）

新–东汉（9～220年）

高约31、宽47厘米

2003年陕西省定边县郝滩乡汉墓出土。现存于陕西省考古研究院。

墓向北。位于墓室东壁南部。图中一人乘驾神鱼牵引的云车向左飞驰。

<div align="right">（撰文：吕智荣、张鹏程　摄影：张明惠）</div>

Feasting of Xiwangmu (Detail 1)

Xin to Eastern Han (9-220 CE)

Height ca. 31 cm; Width 47 cm

Unearthed from a Han Tomb in Haotan Township of Dingbian, Shaanxi, in 2003. Preserved in Shaanxi Provincial Institute of Archaeology.

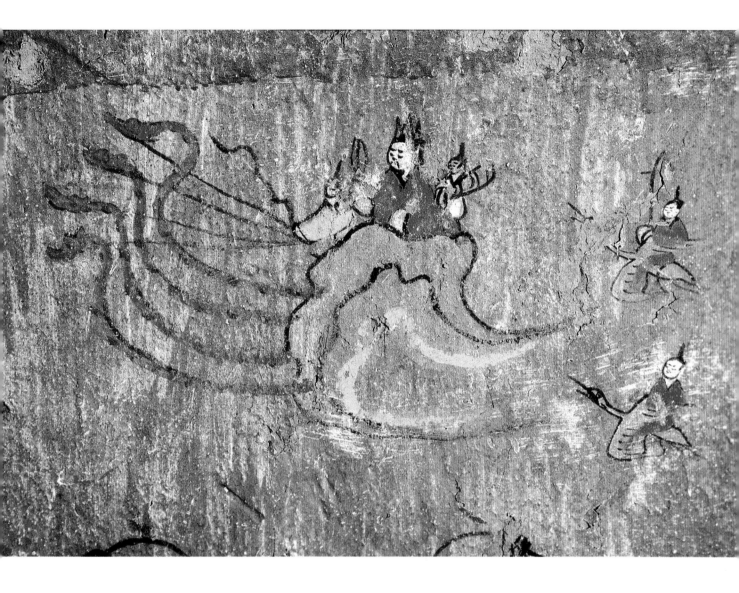

62.西王母宴乐图（局部二）

新-东汉（9～220年）

高约25、宽42厘米

2003年陕西省定边县郝滩乡汉墓出土。现存于陕西省考古研究院。

墓向北。位于墓室东壁南部。图中一仙人乘四龙牵引的车驾赴西王母宴会。

（撰文：吕智荣、张鹏程　摄影：张明惠）

Feasting of Xiwangmu (Detail 2)

Xin to Eastern Han (9-220 CE)

Height ca. 25 cm; Width 42 cm

Unearthed from a Han Tomb in Haotan Township of Dingbian, Shaanxi, in 2003. Preserved in Shaanxi Provincial Institute of Archaeology.

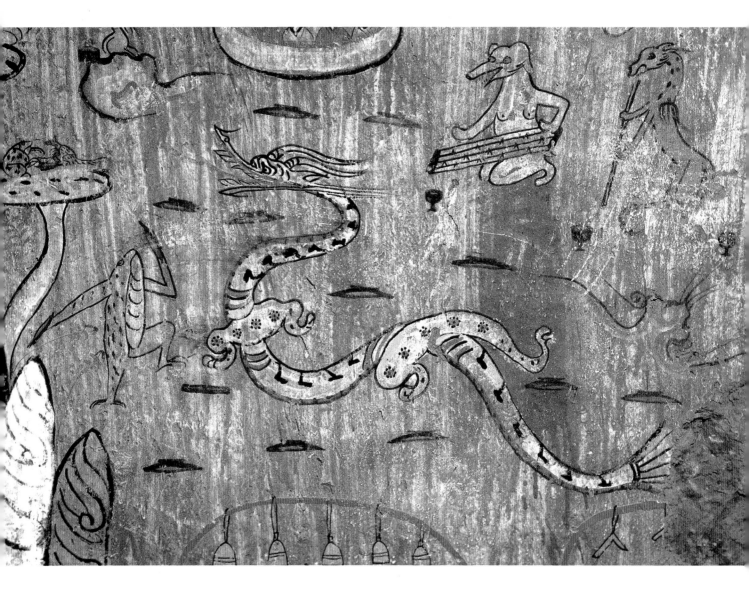

63.西王母宴乐图（局部三）

新–东汉（9～220年）

高约46、宽70厘米

2003年陕西省定边县郝滩乡汉墓出土。现存于陕西省考古研究院。

墓向北。位于墓室东壁南部。随着四周瑞兽所奏的音乐，蟾蜍掷出盘子而龙则舞动于其间。

（撰文：吕智荣、张鹏程　摄影：张明惠）

Feasting of Xiwangmu (Detail 3)

Xin to Eastern Han (9-220 CE)

Height ca. 46 cm; Width 70 cm

Unearthed from a Han Tomb in Haotan Township of Dingbian, Shaanxi, in 2003. Preserved in Shaanxi Provincial Institute of Archaeology.

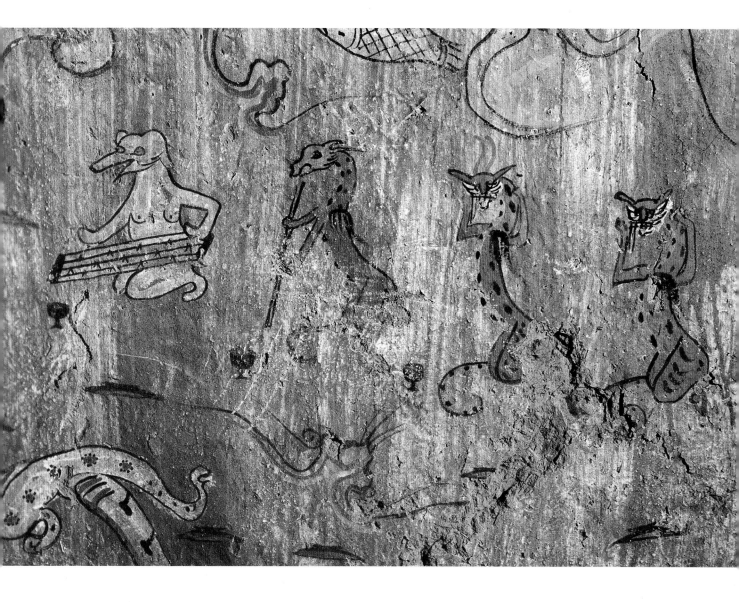

64. 西王母宴乐图（局部四）

新–东汉（9～220年）

高约54、宽81厘米

2003年陕西省定边县郝滩乡汉墓出土。现存于陕西省考古研究院。

墓向北。位于墓室东壁南部。狐、獐等众多瑞兽在演奏乐曲。

（撰文：吕智荣、张鹏程　摄影：张明惠）

Feasting of Xiwangmu (Detail 4)

Xin to Eastern Han (9-220 CE)

Height ca. 54 cm; Width 81 cm

Unearthed from a Han Tomb in Haotan Township of Dingbian, Shaanxi, in 2003. Preserved in Shaanxi Provincial Institute of Archaeology.

65. 前室东壁图

东汉（25～220年）

高149、宽237厘米

2005年陕西省靖边县杨桥畔杨一村东汉墓出土。现存于陕西省考古研究院。

墓向205°。位于前室东壁。壁画布局分上、下两层：上层分前段、中段和后段；下层分前、后两段。内容分别有"仓储"，"孔子见老子"，"云车升仙"，"神仙引魂"和"百戏图"。

（撰文：王望生　摄影：王敏）

Full-view of the East Wall of the Antechamber

Eastern Han (25-220 CE)

Height 149 cm; Width 237 cm

Unearthed from an Eastern Han Tomb at Yangyicun of Yangqiaopan in Jingbian, Shaanxi, in 2005. Preserved in Shaanxi Provincial Institute of Archaeology.

66.孔子见老子图（一）

东汉（25～220年）

2005年陕西省靖边县杨桥畔杨一村东汉墓出土。现存于陕西省考古研究院。

墓向205°。位于墓前室东壁上层的中段。全画共绘7位人物，该画面为第1～3人，分别为老子、项橐、孔子。

（撰文：王望生　摄影：王敏）

Confucius Meeting Laozi (1)

Eastern Han (25-220 CE)

Unearthed from an Eastern Han Tomb at Yangyicun of Yangqiaopan in Jingbian, Shaanxi, in 2005. Preserved in Shaanxi Provincial Institute of Archaeology.

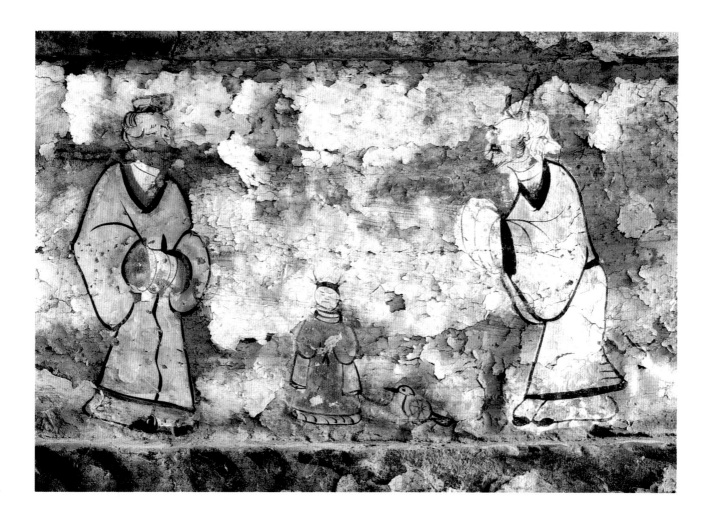

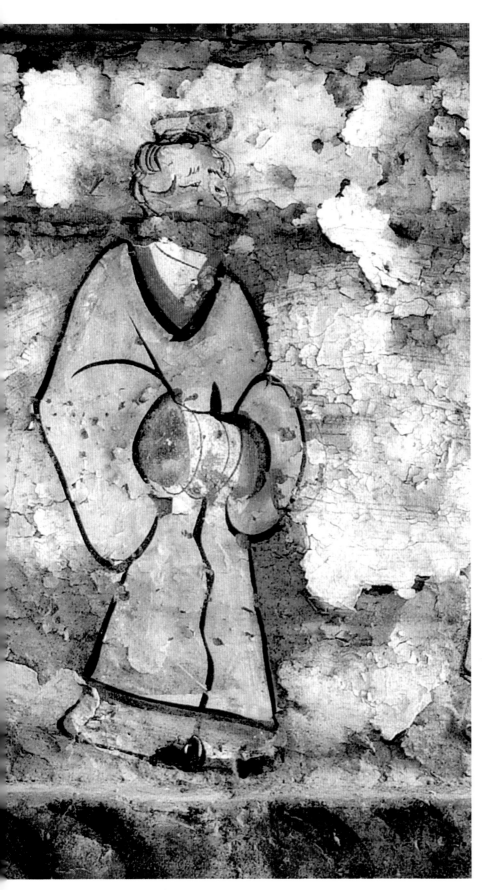

67.孔子见老子图（一）
（局部一）

东汉（25～220年）

2005年陕西省靖边县杨桥畔杨一村东汉墓出土。现存于陕西省考古研究院。

墓向205°。位于墓前室东壁上层的中段。为画面第1人：老子。

（撰文：王望生　摄影：王敏)

Confucius Meeting Laozi (1) (Datail 1)

Eastern Han (25-220 CE)

Unearthed from an Eastern Han Tomb at Yangyicun of Yangqiaopan in Jingbian, Shaanxi, in 2005. Preserved in Shaanxi Provincial Institute of Archaeology.

68.孔子见老子图
（一）（局部二）

东汉（25～220年）

2005年陕西省靖边县杨桥畔杨一村东汉墓出土。现存于陕西省考古研究院。

墓向205°。位于墓前室东壁上层的中段。为画面第3人：孔子。

（撰文：王望生　摄影：王敏)

Confucius Meeting Laozi (1) (Detail 2)

Eastern Han (25-220 CE)
Unearthed from an Eastern Han Tomb at Yangyicun of Yangqiaopan in Jingbian, Shaanxi, in 2005. Preserved in Shaanxi Provincial Institute of Archaeology.

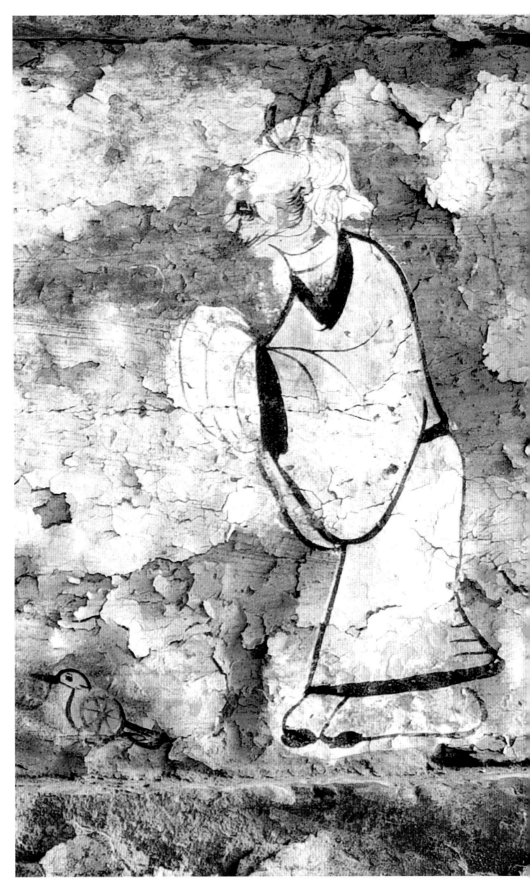

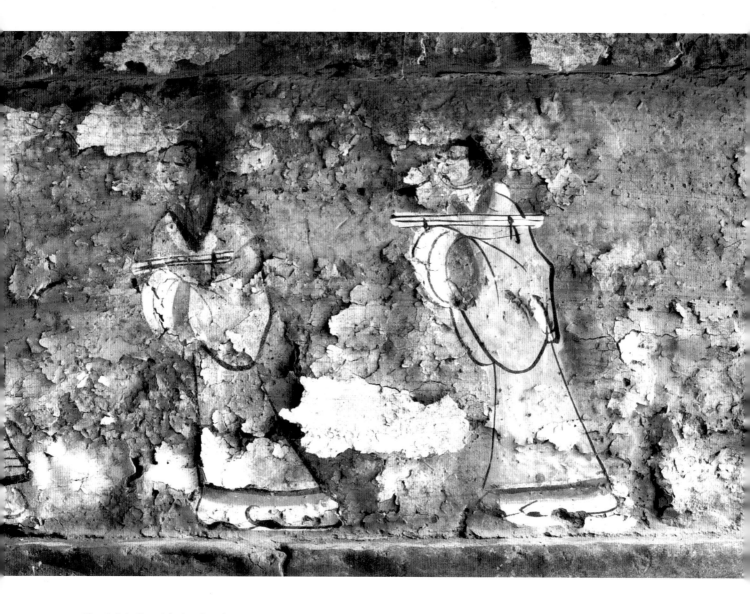

69.孔子见老子图（二）

东汉（25～220年）

高20、宽22厘米

2005年陕西省靖边县杨桥畔杨一村东汉墓出土。现存于陕西省考古研究院。

墓向205°。位于墓前室东壁上层中段。为图中第4～5人的孔子弟子，二人均怀抱竹书，肃穆聆听。

<div align="right">（撰文：王望生　摄影：王敏）</div>

Confucius Meeting Laozi (2)

Eastern Han (25-220 CE)

Height 20 cm; Width 22 cm

Unearthed from an Eastern Han Tomb at Yangyicun of Yangqiaopan in Jingbian, Shaanxi, in 2005. Preserved in Shaanxi Provincial Institute of Archaeology.

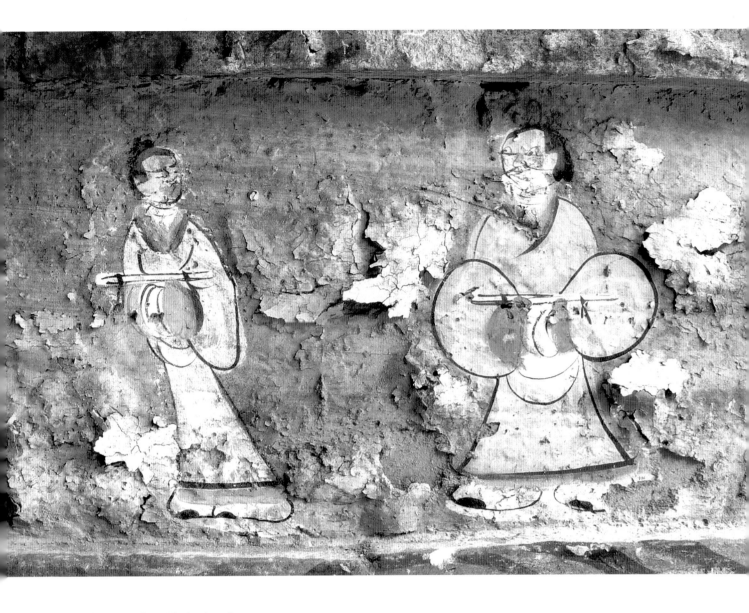

70.孔子见老子图（三）

东汉（25～220年）

高20、宽23厘米

2005年陕西省靖边县杨桥畔杨一村东汉墓出土。现存于陕西省考古研究院。

墓向205°。位于墓前室东壁上层中段。为图中第6～7人，二人怀抱竹书恭立。

（撰文：王望生　摄影：王敏）

Confucius Meeting Laozi (3)

Eastern Han (25-220 CE)

Height 20 cm; Width 23 cm

Unearthed from an Eastern Han Tomb at Yangyicun of Yangqiaopan in Jingbian, Shaanxi, in 2005. Preserved in Shaanxi Provincial Institute of Archaeology.

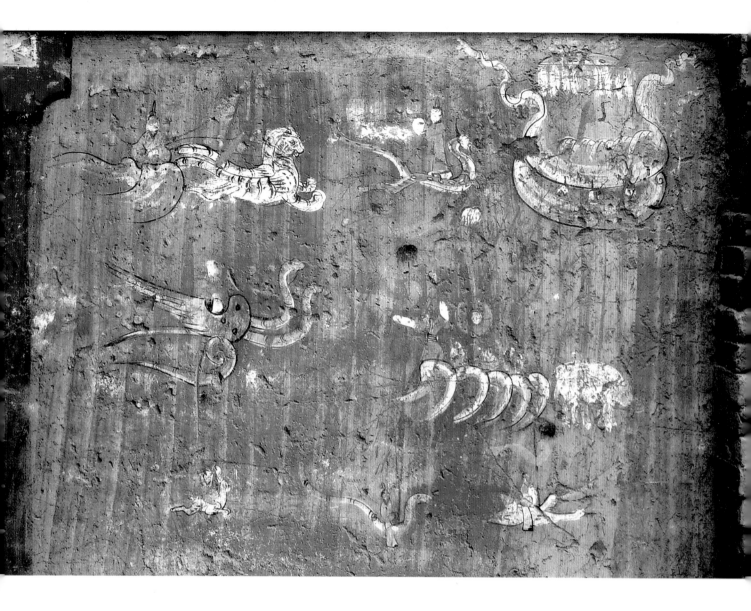

71. 仙人接引图

东汉（25~220年）

高109、宽114厘米

2005年陕西省靖边县杨桥畔杨一村东汉墓出土。现存于陕西省考古研究院。

墓向205°。位于墓前室东壁下层南段。由八小幅画面组成，分别是云车升仙、蓐收升仙、虎车升仙、象车升仙、龙车升仙，仙人乘鹤、仙人乘龙、仙人乘鹿图像。

<div align="right">（撰文：王望生　摄影：王敏）</div>

Immortals Guiding

Eastern Han (25-220 CE)

Height 109 cm; Width 114 cm

Unearthed from an Eastern Han Tomb at Yangyicun of Yangqiaopan in Jingbian, Shaanxi, in 2005. Preserved in Shaanxi Provincial Institute of Archaeology.

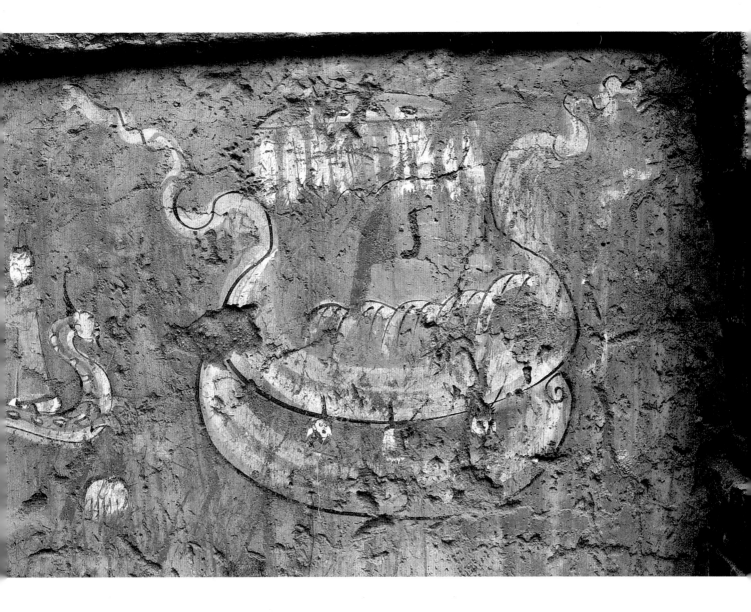

72.云车升仙图

东汉（25～220年）

高32、宽40厘米

2005年陕西省靖边县杨桥畔杨一村东汉墓出土。现存于陕西省考古研究院。

墓向205°。位于墓前室东壁下层南段。车中坐三位神仙，上立一华盖。

<div align="right">（撰文：王望生　摄影：王敏）</div>

Ascending Heaven by Cloud Chariot

Eastern Han (25-220 CE)

Height 32 cm; Width 40 cm

Unearthed from an Eastern Han Tomb at Yangyicun of Yangqiaopan in Jingbian, Shaanxi, in 2005. Preserved in Shaanxi Provincial Institute of Archaeology.

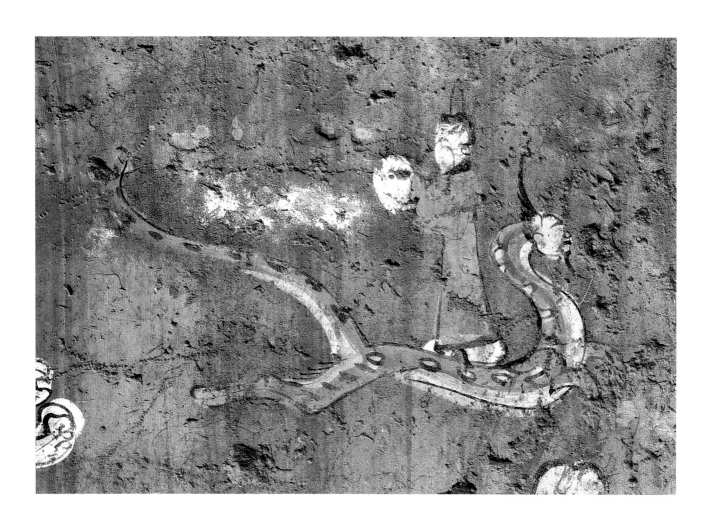

73.蓐收升仙图

东汉（25～220年）

高17、宽28厘米

2005年陕西省靖边县杨桥畔杨一村东汉墓出土。现存于陕西省考古研究院。

墓向205°。位于墓前室东壁下层南段。仙人立于蓐收背上。蓐收乃人面虎身之瑞兽。

<div align="right">（撰文：王望生　摄影：王敏）</div>

Ascending Heaven on the Back of Rushou (the Spirit of the West)

Eastern Han (25-220 CE)

Height 17 cm; Width 28 cm

Unearthed from an Eastern Han Tomb at Yangyicun of Yangqiaopan in Jingbian, Shaanxi, in 2005. Preserved in Shaanxi Provincial Institute of Archaeology.

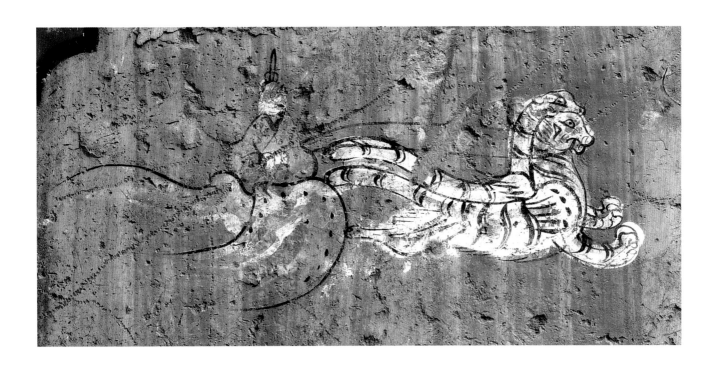

74.虎车升仙图

东汉（25～220年）

高17、宽30厘米

2005年陕西省靖边县杨桥畔杨一村东汉墓出土。现存于陕西省考古研究院。

墓向205°。位于墓前室东壁下层南段。两只白翼虎牵引彩色云车，仙人端坐其上。

<div style="text-align: right">（撰文：王望生　摄影：王敏）</div>

Ascending Heaven by Tiger-drawn Chariot

Eastern Han (25-220 CE)

Height 17 cm; Width 30 cm

Unearthed from an Eastern Han Tomb at Yangyicun of Yangqiaopan in Jingbian, Shaanxi, in 2005. Preserved in Shaanxi Provincial Institute of Archaeology.

75.象车升仙图

东汉（25～220年）

高36、宽30厘米

2005年陕西省靖边县杨桥畔杨一村东汉墓出土。现存于陕西省考古研究院。

墓向205°。位于墓前室东壁下层南段。二匹大象牵引云车，其上有神仙四位，车上立悬鼓一面。

<div style="text-align:right;">（撰文：王望生　摄影：王敏）</div>

Ascending Heaven by Elephant-drawn Chariots

Eastern Han (25-220 CE)

Height 36 cm; Width 30 cm

Unearthed from an Eastern Han Tomb at Yangyicun of Yangqiaopan in Jingbian, Shaanxi, in 2005. Preserved in Shaanxi Provincial Institute of Archaeology.

76. 龙车升仙图

东汉（25～220年）

高18、宽29厘米

2005年陕西省靖边县杨桥畔杨一村东汉墓出土。现存于陕西省考古研究院。

墓向205°。位于墓前室东壁下层南段。双龙并驾有翼云车，其上坐一神仙，其下跟随一飞龙。

<div align="right">（撰文：王望生　摄影：王敏）</div>

Ascending Heaven by Dragon-drawn Chariot

Eastern Han (25-220 CE)

Height 18 cm; Width 29 cm

Unearthed from an Eastern Han Tomb at Yangyicun of Yangqiaopan in Jingbian, Shaanxi, in 2005. Preserved in Shaanxi Provincial Institute of Archaeology.

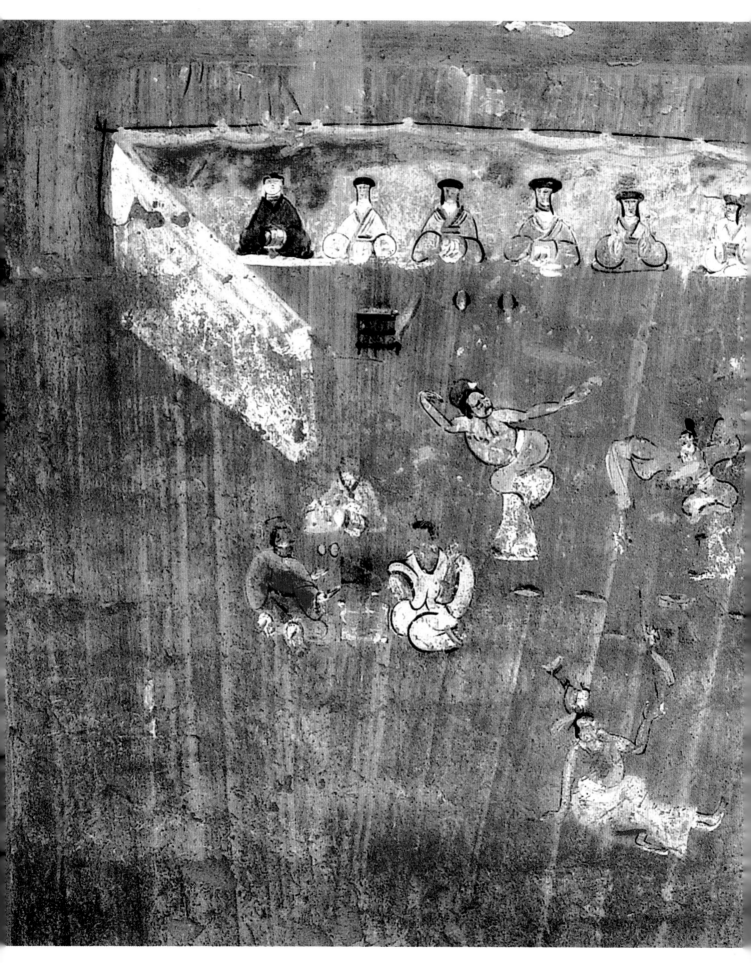

77.百戏图

东汉（25～220年）

高109、宽114厘米

2005年陕西省靖边县杨桥畔杨一村东汉墓出土。现存于陕西省考古研究院。

墓向205°。位于墓前室东壁下层北段。画面为百戏表演与观看场面。

（撰文：王望生　摄影：王敏）

Dancing and Acrobatics Performance

Eastern Han (25-220 CE)

Height 109 cm; Width 114 cm

Unearthed from an Eastern Han Tomb at Yangyicun of Yangqiaopan in Jingbian, Shaanxi, in 2005. Preserved in Shaanxi Provincial Institute of Archaeology.

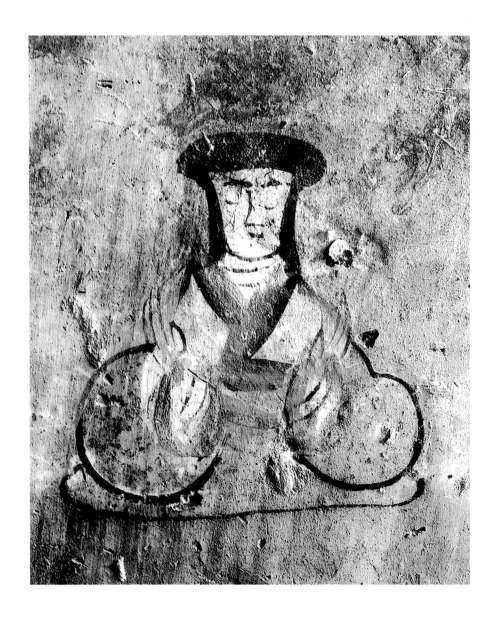

78.百戏图（局部一）

东汉（25～220年）

高12、宽11厘米

2005年陕西省靖边县杨桥畔杨一村东汉墓出土。现存于陕西省考古研究院。

墓向205°。位于墓前室东壁下层北段。为百戏图中观看者之一，图中上部左数第五人。

（撰文：王望生　摄影：王敏）

Dancing and Acrobatics Performance (Detail 1)

Eastern Han (25-220 CE)

Height 12 cm; Width 11 cm

Unearthed from an Eastern Han Tomb at Yangyicun of Yangqiaopan in Jingbian, Shaanxi, in 2005. Preserved in Shaanxi Provincial Institute of Archaeology.

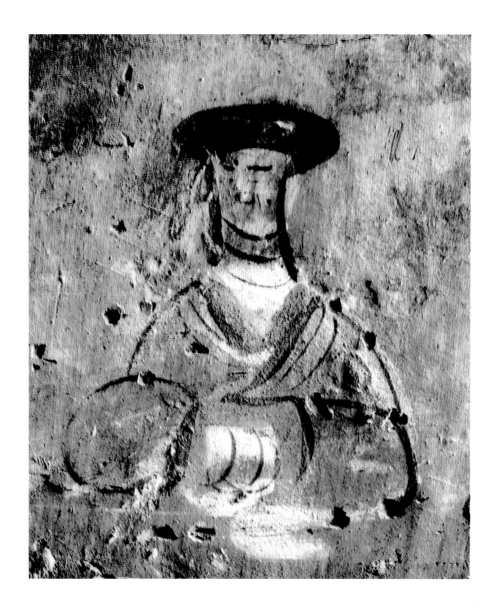

79.百戏图（局部二）

东汉（25～220年）

高14、宽11厘米

2005年陕西省靖边县杨桥畔杨一村东汉墓出土。现存于陕西省考古研究院。

墓向205°。位于墓前室东壁下层北段。为百戏图中观看者之一，图中上部左数第四人，正全神观看表演。

<div align="right">（撰文：王望生　摄影：王敏）</div>

Dancing and Acrobatics Performance (Detail 2)

Eastern Han (25-220 CE)

Height 14 cm; Width 11 cm

Unearthed from an Eastern Han Tomb at Yangyicun of Yangqiaopan in Jingbian, Shaanxi, in 2005. Preserved in Shaanxi Provincial Institute of Archaeology.

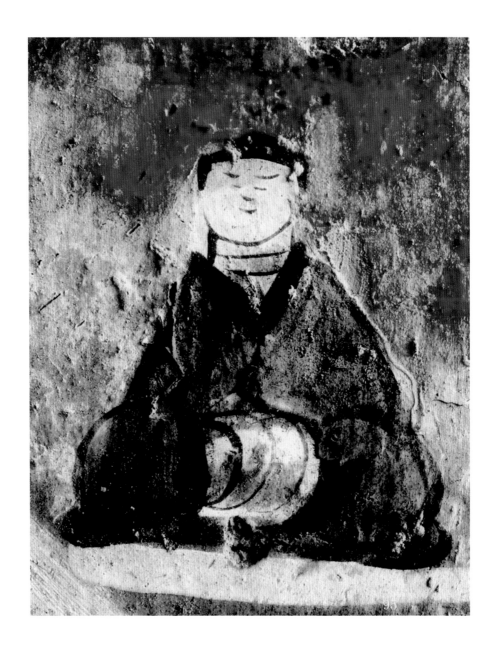

80.百戏图（局部三）

东汉（25～220年）

高13、宽12厘米

2005年陕西省靖边县杨桥畔杨一村东汉墓出土。现存于陕西省考古研究院。

墓向205°。位于墓前室东壁下层北段。为百戏图中观看者之一。为上部左数第一人，表情喜悦，正认真欣赏表演。

（撰文：王望生　摄影：王敏）

Dancing and Acrobatics Performance (Detail 3)

Eastern Han (25-220 CE)

Height 13 cm; Width 12 cm

Unearthed from an Eastern Han Tomb at Yangyicun of Yangqiaopan in Jingbian, Shaanxi, in 2005.
Preserved in Shaanxi Provincial Institute of Archaeology.

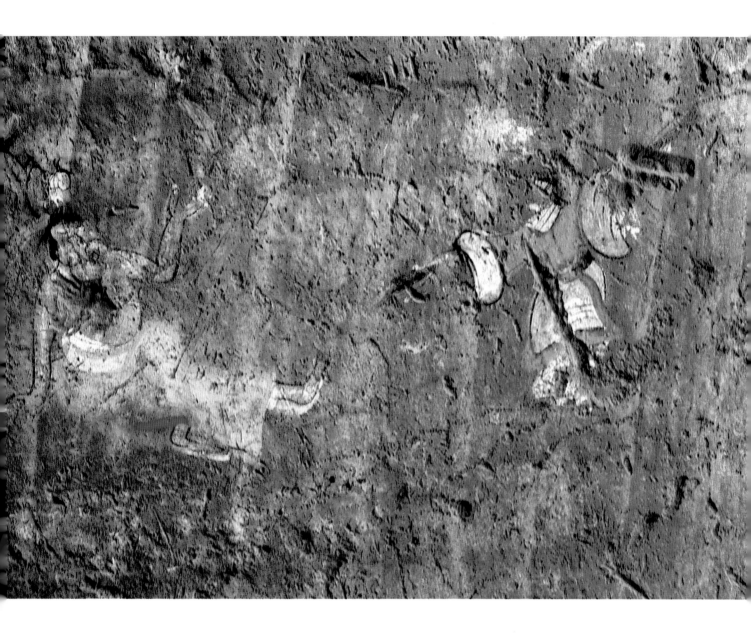

81.百戏图（局部四）

东汉（25～220年）

高18、宽41厘米

2005年陕西省靖边县杨桥畔杨一村东汉墓出土。现存于陕西省考古研究院。

墓向205°。位于墓前室东壁下层北段。为百戏图中最下方的两名表演者。

（撰文：王望生　摄影：王敏）

Dancing and Acrobatics Performance (Detail 4)

Eastern Han (25-220 CE)

Height 18 cm; Width 41 cm

Unearthed from an Eastern Han Tomb at Yangyicun of Yangqiaopan in Jingbian, Shaanxi, in 2005. Preserved in Shaanxi Provincial Institute of Archaeology.

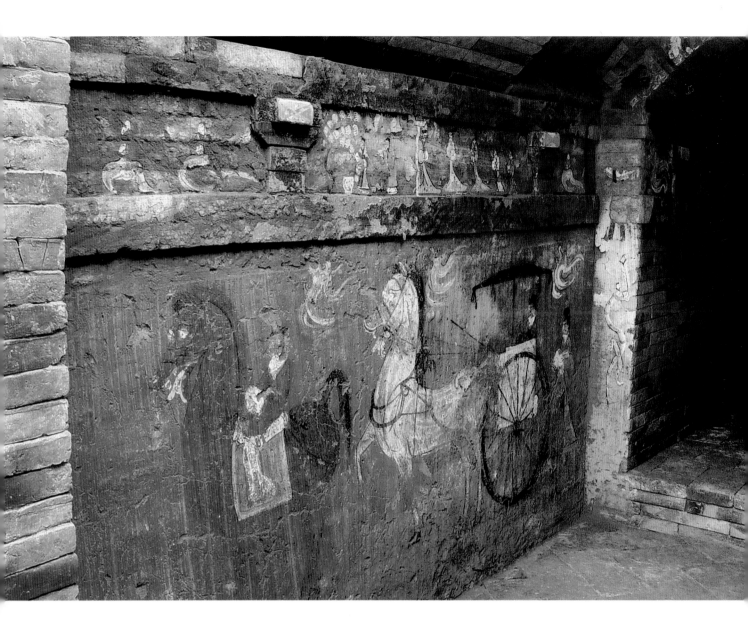

82. 前室西壁图像

东汉（25～220年）

高149、宽237厘米

2005年陕西省靖边县杨桥畔杨一村东汉墓出土。现存于陕西省考古研究院。

墓向205°。位于墓前室西壁。上层画两辆云车升仙、"不死树"等，下层为车马出行画面。

（撰文：王望生　摄影：王敏）

Full-view of the West Wall of the Antechamber

Eastern Han (25-220 CE)

Height 149 cm; Width 237 cm

Unearthed from an Eastern Han Tomb at Yangyicun of Yangqiaopan in Jingbian, Shaanxi, in 2005. Preserved in Shaanxi Provincial Institute of Archaeology.

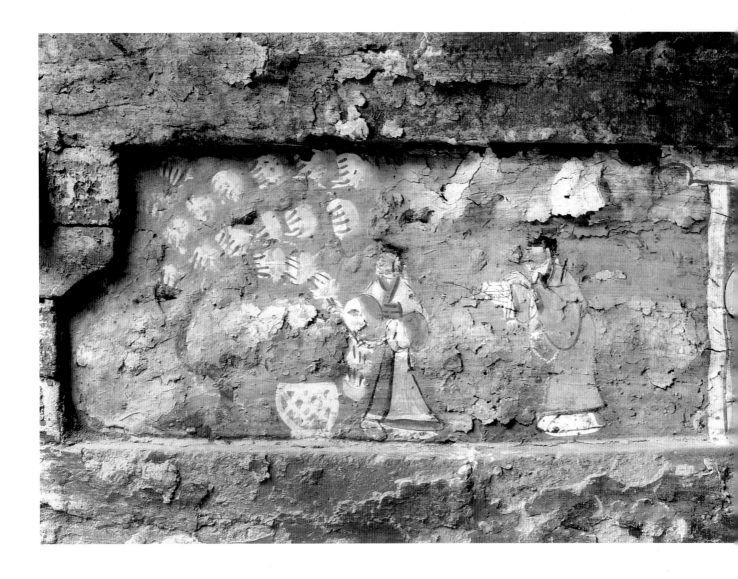

83. 秋胡戏妻图

东汉（25～220年）

高20、宽35厘米

2005年陕西省靖边县杨桥畔杨一村东汉墓出土。现存于陕西省考古研究院。

墓向205°。位于墓前室西壁上层中段。画面左侧为一高大桑树，树下置一竹筐。桑树右侧，一女子正在采桑。画面右侧，秋胡手持方盒，似正送给面前女子。画面表现的是"秋胡戏妻"的故事。

（撰文：王望生　摄影：王敏）

Qiuhu Furting His Wife

Eastern Han (25-220 CE)

Height 20 cm; Width 35 cm

Unearthed from an Eastern Han Tomb at Yangyicun of Yangqiaopan in Jingbian, Shaanxi, in 2005. Preserved in Shaanxi Provincial Institute of Archaeology.

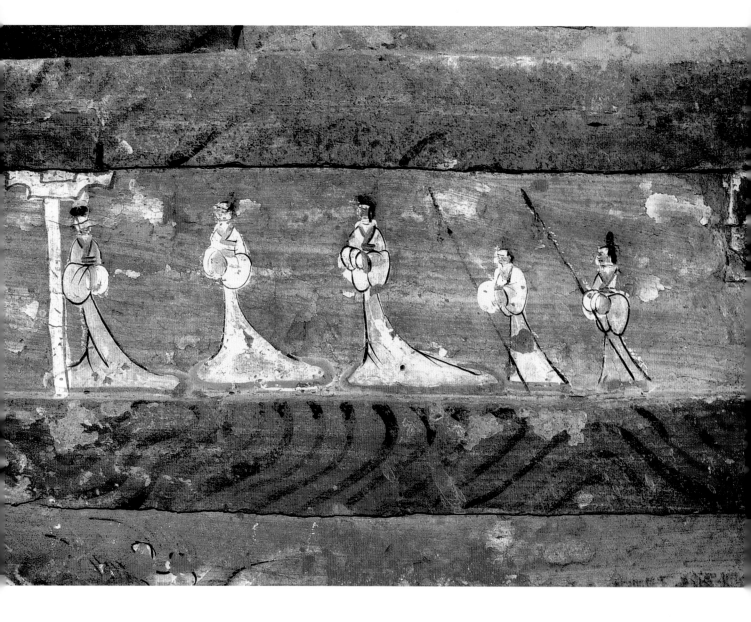

84. 历史故事图

东汉（25～220年）

高20、宽58厘米

2005年陕西省靖边县杨桥畔杨一村东汉墓出土。现存于陕西省考古研究院。

墓向205°。位于墓前室西壁上层中段。共画五人，其中前三人为女子，后二人随从，似手持长柄器。

（撰文：王望生　摄影：王敏）

Historical Tale Scene

Eastern Han (25-220 CE)

Height 20 cm; Width 58 cm

Unearthed from an Eastern Han Tomb at Yangyicun of Yangqiaopan in Jingbian, Shaanxi, in 2005. Preserved in Shaanxi Provincial Institute of Archaeology.

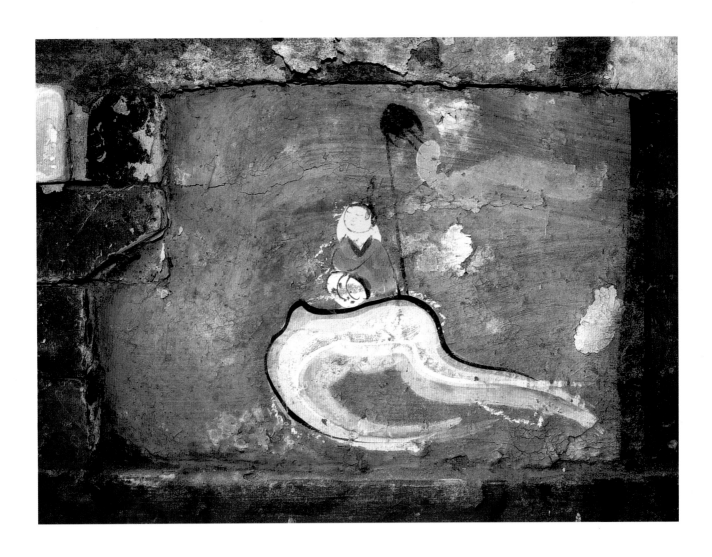

85.云车升仙图

东汉（25～220年）

高20、宽29厘米

2005年陕西省靖边县杨桥畔杨一村东汉墓出土。现存于陕西省考古研究院。

墓向205°。位于墓前室西壁上层北段。神仙头戴黑色高冠，身穿红色博袖袍衣，车上插一幡、引魂升天。

（撰文：王望生　摄影：王敏）

Ascending Heaven by Cloud

Eastern Han (25-220 CE)

Height 20 cm; Width 29 cm

Unearthed from an Eastern Han Tomb at Yangyicun of Yangqiaopan in Jingbian, Shaanxi, in 2005. Preserved in Shaanxi Provincial Institute of Archaeology.

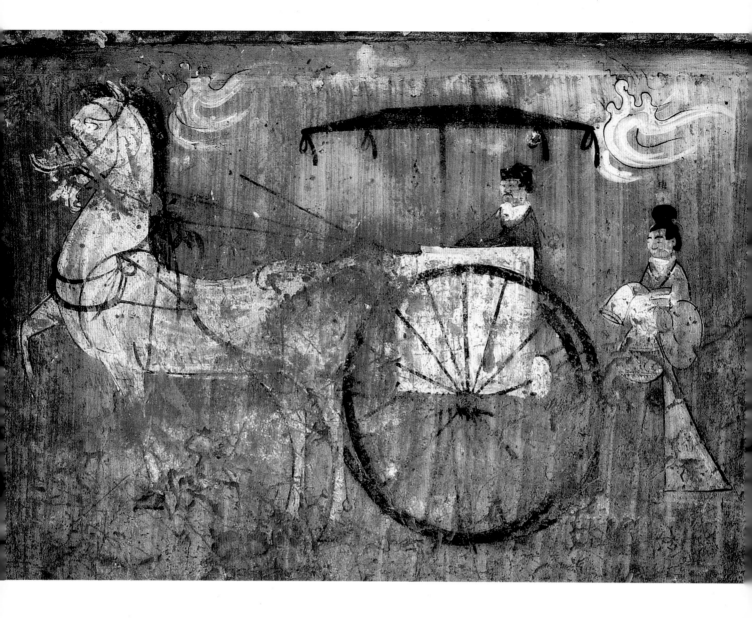

86.轺车图

东汉（25～220年）

高109、宽171厘米

2005年陕西省靖边县杨桥畔杨一村东汉墓出土。现存于陕西省考古研究院。

墓向205°。位于墓前室西壁下层车马出行图的中部。御者端坐车上，一手执策、另一手握二辔，驱马前行。其后仆从跟随。

<div align="right">（撰文：王望生　摄影：王敏）</div>

Light Carriage

Eastern Han (25-220 CE)

Height 109 cm; Width 171 cm

Unearthed from an Eastern Han Tomb at Yangyicun of Yangqiaopan in Jingbian, Shaanxi, in 2005. Preserved in Shaanxi Provincial Institute of Archaeology.

87. 神仙升天图

东汉（25～220年）

高20、宽336厘米

2005年陕西省靖边县杨桥畔杨一村东汉墓出土。现存于陕西省考古研究院。

墓向205°。位于墓后室东壁上层。枋与斗拱之间。其两端各绘一朵祥云，中间共画六幅图像，从南向北依次为鹿车升仙、鹤车升仙、神仙乘鹤、兽车升仙、龙车升仙、雁车升仙。

<div align="right">（撰文：王望生　摄影：王敏）</div>

Immortals Ascending Heaven

Eastern Han (25-220 CE)

Height 20 cm; Width 336 cm

Unearthed from an Eastern Han Tomb at Yangyicun of Yangqiaopan in Jingbian, Shaanxi, in 2005. Preserved in Shaanxi Provincial Institute of Archaeology.

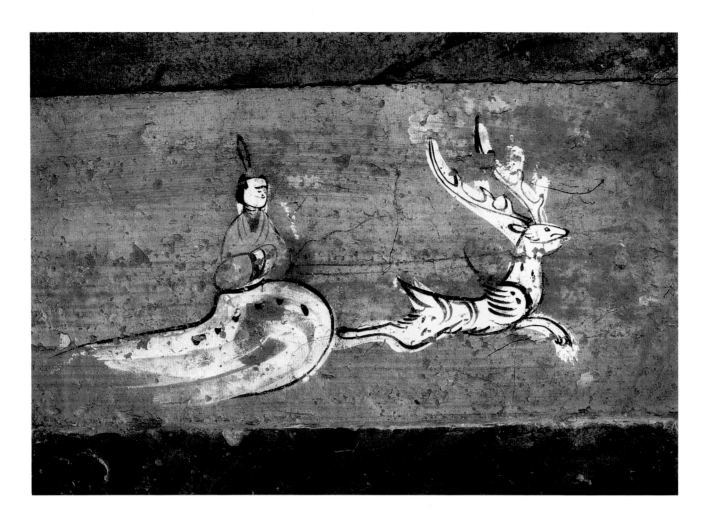

88.鹿车升仙图

东汉（25～220年）

高20、宽31厘米

2005年陕西省靖边县杨桥畔杨一村东汉墓出土。现存于陕西省考古研究院。

墓向205°。位于墓后室东壁上层南起第二幅。云车上之神仙头戴黑色"圭"形冠，身穿红色右衽博袖袍服。白色梅花鹿肩生双翼，牵引云车仰头狂奔。

<div align="right">（撰文：王望生　摄影：王敏）</div>

Ascending Heaven by Deer-drawn Chariot

Eastern Han (25-220 CE)

Height 20 cm; Width 31 cm

Unearthed from an Eastern Han Tomb at Yangyicun of Yangqiaopan in Jingbian, Shaanxi, in 2005. Preserved in Shaanxi Provincial Institute of Archaeology.

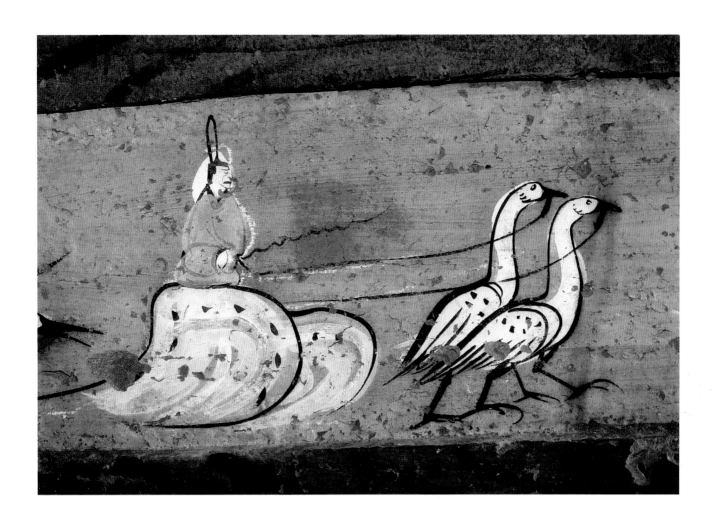

89.鹤车升仙图

东汉（25～220年）

高20、宽38厘米

2005年陕西省靖边县杨桥畔杨一村东汉墓出土。现存于陕西省考古研究院。

墓向205°。位于墓后室东壁上层南端第三幅。神仙头戴黑色"圭"形冠，身穿红色右衽博袖袍服，白色双鹤同牵云车，行走于天界。

（撰文：王望生　摄影：王敏）

Ascending Heaven by Crane-drawn Chariot

Eastern Han (25-220 CE)

Height 20 cm; Width 38 cm

Unearthed from an Eastern Han Tomb at Yangyicun of Yangqiaopan in Jingbian, Shaanxi, in 2005. Preserved in Shaanxi Provincial Institute of Archaeology.

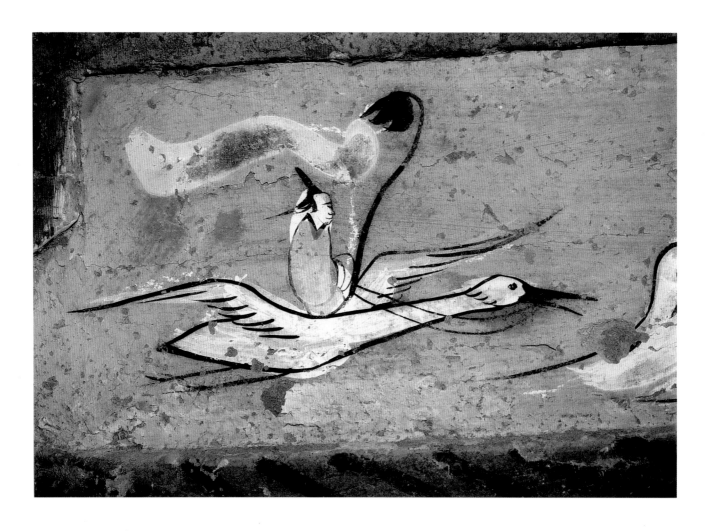

90. 神仙乘鹤图

东汉（25~220年）

高20、宽37厘米

2005年陕西省靖边县杨桥畔杨一村东汉墓出土。现存于陕西省考古研究院。

墓向205°。位于墓后室东壁上层南端第四幅。鹤背之上侧坐一神仙，头戴黑色高冠，身穿红色博袖长袍，乘风而行。

<div align="right">（撰文：王望生　摄影：王敏）</div>

Immortal Riding Crane

Eastern Han (25-220 CE)

Height 20 cm; Width 37 cm

Unearthed from an Eastern Han Tomb at Yangyicun of Yangqiaopan in Jingbian, Shaanxi, in 2005. Preserved in Shaanxi Provincial Institute of Archaeology.

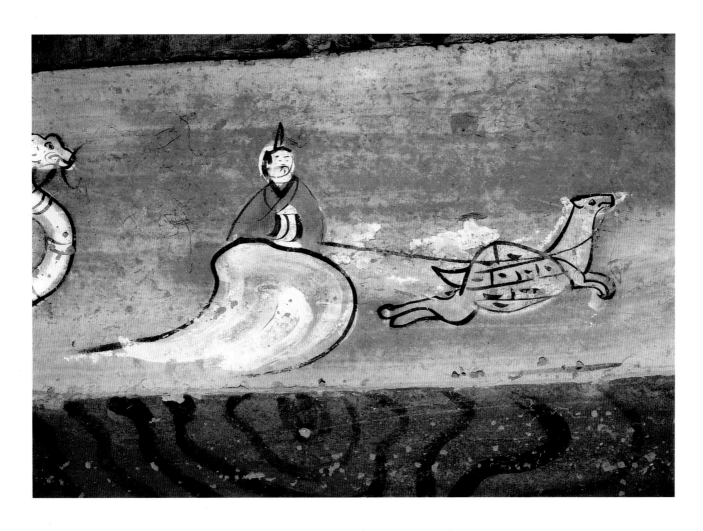

91.兽车升仙图

东汉（25～220年）

高20、宽38厘米

2005年陕西省靖边县杨桥畔杨一村东汉墓出土。现存于陕西省考古研究院。

墓向205°。位于墓后室东壁上层南起第五幅。神仙侧坐云车之上，头戴黑色高冠，身穿红色右衽博袖袍服，云车由一奔跑神兽牵引。

<div style="text-align:right">（撰文：王望生　摄影：王敏）</div>

Ascending Heaven by Mythical Beast-drawn Chariot

Eastern Han (25-220 CE)

Height 20 cm; Width 38 cm

Unearthed from an Eastern Han Tomb at Yangyicun of Yangqiaopan in Jingbian, Shaanxi, in 2005. Preserved in Shaanxi Provincial Institute of Archaeology.

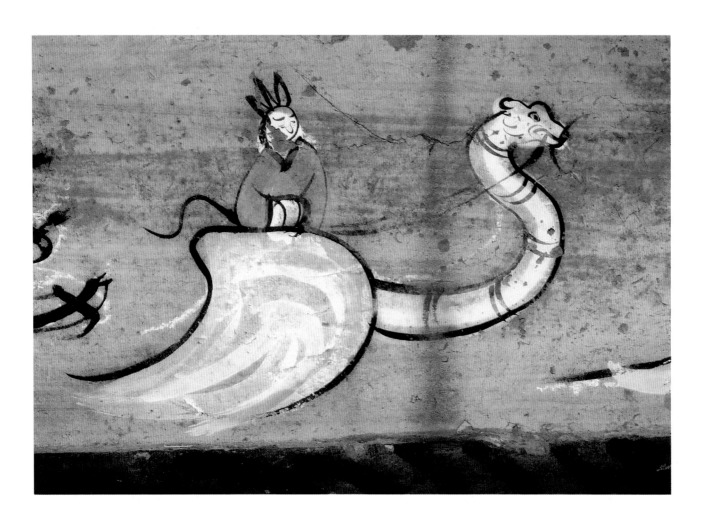

92.龙车升仙图（一）

东汉（25～220年）

高20、宽37厘米

2005年陕西省靖边县杨桥畔杨一村东汉墓出土。现存于陕西省考古研究院。

墓向205°。位于墓后室东壁上层南起第六幅。神仙侧坐于龙车之上，头戴"山"字形黑色冠，身穿红色右衽博袖袍服，白色虬龙仰头曲颈、独驾云车飞行。

（撰文：王望生　摄影：王敏）

Ascending Heaven by Dragon-drawn Chariot (1)

Eastern Han (25-220 CE)

Height 20 cm; Width 37 cm

Unearthed from an Eastern Han Tomb at Yangyicun of Yangqiaopan in Jingbian, Shaanxi, in 2005. Preserved in Shaanxi Provincial Institute of Archaeology.

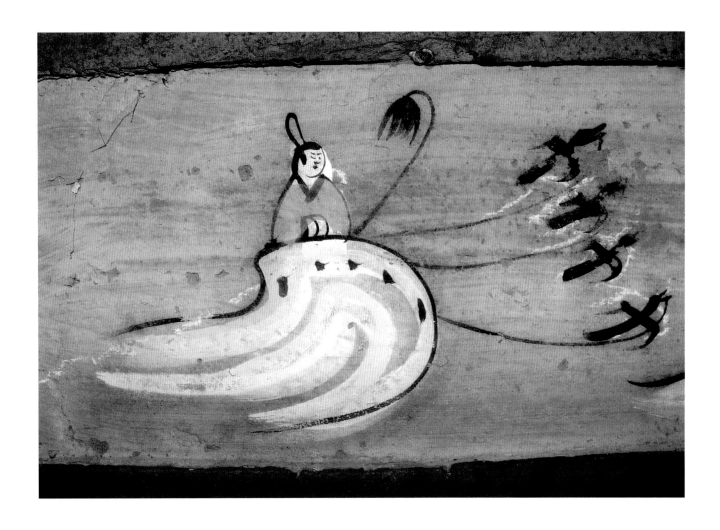

93.雁车升仙图

东汉（25～220年）

高20、宽37厘米

2005年陕西省靖边县杨桥畔杨一村东汉墓出土。现存于陕西省考古研究院。

墓向205°。位于墓后室东壁上层南端第七幅。云车上端坐一神仙，头戴黑色"圭"形冠，身穿淡红色右衽博袖袍服。车上插幡，四只在前，牵引着云车飞行。

（撰文：王望生　摄影：王敏）

Ascending Heaven by Sun Crow-drawn Chariot

Eastern Han (25-220 CE)

Height 20 cm; Width 37 cm

Unearthed from an Eastern Han Tomb at Yangyicun of Yangqiaopan in Jingbian, Shaanxi, in 2005. Preserved in Shaanxi Provincial Institute of Archaeology.

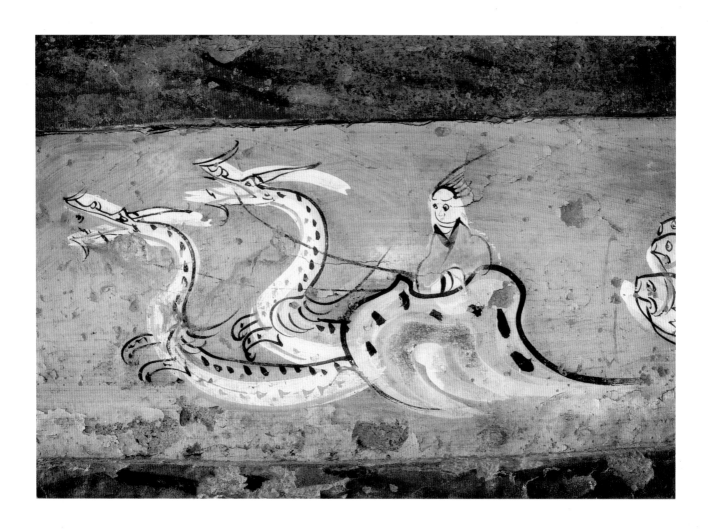

94.龙车升仙图（二）

东汉（25～220年）

高20、宽35厘米

2005年陕西省靖边县杨桥畔杨一村东汉墓出土。现存于陕西省考古研究院。

墓向205°。位于墓后室西壁上层第二幅。仙人身着红色右衽博袖袍服坐于彩色云车之上，两龙驾云车振翼前行。

（撰文：王望生　摄影：王敏）

Ascending Heaven by Dragon-drawn Chariot (2)

Eastern Han (25-220 CE)

Height 20 cm; Width 35 cm

Unearthed from an Eastern Han Tomb at Yangyicun of Yangqiaopan in Jingbian, Shaanxi, in 2005. Preserved in Shaanxi Provincial Institute of Archaeology.

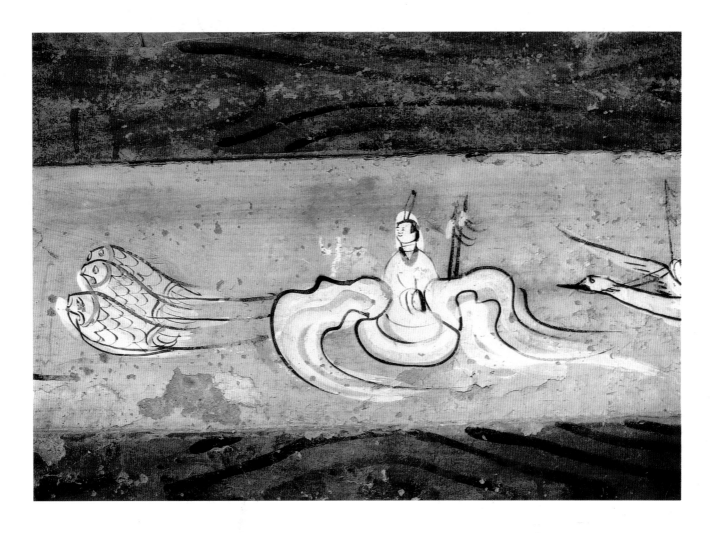

95.鱼车升仙图

东汉（25～220年）

高20、宽45厘米

2005年陕西省靖边县杨桥畔杨一村东汉墓出土，现存于陕西省考古研究院。

墓向205°。位于墓后室西壁上层第三幅。仙人头戴高冠，身穿淡黄色博袖袍服端坐彩云车上，车后置兵器二件。三条灰黄色大鱼，口内衔辔环，并列牵引云车飞速前行。

（撰文：王望生　摄影：王敏）

Ascending Heaven by Fish-drawn Chariot

Eastern Han (25-220 CE)

Height 20 cm; Width 45 cm

Unearthed from an Eastern Han Tomb at Yangyicun of Yangqiaopan in Jingbian, Shaanxi, in 2005. Preserved in Shaanxi Provincial Institute of Archaeology.

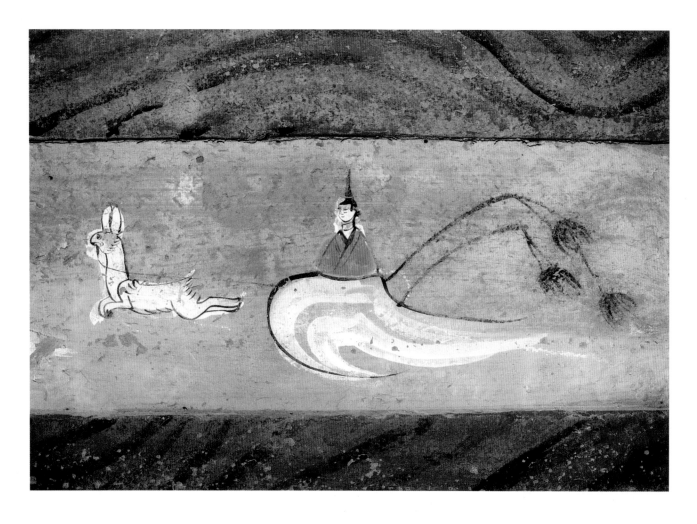

96. 兔车升仙图

东汉（25～220年）

高20、宽39厘米

2005年陕西省靖边县杨桥畔杨一村东汉墓出土。现存于陕西省考古研究院。

墓向205°。位于墓后室西壁上层第七幅。车上端坐之神仙，面目清晰，表情严肃。头戴黑色高冠，身穿红色右衽袍服。车后插有二幡，车前一白兔肩生双翼，牵引云车，向前飞奔。

（撰文：王望生　摄影：王敏）

Ascending Heaven by Hare-drawn Chariot

Eastern Han (25-220 CE)

Height 20 cm; Width 39 cm

Unearthed from an Eastern Han Tomb at Yangyicun of Yangqiaopan in Jingbian, Shaanxi, in 2005. Preserved in Shaanxi Provincial Institute of Archaeology.

97.墓主人及农耕图

东汉（25～220年）

高40、宽154厘米

2005年陕西省靖边县杨桥畔杨一村东汉墓出土。现存于陕西省考古研究院。

墓向205°。位于墓后室北壁。可分上下层，上层为墓主人画像，夫妇凭栏而坐，侍从面立。下层为锄禾图与牛耕图。

（撰文：王望生　摄影：王敏）

Portraits of the Tomb Occupants and Cultivating Scenes

Eastern Han (25-220 CE)

Height 40 cm; Width 154 cm

Unearthed from an Eastern Han Tomb at Yangyicun of Yangqiaopan in Jingbian, Shaanxi, in 2005. Preserved in Shaanxi Provincial Institute of Archaeology.

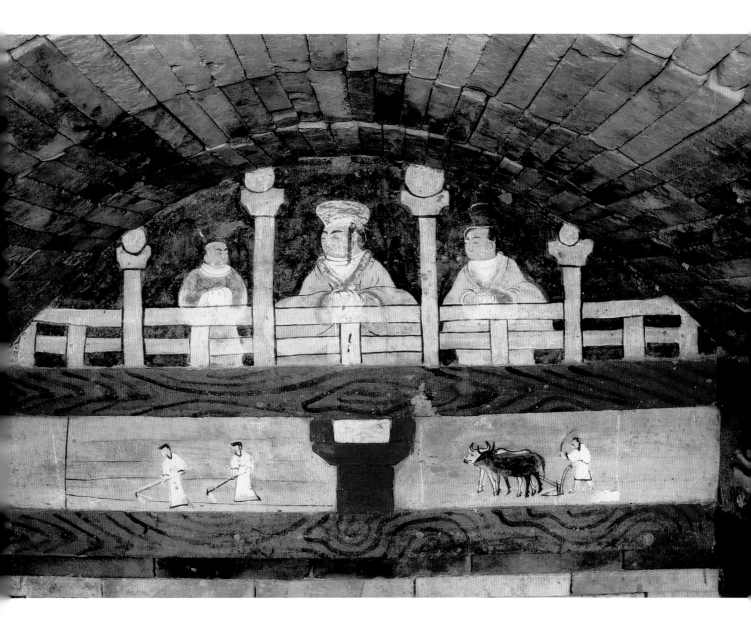

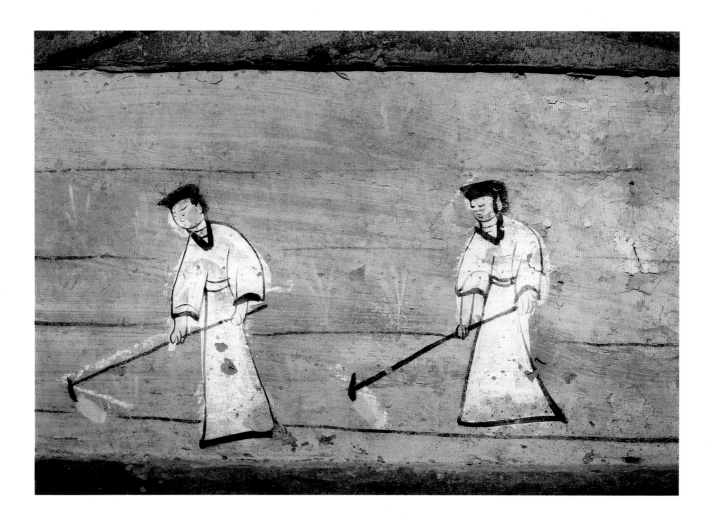

98.锄禾图

东汉（25～220年）

高20、宽67厘米

2005年陕西省靖边县杨桥畔杨一村东汉墓出土。现存于陕西省考古研究院。

墓向205°。位于墓后室北壁下层西段。两农夫身着白袍、持锄劳作田间。

（撰文：王望生　摄影：王敏）

Hoeing Scene

Eastern Han (25-220 CE)

Height 20 cm; Width 67 cm

Unearthed from an Eastern Han Tomb at Yangyicun of Yangqiaopan in Jingbian, Shaanxi, in 2005. Preserved in Shaanxi Provincial Institute of Archaeology.

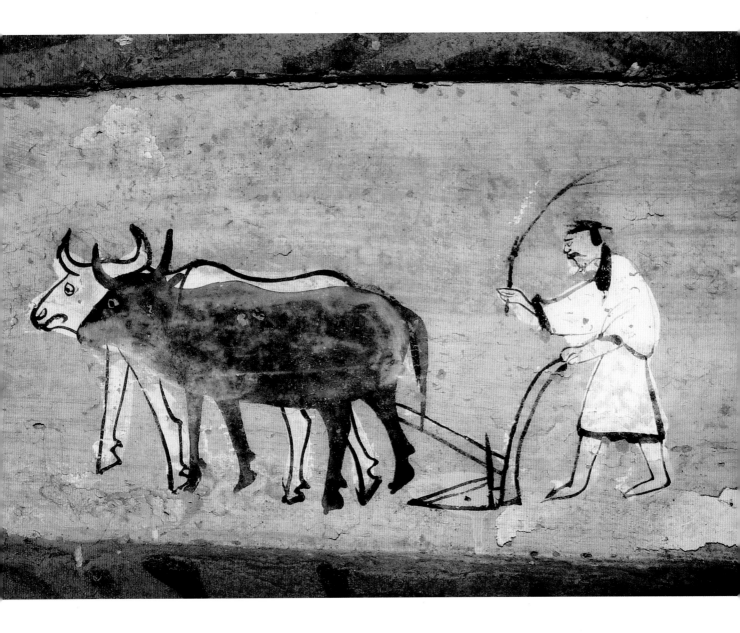

99.牛耕图

东汉（25～220年）

高20、宽67厘米

2005年陕西省靖边县杨桥畔杨一村东汉墓出土。现存于陕西省考古研究院。

墓向205°。位于墓后室北壁下层东段。一农夫身穿白色长袍，赤脚，左手扶犁，右手执鞭，黑、白二牛牵犁而耕。

<div align="right">（撰文：王望生　摄影：王敏）</div>

Ox Plowing Scene

Eastern Han (25-220 CE)

Height 20 cm; Width 67 cm

Unearthed from an Eastern Han Tomb at Yangyicun of Yangqiaopan in Jingbian, Shaanxi, in 2005. Preserved in Shaanxi Provincial Institute of Archaeology.

100. 邠王力士图

东汉（25～220年）

高104厘米

2000年陕西省旬邑县百子村东汉墓出土。现存于陕西省考古研究院。

墓向39°。位于墓门外甬道东壁。力士束额环眼，方形大口，左手持盾，右手扬剑，头后墨书"邠王力士"，前上方朱书"诸观者皆解履乃得入"。

（撰文：尹申平 摄影：张明惠）

Warrior of Prince Bin

Eastern Han (25-220 CE)

Height 104 cm

Unearthed from an Eastern Han Tomb at Baizicun in Xunyi, Shaanxi, in 2000. Preserved in Shaanxi Provincial Institute of Archaeology.

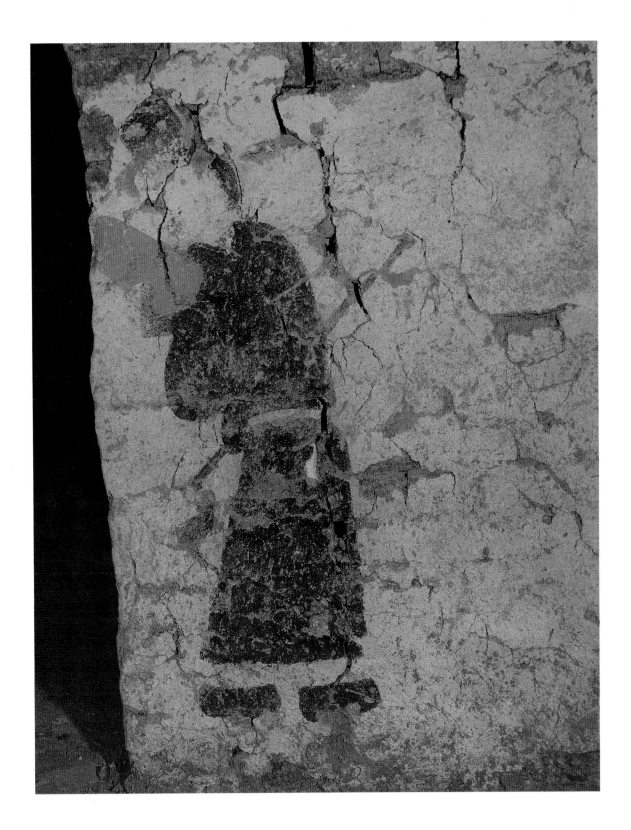

101.亭长图

东汉（25～220年）

高102厘米

2000年陕西省旬邑县百子村东汉墓出土。现存于陕西省考古研究院。墓向39°。位于墓门内甬道东壁。束额，皂衣，持盾，佩剑，头部前上方墨书"亭长"。

（撰文：尹申平　摄影：张明惠）

Neighborhood Head

Eastern Han (25-220 CE)

Height 102 cm

Unearthed from an Eastern Han Tomb at Baizicun in Xunyi, Shaanxi, in 2000. Preserved in Shaanxi Provincial Institute of Archaeology.

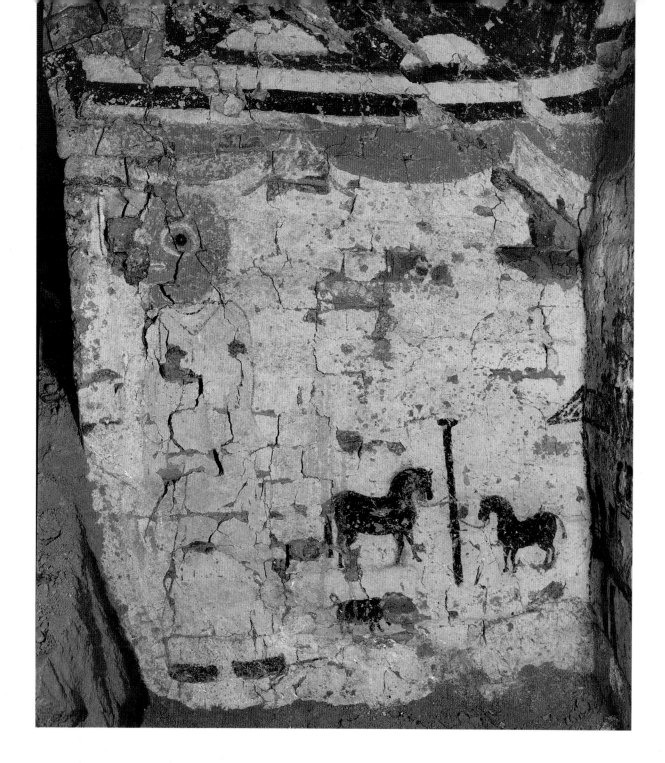

102.方相氏等图

东汉（25～220年）

高119厘米

2000年陕西省旬邑县百子村东汉墓出土。现存于陕西省考古研究院。

墓向39°。位于前室南壁西侧。顶部绘朱红色帷幔，间饰组绶，内容包含方相氏、"□苑"。其中方相氏头戴面具，黄衣执矛。

（撰文：尹申平　摄影：张明惠）

Fangxiang Shi (Regional Inspector) et al.

Eastern Han (25-220 CE)

Height 119 cm

Unearthed from an Eastern Han Tomb at Baizicun in Xunyi, Shaanxi, in 2000. Preserved in Shaanxi Provincial Institute of Archaeology.

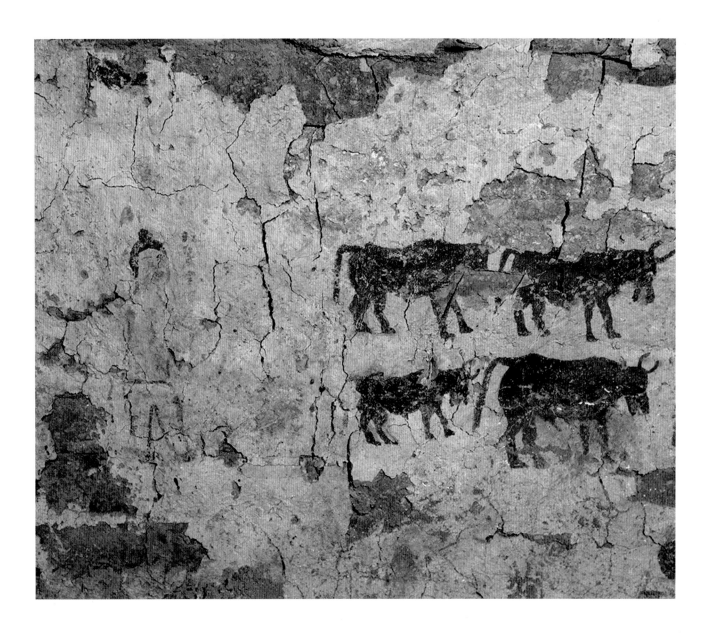

103.牧牛图

东汉（25～220年）

高27、宽52厘米

2000年陕西省旬邑县百子村东汉墓出土。现存于陕西省考古研究院。

墓向39°。位于前室南壁东侧画面右下方。一牧童位于画面左侧，高髻素衣，脸前方墨书"奴□官"。

<div align="right">（撰文：尹申平　摄影：张明惠）</div>

Herding Oxen

Eastern Han (25-220 CE)

Height 27 cm; Width 52 cm

Unearthed from an Eastern Han Tomb at Baizicun in Xunyi, Shaanxi, in 2000. Preserved in Shaanxi Provincial Institute of Archaeology.

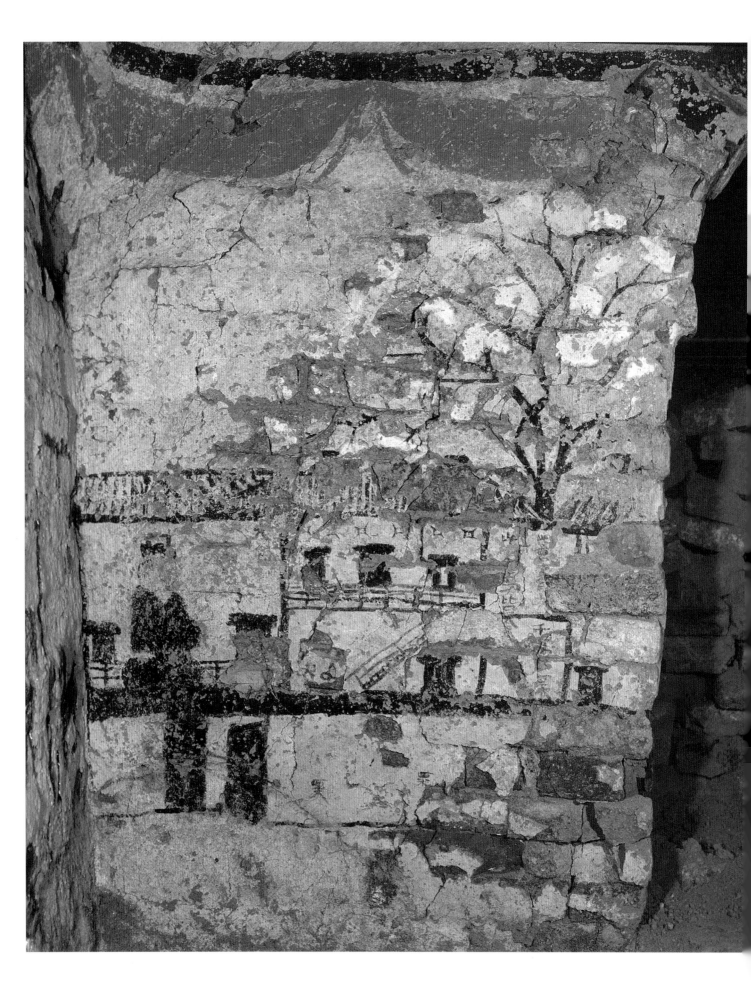

◀104.仓储图

东汉（25～220年）

高147、宽102厘米

2000年陕西省旬邑县百子村东汉墓出土。现存于陕西省考古研究院。

墓向39°。位于前室西壁南侧。画面内容包含仓楼及画面左方的皂衣仓丞，斜坡楼梯的下方，用墨线勾勒的两个负重奴仆正欲拾级而上，动态情容十分传神。一层两门之间墨书"大仓□夫"，画面右侧三纵行分别书写：朱书"邠王"、墨书"此仓□□九千万石粟"、墨书"此仓万皆□□"。

（撰文：尹申平　摄影：张明惠）

Storing Grains

Eastern Han (25-220 CE)

Height 147 cm; Width 102 cm

Unearthed from an Eastern Han Tomb at Baizicun in Xunyi, Shaanxi, in 2000. Preserved in Shaanxi Provincial Institute of Archaeology.

▼105.属吏

东汉（25～220年）

高153、宽91厘米

2000年陕西省旬邑县百子村东汉墓出土。现存于陕西省考古研究院。

墓向39°。位于前室西壁北侧。顶部朱红帷幔，间饰组绶。两位属吏分立于大树左右两侧，左侧属吏矮小，高髻皂衣，头前上方墨书"丞小史"。右侧属吏高大，高冠皂衣。面部已漫漶不清。

（撰文：尹申平　摄影：张明惠）

Clerks

Eastern Han (25-220 CE)

Height 153 cm; Width 91 cm

Unearthed from an Eastern Han Tomb at Baizicun in Xunyi, Shaanxi, in 2000. Preserved in Shaanxi Provincial Institute of Archaeology.

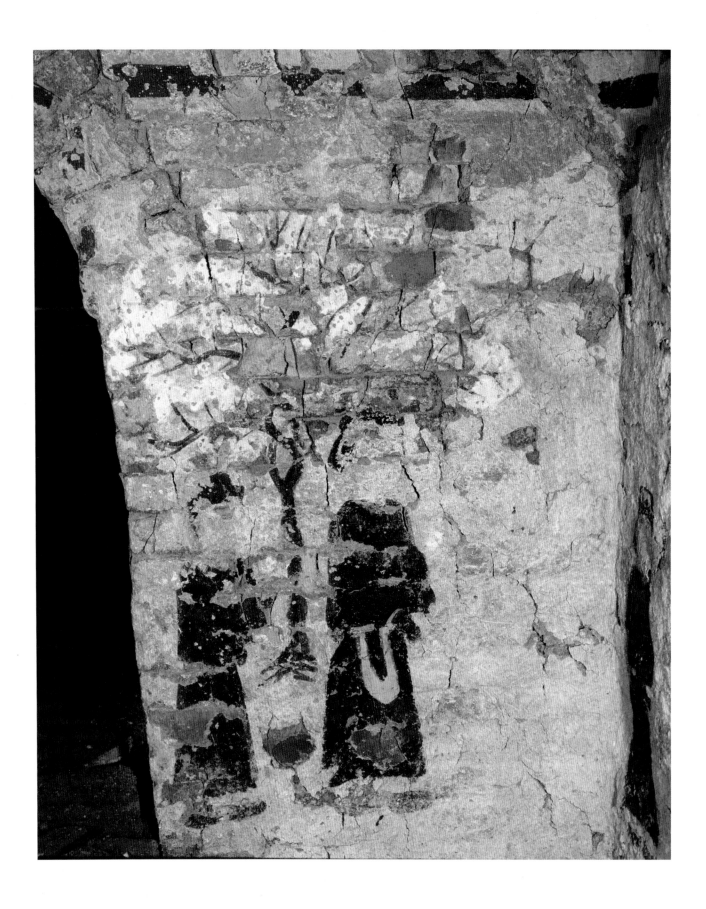

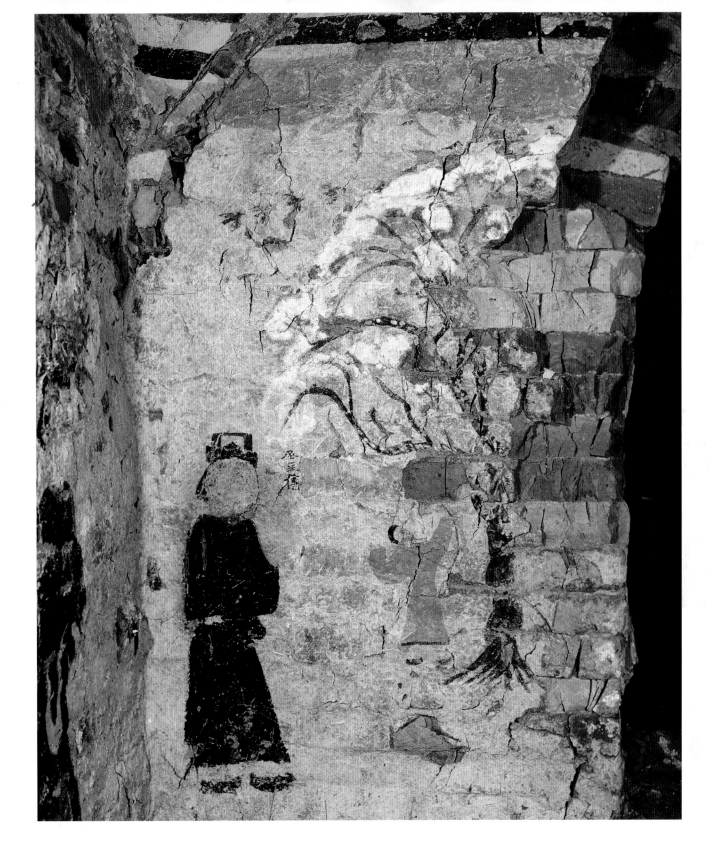

106.射雀（爵）射猴（侯）图

东汉（25～220年）

高145、宽86厘米

2000年陕西省旬邑县百子村东汉墓出土。现存于陕西省考古研究院。墓向39°。位于前室北壁西侧。顶部朱红色帷幔，间饰组绶，画面内容展现了射雀（爵）射猴（侯）情景及侍立丞主薄。

（撰文：尹申平　摄影：张明惠）

Shooting Sparrows and Monkeys (Metaphor of Getting Nobilities)

Eastern Han (25-220 CE)

Height 145 cm; Width 86 cm

Unearthed from an Eastern Han Tomb at Baizicun in Xunyi, Shaanxi, in 2000. Preserved in Shaanxi Provincial Institute of Archaeology.

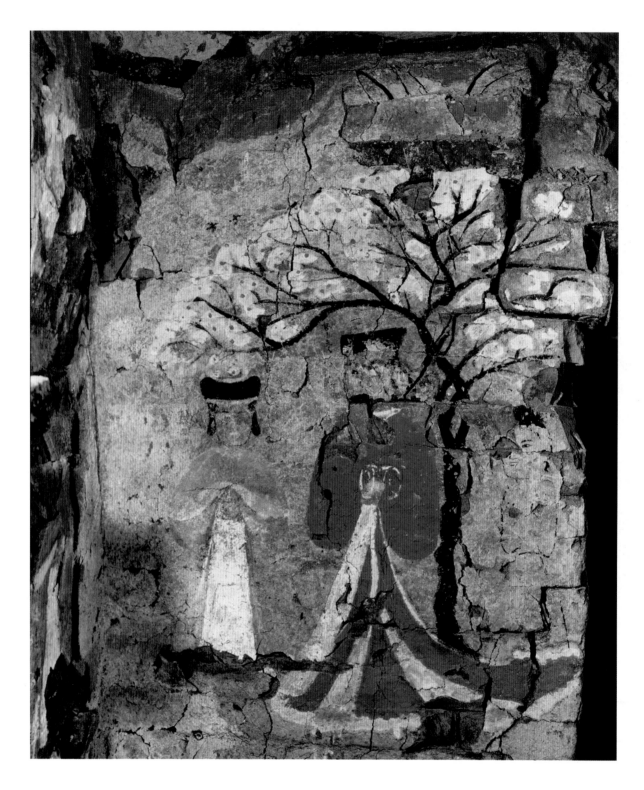

107. 贵妇图

东汉（25～220年）

高150、宽94厘米

2000年陕西省旬邑县百子村东汉墓出土。现存于陕西省考古研究院。墓向39°。位于前室东壁东耳室北侧。大树位于画面右侧，树冠覆盖上部三分之一画面，树冠以白、紫色采用没骨法绘就，成云团状。绘有飞鸟、落雀和红色果实，使画面充满灵动。两贵妇立于树之左侧。

（撰文：尹申平　摄影：张明惠）

Noble Ladies

Eastern Han (25-220 CE)

Height 15 cm; Width 94 cm

Unearthed from an Eastern Han Tomb at Baizicun in Xunyi, Shaanxi, in 2000. Preserved in Shaanxi Provincial Institute of Archaeology.

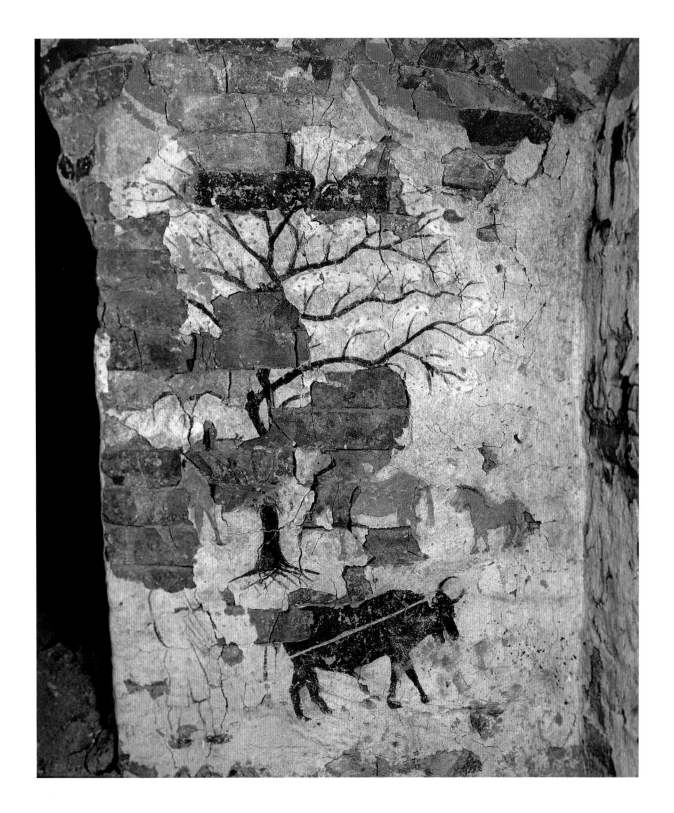

108. 牛耕、牧马图

东汉（25～220年）

高150、宽93厘米

2000年陕西省旬邑县百子村东汉墓出土，现存于陕西省考古研究院。墓向39°。位于前室东壁南侧。顶部朱红色帷幔，间饰组绶，树下拴两匹马，旁有一匹奔跑的马驹，画面下方为牛耕场面。

（撰文：尹申平　摄影：张明惠）

Plowing with Ox and Herding Horses

Eastern Han (25-220 CE)

Height 15 cm; Width 102 cm

Unearthed from an Eastern Han Tomb at Baizicun in Xunyi, Shaanxi, in 2000. Preserved in Shaanxi Provincial Institute of Archaeology.

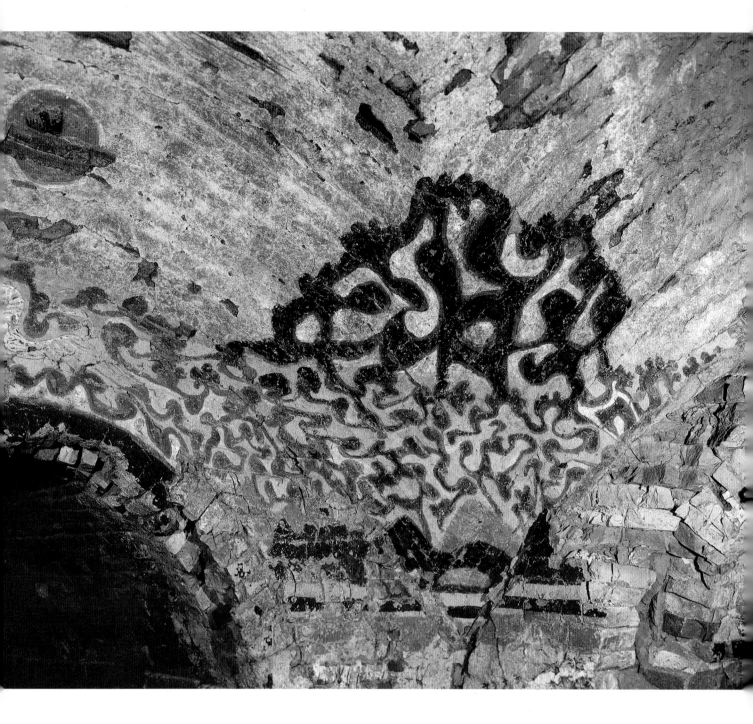

109.云气图

东汉（25～220年）

高80、宽130厘米

2000年陕西省旬邑县百子村东汉墓出土。现存于陕西省考古研究院。

墓向39°。位于前室顶部西北角。以黑、红、黄三色绘云气纹，顶部白色，朱红色星出四芒、五芒、六芒、七芒，以五芒居多，芒按顺时针方向旋转。

（撰文：尹申平　摄影：张明惠）

Auspicious Clouds

Eastern Han (25-220 CE)

Height 80 cm; Width 130 cm

Unearthed from an Eastern Han Tomb at Baizicun in Xunyi, Shaanxi, in 2000. Preserved in Shaanxi Provincial Institute of Archaeology.

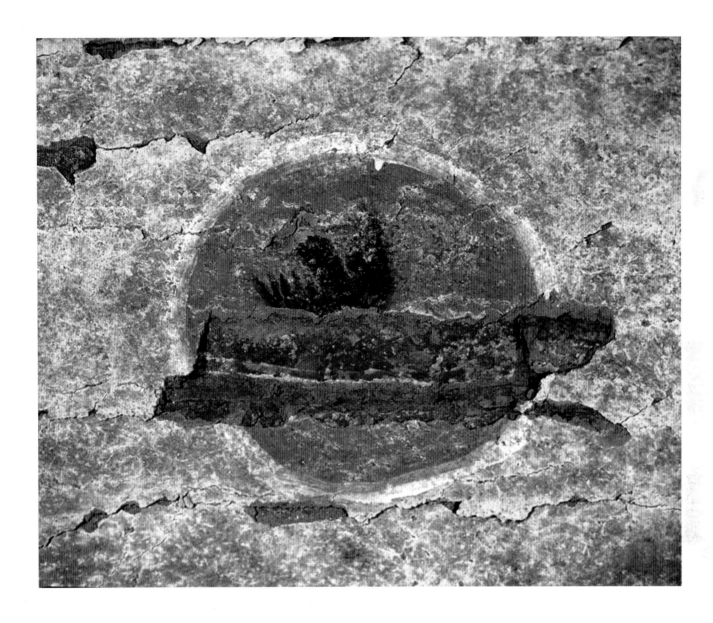

110.日轮图

东汉（25~220年）

直径32厘米

2000年陕西省旬邑县百子村东汉墓出土。现存于陕西省考古研究院。

墓向39°。位于前室西侧顶部。三足乌振羽展翅，呈俯冲状，头部残。

（撰文：尹申平　摄影：张明惠）

The Sun

Eastern Han (25-220 CE)

Diameter 32 cm

Unearthed from an Eastern Han Tomb at Baizicun in Xunyi, Shaanxi, in 2000. Preserved in Shaanxi Provincial Institute of Archaeology.

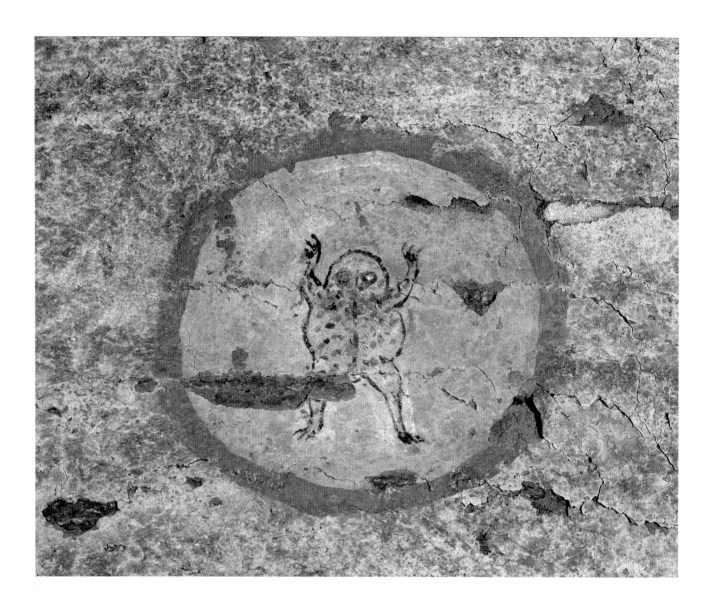

111. 月轮图

东汉（25～220年）

直径34厘米

2000年陕西省旬邑县百子村东汉墓出土。现存于陕西省考古研究院。

墓向39°。位于前室东侧顶部。蟾蜍四足伸展，呈向上爬行状，每爪三指，颜色为紫色上饰以黑、红斑点。

（撰文：尹申平　摄影：张明惠）

The Moon

Eastern Han (25-220 CE)

Diameter 34 cm

Unearthed from an Eastern Han Tomb at Baizicun in Xunyi, Shaanxi, in 2000. Preserved in Shaanxi Provincial Institute of Archaeology.

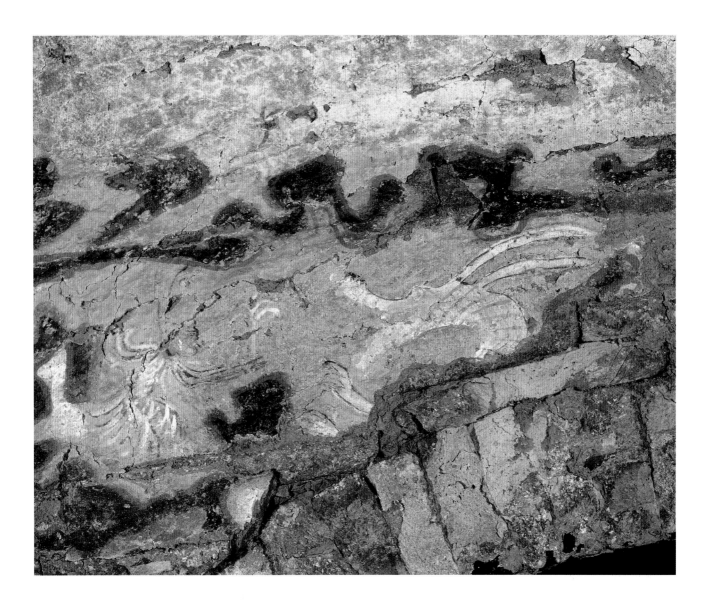

112. 青龙图

东汉（25～220年）

高约30、宽100厘米

2000年陕西省旬邑县百子村东汉墓出土。现存于陕西省考古研究院。

墓向39°。位于前室东耳室上方。左侧为仙人，右侧为青龙。青龙口吐长舌伸向仙人，仙人长有羽翼，手托一株仙草，奉饲青龙。

（撰文：尹申平　摄影：张明惠）

Green Dragon

Eastern Han (25-220 CE)

Height ca. 30 cm; Width 100 cm

Unearthed from an Eastern Han Tomb at Baizicun in Xunyi, Shaanxi, in 2000. Preserved in Shaanxi Provincial Institute of Archaeology.

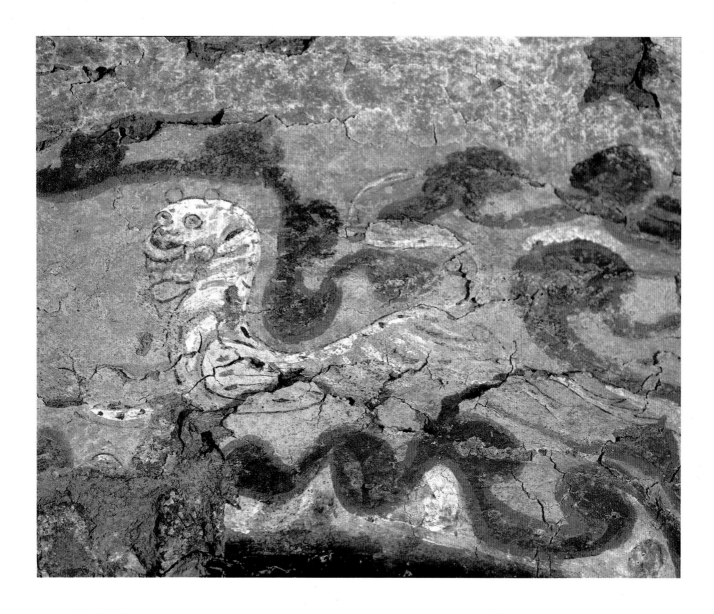

113. 白虎图

东汉（25～220年）

高60、宽120厘米

2000年陕西省旬邑县百子村东汉墓出土。现存于陕西省考古研究院。

墓向39°。位于前室西耳室上方。白虎有翼，呈奔走状，虎头上扬，四肢如刀，身有斑纹。

（撰文：尹申平　摄影：张明惠）

White Tiger

Eastern Han (25-220 CE)

Height 60 cm; Width 120 cm

Unearthed from an Eastern Han Tomb at Baizicun in Xunyi, Shaanxi, in 2000. Preserved in Shaanxi Provincial Institute of Archaeology.

114. 庖厨图

东汉（25～220年）

高113、宽112厘米

2000年陕西省旬邑县百子村东汉墓出土。现存于陕西省考古研究院。

墓向39°。位于前室东耳室南壁。画面三人，两人跽坐于席上，右手执刀切肉，头上方墨书"大宰"，架上悬挂三束肉，其上墨书"牛月"。画面右侧一人，手持两束肉，墨书"奴□□持月"。

（撰文：尹申平　摄影：张明惠）

Cooking

Eastern Han (25-220 CE)

Height 113 cm; Width 112 cm

Unearthed from an Eastern Han Tomb at Baizicun in Xunyi, Shaanxi, in 2000. Preserved in Shaanxi Provincial Institute of Archaeology.

115.益金子像

东汉（25～220年）

高40厘米

2000年陕西省旬邑县百子村东汉墓出土。现存于陕西省考古研究院。墓向39°。位于前室东耳室内北壁。为左侧第四人，头上部题"益金子"三字，当为人名。

（撰文：尹申平　摄影：张明惠）

Yijinzi (The Inscription over the Figure)

Eastern Han (25-220 CE)

Height 40 cm

Unearthed from an Eastern Han Tomb at Baizicun in Xunyi, Shaanxi, in 2000. Preserved in Shaanxi Provincial Institute of Archaeology.

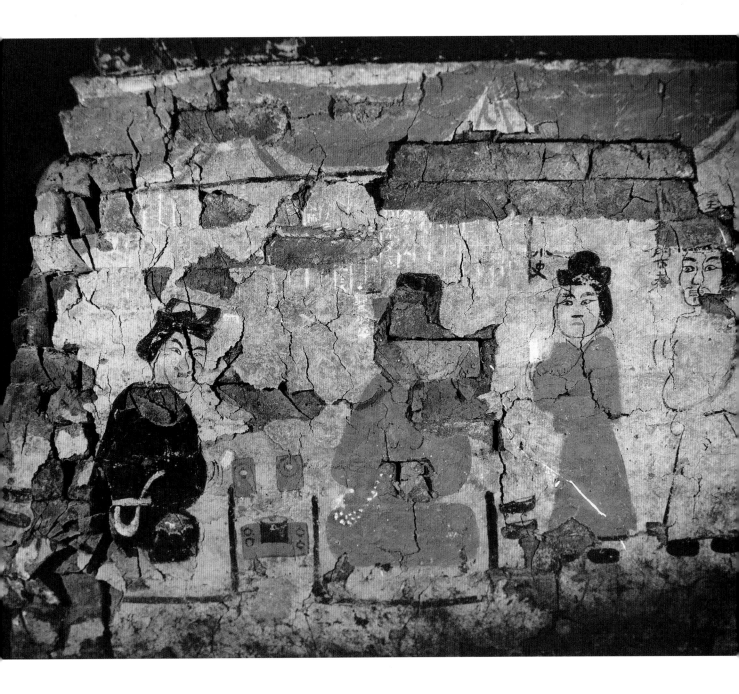

116.宴饮图

东汉（25～220年）

高117厘米

2000年陕西省旬邑县百子村东汉墓出土。现存于陕西省考古研究院。

墓向39°。位于后室西壁。为西壁人物组合中第1～4人。顶部饰朱红帷幔，间饰组绶。南侧二人正对坐宴饮，其南躬立的二人头前分别题"小史"、"将军门下走"。

（撰文：尹申平　摄影：张明惠）

Feasting

Eastern Han (25-220 CE)

Height 117 cm

Unearthed from an Eastern Han Tomb at Baizicun in Xunyi, Shaanxi, in 2000. Preserved in Shaanxi Provincial Institute of Archaeology.

117.将军门下掾（局部）

东汉（25～220年）

人物高70、66、65厘米

2000年陕西省旬邑县百子村东汉墓出土。现存于陕西省考古研究院。墓向39°。位于后室西壁。为人物组合第5～7人。顶部朱红帷幔，间饰组绶。三人皆黑帻素衣，双手捧于胸前托一黄色物，恭立面向饮宴者，头前分别题"将军门下走"。

（撰文：尹申平　摄影：张明惠）

Headquarters Clerks (Detail)

Eastern Han (25-220 CE)

The Heights of the Figures 70, 66 and 65 cm

Unearthed from an Eastern Han Tomb at Baizicun in Xunyi, Shaanxi, in 2000. Preserved in Shaanxi Provincial Institute of Archaeology.

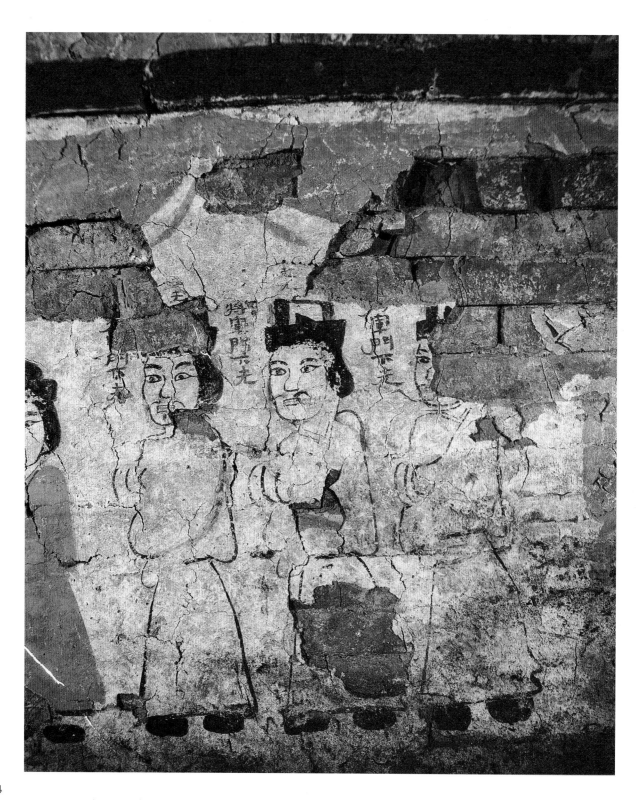

118. 画师工等（局部）

东汉（25～220年）

高70、宽65厘米

2000年陕西省旬邑县百子村东汉墓出土。现存于陕西省考古研究院。墓向39°。位于后室西壁。为人物组合中第8、9人，均残、红衣。第8人头部前方墨书"画师工"，第9人身前墨书"诸□使"、"□邻王"，余漫漶不清。此二人均面迎向车马出行图。

（撰文：尹申平　摄影：张明惠）

Painting Craftsman and other Officials (Detail)

Eastern Han (25-220 CE)

Height 70 cm; Width 65 cm

Unearthed from an Eastern Han Tomb at Baizicun in Xunyi, Shaanxi, in 2000. Preserved in Shaanxi Provincial Institute of Archaeology.

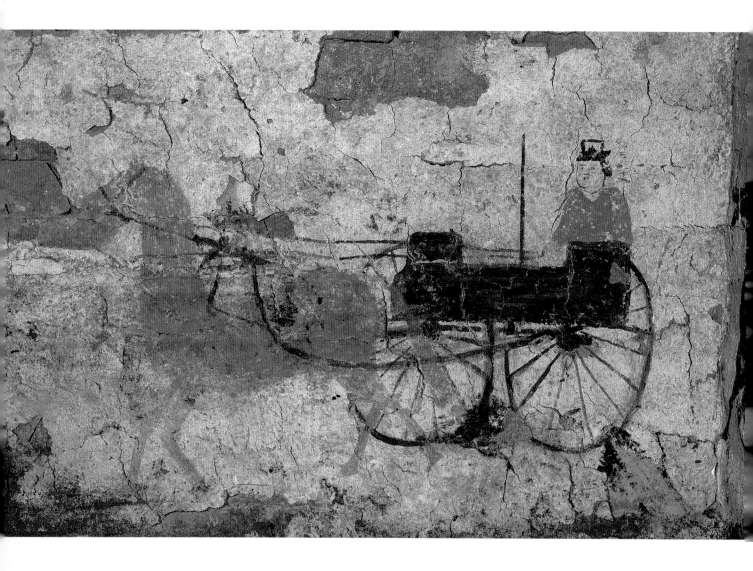

119. 车马出行图（局部）

东汉（25～220年）

高40、宽70厘米

2000年陕西省旬邑县百子村东汉墓出土。现存于陕西省考古研究院。

墓向39°。位于后室西壁最北端的下部。马首向南，驾双辕，一人坐于后舆，戴冠，冠后墨书"邠王御史"。

<div style="text-align: right">（撰文：尹申平　摄影：张明惠）</div>

Procession Scene (Detail)

Eastern Han (25-220 CE)

Height 40 cm; Width 70 cm

Unearthed from an Eastern Han Tomb at Baizicun in Xunyi, Shaanxi, in 2000. Preserved in Shaanxi Provincial Institute of Archaeology.

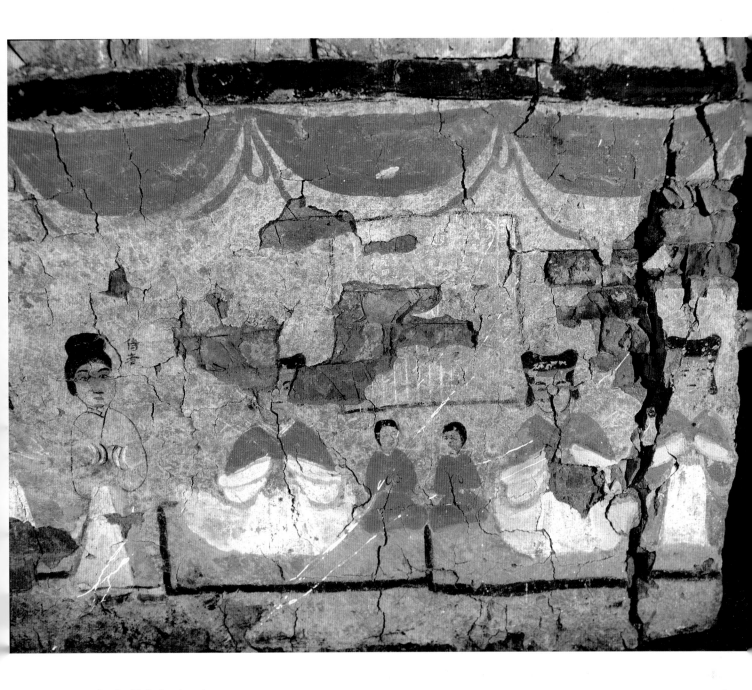

120. 夫人等图（一）

东汉（25～220年）

高120厘米

2000年陕西省旬邑县百子村东汉墓出土。现存于陕西省考古研究院。

墓向39°。位于后室东壁。为东壁人物组合中第1～6人，顶部饰朱红帷幔、间饰组绶。

（撰文：尹申平　摄影：张明惠）

The Dame, Maids and Attendants (1)

Eastern Han (25-220 CE)

Height 120 cm

Unearthed from an Eastern Han Tomb at Baizicun in Xunyi, Shaanxi, in 2000. Preserved in Shaanxi Provincial Institute of Archaeology.

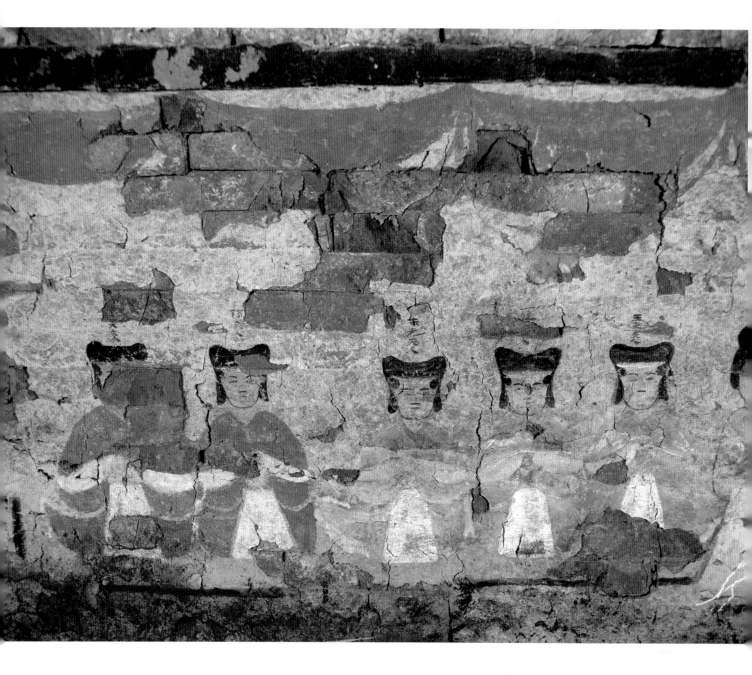

121. 夫人等图（二）

东汉（25～220年）

高120厘米

2000年陕西省旬邑县百子村东汉墓出土。现存于陕西省考古研究院。

墓向39°。位于后室东壁。为东壁人物组合中第7～11人。顶部饰朱红帷幔，间饰组绶。

<div style="text-align: right">（撰文：尹申平　摄影：张明惠）</div>

The Dame, Maids and Attendants (2)

Eastern Han (25-220 CE)

Height 120 cm

Unearthed from an Eastern Han Tomb at Baizicun in Xunyi, Shaanxi, in 2000. Preserved in Shaanxi Provincial Institute of Archaeology.

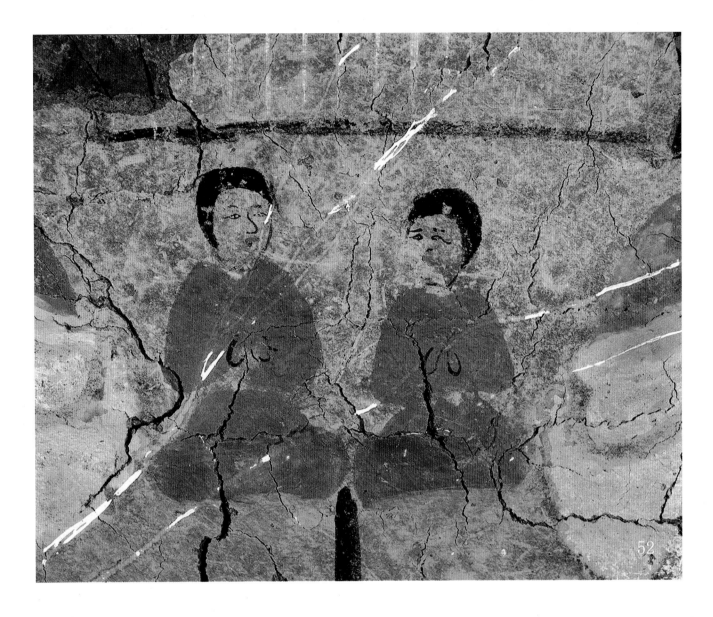

122.孩童图

东汉（25～220年）

高23、宽25厘米

2000年陕西省旬邑县百子村东汉墓出土。现存于陕西省考古研究院。

墓向39°。位于后室东壁。为东壁人物组合中第3、4人。

（撰文：尹申平　摄影：张明惠）

Children

Eastern Han (25-220 CE)

Height 23 cm; Width 25 cm

Unearthed from an Eastern Han Tomb at Baizicun in Xunyi, Shaanxi, in 2000. Preserved in Shaanxi Provincial Institute of Archaeology.

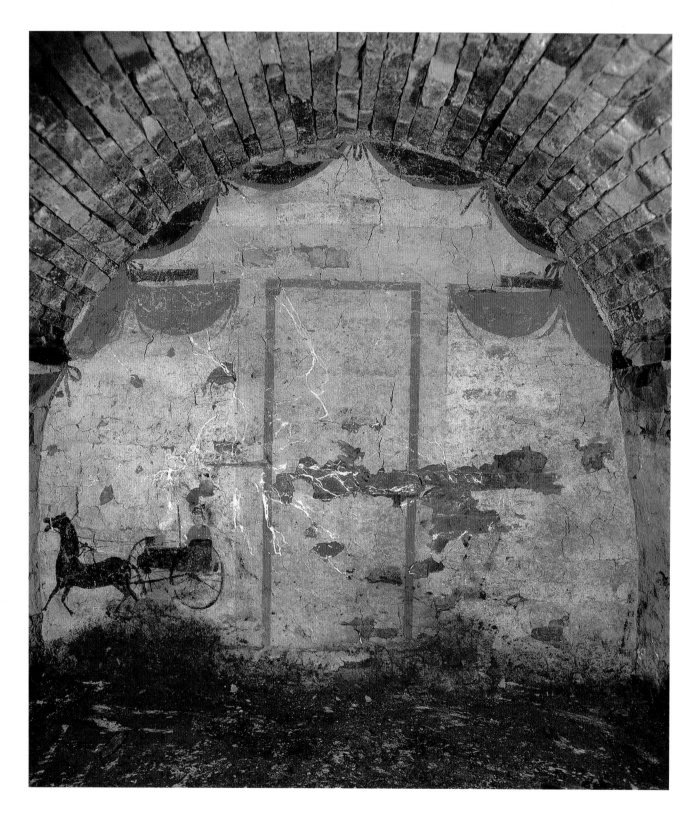

123. 天门及车马出行图

东汉（25～220年）

高190厘米

2000年陕西省旬邑县百子村东汉墓出土。现存于陕西省考古研究院。

墓向39°。位于后室北壁。窿形顶饰黑色帷幔，间饰黑色组绥，天门T形黄色，高125厘米，两侧饰朱红帷幔，黄色T形内以朱红色绘一长方形框。天门左下侧为车马出行画面。

（撰文：尹申平　摄影：张明惠）

The Heaven Gate and Procession

Eastern Han (25-220 CE)

Height 190 cm

Unearthed from an Eastern Han Tomb at Baizicun in Xunyi, Shaanxi, in 2000. Preserved in Shaanxi Provincial Institute of Archaeology.

124.挂刀侍卫图

北周天和七年（572年）

高约130、宽50厘米

1999～2000年陕西省西安市咸阳国际机场北周宇文通墓出土。现存于陕西省考古研究院。

墓向南。位于墓道第四天井东壁，绘一个正面站立的侍卫，面敷肉红色，五官模糊。上身穿红色广袖袍，下穿白色大口缚裤，脚踏黑色鞋。双手合拱于胸前，挂一黑色仪刀。

<div align="right">（撰文：李明　摄影：张明惠）</div>

Guard Holding Sword

7th Year of Tianhe Era, Northern Zhou (572 CE)

Height ca. 130 cm; Width 50 cm

Unearthed from Yuwen Tong's Tomb of the Northern Zhou Dynasty on the Site of Xi'an Xianyang International Airport in 1999-2000. Preserved in Shaanxi Provincial Institute of Archaeology.

125.侍卫图

北周天和七年（572年）

高约130、宽210厘米

1999～2000年陕西省西安市咸阳国际机场北周宇文通墓出土。现存于陕西省考古研究院。

墓向南。位于墓道第五天井东壁，绘两个正面站立的侍卫，皆穿红色及膝长袍，红裤、黑鞋。双手合拱于胸前侍立。

（撰文：李明　摄影：张明惠）

Guards

7th Year of Tianhe Era, Northern Zhou (572 CE)

Height ca. 130 cm; Width 210 cm

Unearthed from Yuwen Tong's Tomb of the Northern Zhou Dynasty on the Site of Xi'an Xianyang International Airport in 1999-2000. Preserved in Shaanxi Provincial Institute of Archaeology.

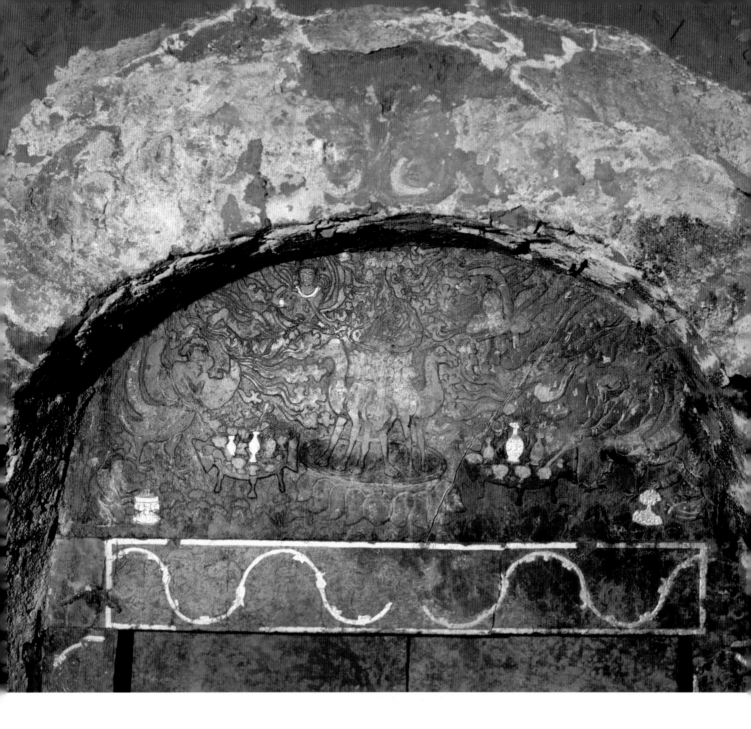

126.门楣

北周（535～580年）

高约50、宽130厘米

2000年陕西省西安北周安伽墓出土。现存于陕西省考古研究院。

墓向不明。位于甬道口的门楣上。整体呈圆拱形。正中绘挺立盛开的红色莲花，两侧亦各有一朵花瓣较少的莲花。

<div align="right">（撰文：李明　摄影：张明惠）</div>

Door Lintel

Northern Zhou (535-580 CE)

Height ca. 50 cm; Width 130 cm

Unearthed from An Jia's Tomb of the Northern Zhou Dynasty in Xi'an, Shaanxi, in 2000. Preserved in Shaanxi Provincial Institute of Archaeology.

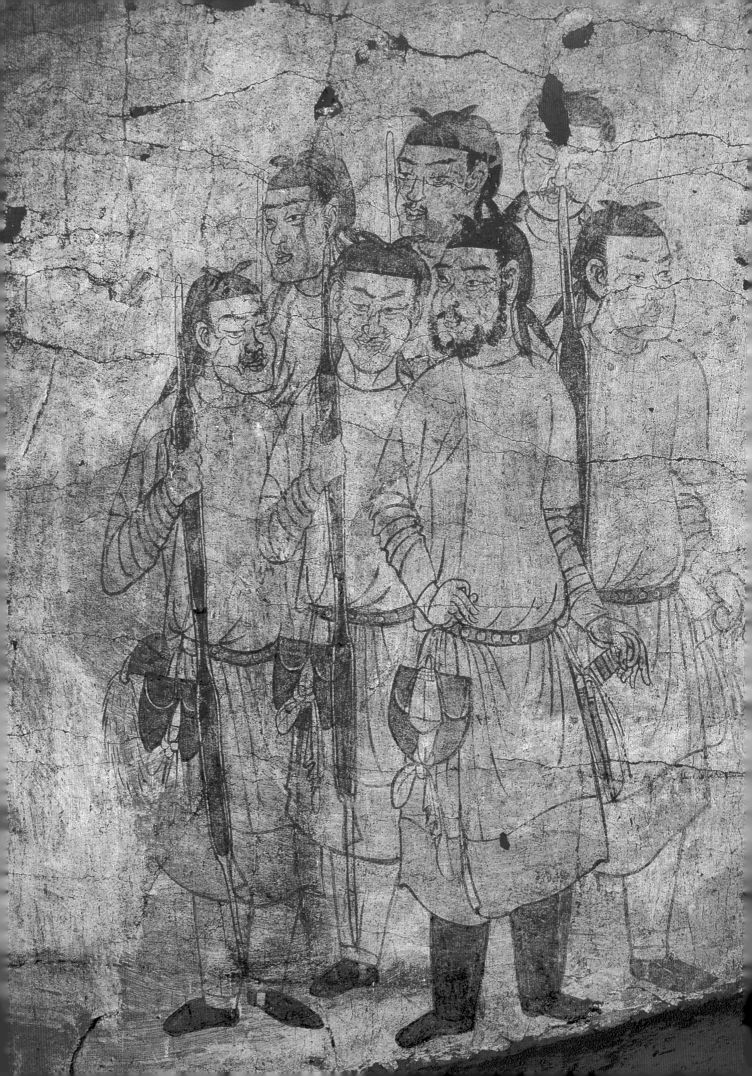

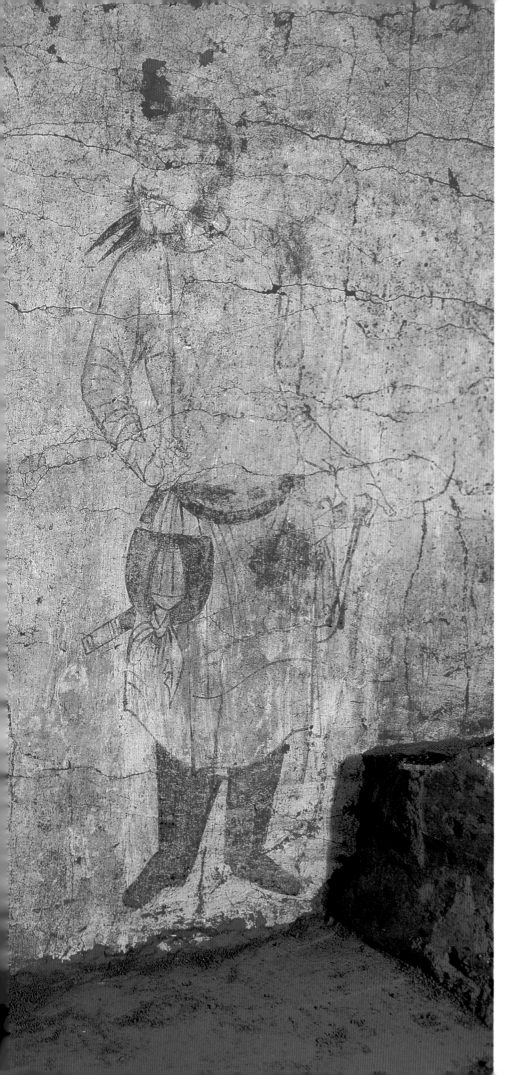

127.仪仗队列图（一）

隋（581～618年）

高约190、宽240厘米

2005年陕西省潼关税村隋代壁画墓
出土。现存于陕西省考古研究院。
墓向南。位于墓道东壁南端（第二
组）。为墓道东壁46人组成的仪仗
队伍中的第3～10人。人物均头裹黑
色幞头，着团领直襟窄袖衫，手执
不张弦的弓，腰间挎仪刀，带箭箙
和�囊。

（撰文：李明　摄影：张明惠）

Guards of Honor (1)

Sui (581-618 CE)

Height ca. 190 cm; Width 240 cm

Unearthed from a Mural Tomb of the
Sui Dynasty at Shuicun in Tongguan,
Shaanxi, in 2005. Preserved in Shaanxi
Provincial Institute of Archaeology.

128.仪仗队列图（二）

隋（581～618年）

高约270、宽250厘米

2005年陕西省潼关税村隋代壁画墓出土。现存于陕西省考古研究院。

墓向南。位于墓道东壁中段（第三组）。为墓道东壁46人组成的仪仗队伍中的第11～18人。人物均头裹黑色幞头，着团领直襟窄袖衫，手执旗帜，腰间挎仪刀，带箭箙和鞶囊。领队人物腰间插笏板。旗帜长方形，有四条旒。第一面旗帜杆顶饰大纛，旒饰雉尾纹。

<div align="right">（撰文：李明　摄影：张明惠）</div>

Guards of Honor (2)

Sui (581-618 CE)

Height ca. 270 cm; Width 250 cm

Unearthed from a Mural Tomb of the Sui Dynasty at Shuicun in Tongguan, Shaanxi, in 2005. Preserved in Shaanxi Provincial Institute of Archaeology.

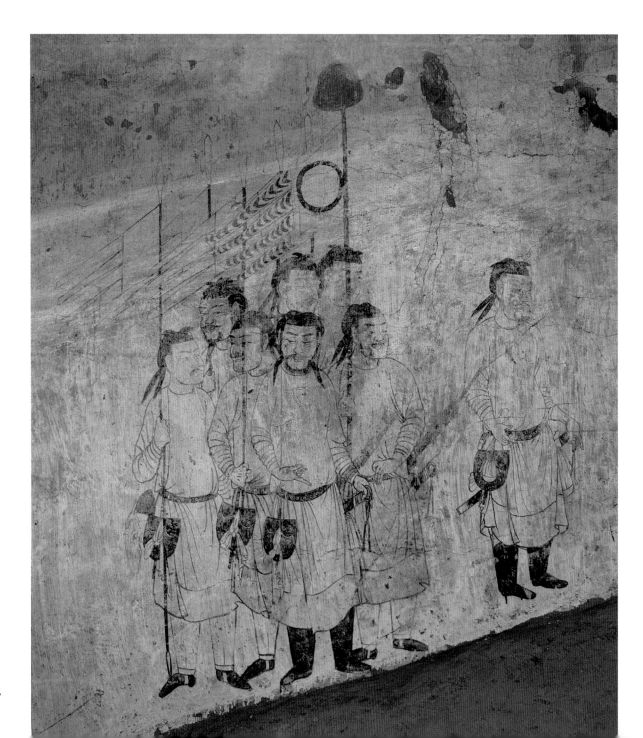

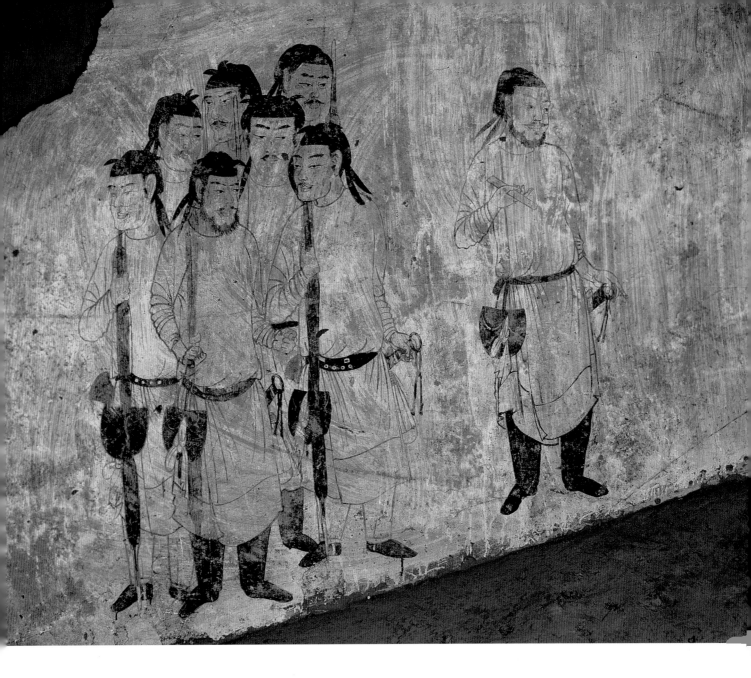

129. 仪仗队列图（三）

隋（581~618年）

高约205、宽205厘米

2005年陕西省潼关税村隋代壁画墓出土。现存于陕西省考古研究院。

墓向南。位于墓道东壁中段（第四组）。为墓道东壁46人组成的仪仗队伍中的第19~26人。人物均头裹黑色幞头，着团领直襟窄袖衫，手执不张弦的弓，腰间挎仪刀，带箭箙和鞶囊。

（撰文：李明　摄影：张明惠）

Guards of Honor (3)

Sui (581-618 CE)

Height ca. 205 cm; Width 205 cm

Unearthed from a Mural Tomb of the Sui Dynasty at Shuicun in Tongguan, Shaanxi, in 2005. Preserved in Shaanxi Provincial Institute of Archaeology.

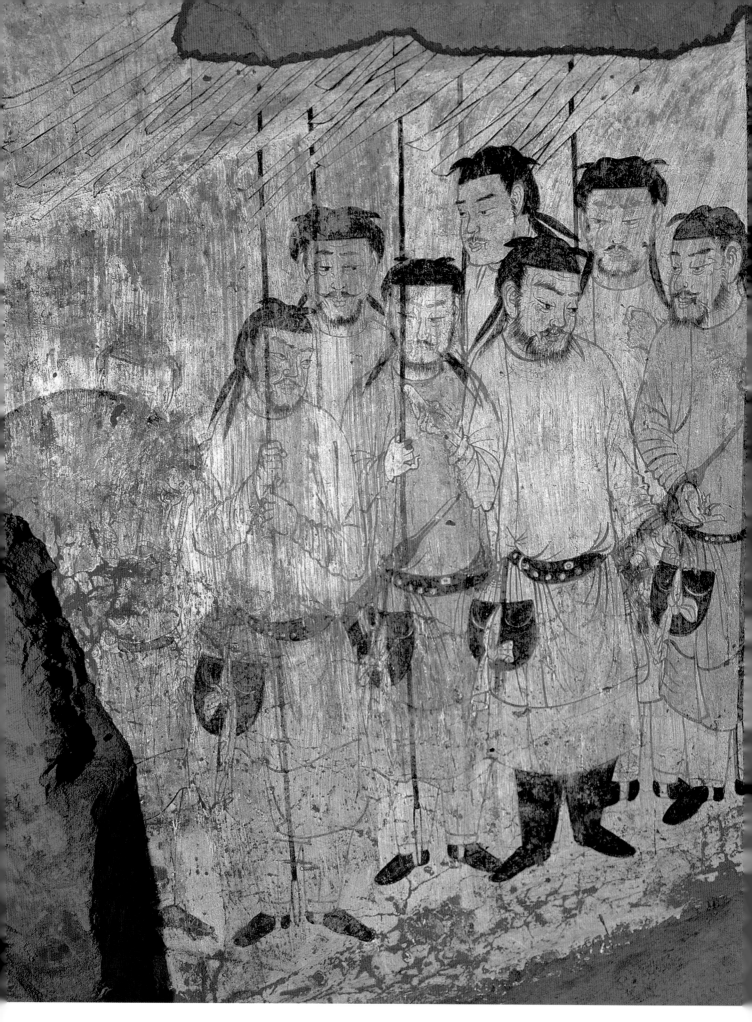

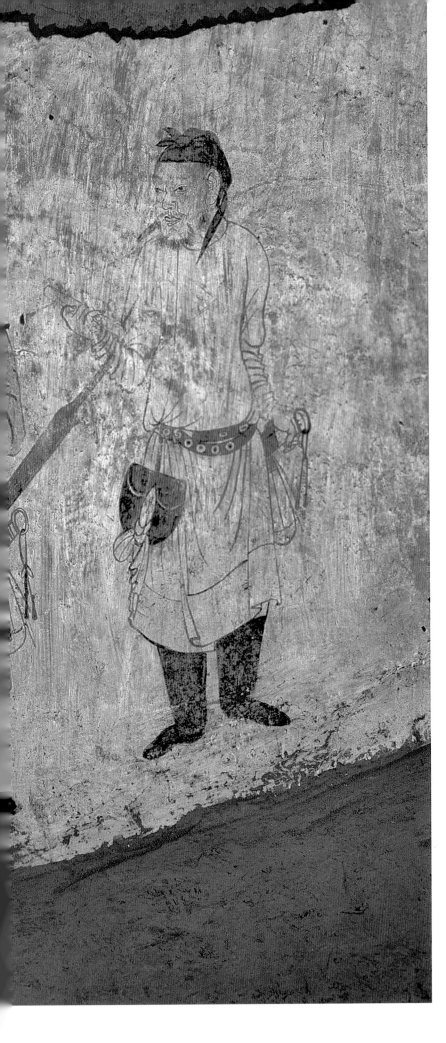

130. 仪仗队列图（四）

隋（581～618年）

高约230、宽270厘米

2005年陕西省潼关税村隋代壁画墓出土。现存于陕西省考古研究院。

墓向南。位于墓道东壁中段（第五组）。为墓道东壁46人组成的仪仗队伍中的第27～34人。人物均头裹黑色幞头，着团领直襟窄袖衫，手执旗帜，腰间挎仪刀、弓，带箭箙和鞶囊。领队人物右手拈笏板。旗帜残损。

（撰文：李明　摄影：张明惠）

Guards of Honor (4)

Sui (581-618 CE)

Height ca. 230 cm; Width 270 cm

Unearthed from a Mural Tomb of the Sui Dynasty at Shuicun in Tongguan, Shaanxi, in 2005. Preserved in Shaanxi Provincial Institute of Archaeology.

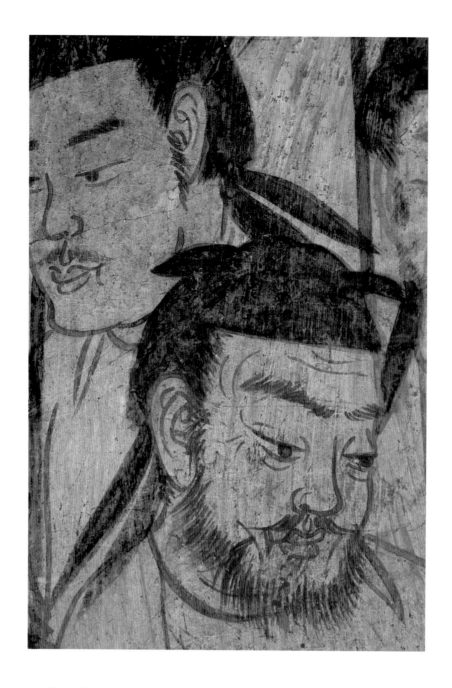

131.仪仗队列图（四）（局部）

隋（581~618年）

高约120、宽80厘米

2005年陕西省潼关税村隋代壁画墓出土。现存于陕西省考古研究院。

墓向南。位于墓道东壁中段。前者为墓道东壁46人组成的仪仗队伍中的第28人，是第五组的领队人物之一，后者为第34人。人物面部的描绘非常注重细节：前者年龄稍长，胡须疏朗，额上的抬头纹和眼角的鱼尾纹，乃至体现年龄的眼袋也都给予描绘；后者面部光洁没有皱纹，唇上有细密的小胡须，年轻而俊美。

（撰文：李明　摄影：张明惠）

Guards of Honor (4) (Detail)

Sui (581-618 CE)

Height ca. 120 cm; Width 80 cm

Unearthed from a Mural Tomb of the Sui Dynasty at Shuicun in Tongguan, Shaanxi, in 2005.

Preserved in Shaanxi Provincial Institute of Archaeology.

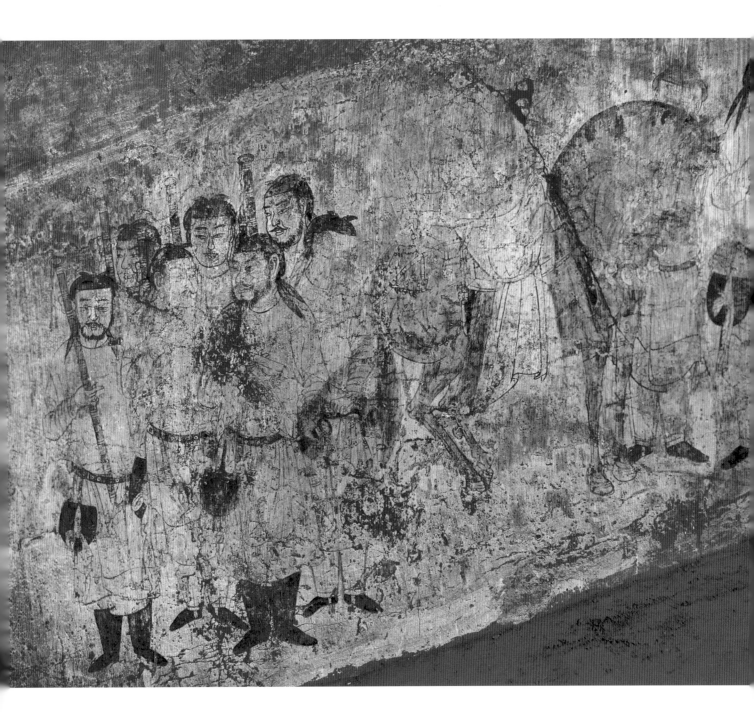

132.仪仗队列图（五）

隋（581~618年）

高约190、宽210厘米

2005年陕西省潼关税村隋代壁画墓出土。现存于陕西省考古研究院。

墓向南。位于墓道东壁北端（第六组），为墓道东壁46人组成的仪仗队伍中的第35~42人。人物均头裹黑色幞头，着团领直襟窄袖衫，手举仪刀，腰间带鞶囊。最前一人独立于队列之外，牵马。

（撰文：李明 摄影：张明惠）

Guards of Honor (5)

Sui (581-618 CE)

Height ca. 190 cm; Width 210 cm

Unearthed from a Mural Tomb of the Sui Dynasty at Shuicun in Tongguan, Shaanxi, in 2005. Preserved in Shaanxi Provincial Institute of Archaeology.

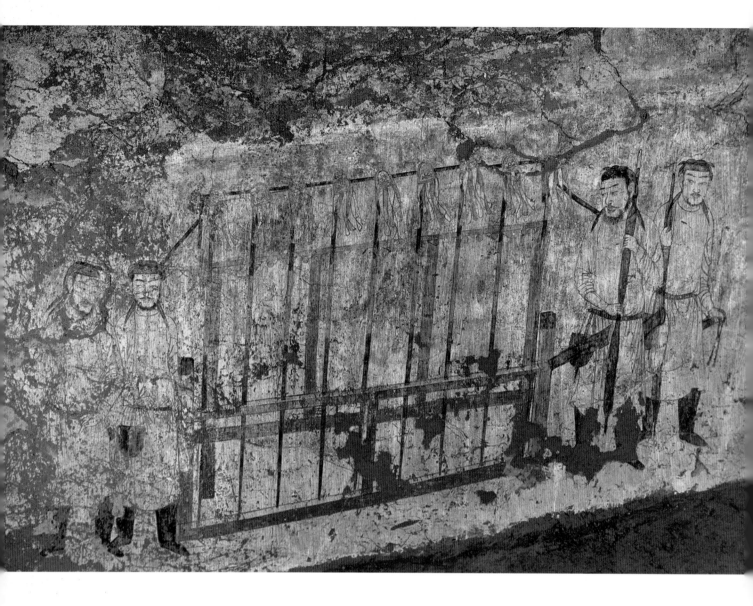

133．列戟架图

隋代（581～618年）

高约215、宽330厘米

2005年陕西省潼关税村隋代壁画墓出土。现存于陕西省考古研究院。

墓向南。位于墓道东壁最北端（第七组），为墓道东壁46人组成的仪仗队伍中的第43～46人。4个人物分两组侍立在列戟架两侧，人物均头裹黑色幞头，着团领直襟窄袖衫，手执不张弦的弓，腰间挎仪刀，带箭箙和鞬囊。列戟架由上下梁和三根立柱组成，梁上钻孔，插戟9杆。戟头双刃，戟颈饰虎头纹彩幡。列戟架后为木构仿歇山顶建筑。

（撰文：李明　摄影：张明惠）

Halberd Display

Sui (581-618 CE)

Height ca. 215 cm; Width 330 cm

Unearthed from a Mural Tomb of the Sui Dynasty at Shuicun in Tongguan, Shaanxi, in 2005. Preserved in Shaanxi Provincial Institute of Archaeology.

134. 仪仗队列图（六）

隋（581～618年）

高约215、宽240厘米

2005年陕西省潼关税村隋代壁画墓出土。现存于陕西省考古研究院。

墓向南。位于墓道西壁中段（第三组），为墓道西壁46人组成的仪仗队伍中的第11～18人。人物均头裹黑色幞头，着团领直襟窄袖衫，手执旗帜，腰间挎仪刀，带箭箙、弓袋和鞶囊。旗帜皆残。

（撰文：李明　摄影：张明惠）

Guards of Honor (6)

Sui (581-618 CE)

Height ca. 215 cm; Width 240 cm

Unearthed from a Mural Tomb of the Sui Dynasty at Shuicun in Tongguan, Shaanxi, in 2005. Preserved in Shaanxi Provincial Institute of Archaeology.

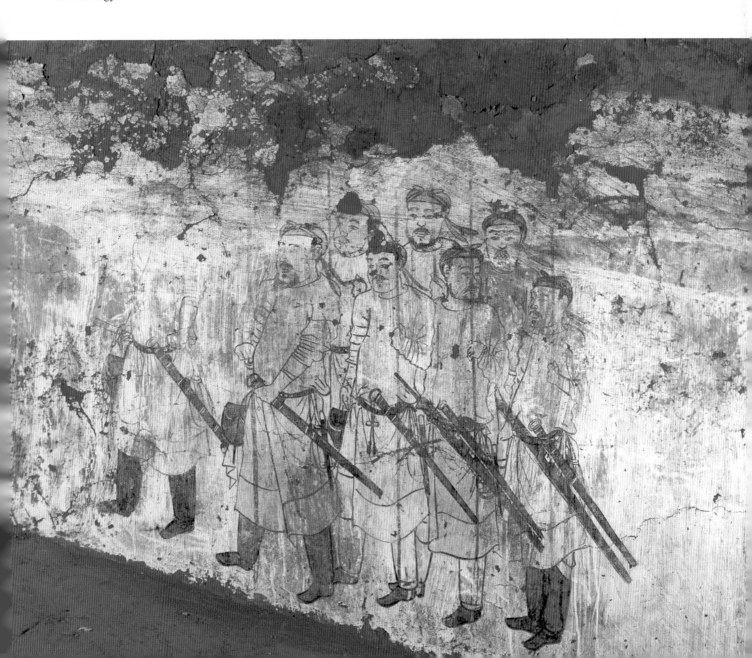

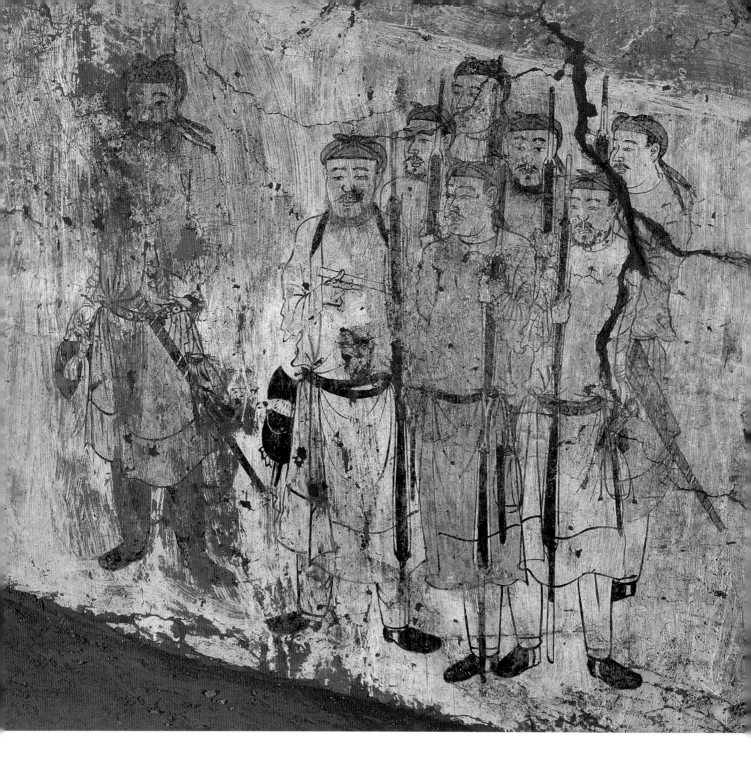

135.仪仗队列图（七）

隋（581～618年）

高约200、宽约200厘米

2005年陕西省潼关税村隋代壁画墓出土。现存于陕西省考古研究院。

墓向南。位于墓道西壁中段（第四组），为墓道西壁46人组成的仪仗队伍中的第19～26人。人物均头裹黑色幞头，着团领直襟窄袖衫，手执不张弦的弓，腰间挎仪刀，带箭箙、弓袋和鞶囊。领队人物手执笏板。

<div align="right">（撰文：李明　摄影：张明惠）</div>

Guards of Honor (7)

Sui (581-618 CE)

Height ca. 200 cm; Width ca. 200 cm

Unearthed from a Mural Tomb of the Sui Dynasty at Shuicun in Tongguan, Shaanxi, in 2005. Preserved in Shaanxi Provincial Institute of Archaeology.

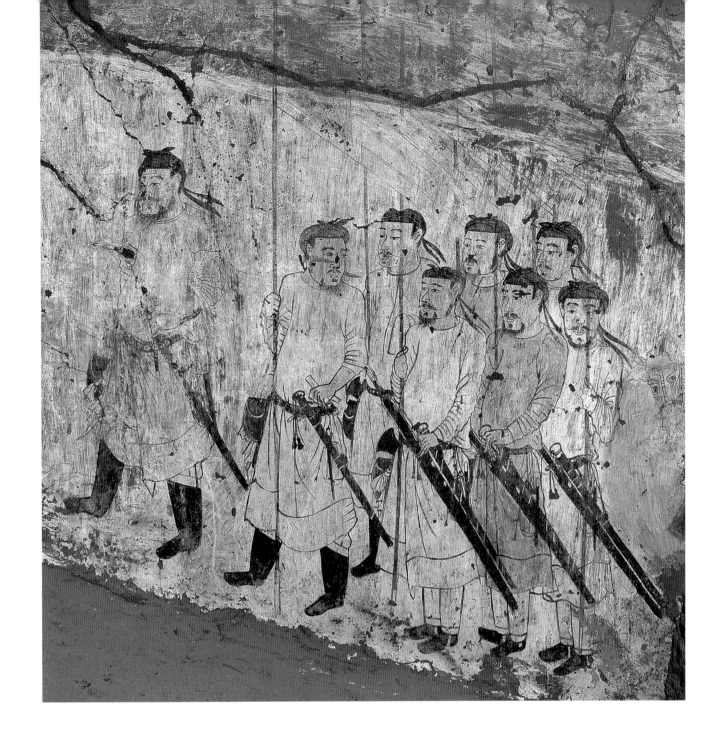

136.仪仗队列图（八）

隋（581～618年）

高约220、宽245厘米

2005年陕西省潼关税村隋代壁画墓出土。现存于陕西省考古研究院。

墓向南。位于墓道西壁中段（第五组），为墓道西壁46人组成的仪仗队伍中的第27～34人。人物均头裹黑色幞头，着团领直襟窄袖衫，手执旗帜，腰间挎仪刀、弓，带箭箙和鞶囊。旗帜长方形，有四条旒。第一面旗帜杆顶饰大纛，旗面为朱红色，上绘一只奔跑的白虎。

（撰文：李明　摄影：张明惠）

Guards of Honor (8)

Sui (581-618 CE)

Height ca. 220 cm; Width 245 cm

Unearthed from a Mural Tomb of the Sui Dynasty at Shuicun in Tongguan, Shaanxi, in 2005. Preserved in Shaanxi Provincial Institute of Archaeology.

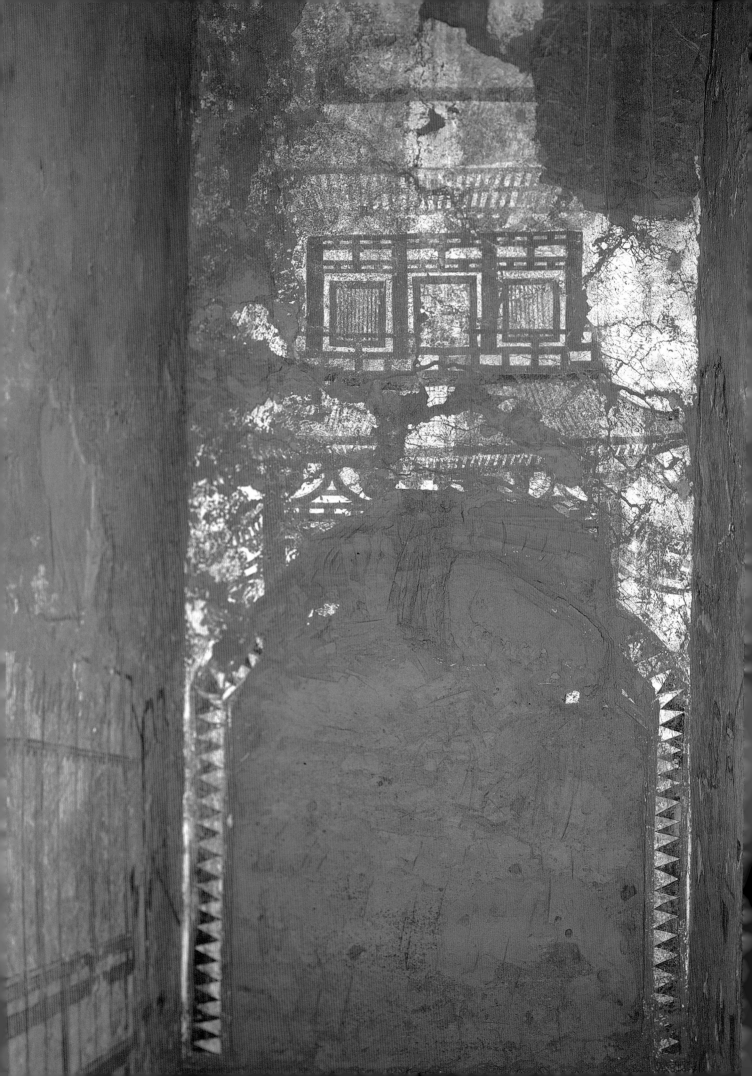

137.门楼图

隋（581～618年）

高约440、宽230厘米

2005年陕西省潼关税村隋代壁画墓出土。现存于陕西省考古研究院。

墓向南。位于墓道北壁。绘一座双层砖木结构的楼阁式建筑的正面，楼阁上层为庑殿顶，屋身三开间，正间开双扇门，两侧间各开一直棂窗。屋身外有勾栏一周。下层亦为三开间，已损毁。再下为第一过洞的圆拱形门洞。

（撰文：李明　摄影：张明惠）

Gate Tower

Sui (581-618 CE)

Height ca. 440 cm; Width 230 cm

Unearthed from a Mural Tomb of the Sui Dynasty at Shuicun in Tongguan, Shaanxi, in 2005.
Preserved in Shaanxi Provincial Institute of Archaeology.

138. 星汉图

隋（581～618年）

高约440、宽约230厘米

2005年陕西省潼关税村隋代壁画墓出土。现存于陕西省考古研究院。

墓向南。位于墓室内层穹隆顶内侧。在用黑色烟炱熏黑的顶壁上，用白灰浆水绘出银河和众星。白色的银河为东北—西南走向，贯通整个墓室穹隆顶。银河两侧的天穹上，遍布大大小小的白色星辰，其分布似乎没有规律，仅在银河西北角有一处形似汤匙的星圈较为特殊。

（撰文：李明　摄影：张明惠）

Milky Way and Constellations

Sui (581-618 CE)

Height ca. 440 cm; Width ca. 230 cm

Unearthed from a Mural Tomb of the Sui Dynasty at Shuicun in Tongguan, Shaanxi, in 2005. Preserved in Shaanxi Provincial Institute of Archaeology.

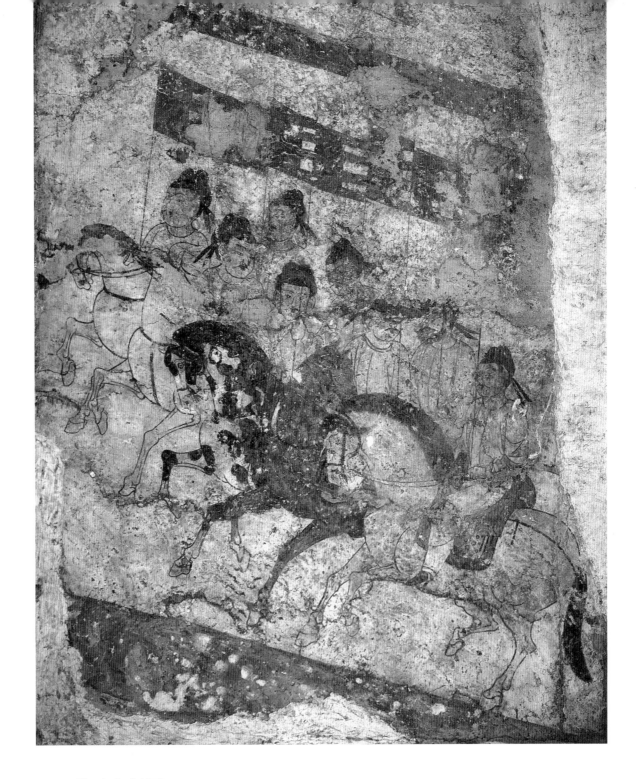

139. 骑马出行图

唐贞观五年（631年）

高213、宽166厘米

1971年陕西省三原县李寿墓出土。现存于陕西历史博物馆。

墓向166°。位于墓道西壁中段，为42匹马和48人组成的骑马出行图中的第三组第四列中的8人，骑士均身穿戎衣，缚绔，骑各色骏马疾行。

<div align="right">（撰文：申秦雁　摄影：邱子渝）</div>

Procession

5th Year of Zhenguan Era, Tang (631 CE)

Height 213 cm; Width 166 cm

Unearthed from Li Shou's Tomb in Sanyuan, Shaanxi, in 1971. Preserved in Shaanxi History Museum.

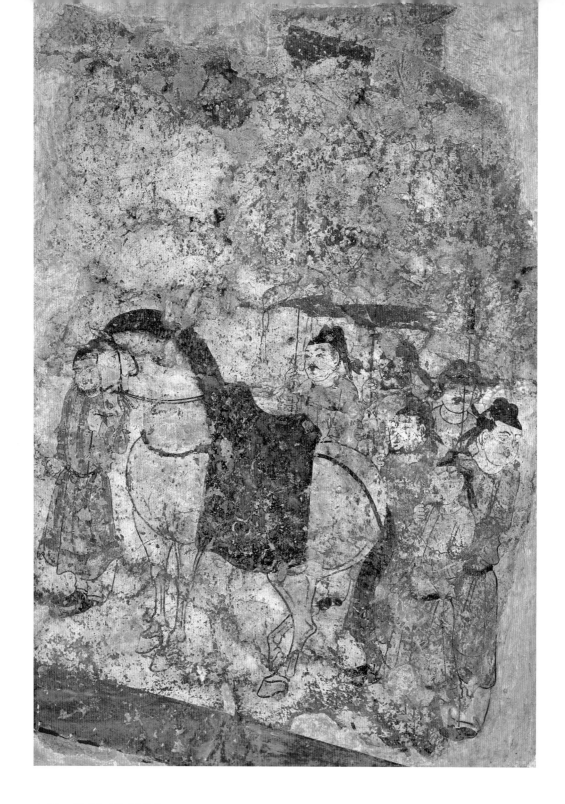

140.备马待行图

唐贞观五年（631年）

高196、宽131厘米

1971年陕西省三原县李寿墓出土。现存于陕西历史博物馆。

墓向166°。位于墓道西壁，紧接在骑马出行图之后、第一过洞之前。马鞍鞯齐备，6名侍从或持伞、或举雉尾扇、或持弓，等待出行。

<div align="right">（撰文：申秦雁　摄影：邱子渝）</div>

Fitted Horses and Readied Attendants

5th Year of Zhenguan Era, Tang (631 CE)

Height 196 cm; Width 131 cm

Unearthed from Li Shou's Tomb in Sanyuan, Shaanxi, in 1971. Preserved in Shaanxi History Museum.

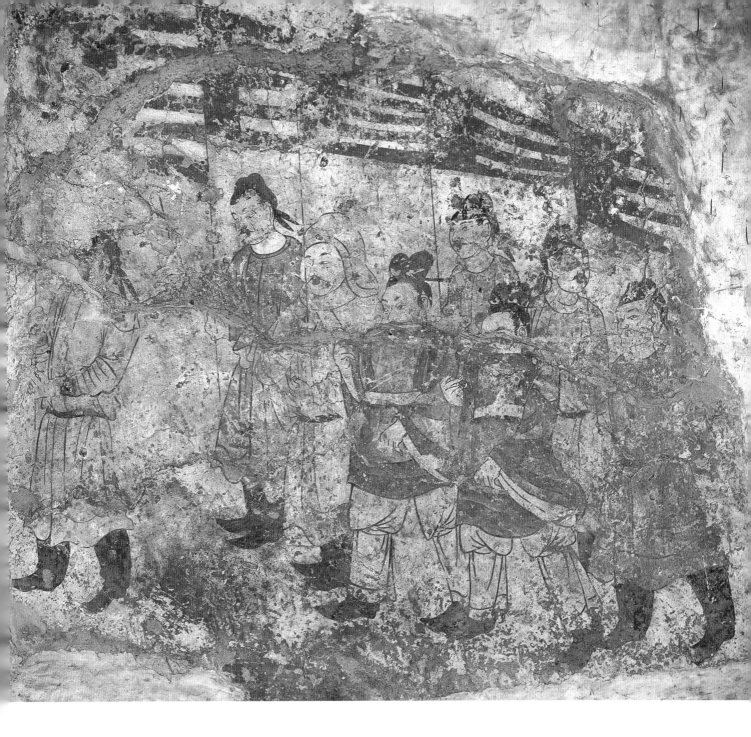

141. 步行仪仗图（一）

唐贞观五年（631年）

高175、宽197厘米

1971年陕西省三原县李寿墓出土。现存于陕西历史博物馆。

墓向166°。位于第一过洞西壁。是过洞及天井处12幅步行仪仗图的第2幅、近百名仪仗队伍中的8人。人物动作、神态富有变化，画面具有动感和生气。

（撰文：申秦雁　摄影：邱子渝）

Infantry Guards of Honor (1)

5th Year of Zhenguan Era, Tang (631 CE)

Height 175 cm; Width 197 cm

Unearthed from Li Shou's Tomb in Sanyuan, Shaanxi, in 1971. Preserved in Shaanxi History Museum.

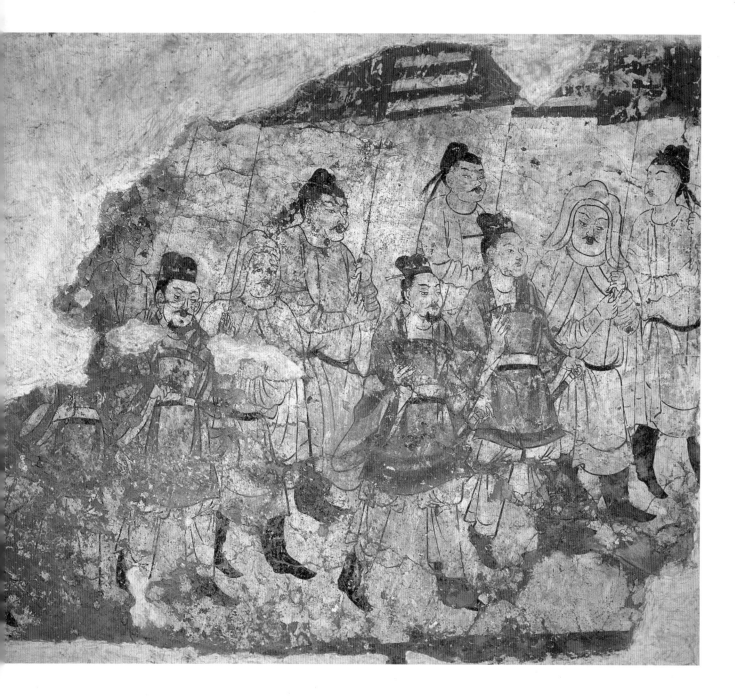

142.步行仪仗图（二）

唐贞观五年（631年）

高174、宽216厘米

1971年陕西省三原县李寿墓出土。现存于陕西历史博物馆。

墓向166°。位于第二过洞东壁。是过洞及天井处12幅步行仪仗图的第5幅、近百名仪仗队伍中的10人。人物装束不同，均手持红色四旒旗，前两位左侧佩剑。

（撰文：申秦雁　摄影：邱子渝）

Infantry Guards of Honor (2)

5th Year of Zhenguan Era, Tang (631 CE)

Height 174 cm; Width 216 cm

Unearthed from Li Shou's Tomb in Sanyuan, Shaanxi, in 1971. Preserved in Shaanxi History Museum.

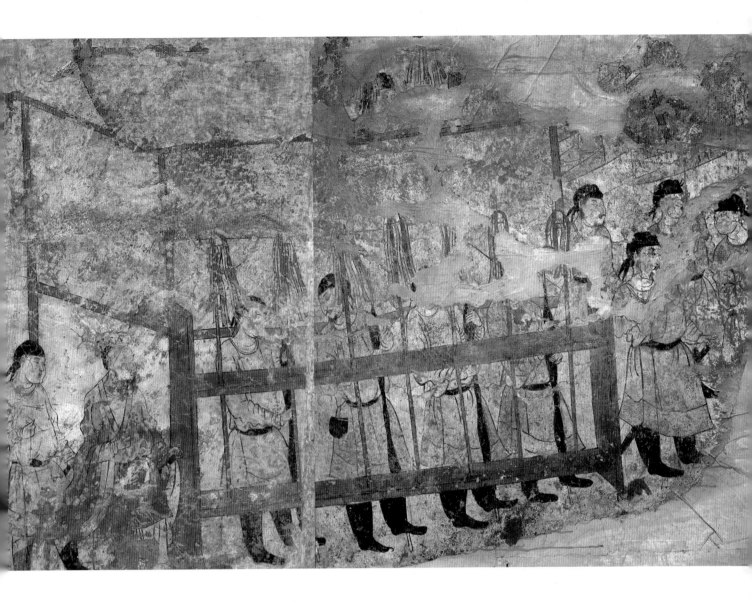

143.列戟图

唐贞观五年（631年）

高164、宽142厘米

1971年陕西省三原县李寿墓出土。现存于陕西历史博物馆。

墓向166°。位于第四天井东壁。与西壁列戟相合共14杆，符合李寿从一品官身份。列戟为初唐形制，沿袭北朝、隋代特点。

<div align="right">（撰文：申秦雁　摄影：邱子渝）</div>

Halberd Display

5th Year of Zhenguan Era, Tang (631 CE)

Height 164 cm; Width 142 cm

Unearthed from Li Shou's Tomb in Sanyuan, Shaanxi, in 1971. Preserved in Shaanxi History Museum.

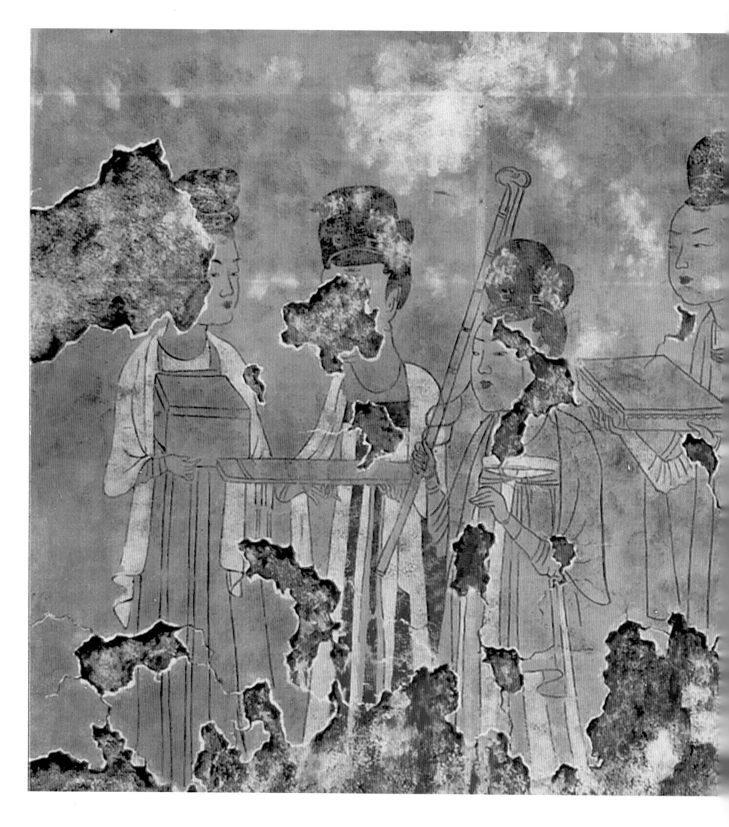

（临摹：不详　撰文、摄影：李浪涛）

144.群侍图（摹本）

唐贞观十四年（640年）

高98、宽193厘米

1979年陕西省礼泉县烟霞镇山底村杨温墓出土。现存于昭陵博物馆。

位于墓室东壁。由七人组成，均持物件，左起第一人捧方盒，第二人捧琴，第三人似持杖，第四人似捧案（扁平且四侧辟有壶门），第五人捧葵口器皿（似玉器），第六人执扇，第七人持如意。

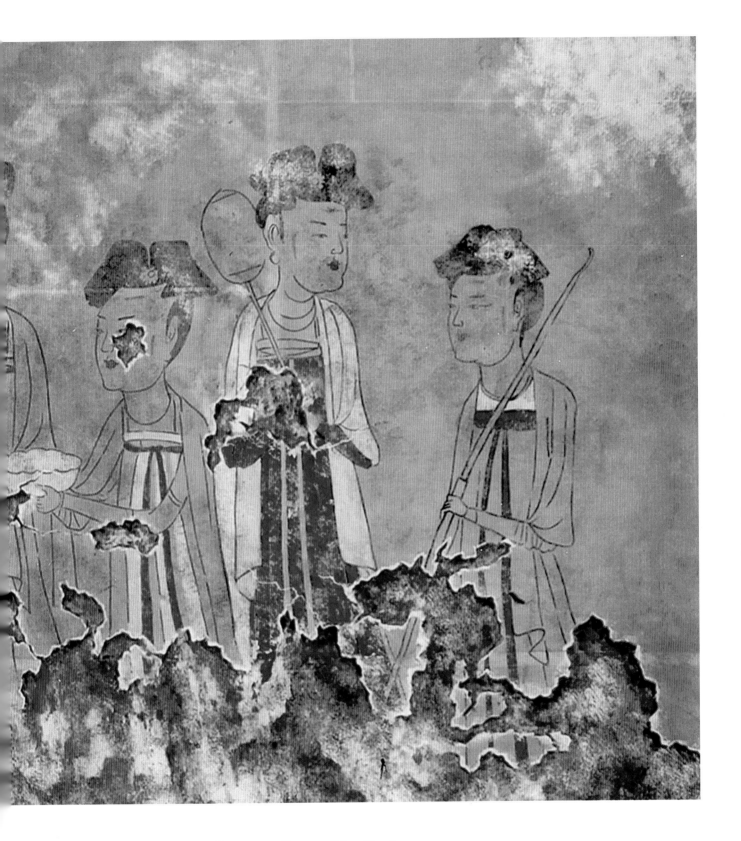

Maids Holding Miscellaneous Items (Replica)

14th Year of Zhenguan Era, Tang (640 CE)

Height 98 cm; Width 193 cm

Unearthed from Yang Wen's Tomb at Shandicun of Yanxia in Liquan, Shaanxi, in 1979. Preserved in Zhaoling Museum.

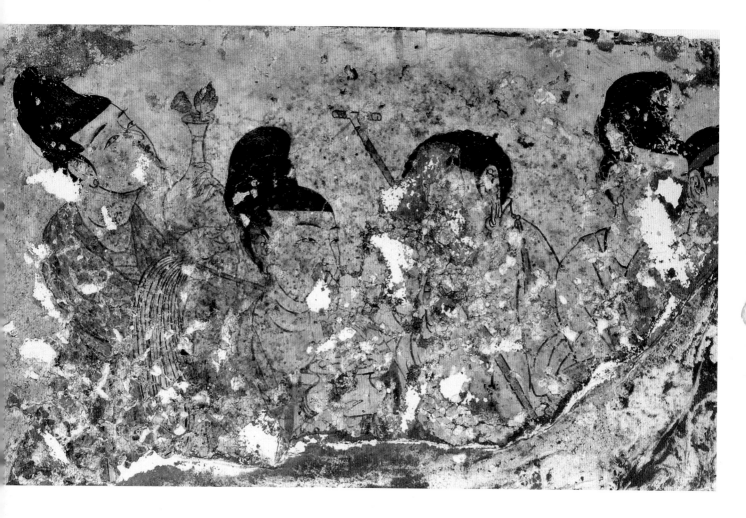

145.群侍图

唐贞观十七年（643年）

残高120、宽100厘米

1986年陕西省礼泉县烟霞镇陵光村长乐公主墓出土。现存于昭陵博物馆。

墓向174°。位于甬道东壁第一、二石门之间。绘女侍五人，或捧盂、或持拂尘、或持丁字杖、或手捧花瓶。右起第一人残损严重，可见头扎红色抹额；第二、四、五人梳高髻，系长裙，披帔帛；最为特别的是第三人，手持丁字杖，肤色较深，卷发，戴耳环，身着袍服，专家认为是"昆仑奴"的形象。

（撰文：李浪涛　摄影：张展望）

Maids Holding Miscellaneous Items

17th Year of Zhenguan Era, Tang (643 CE)

Surviving height 120 cm; Width 100 cm

Unearthed from Princess Changle's Tomb at Lingguangcun of Yanxia in Liquan, Shaanxi, in 1986. Preserved in Zhaoling Museum.

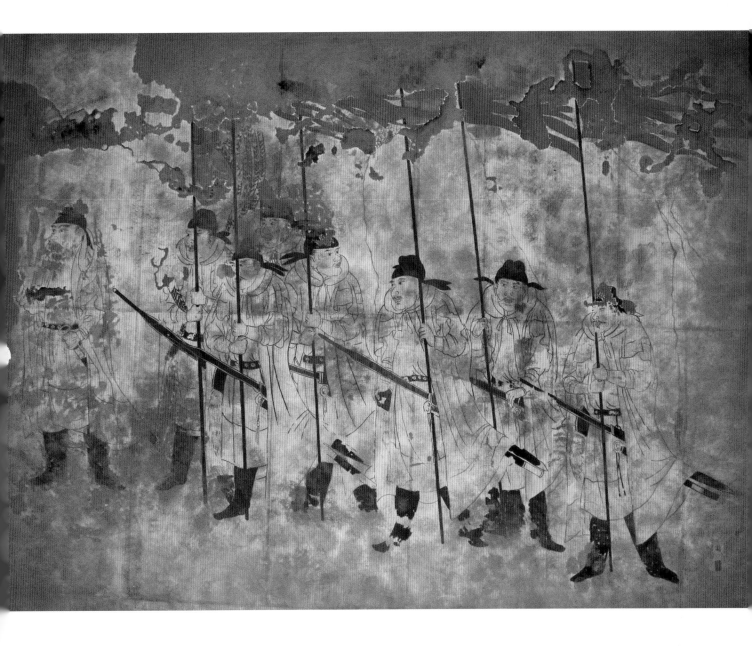

146.袍服仪卫图（摹本）

唐贞观十七年（643年）

高260、宽350厘米

1986年陕西省礼泉县烟霞镇陵光村长乐公主墓出土。现存于昭陵博物馆。

墓向174°。位于墓道西壁中段。共绘八人，人物服饰基本一致，除领队腰佩仪刀，右臂屈肘握拳，左手按握剑柄外，后边七人均头戴黑色幞头，内穿白长袍，外披淡青色大衣，足蹬黑尖靴，腰佩仪刀、弓韬、箭箙，手执五旒红旗，第一面旗上绘玄鸟。

（临摹：不详　撰文、摄影：李浪涛）

Guards of Honor in Robe and Cloak (Replica)

17th Year of Zhenguan Era, Tang (643 CE)

Height 260 cm; Width 350 cm

Unearthed from Princess Changle's Tomb at Lingguangcun of Yanxia in Liquan, Shaanxi, in 1986. Preserved in Zhaoling Museum.

147.袍服仪卫领队
（一）

唐贞观十七年（643年）

人物高127厘米

1986年陕西省礼泉县烟霞镇陵光村长乐公主墓出土。现存于昭陵博物馆。

墓向174°。位于墓道西壁。为袍服仪卫南起第一人。腰佩仪刀，右臂屈肘握拳置胸前，左手提握仪刀柄。头裹幞头，面相饱满，粗眉大眼、高鼻、红唇，面部施粉彩、络腮胡细密垂至胸前，一副威武雄壮不可侵犯的气势。

（撰文：李浪涛　摄影：张展望）

Leader of the Guards of Honor in Robe and Cloak (1)

17th Year of Zhenguan Era, Tang (643 CE)

Figure Height 127 cm

Unearthed from Princess Changle's Tomb at Lingguangcun of Yanxia in Liquan, Shaanxi, in 1986. Preserved in Zhaoling Museum.

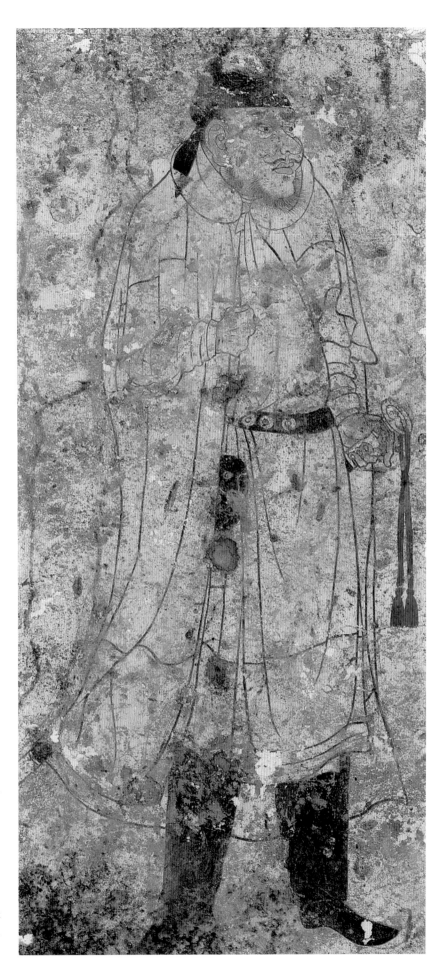

148.袍服仪卫领队（二）

唐贞观十七年（643年）

1986年陕西省礼泉县烟霞镇陵光村长乐公主墓出土。现存于昭陵博物馆。

墓向174°。位于墓道东壁中段。为袍服仪卫南起第一人，头戴黑色幞头，内穿白色圆领窄袖袍，束腰，外着淡青色系领敞襟短袖风衣，足着黑色长筒尖头靴，左手提握握仪刀，右手握拳。

（撰文：李浪涛　摄影：张展乐）

Leader of the Guards of Honor in Robe and Cloak (2)

17th Year of Zhenguan Era, Tang (643 CE)
Unearthed from Princess Changle's Tomb at Lingguangcun of Yanxia in Liquan, Shaanxi, in 1986. Preserved in Zhaoling Museum.

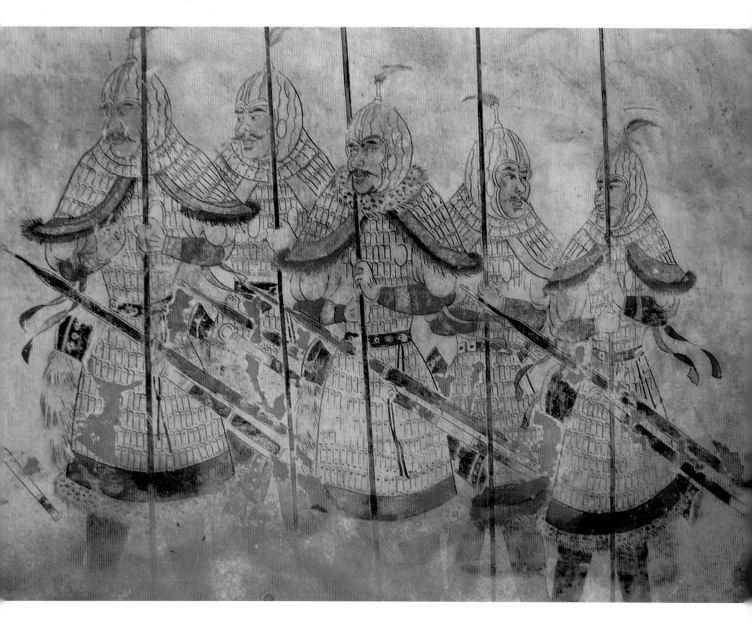

149. 甲胄仪卫图（一）（摹本）

唐贞观十七年（643年）

高260、宽400厘米

1986年陕西省礼泉县烟霞镇陵光村长乐公主墓出土。现存于昭陵博物馆。

墓向174°。位于墓道西壁北段。共绘甲胄仪卫六人。左起前边一人为领队，后边五人参差排列，均佩长剑，弓韬，箭箙，手执五旒红旗。图中人物均头戴兜鍪，身穿毛皮甲袍，着长统尖头套黑靴。

（临摹：不详　撰文、摄影：李浪涛）

Guards of Honor in Armor (I) (Replica)

17th Year of Zhenguan Era, Tang (643 CE)

Height 260 cm; Width 400 cm

Unearthed from Princess Changle's Tomb at Lingguangcun of Yanxia in Liquan, Shaanxi, in 1986. Preserved in Zhaoling Museum.

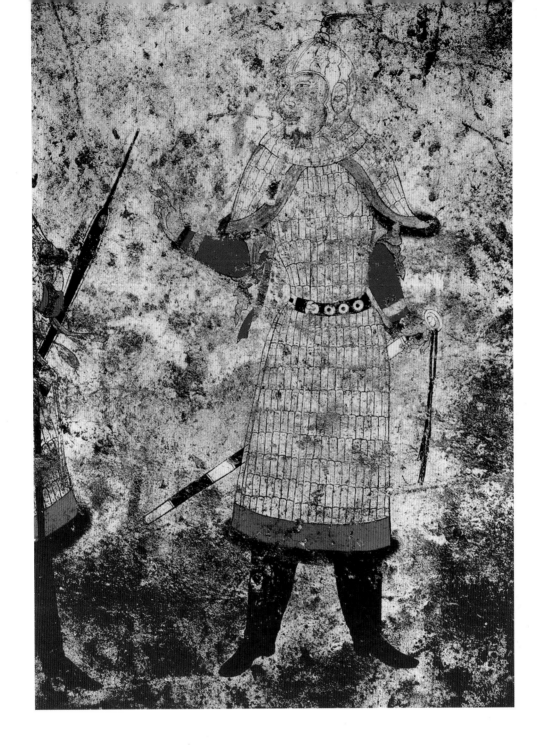

150.甲胄仪卫领队（二）

唐贞观十七年（643年）

人物高153、宽68厘米

1986年陕西省礼泉县烟霞镇陵光村长乐公主墓出土。现存于昭陵博物馆。

墓向174°。位于墓道东壁北段。甲胄仪卫南起第一人为领队，左手提握仪刀、右手指点，面西站立，头向右回转，似在向身后五人吩咐什么，表情严肃。其护肩、袖口、袍下沿饰毛皮边，小臂、袍下摆毛皮边沿饰鲜红色，特别醒目。

（撰文：李浪涛 摄影：张展望）

Leader of Guards of Honor in Armor (2)

17th Year of Zhenguan Era, Tang (643 CE)

Figure Height 153 cm; Width 68 cm

Unearthed from Princess Changle's Tomb at Lingguangcun of Yanxia in Liquan, Shaanxi, in 1986.
Preserved in Zhaoling Museum.

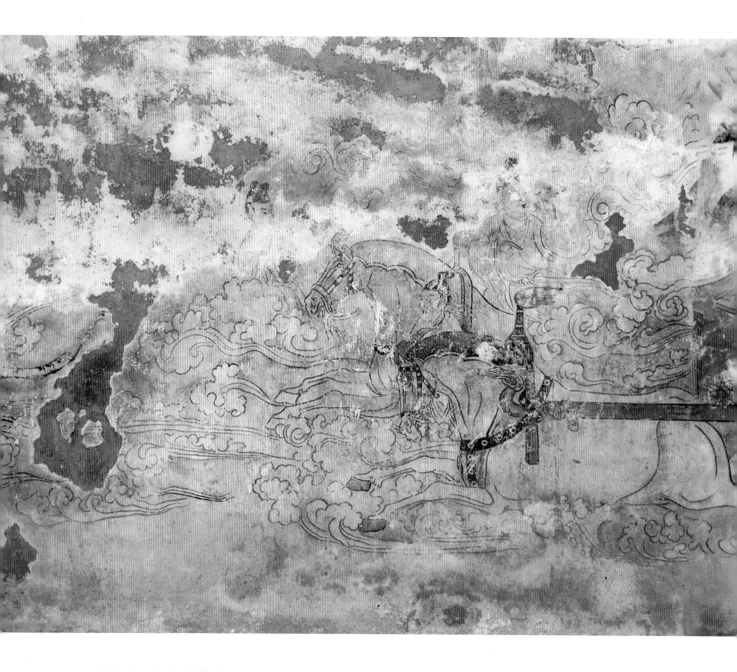

151.云中车马图（摹本）

唐贞观十七年（643年）

高176、宽390厘米。

1986年陕西省礼泉县烟霞镇陵光村长乐公主墓出土。现存于昭陵博物馆。

墓向174°。位于墓道西壁南段，介于白虎与袍服仪卫之间。二马驾辕奔驰，一马淡红色，一马淡青色，皆缚尾，两马间有一人，右手牵马，穿长衫、束发。马右侧有二人，皆束发，穿长衫，回头北望。车厢中坐一男一女二人，其右边车厢亦坐一人。车的左下方有一摩羯鱼，张嘴伸舌，鳍尾俱全。

（临摹：不详　撰文、摄影：李浪涛）

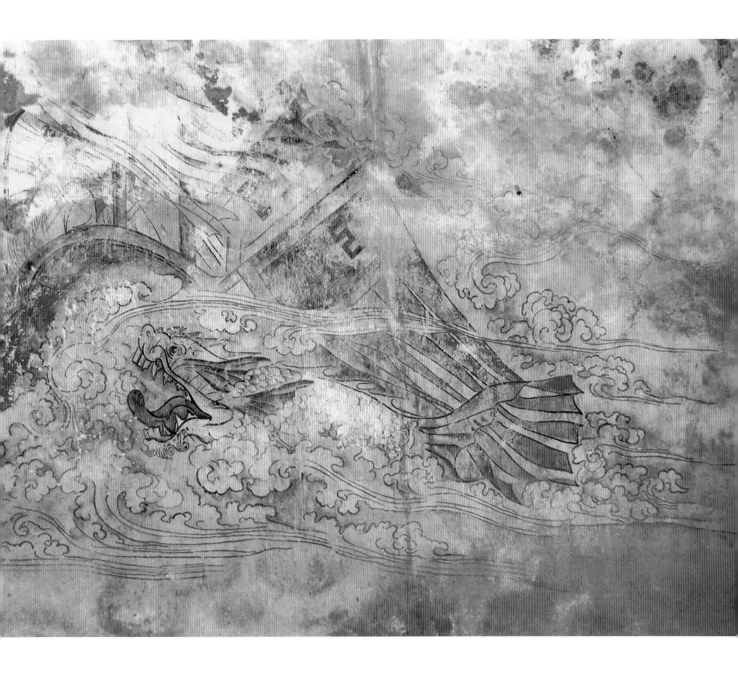

Chariot Advancing in the Clouds (Replica)

17th Year of Zhenguan Era, Tang (643 CE)

Height 176 cm; Width 390 cm

Unearthed from Princess Changle's Tomb at Lingguangcun of Yanxia in Liquan, Shaanxi, in 1986. Preserved in Zhaoling Museum.

▲152.藻井图

唐贞观十七年（643年）

边长25～28厘米

1986年陕西省礼泉县烟霞镇陵光村长乐公主墓出土。现存
于昭陵博物馆。

墓向174°。位于甬道顶部。图案为四种，均为正方形，四
种图案，相次排列，装饰了长8.25米的甬道拱顶部分。这
些图案是先单独分块绘在纸上，再按一定的排列顺序一块
一块拓上去，然后在每块图案之间以红色划界。

（撰文：李浪涛　摄影：张展望）

Caisson Ceiling

17th Year of Zhenguan Era, Tang (643 CE)

Side Length 25-28 cm

Unearthed from Princess Changle's Tomb at Lingguangcun
of Yanxia in Liquan, Shaanxi, in 1986. Preserved in Zhaoling
Museum.

153.二女侍图▶

唐贞观二十一年（647年）

高150、宽112厘米

1992年陕西省礼泉县昭陵乡庄河村李思摩墓出土。现存于
昭陵博物馆。

位于墓室西壁。为二女子相向立于竹间。右侧女侍头梳高
髻，上穿白色襦衫、披白色帔帛，系红白相间条纹裙，足
蹬黑色尖头履。左手似提波斯壶。左侧女侍似梳高髻，内
穿白色圆领窄袖襦及长裙，外披红色高领窄袖大衣或袍。
双手捧瓶。

（撰文：李浪涛　摄影：张展望）

Two Maids

21st Year of Zhenguan Era, Tang (647 CE)

Height 150 cm; Width 112 cm

Unearthed from Li Simo's Tomb at Zhuanghecun of Zhaoling
in Liquan, Shaanxi, in 1992. Preserved in Zhaoling Museum.

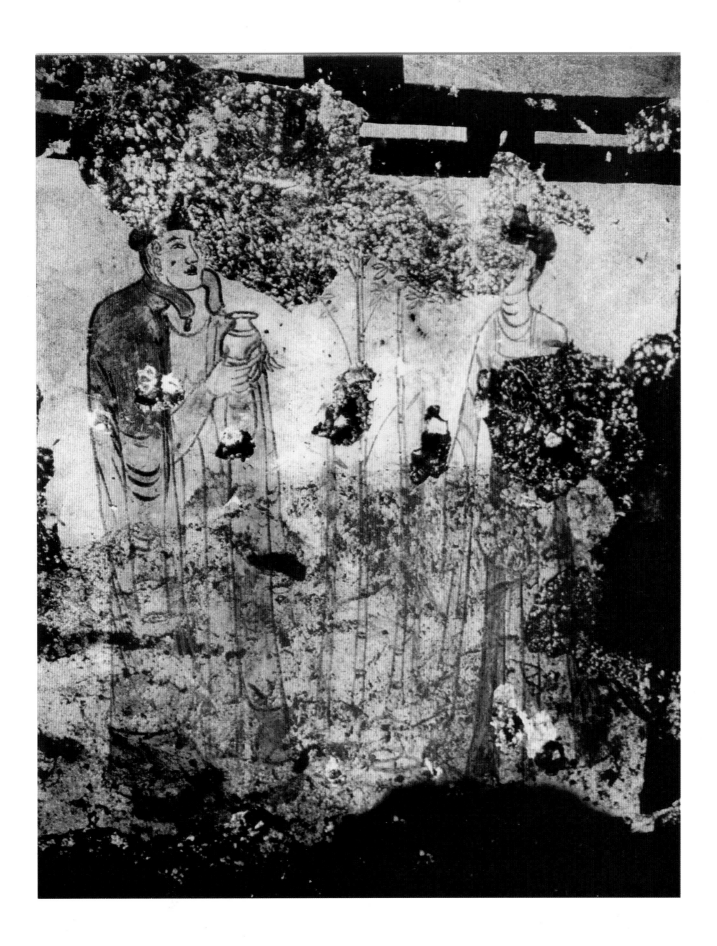

154.乐伎图

唐贞观二十一年（647年）

高148、宽106厘米

1992年陕西省礼泉县昭陵乡庄河村李思摩墓出土。现存于昭陵博物馆。

位于墓室西壁，残损较重。为一女子怀抱琵琶，左手握琵琶颈，右手弹拨。女侍头梳高髻，上穿白色襦衫、披白色帔帛，系红白相间宽条纹裙，足蹬黑色高头履。眼睑及面颊与琵琶颜色一致，身旁绘古树一颗。女子额头中部有一短条形红色颜料，可能是当时绘制红色栏额时滴落所致。

<div align="right">（撰文：李浪涛　摄影：张展望）</div>

Pipa-lute Player

21st Year of Zhenguan Era, Tang (647 CE)

Height 148 cm; Width 106 cm

Unearthed from Li Simo's Tomb at Zhuanghecun of Zhaoling in Liquan, Shaanxi, in 1992. Preserved in Zhaoling Museum.

155.男侍图（一）

唐永徽二年（651年）

高170、宽84厘米

1978～1979年陕西省礼泉县烟霞镇张家山村段简璧墓出土。现存于昭陵博物馆。

墓向南。位于第二过洞东壁北段。头裹黑色长垂角幞头，身穿圆领窄袖加襕白袍，腰系黑带，右侧悬挂圆柱型囊袋，左侧悬挂打结巾袋，巾梢几与裙下摆齐平，足蹬黑靴。左手握拳置胸前，右臂屈肘向右指点，头微仰，张嘴呲牙，呈指责讥讽状。

（撰文：李浪涛　摄影：骆福荣、张明惠）

Servant (1)

2nd Year of Yonghui Era, Tang (651 CE)

Height 170 cm; Width 84 cm

Unearthed from Duan Jianbi's Tomb at Zhangjiashan cun of Yanxia in Liquan, Shaanxi, in 1978. Preserved in Zhaoling Museum.

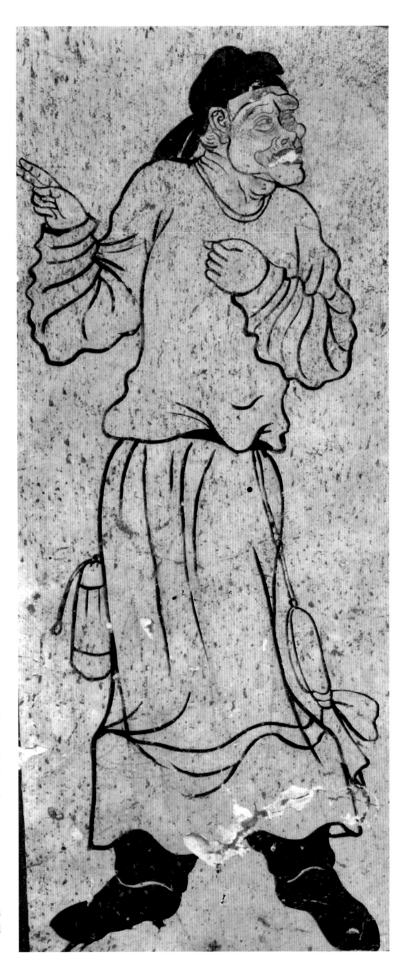

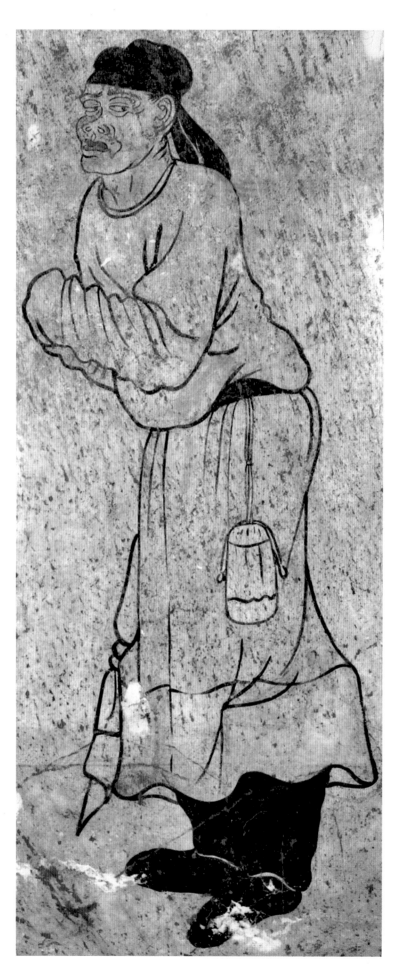

156. 男侍图（二）

唐永徽二年（651年）

高170、宽84厘米。

1978～1979年陕西省礼泉县烟霞镇张家山村段简璧墓出土。现存于昭陵博物馆。

墓向南。位于第二过洞西壁南段。头裹黑色长垂角幞头，身穿圆领窄袖加襕白袍，腰系黑带，足蹬黑靴。左侧悬挂圆柱型囊袋，右侧悬挂打结巾袋、巾梢过裙下摆，弯腰拱手，双目斜视，既奴颜婢膝又心怀叵测。

（撰文：李浪涛　摄影：骆福荣、张明惠）

Servant (2)

2nd Year of Yonghui Era, Tang (651 CE)

Height 170 cm; Width 84 cm

Unearthed from Duan Jianbi's Tomb at Zhangjiashan cun of Yanxia in Liquan, Shaanxi, in 1978. Preserved in Zhaoling Museum.

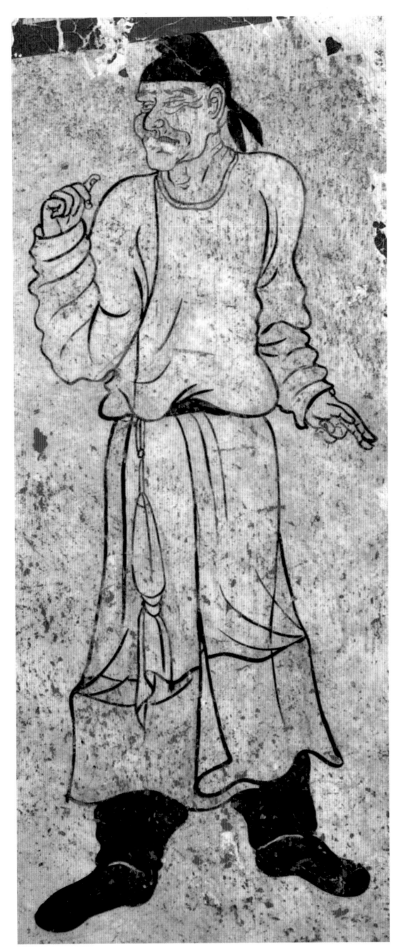

157. 男侍图（三）

唐永徽二年（651年）

高170、宽84厘米

1978～1979年陕西省礼泉县烟霞镇张家山村段简璧墓出土。现存于昭陵博物馆。

墓向南。位于第二过洞西壁北段。头裹上有双角幞头，身穿圆领窄袖加襕白袍，腰系黑带，右侧悬挂打三结的细长锦囊袋，右臂屈肘竖起大拇指，左臂微曲三指展开指点，呈矜夸貌。

（撰文：李浪涛　摄影：骆福荣、张明惠）

Servant (3)

2nd Year of Yonghui Era, Tang (651 CE)

Height 170 cm; Width 84 cm

Unearthed from Duan Jianbi's Tomb at Zhangjiashan cun of Yanxia in Liquan, Shaanxi, in 1978. Preserved in Zhaoling Museum.

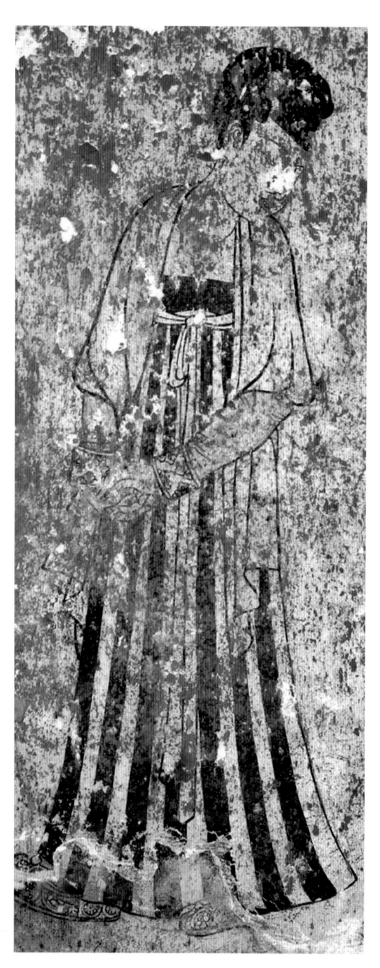

158.仕女图（一）

唐永徽二年（651年）

高172、宽72厘米

1978～1979年陕西省礼泉县烟霞镇张家山村段简璧墓出土。现存于昭陵博物馆。

墓向南。位于第三天井东壁南段。仕女头梳高髻，发饰金簪，眼睑和面颊淡涂胭脂。上穿淡青色窄袖襦，袖口饰锦纹，披白色帔帛，系紫、白相间条纹裙，着团花锦鞋。双手掌心相对扣于腹侧，双脚作前行状，头向左后回顾，面部表情恬淡自然，红唇微启。

（撰文：李浪涛　摄影：骆福荣、张明惠）

Beauty (1)

2nd Year of Yonghui Era, Tang (651 CE)

Height 172 cm; Width 72 cm

Unearthed from Duan Jianbi's Tomb at Zhangjiashan cun of Yanxia in Liquan, Shaanxi, in 1978. Preserved in Zhaoling Museum.

159.仕女图（二）

唐永徽二年（651年）

高172、宽70厘米

1978～1979年陕西省礼泉县烟霞镇张家山村段简璧墓出土。现存于昭陵博物馆。

墓向南。位于第三天井西壁小龛南。面右站立。头梳高髻，发饰金簪，眼睑和面颊淡涂胭脂，长眉细目、高鼻、樱桃小嘴，面相俊秀。上穿白色帔帛裹臂，袖手置腹前，仅露花边袖口锦纹，系紫、白相间条纹裙，足蹬绣花锦鞋。

（撰文：李浪涛　摄影：骆福荣、张明惠）

Beauty (2)

2nd Year of Yonghui Era, Tang (651 CE)

Height 172 cm; Width 70 cm

Unearthed from Duan Jianbi's Tomb at Zhangjiashan cun of Yanxia in Liquan, Shaanxi, in 1978. Preserved in Zhaoling Museum.

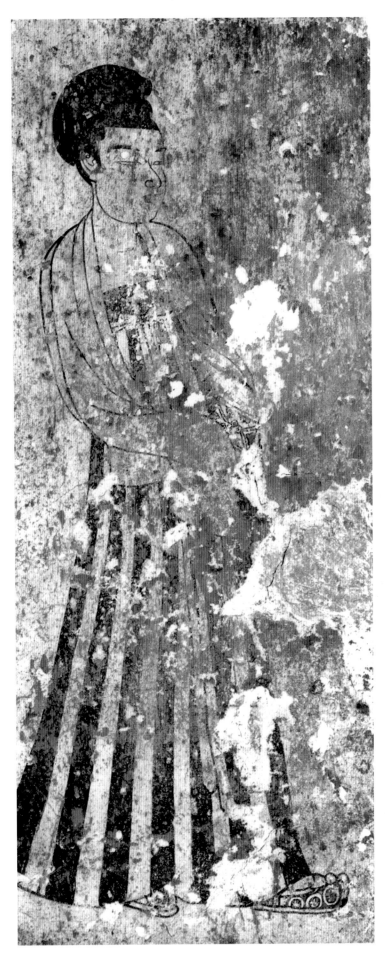

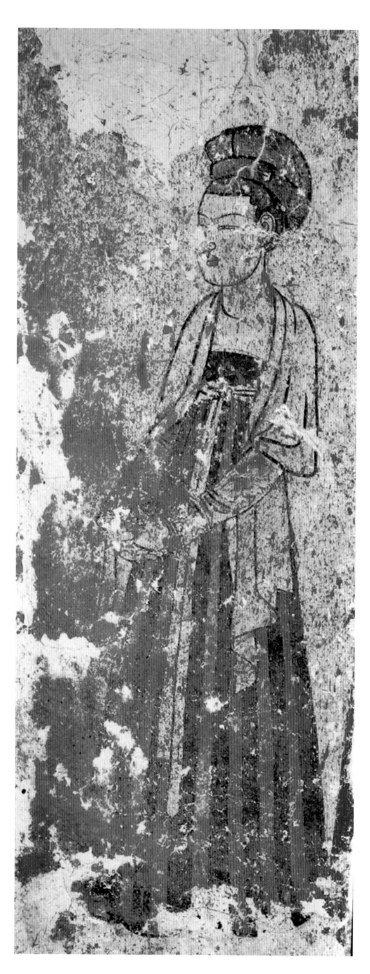

160. 仕女图（三）

唐永徽二年（651年）

高170、宽69厘米

1978~1979年陕西省礼泉县烟霞镇张家山村段简璧墓出土。现存于昭陵博物馆。

墓向南。位于第四天井东壁小龛南，面左站立。头梳高髻，发饰金簪，眼睑和面颊淡涂胭脂，长眉细目、高鼻、樱桃小嘴，面相俊秀。上穿淡红色窄袖襦，袖口饰锦纹，披灰白色帔帛，系紫、红相间条纹裙，足蹬黑色高头履。

（撰文：李浪涛　摄影：骆福荣、张明惠）

Beauty (3)

2nd Year of Yonghui Era, Tang (651 CE)

Height 170 cm; Width 69 cm

Unearthed from Duan Jianbi's Tomb at Zhangjiashan cun of Yanxia in Liquan, Shaanxi, in 1978. Preserved in Zhaoling Museum.

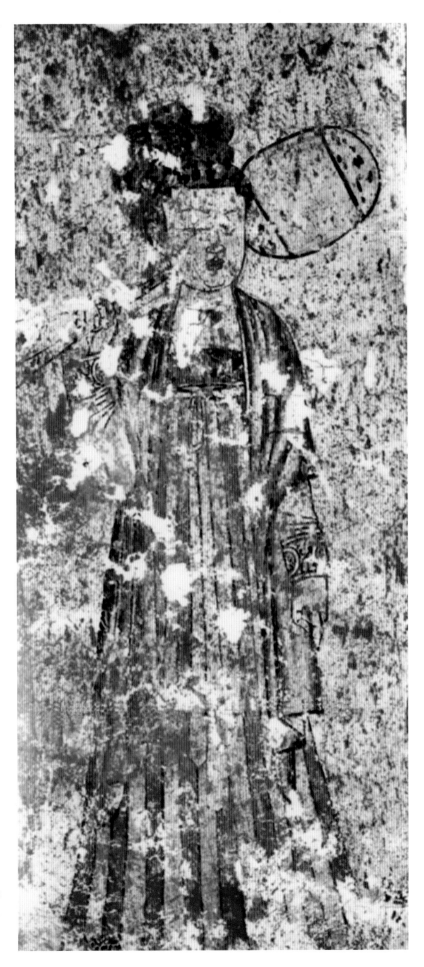

161. 持扇女侍图

唐永徽二年（651年）

高170、宽68厘米

1978~1979年陕西省礼泉县烟霞镇张家山村段
简璧墓出土。现存于昭陵博物馆。

墓向南。位于第四天井西壁小龛北。头微右
偏，头梳高髻，眼睑和面颊淡涂胭脂，长眉
细目、巧鼻、樱桃小嘴，面相丰腴。上穿白
色袖口饰花窄袖襦，披淡棕色帔帛，系红、
绿相间条纹裙，足蹬黑色高头履。右臂屈肘
手握团扇柄斜持右肩上，左臂自然下垂。

（撰文：李浪涛　摄影：骆福荣、张明惠）

Maid Holding a Fan

2nd Year of Yonghui Era, Tang (651 CE)

Height 170 cm; Width 68 cm

Unearthed from Duan Jianbi's Tomb at
Zhangjiashan cun of Yanxia in Liquan, Shaanxi,
in 1978. Preserved in Zhaoling Museum.

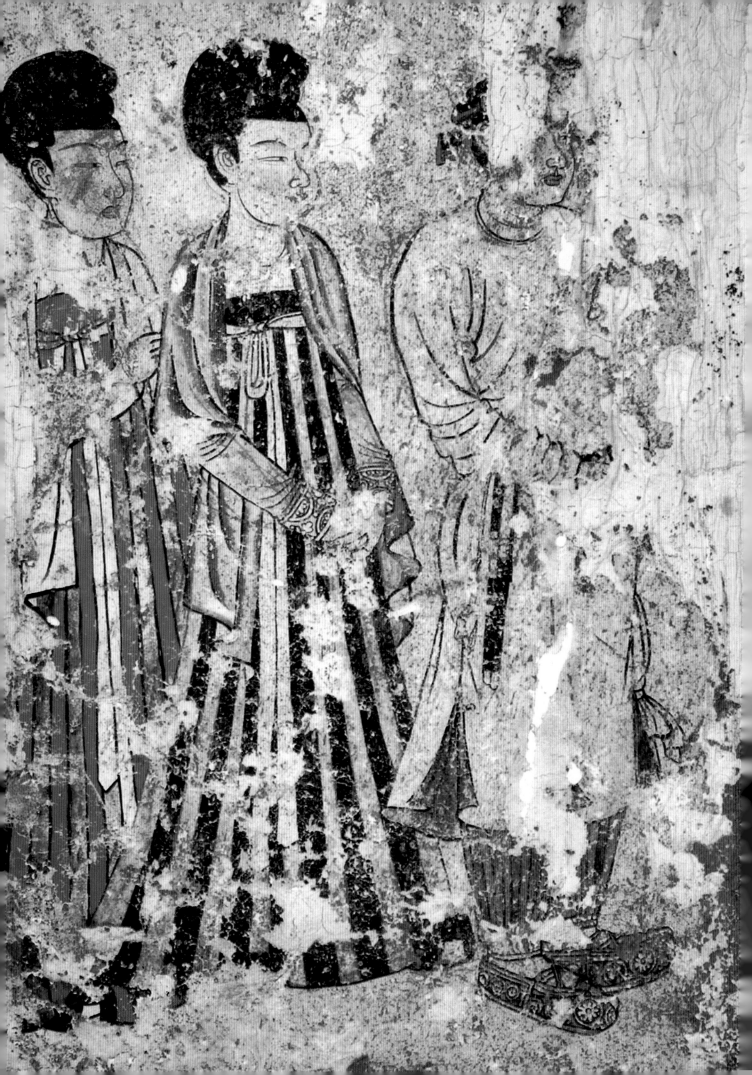

◀162.三仕女图（一）

唐永徽二年（651年）

高174、宽115厘米

1978~1979年陕西省礼泉县烟霞镇张家山村段简璧墓出土。现存于昭陵博物馆。

墓向南。位于第五天井东壁小龛北。右起第一人头扎红带花抹额，面部残，仅见小巧鼻、樱桃小嘴，面相俊秀。着白色（蓝里）圆领窄袖袍，腰右侧佩短刀、蹀躞带、悬挂小佩饰，左侧悬挂香囊袋、囊袋底部两巾打结后自然下垂，下穿红蓝相间条纹裤，足蹬红蓝相间花锦鞋。右起第二、三人均头梳高髻，着条纹裙，外系白色长条带，足蹬黑色高头履。

（撰文：李浪涛　摄影：骆福荣、张明惠）

Three Beauties (1)

2nd Year of Yonghui Era, Tang (651 CE)

Height 174 cm; Width 115 cm

Unearthed from Duan Jianbi's Tomb at Zhangjiashan cun of Yanxia in Liquan, Shaanxi, in 1978. Preserved in Zhaoling Museum.

▼163.三仕女图（二）

唐永徽二年（651年）

高175、宽117厘米

1978~1979年陕西省礼泉县烟霞镇张家山村段简璧墓出土。现存于昭陵博物馆。

墓向南。位于第五天井东壁小龛南。左起第一人头扎红带花抹额。着淡绿色圆领窄袖袍，腰右侧悬挂囊带，左侧悬挂香囊袋，穿红绿相间条纹裤，足蹬红蓝相间绣花锦鞋。左起第二、三人均头梳高髻，着条纹裙，外系白色长条带，足蹬黑色高头履。

（撰文：李浪涛　摄影：骆福荣、张明惠）

Three Beauties (2)

2nd Year of Yonghui Era, Tang (651 CE)

Height 175 cm; Width 117 cm

Unearthed from Duan Jianbi's Tomb at Zhangjiashan cun of Yanxia in Liquan, Shaanxi, in 1978. Preserved in Zhaoling Museum.

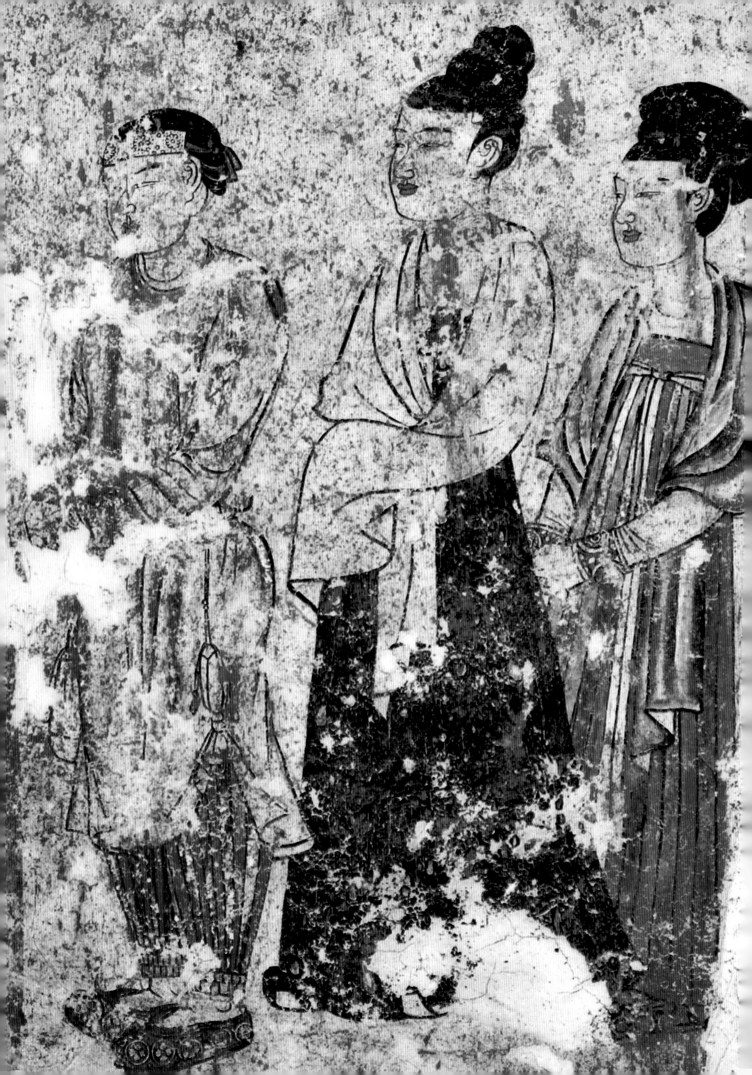

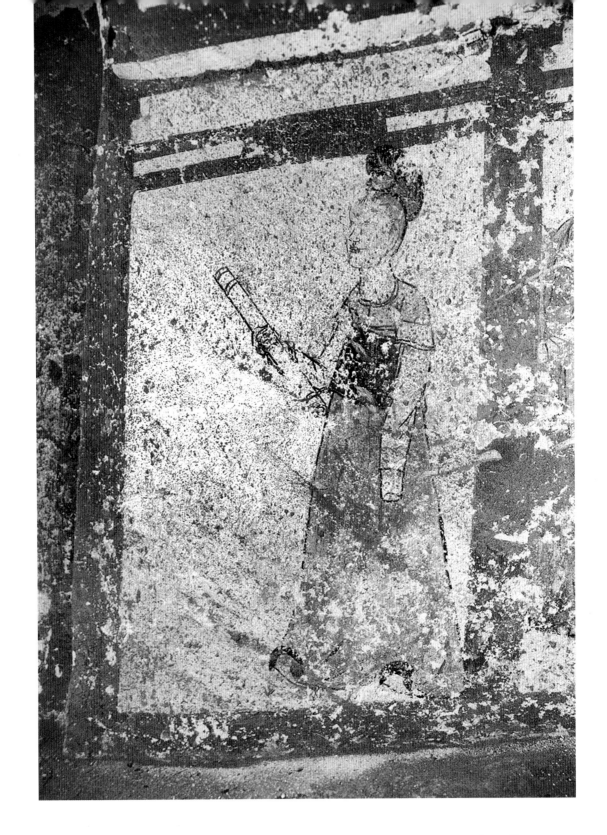

164.持卷轴侍女图

唐龙朔三年（663年）

高150、宽80厘米

1994~1995年陕西省礼泉县昭陵新城长公主墓出土。现存于陕西历史博物馆。

墓向193°。位于第四过洞东壁，为北侧开间。仅绘一位侍女。图中侍女右手持一卷轴，正侧身向北，似与他人作呼应。

（撰文：申秦雁　摄影：王建荣）

Maid Holding a Scroll

3rd Year of Longshuo Era, Tang (663 CE)

Height 150 cm; Width 80 cm

Unearthed from Grand Princess Xincheng's Tomb, which was an Attendant Tomb of Zhaoling Mausoleum, in Liquan, Shaanxi, in 1995. Preserved in Shaanxi History Museum.

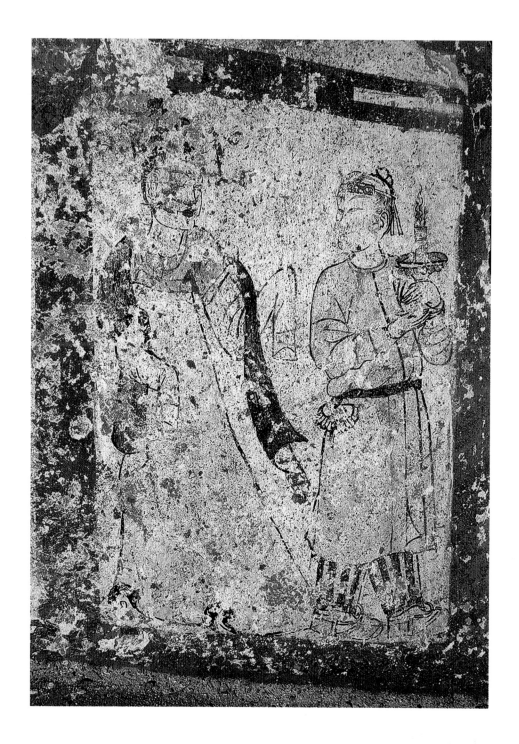

165. 端蜡烛侍女图

唐龙朔三年（663年）

高150、宽82厘米

1994~1995年陕西省礼泉县昭陵新城长公主墓出土。现存于陕西历史博物馆。

墓向193°。位于第四过洞西壁，为北侧开间。图中两位侍女，一边行走，一边交谈，充满动感。

（撰文：申秦雁　摄影：王建荣）

Maids Holding Candles

3rd Year of Longshuo Era, Tang (663 CE)

Height 150 cm; Width 82 cm

Unearthed from Grand Princess Xincheng's Tomb, which was an Attendant Tomb of Zhaoling Mausoleum, in Liquan, Shaanxi, in 1995. Preserved in Shaanxi History Museum.

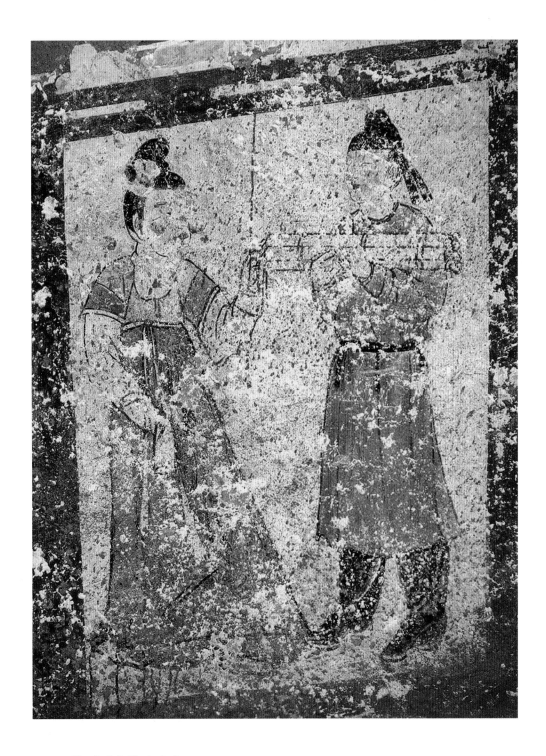

166.捧卷轴侍女图

唐龙朔三年（663年）

高170、宽89～90厘米

1994～1995年陕西省礼泉县昭陵新城长公主墓出土。现存于陕西历史博物馆。

墓向193°。位于第五过洞东壁。是中间开间的两位侍女，其中一位双手捧一捆卷轴，另一位左手抚摸卷轴，二人面面相视，似乎正在商量着什么。

（撰文：申秦雁　摄影：王建荣）

Maids Holding Scrolls

3rd Year of Longshuo Era, Tang (663 CE)

Height 170 cm; Width 89-90 cm

Unearthed from Grand Princess Xincheng's Tomb, which was an Attendant Tomb of Zhaoling Mausoleum, in Liquan, Shaanxi, in 1995. Preserved in Shaanxi History Museum.

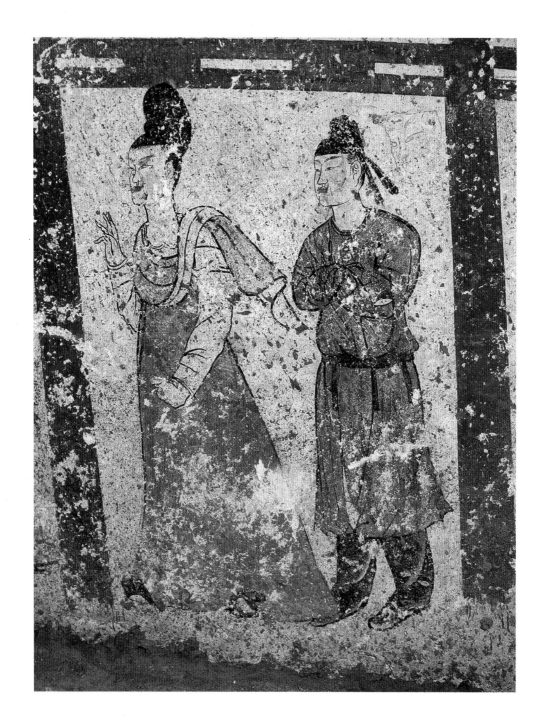

167.侍女图（一）

唐龙朔三年（663年）

高154、宽202厘米

1994~1995年陕西省礼泉县昭陵新城长公主墓出土。现存于陕西历史博物馆。

墓向193°。位于第五过洞西壁。为三个开间中间开间的两位侍女，其中一位右手伸出三指正在比划着什么，后面的男装侍女，恭恭敬敬跟随于其后。

（撰文：申秦雁 摄影：王建荣）

Maids (1)

3rd Year of Longshuo Era, Tang (663 CE)

Height 154 cm; Width 202 cm

Unearthed from Grand Princess Xincheng's Tomb, which was an Attendant Tomb of Zhaoling Mausoleum, in Liquan, Shaanxi, in 1995. Preserved in Shaanxi History Museum.

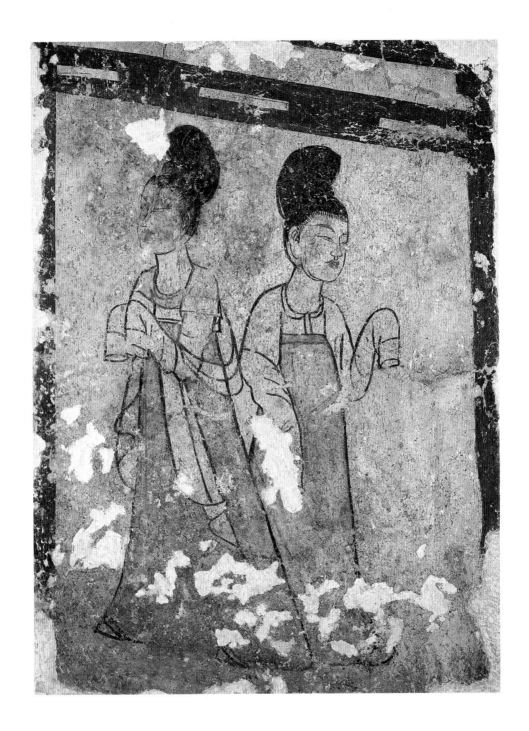

168.侍女图（二）

唐龙朔三年（公元663年）

高154、宽202厘米

1994~1995年陕西省礼泉县昭陵新城长公主墓出土。现存于陕西历史博物馆。

墓向193°。位于第五过洞西壁。为北侧开间的两位侍女。阑枋、廊柱均用墨斗弹出直线，人物用浅褐色土块起稿，痕迹明显。

（撰文：申秦雁　摄影：王建荣）

Maids (2)

3rd Year of Longshuo Era, Tang (663 CE)

Height 154 cm; Width 202 cm

Unearthed from Grand Princess Xincheng's Tomb, which was an Attendant Tomb of Zhaoling Mausoleum, in Liquan, Shaanxi, in 1995. Preserved in Shaanxi History Museum.

169.擔子图

唐龙朔三年（663年）

高207、宽315厘米

1994~1995年陕西省礼泉县昭陵新城长公主墓出土。现存于陕西历史博物馆。

墓向193°。位于墓道东壁、鞍马之后。擔子即轿子，又称肩舆，为朝廷命妇的乘舆，以抬轿力夫人数来表示等级。

（撰文：申秦雁　摄影：王建荣）

Sedan

3rd Year of Longshuo Era, Tang (663 CE)

Height 207 cm; Width 315 cm

Unearthed from Grand Princess Xincheng's Tomb, which was an Attendant Tomb of Zhaoling Mausoleum, in Liquan, Shaanxi, in 1995.

Preserved in Shaanxi History Museum.

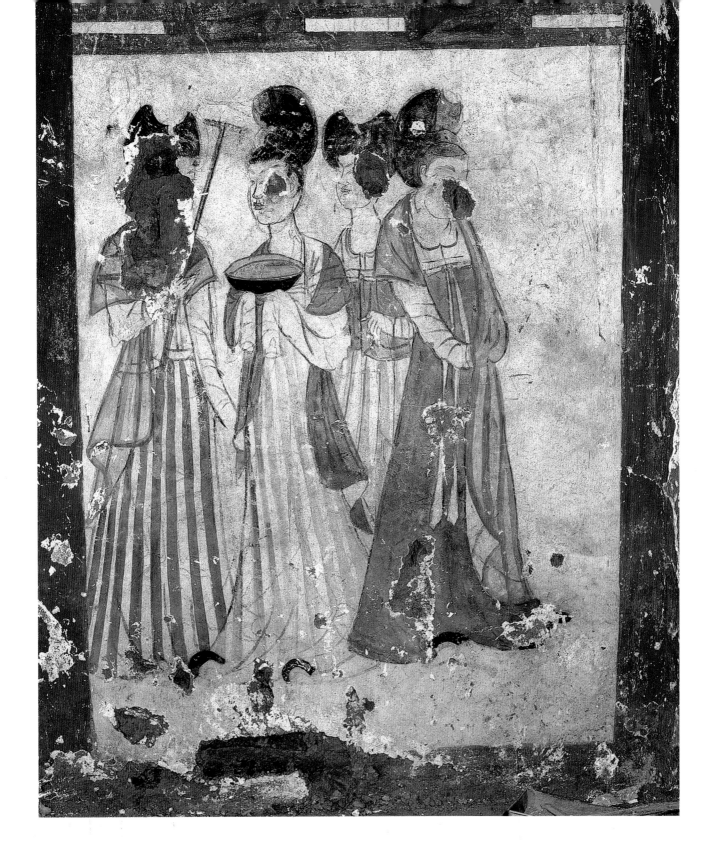

170. 侍女图（三）

唐龙朔三年（663年）

高155、宽280厘米

1994~1995年陕西省礼泉县昭陵新城长公主墓出土。现存于陕西历史博物馆。墓向193°。位于墓室东壁，壁面被分成三个开间，每个开间绘出3~4位侍女。此图为东壁南侧开间。

（撰文：申秦雁　摄影：王建荣）

Maids (3)

3rd Year of Longshuo Era, Tang (663 CE)

Height 155 cm; Width 280 cm

Unearthed from Grand Princess Xincheng's Tomb, which was an Attendant Tomb of Zhaoling Mausoleum, in Liquan, Shaanxi, in 1995. Preserved in Shaanxi History Museum.

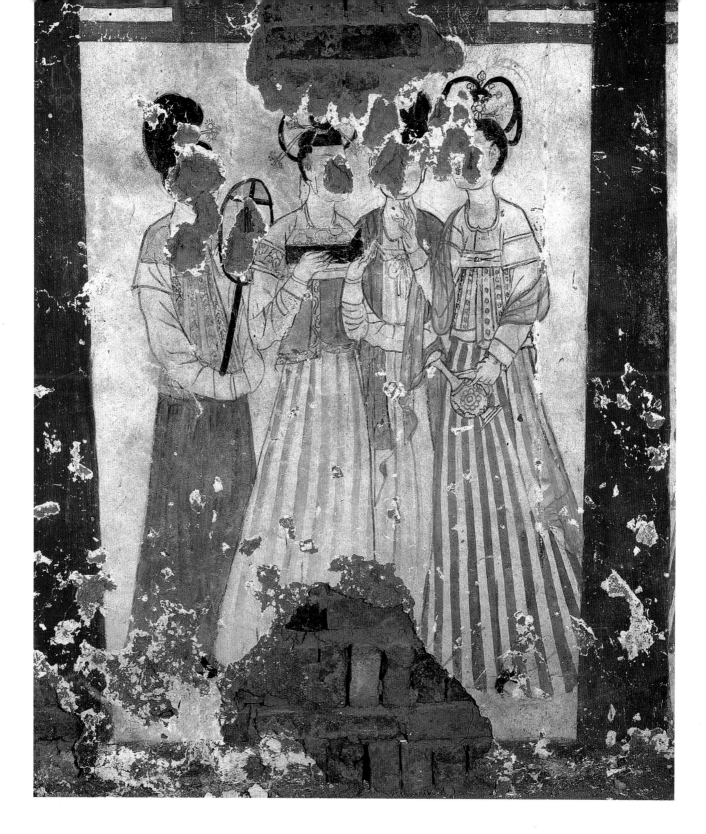

171.侍女图（四）

唐龙朔三年（663年）

高155、宽280厘米

1994~1995年陕西省礼泉县昭陵新城长公主墓出土。现存于陕西历史博物馆。

墓向193°。位于墓室东壁，为中间开间的四位侍女。个个容貌美丽端庄，装束华丽典雅，应该是公主府内掌食、掌筵等各种内官。

（撰文：申秦雁　摄影：王建荣）

Maids (4)

3rd Year of Longshuo Era, Tang (663 CE)

Height 155 cm; Width 280 cm

Unearthed from Grand Princess Xincheng's Tomb, which was an Attendant Tomb of Zhaoling Mausoleum, in Liquan, Shaanxi, in 1995. Preserved in Shaanxi History Museum.

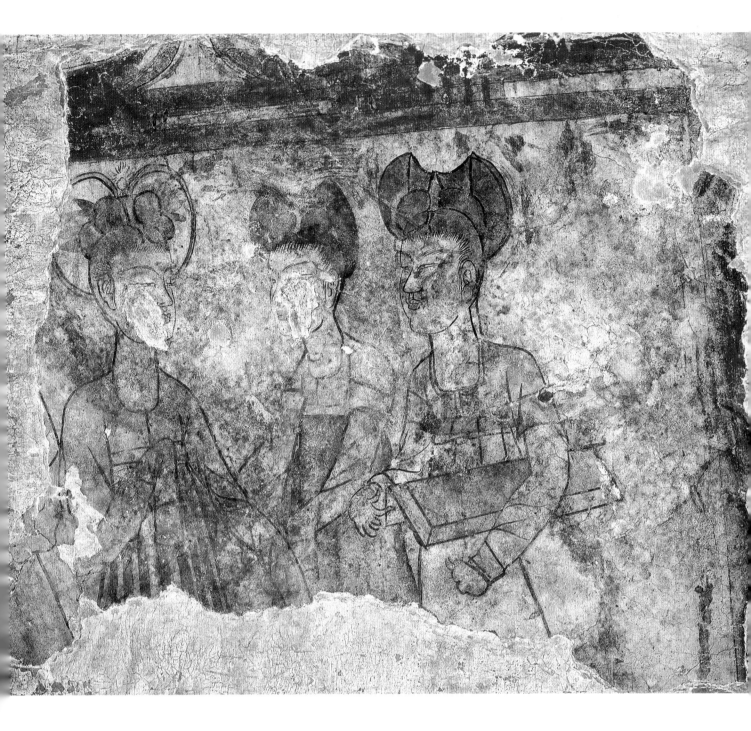

172.侍女图（五）

唐龙朔三年（663年）

高154、宽109厘米

1994~1995年陕西省礼泉县昭陵新城长公主墓出土。现存于陕西历史博物馆。

墓向193°。位于墓室南壁，为仅存的西侧开间中的三位侍女。人物均为柳眉细眼，樱桃小口，面部靬染出粉红色。用色淡雅，着墨较轻。

（撰文：申秦雁　摄影：王建荣）

Maids (5)

3rd Year of Longshuo Era, Tang (663 CE)

Height 154 cm; Width 109 cm

Unearthed from Grand Princess Xincheng's Tomb, which was an Attendant Tomb of Zhaoling Mausoleum, in Liquan, Shaanxi, in 1995.
Preserved in Shaanxi History Museum.

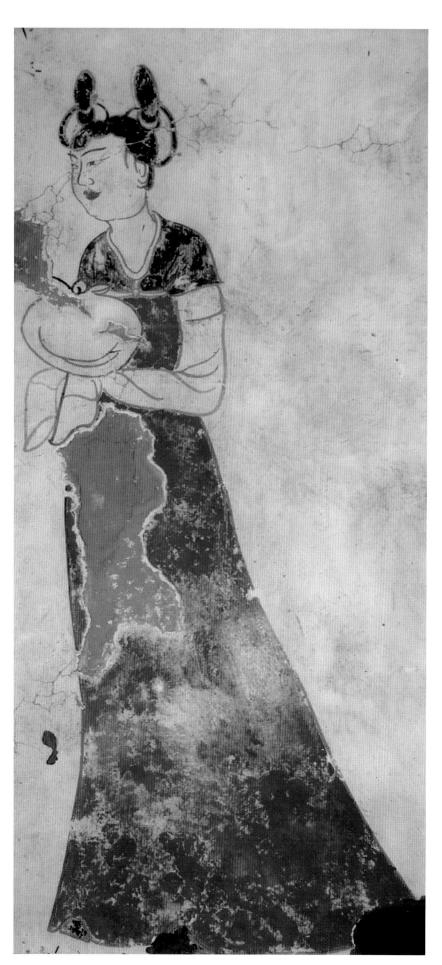

173.捧包裹女侍图

唐麟德二年（665年）

1973陕西省礼泉县烟霞镇西侧李震墓出土。现存于昭陵博物馆。

位于第二天井西壁。绘一女侍头梳双环望仙髻，面容丰腴，柳眉细目，巧鼻朱唇，身材修长，着白色窄袖襦，外穿紫色圆领半臂，系红色长裙，足蹬黑色尖头履，双手捧一淡黄色包裹于胸前，衣袖口下垂，把一个贵族家庭女侍丰韵动人的形象生动的展现出来。

（撰文：李浪涛　摄影：骆福荣、张明惠）

Maid Holding a Package

2nd Year of Linde Era, Tang (665 CE)
Unearthed from Li Zhen's Tomb to the west of Yanxia in Liquan, Shaanxi, in 1973. Preserved in Zhaoling Museum.

174. 托颔黄袍给使图

唐麟德二年（665年）

高97、宽51厘米

1973年陕西省礼泉县烟霞镇西侧李震墓出土。现存于昭陵博物馆。

位于第二过洞东壁。人物头戴黑色幞头，三角眼，八字形嘴身穿黄色窄袖袍，腰束黑带，足蹬黑色长筒靴。向右屈膝躬背、耸肩，左手隐袖中置下颔处、右臂屈肘，手置胸前，呈奴颜婢膝又心怀叵测貌。

（撰文：李浪涛　摄影：骆福荣、张明惠）

Servant in Yellow Robe and Holding Chin

2nd Year of Linde Era, Tang (665 CE)

Height 97 cm; Width 51 cm

Unearthed from Li Zhen's Tomb to the west of Yanxia in Liquan, Shaanxi in 1973. Preserved in Zhaoling Museum.

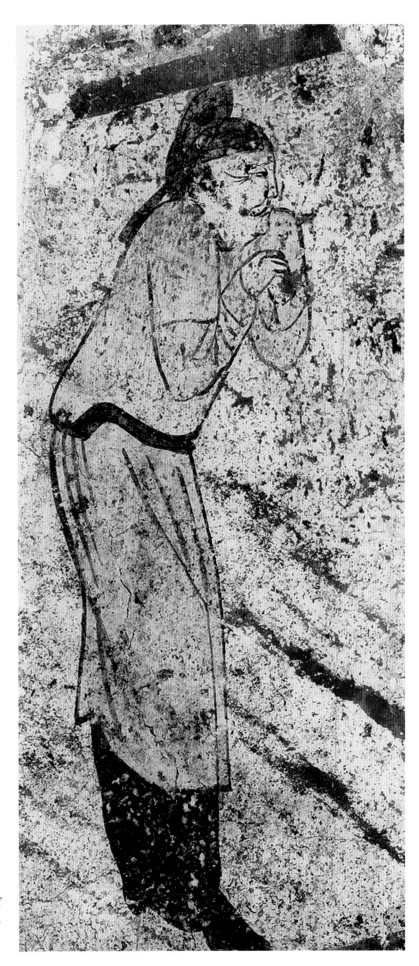

175.嬉戏图

唐麟德二年（665年）

高100、宽66厘米

1973年陕西省礼泉县烟霞镇西侧李震墓出土。现存于昭陵博物馆。

位于第三过洞东壁。绘女侍2人，均头梳双螺髻，着窄袖襦，披帔帛。一女侍将另一女侍从身后拦腰抱住，左手抓握女侍执团扇之手，右手则突然抓捏前女侍大腿处，前女侍极力摆脱，扭头作嗔怒状。生动地表现出宫廷少女偷闲嬉戏、天真活泼的一面。

（撰文：李浪涛　摄影：骆福荣、张明惠）

Sporting Maids

2nd Year of Linde Era, Tang (665 CE)

Height 100 cm; Width 66 cm

Unearthed from Li Zhen's Tomb to the west of Yanxia in Liquan, Shaanxi in 1973. Preserved in Zhaoling Museum.

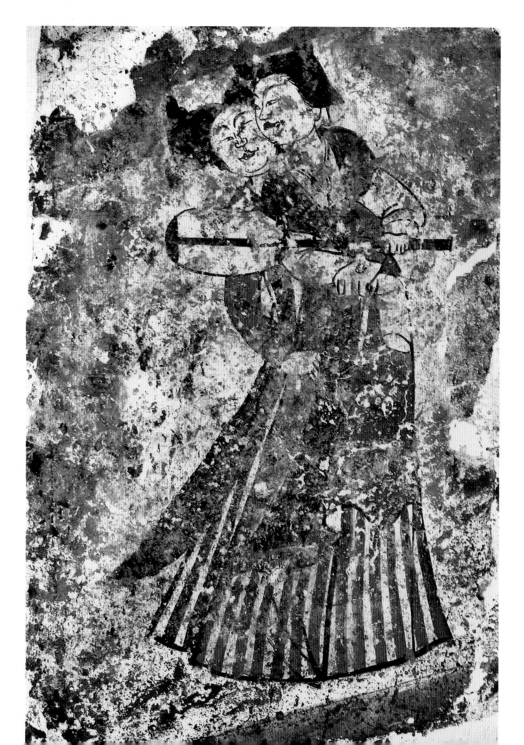

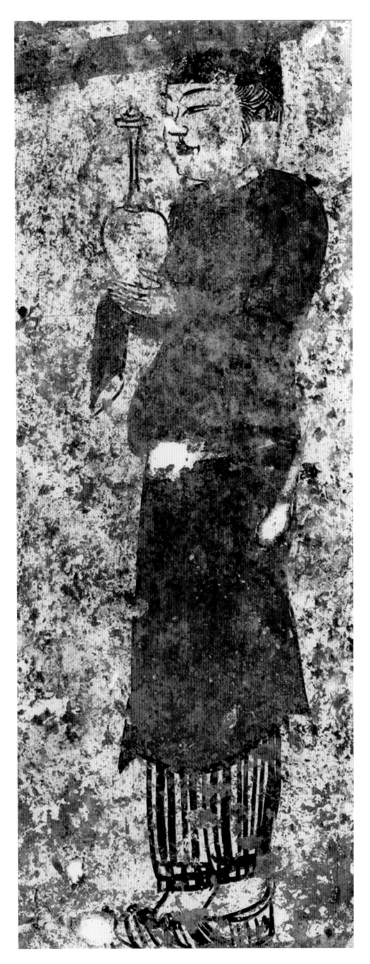

176.捧细颈瓶女侍图

唐麟德二年（665年）

高87、宽54厘米

1973年陕西省礼泉县烟霞镇西侧李震墓出土。现存于昭陵博物馆。

位于第三过洞东壁。人物头顶被红色阑额覆盖，发式不明，头似裹幞头，面相圆润，柳叶眉、细眼、高鼻、朱唇，面颊涂粉彩。身穿圆领窄袖红袍，腰系白带，下穿黑白相间条纹裤，足蹬线鞋。双手捧白瓷细颈瓶面朝墓室方向侧立（右手隐袖中、袖头下垂）。

（撰文：李浪涛　摄影：骆福荣、张明惠）

Maid Holding a Flask

2nd Year of Linde Era, Tang (665 CE)

Height 187 cm; Width 54 cm

Unearthed from Li Zhen's Tomb to the west of Yanxia in Liquan, Shaanxi in 1973. Preserved in Zhaoling Museum.

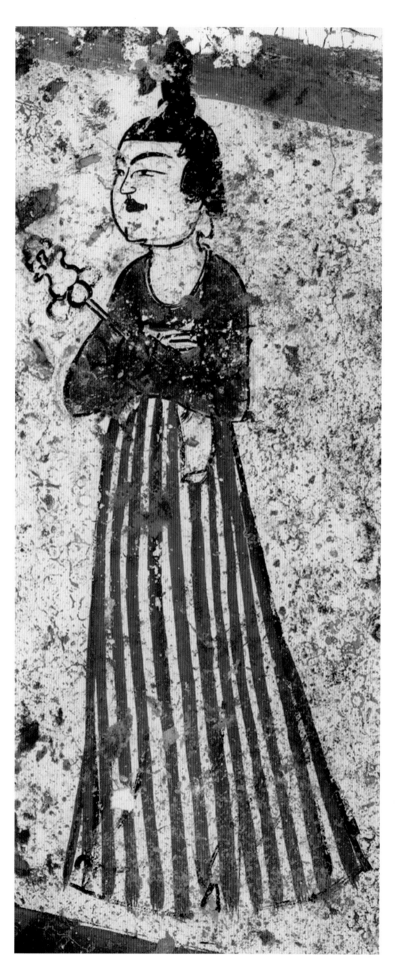

177.持花蕊女侍图

唐麟德二年（665年）

高89、宽50厘米

1973年陕西省礼泉县烟霞镇西侧李震墓出土。现存于昭陵博物馆。

位于第三过洞西壁。头梳椎髻，身穿红色圆领窄袖襦，紫红色半臂，系红白相间条纹裙，足蹬白色尖头履。双臂屈肘手隐袖中，持一花蕊或为玩具，朝左侧立。

（撰文：李浪涛　摄影：骆福荣、张明惠）

Maid Holding a Pistil

2nd Year of Linde Era, Tang (665 CE)

Height 89 cm; Width 50 cm

Unearthed from Li Zhen's Tomb to the west of Yanxia in Liquan, Shaanxi in 1973. Preserved in Zhaoling Museum.

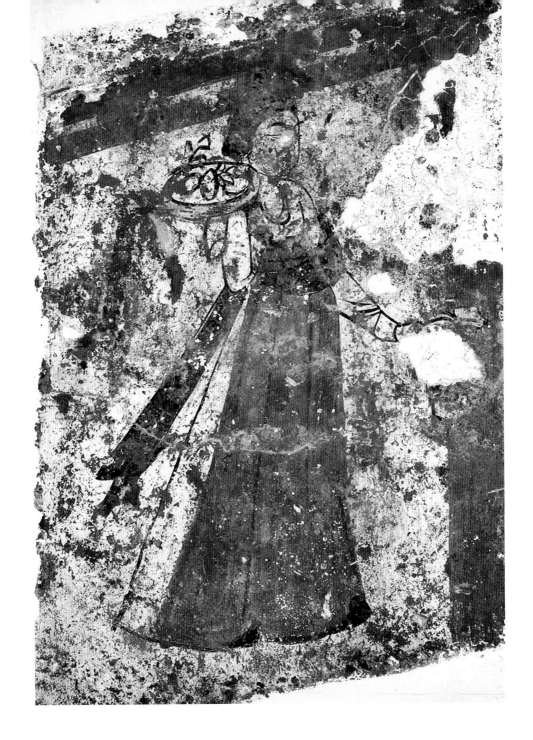

178.托盘执壶女侍图

唐麟德二年（665年）

高83、宽68厘米

1973年陕西省礼泉县烟霞镇西侧李震墓出土。现存于昭陵博物馆。

位于第四过洞东壁。绘一女侍头梳螺髻，弯眉细目，朱唇，神态自然，上着白色圆领窄袖襦，披紫色帔帛，下穿前红后白长裙，足蹬黑色尖头履，右手托盘，左手执壶；帔帛飘拂，步履匆匆，显示出宫廷侍女忙忙碌碌，精明能干的一面。

（撰文：李浪涛　摄影：骆福荣、张明惠）

Maid Holding a Tray and a Pitcher

2nd Year of Linde Era, Tang (665 CE)

Height 83 cm; Width 68 cm

Unearthed from Li Zhen's Tomb to the west of Yanxia in Liquan, Shaanxi in 1973. Preserved in Zhaoling Museum.

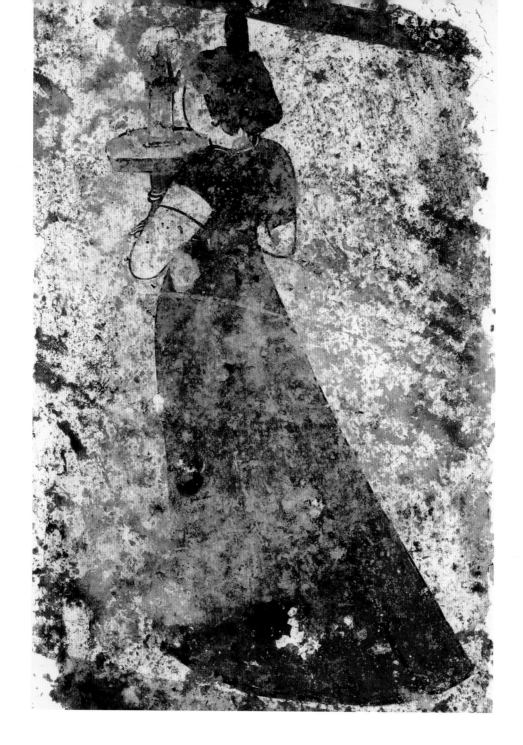

179.秉烛女侍图

唐麟德二年（公元665年）

高90、宽62厘米

1973年陕西省礼泉县烟霞镇西侧李震墓出土。现存于昭陵博物馆。

位于第四过洞西壁。绘一女侍头梳螺髻，身穿白色圆领窄袖襦，外着红色半臂，系朱红色长裙，双手捧一烛台，背身朝南行走。烛台上有一正在燃烧的蜡烛，蜡烛粗壮，火苗熊熊燃烧，火焰似燃烧的火把，十分壮观。

<div align="right">（撰文：李浪涛　摄影：张明惠）</div>

Maid Holding a Candlestick

2nd Year of Linde Era, Tang (665 CE)

Height 90 cm; Width 62 cm

Unearthed from Li Zhen's Tomb to the west of Yanxia in Liquan, Shaanxi in 1973. Preserved in Zhaoling Museum.

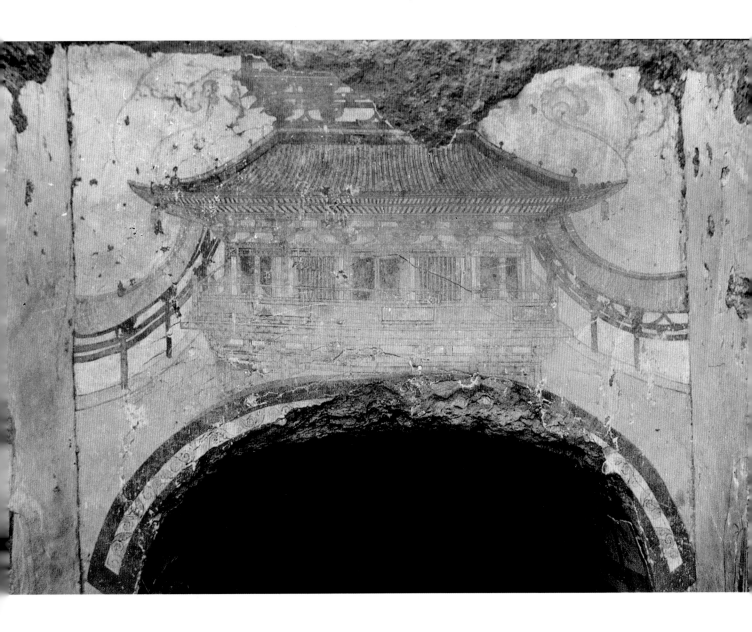

180.门阙建筑图

唐乾封二年（667年）

残高160、宽248厘米

1990年陕西省礼泉县烟霞镇陵光村韦贵妃墓出土。现存于昭陵博物馆。

位于墓道北壁。门阙为双层四阿顶全木结构。一层五间，正面两窗三门，两侧有廊房。于门墙之上起六朵斗拱，每个斗拱之间有一支柱；门与房檐之间均以斗拱支撑，于第一层房脊上又绘双层斗拱支撑上层，上层已残缺不全，门阙两侧绘有瑞气祥云。

<div align="right">（撰文：李浪涛　摄影：张展望）</div>

Gate Tower

2nd Year of Qianfeng Era, Tang (667 CE)

Height 160 cm; Width 248 cm

Unearthed from Honored Imperial Concubine Wei's Tomb at Lingguangcun of Yanxia in Liquan, Shaanxi, in 1990. Preserved in Zhaoling Museum.

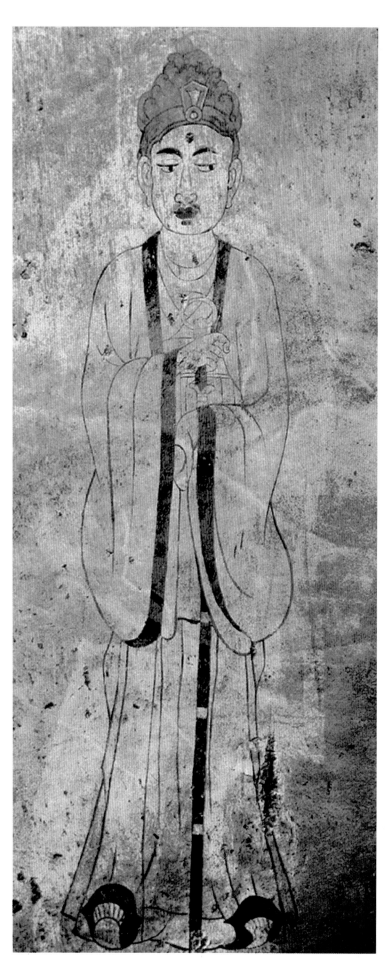

181.门吏图（一）

唐乾封二年（667年）

高205、宽47厘米

1990年陕西省礼泉县烟霞镇陵光村韦贵妃墓出土。
现存于昭陵博物馆。

位于墓道西壁北段北起第一幅。门吏头戴山形冠，
衣着动作与东壁门吏相似，只是面东正立、双目斜
视，表情木然，右手在上、左手隐袖中在下握仪
刀。

（撰文：李浪涛　摄影：张展望）

Petty Official (1)

2nd Year of Qianfeng Era, Tang (667 CE)

Height 205 cm; Width 47 cm

Unearthed from Honored Imperial Concubine Wei's
Tomb at Lingguangcun of Yanxia in Liquan, Shaanxi,
in 1990. Preserved in Zhaoling Museum.

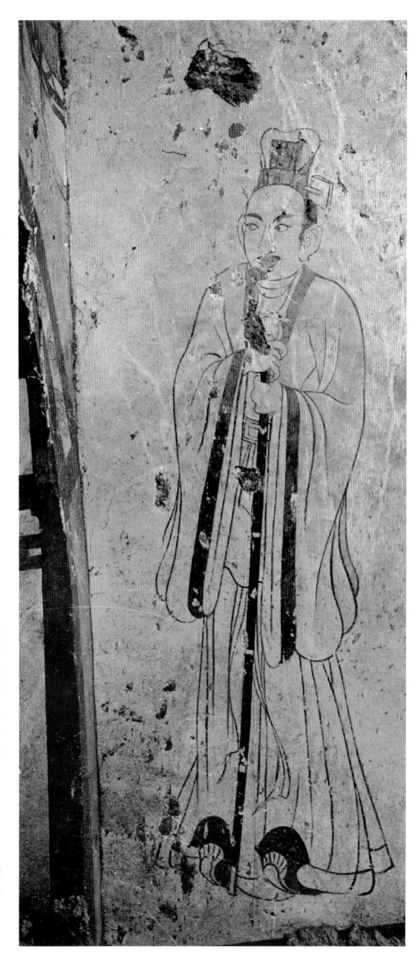

182.门吏图（二）

唐乾封二年（667年）

高196、宽47厘米

1990年陕西省礼泉县烟霞镇陵光村韦贵妃墓出土。现存于昭陵博物馆。

位于墓道东壁北段左起第一幅。门吏身材较高大，头戴灰黑色束发冠，冠左侧插一方首簪；面庞较丰满，浓眉大眼，两耳较大，鼻翼较宽，嘴略小，面颊淡涂粉红，红唇上部绘出黑色小胡须；上身内着圆领襦衫，外套白色交衽阔袖长衫，袖边及衣领饰紫褐色锦边，足蹬褐色圆头履。身略侧向左，双手拄仪刀。面微侧向，两眼向过洞口处斜视，仿佛在关注门内之事。

（撰文：李浪涛 摄影：张展望）

Petty Official (2)

2nd Year of Qianfeng Era, Tang (667 CE)

Height 196 cm; Width 47 cm

Unearthed from Honored Imperial Concubine Wei's Tomb at Lingguangcun of Yanxia in Liquan, Shaanxi, in 1990. Preserved in Zhaoling Museum.

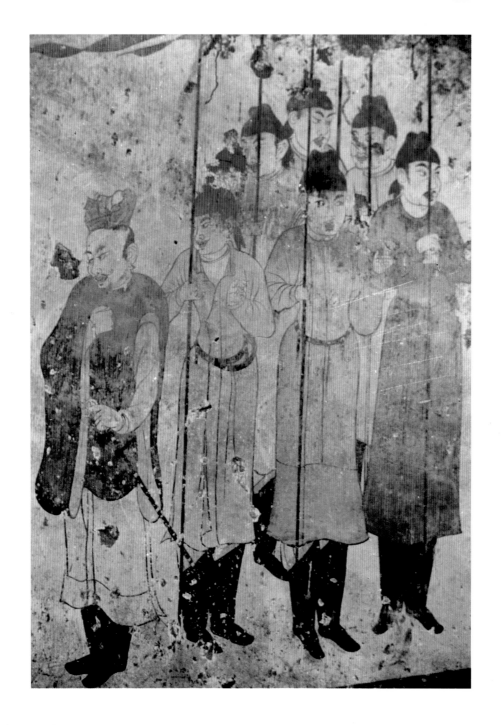

183. 袍服仪卫图

唐乾封二年（667年）

高266、宽170厘米

1990年陕西省礼泉县烟霞镇陵光村韦贵妃墓出土。现存于昭陵博物馆。

位于墓道东壁北段左起第二幅，共绘七人。左一似为领班，人物高185厘米，头戴进贤冠，穿深赭色圆领阔袖衫，白色裳，足蹬长筒黑靴。右手握拳曲胸前，左手提剑。其他六人作三角形站立，人物高180~195厘米。均戴黑幞头，分别穿红、黄、蓝、白各色窄袖袍，且领队后一人领口敞开。束腰，着长筒黑靴，竖执旗帜。他们或左顾右盼，或张嘴瞠目，或窃窃私语，神情各异，生动活泼。

（撰文：李浪涛　摄影：张展望）

Guards of Honor in Robes

2nd Year of Qianfeng Era, Tang (667 CE)

Height 266 cm; Width 170 cm

Unearthed from Honored Imperial Concubine Wei's Tomb at Lingguangcun of Yanxia in Liquan, Shaanxi, in 1990. Preserved in Zhaoling Museum.

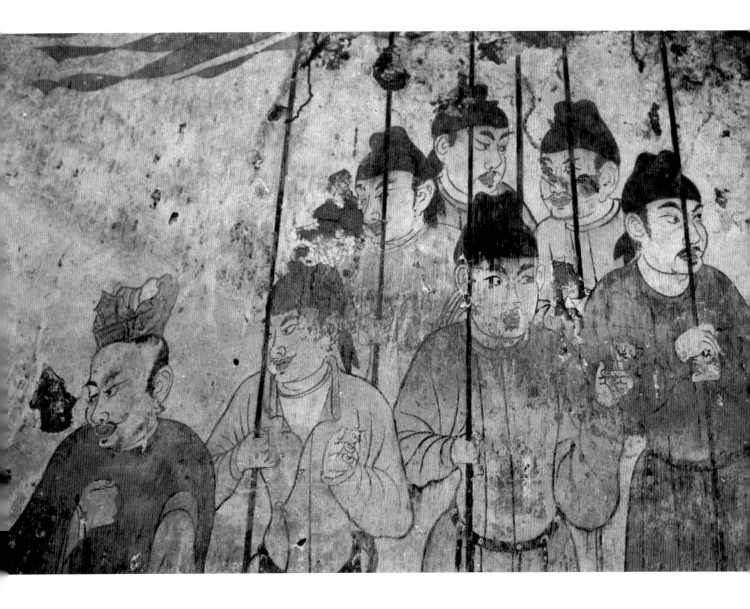

184.袍服仪卫图（局部）

唐乾封二年（667年）

高约130、宽164厘米

1990年陕西省礼泉县烟霞镇陵光村韦贵妃墓出土。现存于昭陵博物馆。

位于墓道东壁北段左起第二幅，为七人上半身。

（撰文：李浪涛　摄影：张展望）

Guards of Honor in Robes (Detail)

2nd Year of Qianfeng Era, Tang (667 CE)

Height ca. 130 cm; Width 164 cm

Unearthed from Honored Imperial Concubine Wei's Tomb at Lingguangcun of Yanxia in Liquan, Shaanxi, in 1990. Preserved in Zhaoling Museum.

185.甲胄仪卫图 ▶

唐乾封二年（667年）

高210、宽170厘米

1990年陕西省礼泉县烟霞镇陵光村韦贵妃墓出土。现存于昭陵博物馆。

位于墓道西壁中段。图中七人，人物高165~185厘米。均戴尖顶盔，身扎甲战袍，甲有条纹、片纹、鱼鳞纹几种，足蹬黑色长筒靴。左一人为领班，右手指点，左手提握仪刀。其他六人分前后两排站立执旗（旗面残，后排左一、二仪卫面残）。侧转，或对视，各俱神态。

（撰文：李浪涛　摄影：张展望）

Guards of Honor in Armors

2nd Year of Qianfeng Era, Tang (667 CE)

Height 210 cm; Width 170 cm

Unearthed from Honored Imperial Concubine Wei's Tomb at Lingguangcun of Yanxia in Liquan, Shaanxi, in 1990. Preserved in Zhaoling Museum.

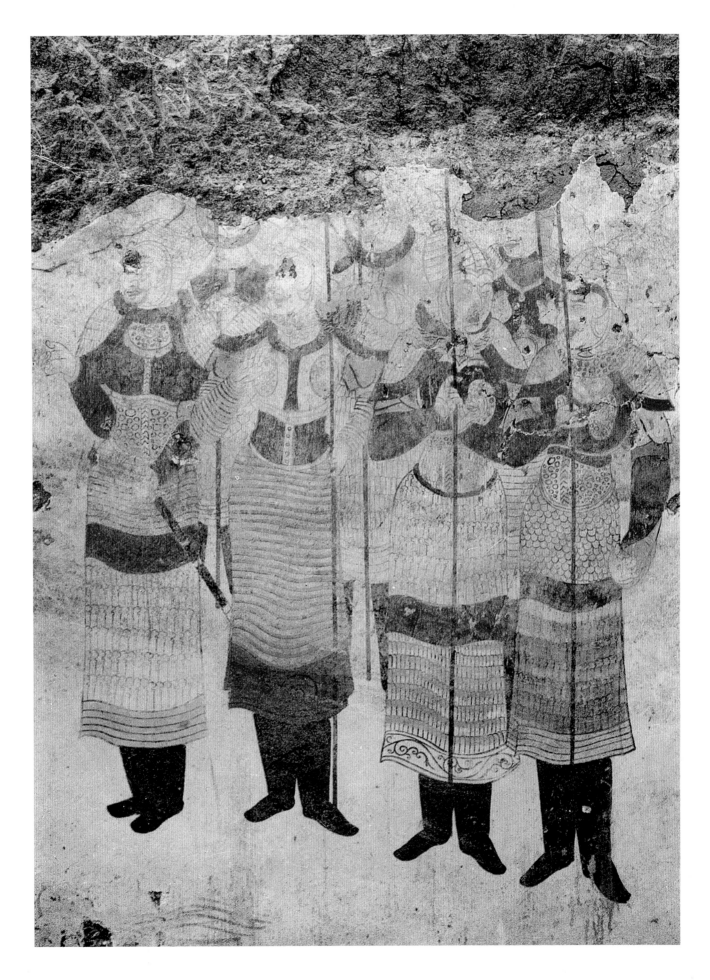

186.备马图

唐乾封二年（667年）

高150、宽140厘米

1990年陕西省礼泉县烟霞镇陵光村韦贵妃墓出土。现存于昭陵博物馆。

位于第一天井东壁。图中绘二名控夫和一匹白马，两名控夫高100～107厘米，卷发阔口，高鼻深目，着民族服装，是典型的少数民族形象；白马头小身高，肌肉发达，也是胡马形象。马高103、长115厘米。烈马刚被驯服，余怒未息，抬起的蹄子还未最终放下，嘴巴还未最终合拢；二控夫一人夹托马颈，一人勒缰后倾。

（撰文：李浪涛 摄影：张展望）

Fitting the Horse

2nd Year of Qianfeng Era, Tang (667 CE)

Height 150 cm; Width 140 cm

Unearthed from Honored Imperial Concubine Wei's Tomb at Lingguangcun of Yanxia in Liquan, Shaanxi, in 1990. Preserved in Zhaoling Museum.

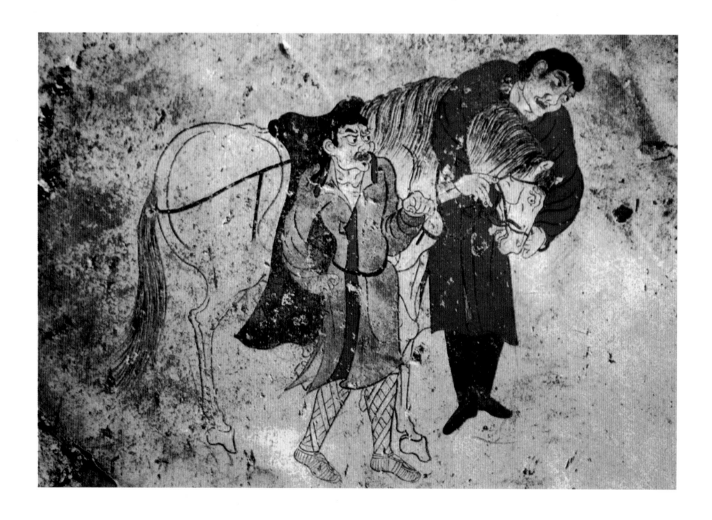

187. 列戟图（局部）

唐乾封二年（667年）

高215、宽135厘米

1990年陕西省礼泉县烟霞镇陵光村韦贵妃墓出土。现存于昭陵博物馆。位于第二天井西壁。右上部脱落殆尽，仅见红色戟架，底座宽218厘米，高133厘米，上层横木右端出头，戟杆高62～174厘米（完整戟，高174厘米）。图右上部残、仅见黑色戟杆；左边保存尚好，戟头为三叉戟、戟杆顶端涂红、下部涂黑，戟下挂兽面衣幡，衣幡涂绿、幡条内绿外橘黄。

（撰文：李浪涛　摄影：张展望）

Halberd Display (Detail)

2nd Year of Qianfeng Era, Tang (667 CE)

Height 215 cm; Width 135 cm

Unearthed from Honored Imperial Concubine Wei's Tomb at Lingguangcun of Yanxia in Liquan, Shaanxi, in 1990. Preserved in Zhaoling Museum.

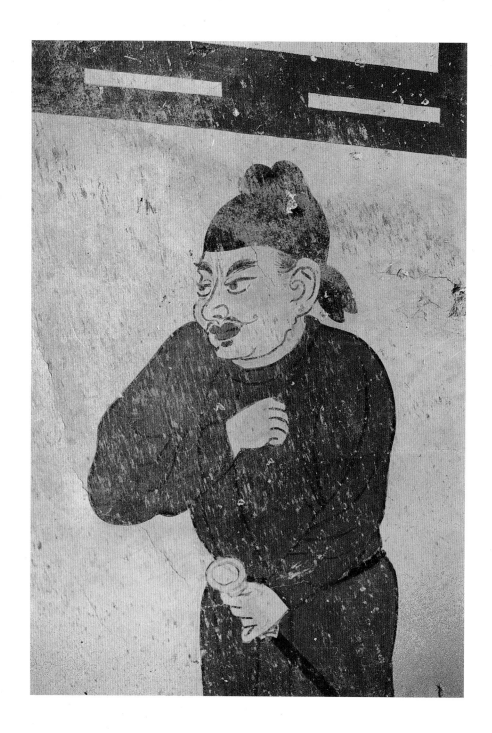

188. 红袍男侍图（局部）

唐乾封二年（667年）

高80、宽56厘米

1990年陕西省礼泉县烟霞镇陵光村韦贵妃墓出土。现存于昭陵博物馆。

位于第一过洞西壁南间。男侍通高100厘米。头戴黑色幞头，身穿红色圆领窄袖袍，左手提握仪刀，右臂屈肘于胸前，头微低，一副若有所思的神情。

<div align="right">（撰文：李浪涛　摄影：张展望）</div>

Guard in Red Robe (Detail)

2nd Year of Qianfeng Era, Tang (667 CE)

Height 80 cm; Width 56 cm

Unearthed from Honored Imperial Concubine Wei's Tomb at Lingguangcun of Yanxia in Liquan, Shaanxi, in 1990. Preserved in Zhaoling Museum.

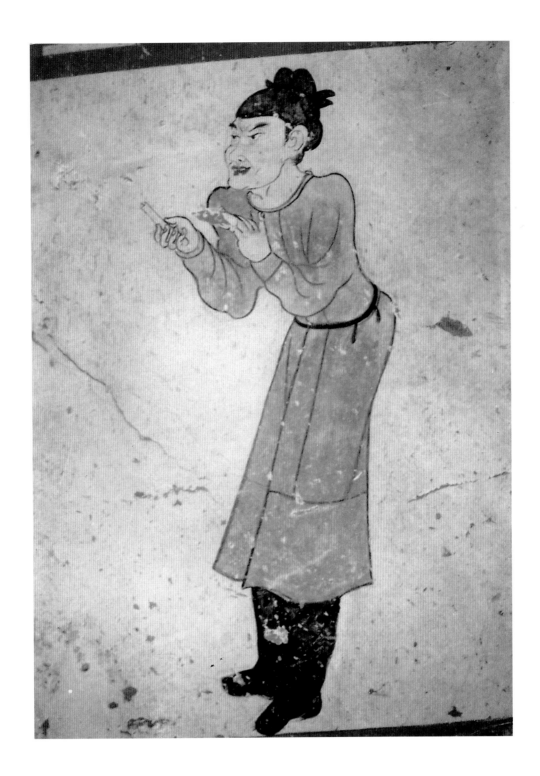

189.秉烛黄袍男侍图

唐乾封二年（667年）

高132、宽120厘米

1990年陕西省礼泉县烟霞镇陵光村韦贵妃墓出土。现存于昭陵博物馆。位于第二过洞东壁北间。其南为红袍执笏男侍，其北为第二天井东壁列戟图。男侍高99厘米。头戴黑色幞头，身穿橘黄色圆领窄袖袍，腰系黑带，足蹬黑靴。右手持一根蜡烛，向墓室方向斜伸，左手比划躬身，腰间垂两条短蹀躞带。

（撰文：李浪涛　摄影：张展望）

Servant Holding a Candle and in Yellow Robe

2nd Year of Qianfeng Era, Tang (667 CE)

Height 132 cm; Width 120 cm

Unearthed from Honored Imperial Concubine Wei's Tomb at Lingguangcun of Yanxia in Liquan, Shaanxi, in 1990. Preserved in Zhaoling Museum.

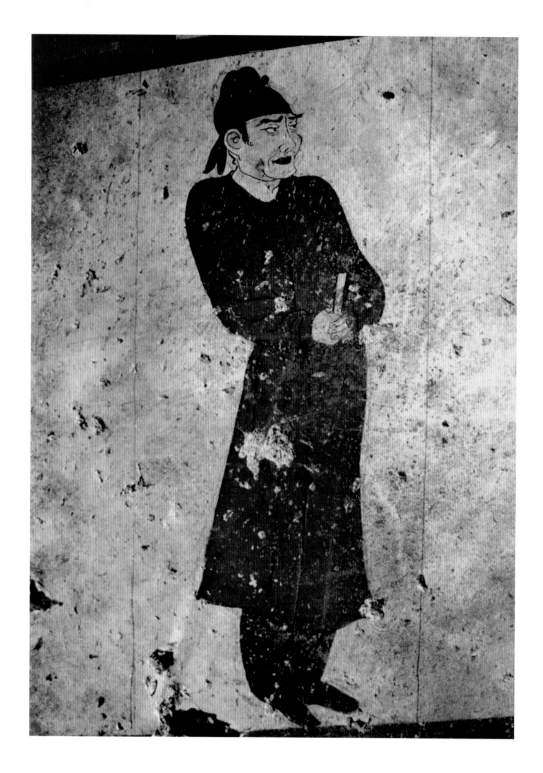

190. 红袍执笏男侍图

唐乾封二年（667年）

高115、宽100厘米

1990年陕西省礼泉县烟霞镇陵光村韦贵妃墓出土。现存于昭陵博物馆。

位于第二过洞东壁南间。图中绘一男侍，人物高104厘米。头戴黑幞头，身穿圆领窄袖红袍，坚眉深目，目光斜视，双手持笏于胸前，一幅傲慢自得的神情。

（撰文：李浪涛　摄影：张展望）

Servant Holding Hu-tablet and in Red Robe

2nd Year of Qianfeng Era, Tang (667 CE)

Height 115 cm; Width 100 cm

Unearthed from Honored Imperial Concubine Wei's Tomb at Lingguangcun of Yanxia in Liquan, Shaanxi, in 1990. Preserved in Zhaoling Museum.

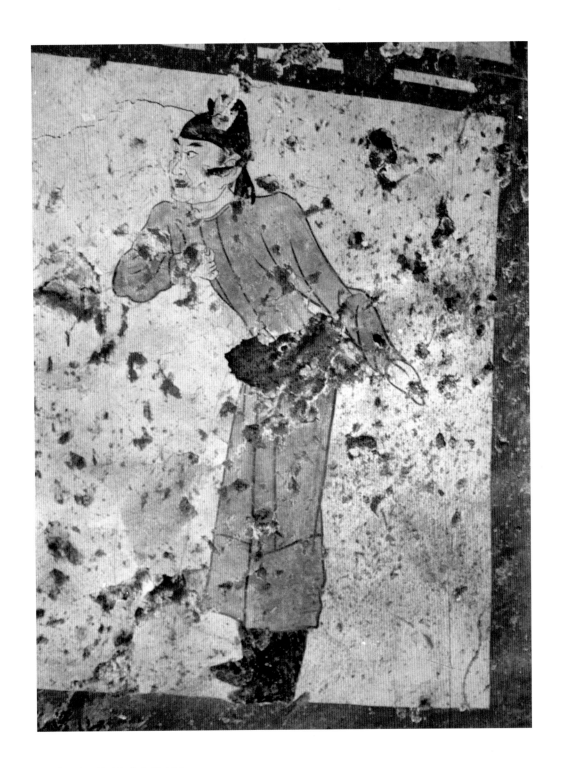

191. 躬身黄袍男侍图

唐乾封二年（667年）

高133、宽90厘米

1990年陕西省礼泉县烟霞镇陵光村韦贵妃墓出土。现存于昭陵博物馆。

位于第二过洞西壁北间。男侍高104厘米。头戴黑幞头，身穿橘黄色圆领窄袖袍，腰系黑带，足蹬黑靴，上身前倾，弓腰而立，左袖后甩，右手握拳锤胸，仿佛在主人面前一边诽谤他人，一边表示自己的忠实。

（撰文：李浪涛　摄影：张展望）

Bowing Servant in Yellow Robe

2nd Year of Qianfeng Era, Tang (667 CE)
Height 133 cm; Width 90 cm
Unearthed from Honored Imperial Concubine Wei's Tomb at Lingguangcun of Yanxia in Liquan, Shaanxi, in 1990. Preserved in Zhaoling Museum.

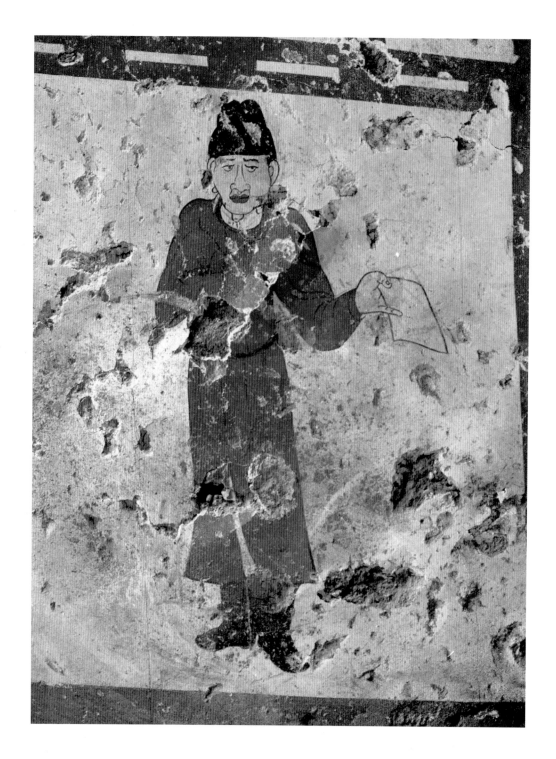

192.展纸红袍男侍图

唐乾封二年（667年）

高150、宽103厘米

1990年陕西省礼泉县烟霞镇陵光村韦贵妃墓出土。现
存于昭陵博物馆。

位于第二过洞西壁南间。男侍高97厘米。头戴黑色幞
头，身穿红色圆领窄袖袍，腰系黑带，足蹬黑靴；右
手曲胸前，左手摊开一张纸，尖嘴猴腮，目光阴险莫
测，仿佛在主人面前搬弄是非，陷害忠良。

（撰文：李浪涛　摄影：张明惠）

Servant Holding a Sheet of Paper and in Red Robe

2nd Year of Qianfeng Era, Tang (667 CE)

Height 150 cm; Width 103 cm

Unearthed from Honored Imperial Concubine
Wei's Tomb at Lingguangcun of Yanxia
in Liquan, Shaanxi, in 1990. Preserved in
Zhaoling Museum.

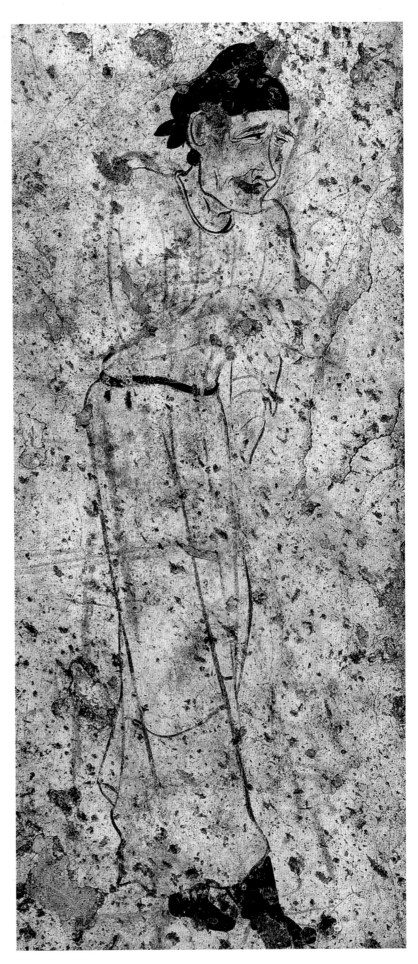

193.白袍男侍图

唐乾封二年（667年）

人物高78厘米

1990年陕西省礼泉县烟霞镇陵光村韦贵妃墓出土。现存于昭陵博物馆。

位于第三过洞东壁北间。男侍头戴黑幞头，身穿圆领窄袖白袍，腰系黑带，足蹬黑靴，拱手胸前，袖口下垂，高颧尖颔，双脚交叠，似畏缩不前的样子。

（撰文：李浪涛　摄影：张展望）

Servant in White Robe

2nd Year of Qianfeng Era, Tang (667 CE)

Figure Height 78 cm

Unearthed from Honored Imperial Concubine Wei's Tomb at Lingguangcun of Yanxia in Liquan, Shaanxi, in 1990. Preserved in Zhaoling Museum.

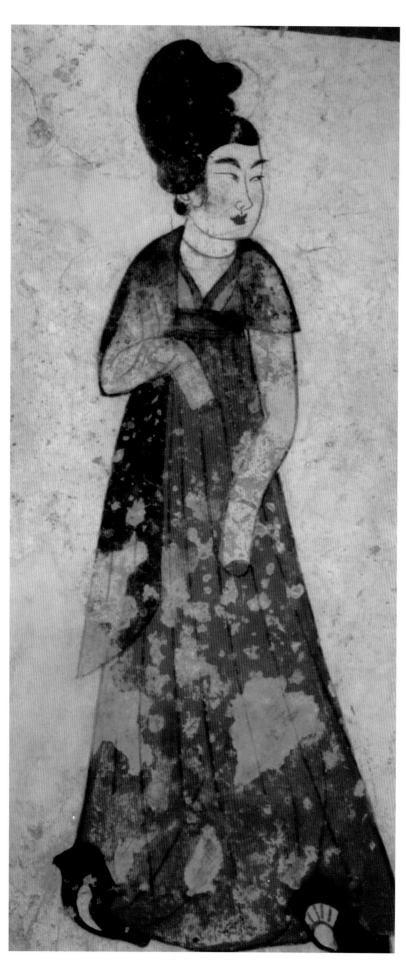

194.回首女侍图

唐乾封二年（667年）

人物高79厘米

1990年陕西省礼泉县烟霞镇陵光村韦贵妃墓出土。现存于昭陵博物馆。

位于第四过洞西壁北间。女侍头梳单刀半翻髻，面相秀美，粗眉杏目，俏鼻，樱桃小嘴、上穿淡绿色窄袖交衽襦，披紫色帔帛，右臂曲肘置胸前，左臂自然下垂向前摆，下穿红色曳地长裙，足蹬黑色高头履。作回首北望状。

（撰文：李浪涛　摄影：张展望）

Maid Looking Sideways

2nd Year of Qianfeng Era, Tang (667 CE)

Figure Height 79 cm

Unearthed from Honored Imperial Concubine Wei's Tomb at Lingguangcun of Yanxia in Liquan, Shaanxi, in 1990. Now Collected in Zhaoling Museum.

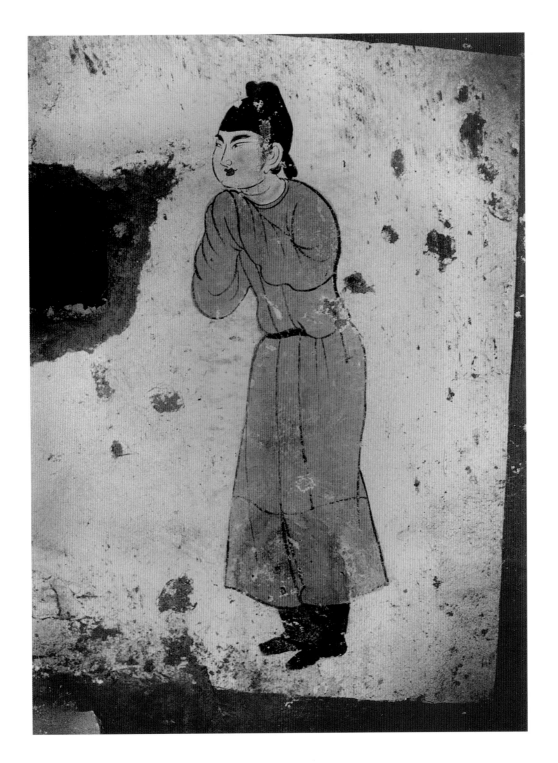

195.橘黄袍男装女侍图

唐乾封二年（667年）

画面高78、宽108、人物高82厘米

1990年陕西省礼泉县烟霞镇陵光村韦贵妃墓出土。现存于昭陵博物馆。位于前甬道西壁南间。女侍头戴黑色幞头，粗眉细目、鼻直口方、樱桃小嘴，面相圆胖，面施胭脂口红，着圆领窄袖有襕橘黄袍，双手隐袖中拱举胸前朝南站立，躯体微前倾。腰系黑带、袍服宽松以致左侧腹部袍下垂遮住革带，足蹬黑靴。

（撰文：李浪涛　摄影：张展望）

Maid in Orange Male Costume

2nd Year of Qianfeng Era, Tang (667 CE)
Height 78 cm; Width 108 cm; Figure Height 82 cm
Unearthed from Honored Imperial Concubine Wei's Tomb at Lingguangcun of Yanxia in Liquan, Shaanxi, in 1990. Preserved in Zhaoling Museum.

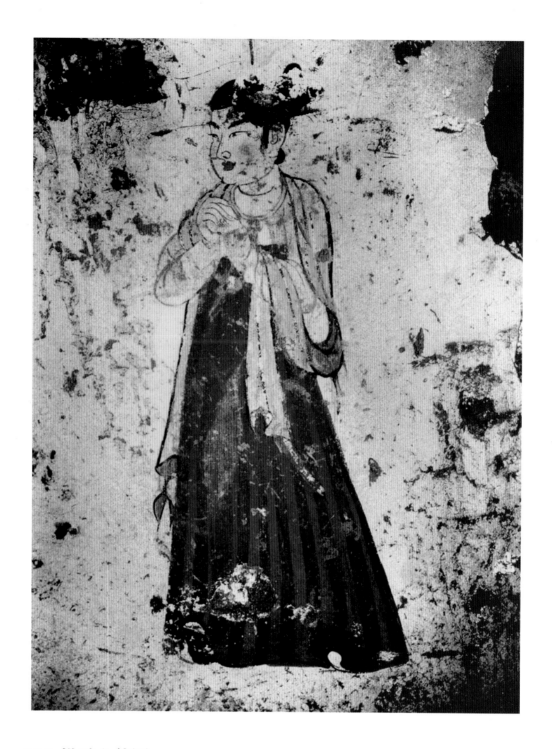

196.拱手女侍图

唐乾封二年（667年）

高91、宽96、人高81厘米

1990年陕西省礼泉县烟霞镇陵光村韦贵妃墓出土。现存于昭陵博物馆。

位于前甬道西壁北间。女侍矮胖，头梳锥髻，面相丰腴、粗眉细目、高鼻、朱唇，朝南行进。身穿白色圆领窄袖襦，披淡蓝色红里帔帛，其左端搭在左臂上，右手握左手（手隐袖中）、拱手胸前，腰系红褐相间宽条纹裙（或为红色暗条纹裙），足蹬黑色扇面形高头履。

（撰文：李浪涛　摄影：张展望）

Maid Joining Hands Before Breast

2nd Year of Qianfeng Era, Tang (667 CE)
Height 91 cm; Width 96 cm; Figure Height 81 cm
Unearthed from Honored Imperial Concubine Wei's Tomb at Lingguangcun of Yanxia in Liquan, Shaanxi, in 1990. Preserved in Zhaoling Museum.

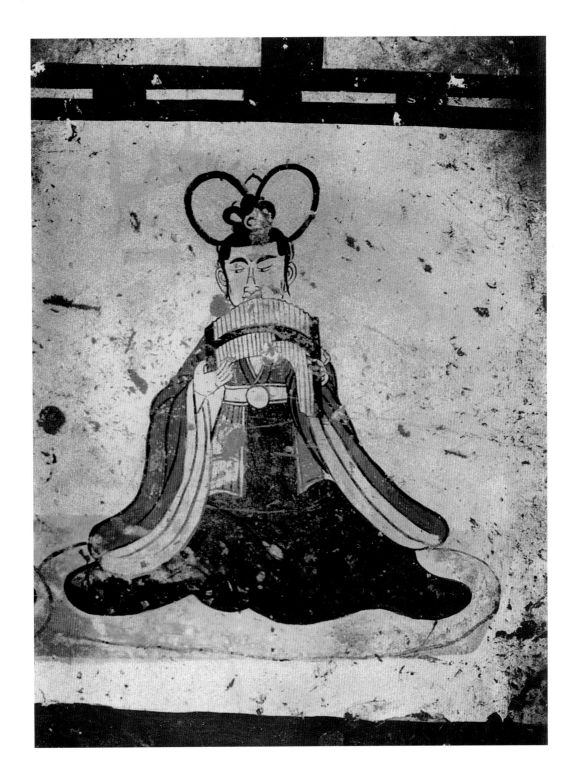

197.吹排箫乐伎图

唐乾封二年（667年）

高140、宽85厘米

1990年陕西省礼泉县烟霞镇陵光村韦贵妃墓出土。现存于昭陵博物馆。

位于北后甬道西壁中段偏北处。女乐伎着红色宽袖交衽襦、下穿紫色裙、裙上部施围裳，双手持20管排箫吹奏，其目光向左下斜视。

（撰文：李浪涛　摄影：张展望）

The Panpipes Player in the Music Band

2nd Year of Qianfeng Era, Tang (667 CE)

Height 140 cm; Width 85 cm

Unearthed from Honored Imperial Concubine Wei's Tomb at Lingguangcun of Yanxia in Liquan, Shaanxi, in 1990. Preserved in Zhaoling Museum.

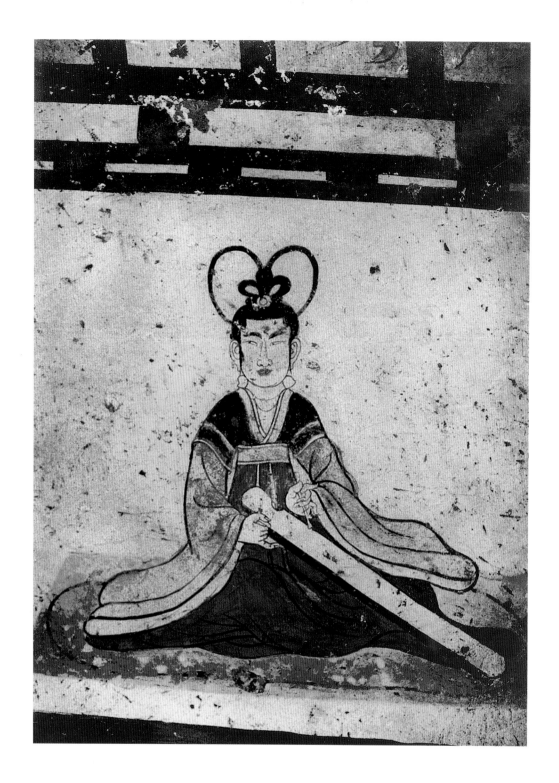

198.弹琴乐伎图

唐乾封二年（667年）

高139、宽92厘米

1990年陕西省礼泉县烟霞镇陵光村韦贵妃墓出土。现存于昭陵博物馆。

位于北后甬道西壁中段偏南处。人物高88厘米，着淡绿色高领宽袖袍、外套紫色交衽半臂，腰系红裙；右手托云和上端、左手握弹拨棒作弹拨状；向左斜视。

（撰文：李浪涛　摄影：张展望）

Qin-zither Player in the Music Band

2nd Year of Qianfeng Era, Tang (667 CE)
Height 139 cm; Width 92 cm
Unearthed from Honored Imperial Concubine Wei's Tomb at Lingguangcun of Yanxia in Liquan, Shaanxi, in 1990. Preserved in Zhaoling Museum.

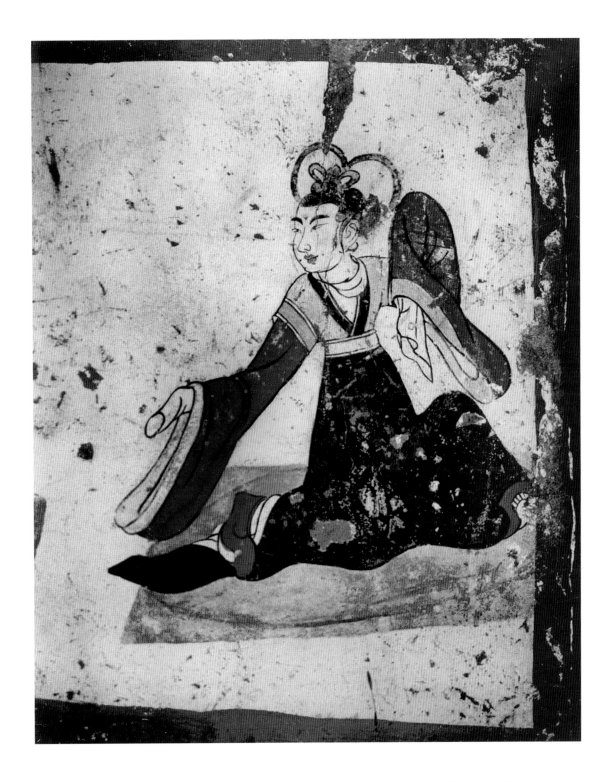

199.舞蹈乐伎图

唐乾封二年（667年）

高130、宽80厘米

1990年陕西省礼泉县烟霞镇陵光村韦贵妃墓出土。现存于昭陵博物馆。
位于后甬道西壁北间。为左起第二人，人物高85厘米，宽67厘米，保存
尚好。身朝东头偏向南，左臂上举、右臂向南斜伸，右膝着地，左膝向
上欲起舞。身着白色圆领窄袖襦、外套红色宽袖袍、淡绿色交衽半臂，
腰系赭色裙，足蹬红色高头履。

（撰文：李浪涛　摄影：张展望）

Performing Dancer

2nd Year of Qianfeng Era, Tang (667 CE)
Height 130 cm; Width 80 cm
Unearthed from Honored Imperial
Concubine Wei's Tomb at Lingguangcun
of Yanxia in Liquan, Shaanxi, in 1990.
Preserved in Zhaoling Museum.

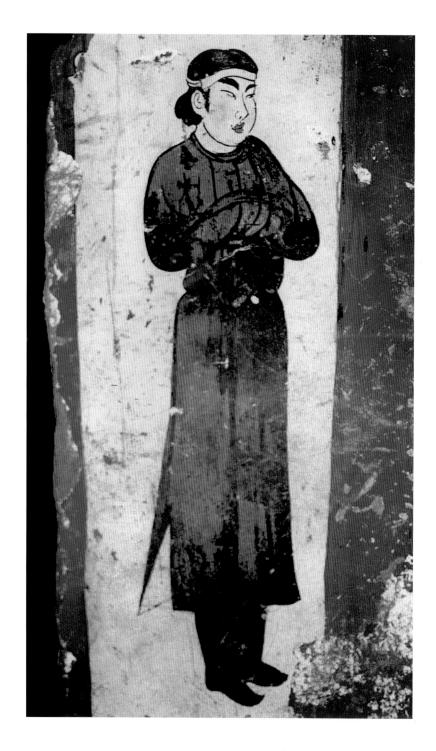

200.头扎抹额女侍图

唐乾封二年（667年）

人物高98厘米

1990年陕西省礼泉县烟霞镇陵光村韦贵妃墓出土。现存于昭陵博物馆。
位于墓室南壁后甬道口西侧。女侍头梳短发并系白色抹额，粗眉细目呈
倒八字形眼珠，向右漠视，目光微下视，眼珠极小，朱唇，鸭蛋形脸圆
润，面施胭脂着紫色圆领窄袖袍，局部脱落成红色，袖手置胸前，朝右
站立，腰系黑带、足蹬黑靴，黑靴左右残留着色定稿前的草稿"靴"的
轮廓（草稿略大于定稿）。

（撰文：李浪涛　摄影：张展望）

Maid Wearing Forehead
Hood

2nd Year of Qianfeng Era, Tang (667 CE)
Figure Height 98 cm
Unearthed from Honored Imperial
Concubine Wei's Tomb at Lingguangcun
of Yanxia in Liquan, Shaanxi, in 1990.
Preserved in Zhaoling Museum.

201.着男装吹箫侍女图

唐总章元年（668年）

高185、宽92厘米

1956年陕西省西安市雁塔区羊头镇李爽墓出土。现存于陕西历史博物馆。

墓向南。位于墓室东壁。为右起第二人，图中女伎着男装，面容圆润，正十指按持长箫作吹奏状，形象生动逼真。

（撰文：申秦雁　摄影：邱子渝）

Maid in Male Costume and Playing a *Xiao*-flute

1st Year of Zongzhang Era, Tang (668 CE)

Height 185 cm; Width 92 cm

Unearthed from Li Shuang's Tomb in Yangtou Township, Yanta District, Xi'an, Shaanxi, in 1956. Preserved in Shaanxi History Museum.

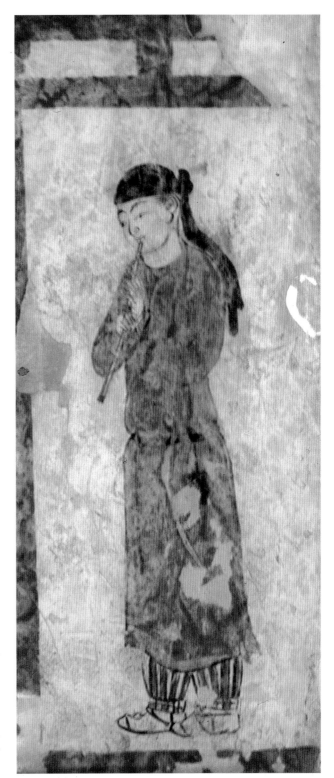

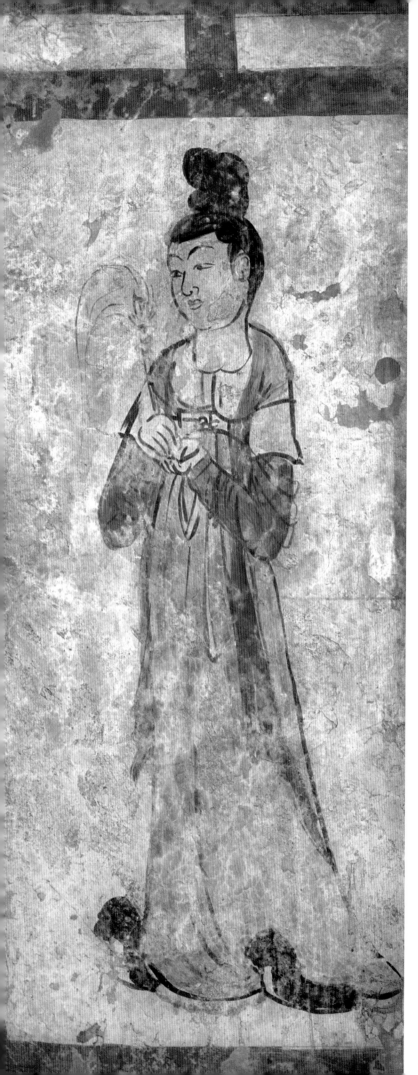

202.执拂尘侍女图

唐总章元年（668年）

高212、宽110厘米

1956年陕西省西安市雁塔区羊头镇李爽墓出土。现存于陕西历史博物馆。

墓向南。位于墓室东壁。为右起第三人，侍女双手上下相扣地执一把拂尘，作静静站立状。拂尘，又称拂子，用于掸除灰尘和驱赶蚊蝇。

（撰文：申秦雁　摄影：邱子渝）

Maid Holding Fly Whisk

1st Year of Zongzhang Era, Tang (668 CE)

Height 212 cm; Width 110 cm

Unearthed from Li Shuang's Tomb in Yangtou Township, Yanta District, Xi'an, Shaanxi, in 1956. Preserved in Shaanxi History Museum.

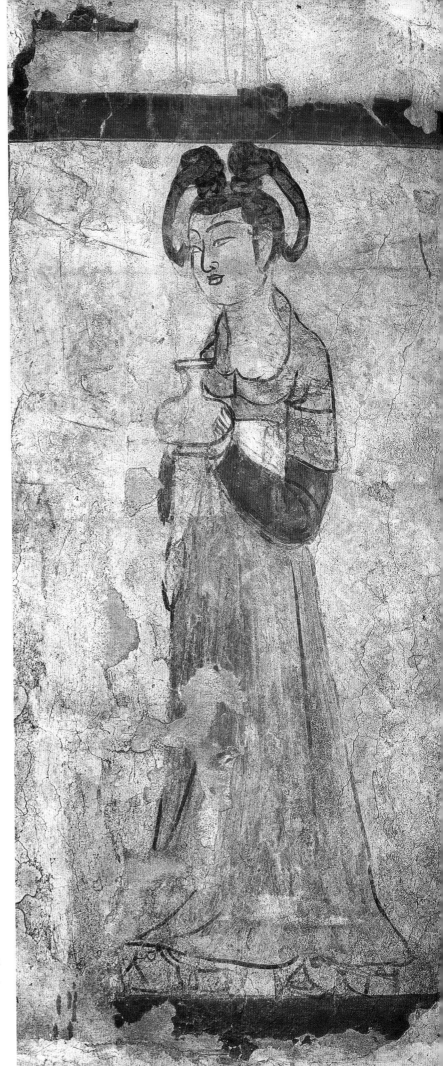

203.捧唾盂侍女图

唐总章元年（668年）

高185、宽77厘米

1956年陕西省西安市雁塔区羊头镇李爽墓出土。
现存于陕西历史博物馆。

墓向南。位于墓室北壁。为右起第四人，侍女
双手捧一只唾盂于腹前。唾盂又叫唾壶，为承
唾之器，也是唐代日常生活中使用频繁的器
物，多用陶瓷制作。

（撰文：申秦雁　摄影：邱子渝）

Maid Holding a Spittoon

1st Year of Zongzhang Era, Tang (668 CE)

Height 185 cm; Width 77 cm

Unearthed from Li Shuang's Tomb in Yangtou
Township, Yanta District, Xi'an, Shaanxi, in 1956.
Preserved in Shaanxi History Museum.

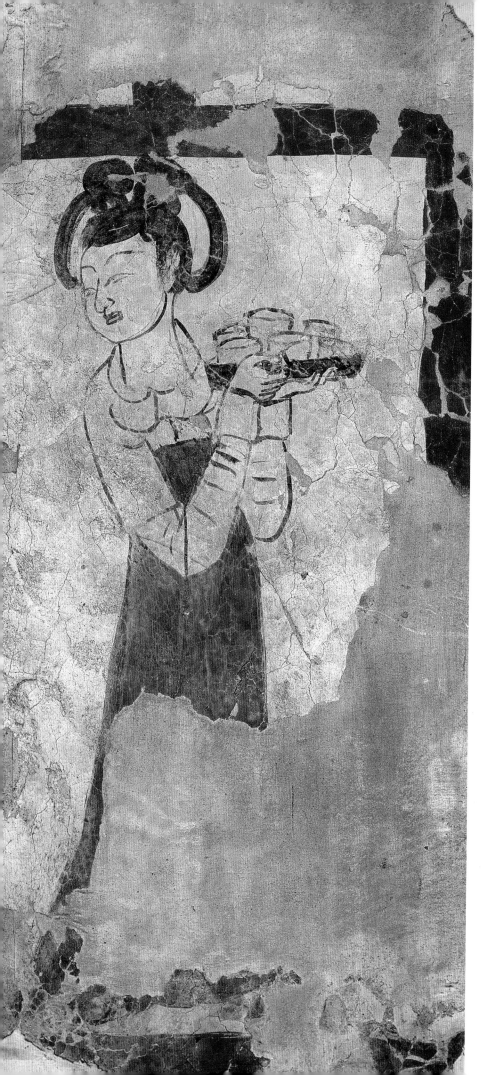

204. 托盘侍女图

唐总章元年（668年）

高172、宽89厘米

1956年陕西省西安市雁塔区羊头镇李爽墓出土。现存于陕西历史博物馆。

墓向南。位于墓室西壁。为右起第二人。侍女双手托子母盏盘于左肩，前行中正回眸顾盼，身份应该是官宦人家中的奴婢僮仆。

（撰文：申秦雁　摄影：邱子渝）

Maid Holding a Tray

1st Year of Zongzhang Era, Tang (668 CE)

Height 172 cm; Width 89 cm

Unearthed from Li Shuang's Tomb in Yangtou Township, Yanta District, Xi'an, Shaanxi, in 1956. Preserved in Shaanxi History Museum.

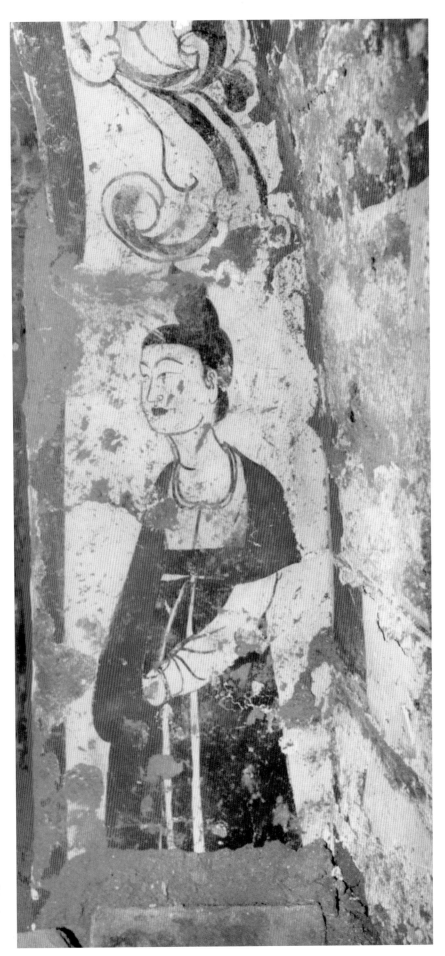

205.袖手女侍图

唐咸亨三年（672年）

高170、宽51厘米

1990年陕西省礼泉县烟霞镇东坪村昭陵陪葬墓燕妃墓出土。原址保存。

位于石门外北壁东侧。人物高121厘米，头梳锥髻，身穿白色窄袖襦外套淡绿色半臂，披红色帔帛，系深褐色曳地长裙，腰束白色长带，袖手裹帔帛里置于腹前，面左站立。

（撰文：李浪涛　摄影：张展望）

Maid Folding Hands in the Sleeves

3rd Year of Xianheng Era, Tang (672 CE)

Height 170 cm; Width 51 cm

Unearthed From Imperial Concubine Yan's Tomb, which was an Attendant Tomb of Zhaoling Mausoleum, at Dongpingcun of Yanxia in Liquan, Shaanxi, in 1990. Preserved on the original site.

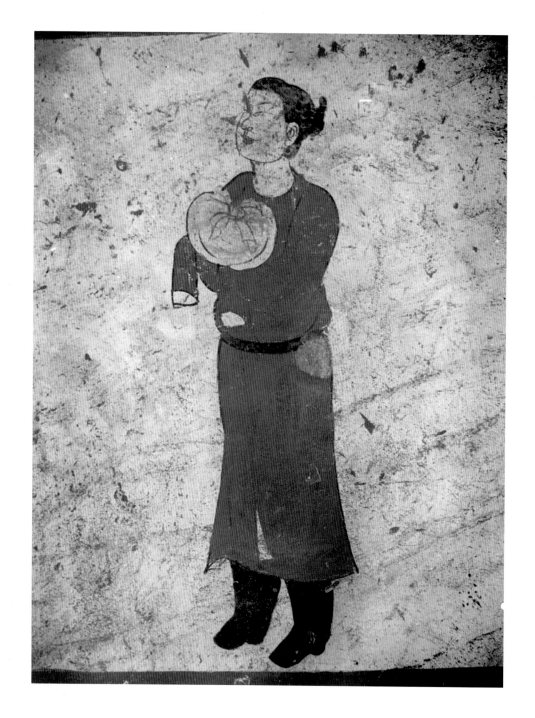

206.捧包裹女侍图

唐咸亨三年（672年）

高100、宽30厘米

1990年陕西省礼泉县烟霞镇东坪村昭陵陪葬墓燕妃墓出土。原址保存。

位于前甬道东壁中间。女侍头发挽于脑后成泡髻，着圆领窄袖红袍，腰系黑带，足蹬黑靴，双手捧一淡黄色包裹于胸前，手隐袖中，袖口下垂。面容圆润，头微抬，双目上前视。

<div align="right">（撰文：李浪涛　摄影：张展望）</div>

Maid Holding a Package

3rd Year of Xianheng Era, Tang (672 CE)

Height 100 cm; Width 30 cm

Unearthed From Imperial Concubine Yan's Tomb, which was an Attendant Tomb of Zhaoling Mausoleum, at Dongpingcun of Yanxia in Liquan, Shaanxi, in 1990. Preserved on the original site.

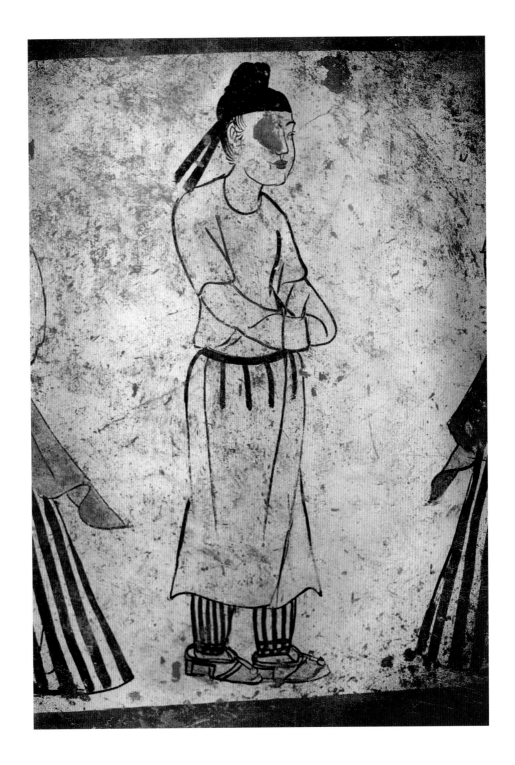

207. 男装女侍图

唐咸亨三年（672年）

高111、宽32厘米

1990年陕西省礼泉县烟霞镇东坪村昭陵陪葬墓燕妃墓
出土。原址保存。

位于前甬道东壁南间，右起第二人。女侍头戴黑色垂
脚幞头，身穿土黄色圆领窄袖袍，腰系黑带并佩蹀躞
带四条，穿赭白相间条纹裤，足蹬青色尖头鞋，袖手
置腹，面朝右侧立。

（撰文：李浪涛　摄影：张展望）

Maid in Male Costume

3rd Year of Xianheng Era, Tang (672 CE)
Height 111 cm; Width 32 cm
Unearthed From Imperial Concubine Yan's
Tomb, which was an Attendant Tomb of
Zhaoling Mausoleum, at Dongpingcun
of Yanxia in Liquan, Shaanxi, in 1990.
Preserved on the original site.

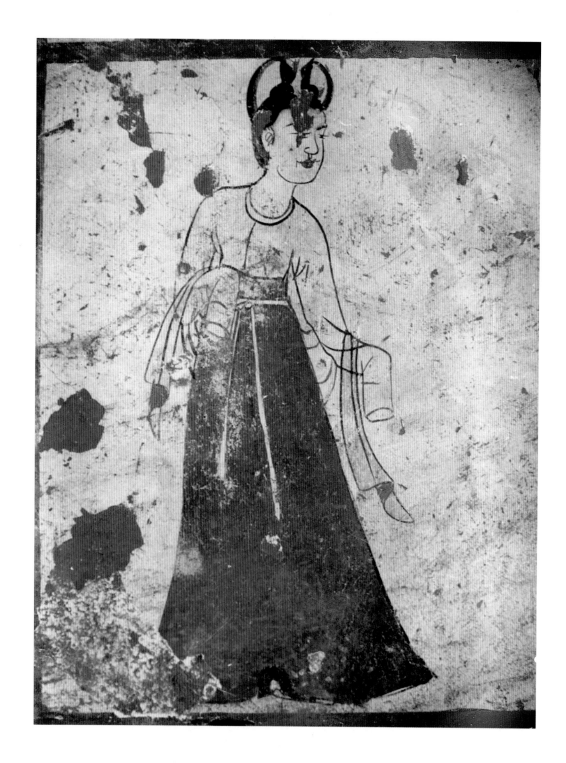

208.女侍图（一）

唐咸亨三年（672年）

高107、宽45厘米

1990年陕西省礼泉县烟霞镇东坪村昭陵陪葬墓燕妃墓出
土。原址保存。

位于前甬道东壁中间，右起第三人。女侍头梳双环髻，
着色圆领窄袖襦，披淡青色帔帛，腰系赭色长裙，足蹬
黑色履；右臂曲肘抬起，左臂欲向左伸出；两肘上搭淡
青色帔帛，回首张望身后二人，好像在叮嘱什么。

（撰文：李浪涛　摄影：张展望）

Maid (1)

3rd Year of Xianheng Era, Tang (672 CE)
Height 107 cm; Width 45 cm
Unearthed From Imperial Concubine
Yan's Tomb, which was an Attendant
Tomb of Zhaoling Mausoleum, at
Dongpingcun of Yanxia in Liquan,
Shaanxi, in 1990. Preserved on the
original site.

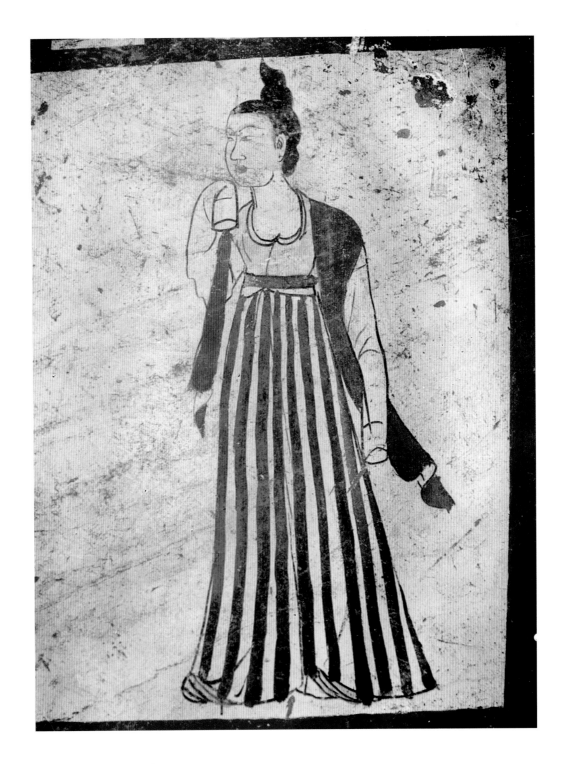

209. 女侍图（二）

唐咸亨三年（672年）

高109、宽50厘米

1990年陕西省礼泉县烟霞镇东坪村昭陵陪葬墓燕妃墓出土。原址保存。

位于前甬道东壁中幅，为右起第一人。女侍头梳椎髻，着白色窄袖襦，外套淡绿色半臂，系赭白相间条纹裙，足蹬淡绿色尖头履，朝左站立。披红色帔帛，左臂下垂，右手上举至颔部，目光迟疑，表情茫然。

（撰文：李浪涛　摄影：张展望）

Maid (2)

3rd Year of Xianheng Era, Tang (672 CE)

Height 109 cm; Width 50 cm

Unearthed From Imperial Concubine Yan's Tomb, which was an Attendant Tomb of Zhaoling Mausoleum, at Dongpingcun of Yanxia in Liquan, Shaanxi, in 1990. Preserved on the original site.

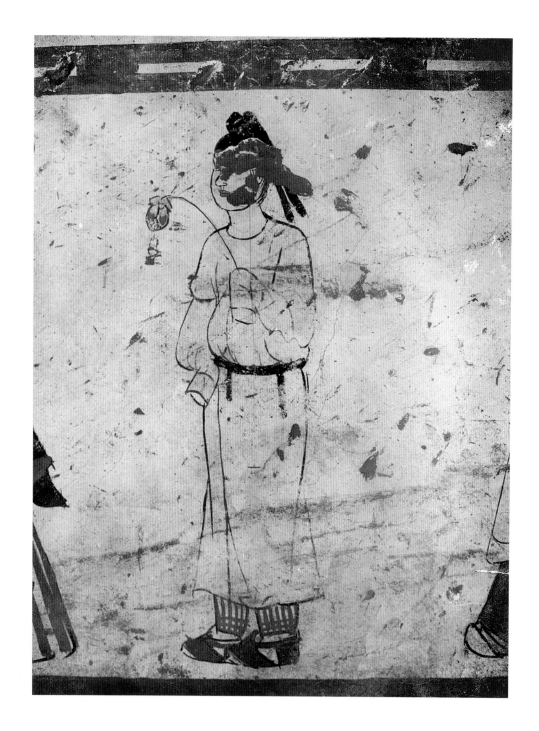

210. 持莲男装女侍图

唐咸亨三年（672年）

高98、宽30厘米

1990年陕西省礼泉县烟霞镇东坪村昭陵陪葬墓燕妃墓出土。原址保存。

位于前甬道东壁北间，南起第二人。头戴黑色幞头，面容圆润俊美，高鼻朱唇，着白色圆领窄袖袍，红白相间条纹裤，足蹬棕色尖头鞋，手隐袖中，右手挂右胯，左手持一枝莲花于胸前，莲花杆颈细长微曲，莲蕾尖下垂。

（撰文：李浪涛　摄影：张展望）

Maid in Male Costume and Holding a Lotus Flower

3rd Year of Xianheng Era, Tang (672 CE)

Height 98 cm; Width 30 cm

Unearthed From Imperial Concubine Yan's Tomb, which was an Attendant Tomb of Zhaoling Mausoleum, at Dongpingcun of Yanxia in Liquan, Shaanxi, in 1990. Preserved on the original site.

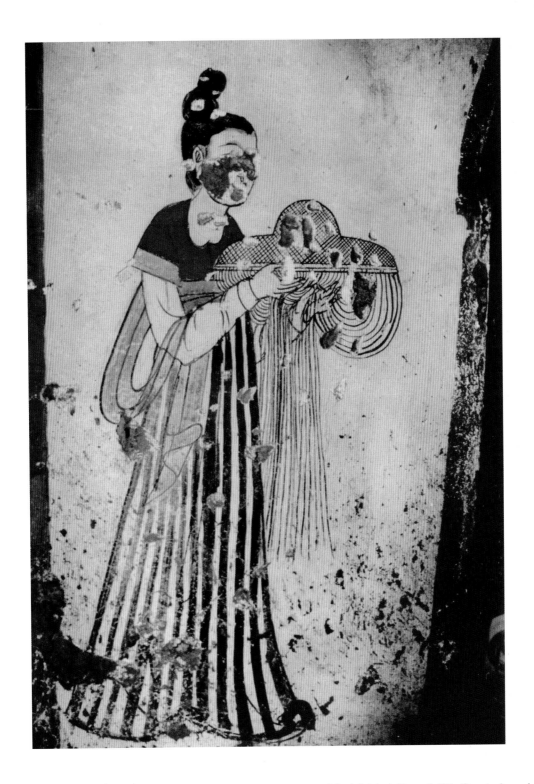

211.捧幂篱女侍图

唐咸亨三年（672年）

高134、宽75厘米

1990年陕西省礼泉县烟霞镇东坪村昭陵陪葬墓燕妃墓出土。
原址保存。

位于前室北壁西侧。头梳锥髻，身穿白色窄袖襦外套红色半
臂，披土黄与淡绿色帔帛，下穿赭白相间条纹裙，双手捧幂
篱帽，面右而行。因幂篱较长而折叠托起，实为少见。

（撰文：李浪涛　摄影：张展望）

Maid Holding Mili-Curtained Hat

3rd Year of Xianheng Era, Tang (672 CE)

Height 134 cm; Width 75 cm

Unearthed From Imperial Concubine Yan's
Tomb, which was an Attendant Tomb of
Zhaoling Mausoleum, at Dongpingcun of
Yanxia in Liquan, Shaanxi, in 1990. Preserved
on the original site.

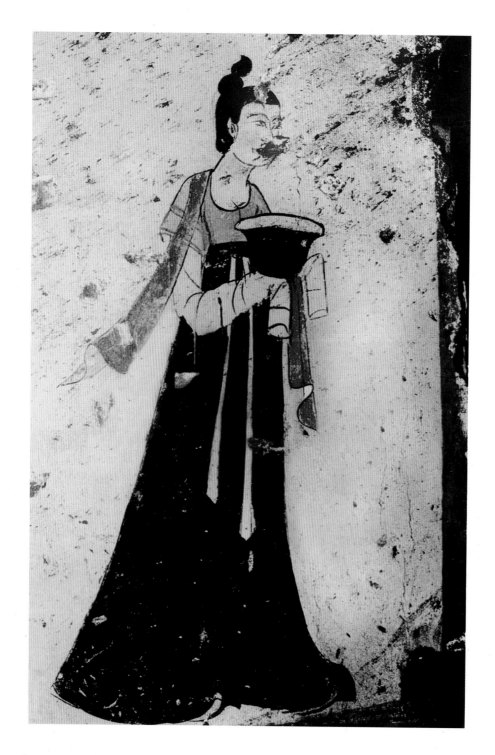

212.捧盆女侍图

唐咸亨三年（672年）

高165、宽98厘米

1990年陕西省礼泉县烟霞镇东坪村昭陵陪葬墓燕妃墓出土。原址保存。

位于前室南壁东侧。女侍头梳锥髻，身穿白色窄袖襦外套绿色半臂，披橘黄色帔帛，系深褐色曳地长裙，腰束白色长带，双手捧内白外黑侈口盆（亦有学者以为是帽子之类），面右而行。

（撰文：李浪涛　摄影：张展望）

Maid Holding a Basin

3rd Year of Xianheng Era, Tang (672 CE)

Height 165 cm; Width 98 cm

Unearthed From Imperial Concubine Yan's Tomb, which was an Attendant Tomb of Zhaoling Mausoleum, at Dongpingcun of Yanxia in Liquan, Shaanxi, in 1990. Preserved on the original site.

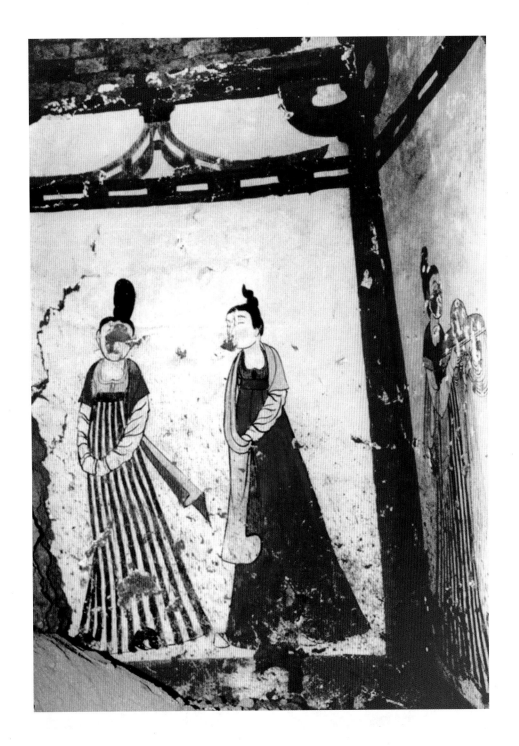

213. 袖手二女侍图

唐咸亨三年（672年）

高167、宽140厘米

1990年陕西省礼泉县烟霞镇东坪村昭陵陪葬墓燕妃墓出土。原址保存。

位于前室西壁北幅。绘女侍二人，人物高140~145厘米。其右者头梳锥髻，身穿白色窄袖襦，外着紫色低胸对襟半臂，披绿面紫里色帔帛，系红色长裙，足蹬白色尖头履，袖手拥帔帛于腹前。左女头梳高髻，面部残损，身穿白色窄袖襦，外着绿色对襟半臂，披红面绿里双色帔帛，系赭白相间条纹长裙，足蹬黑色高头履，袖手置腹前。

（撰文：李浪涛　摄影：张展望）

Two Maids Folding Hands in the Sleeves

3rd Year of Xianheng Era, Tang (672 CE)
Height 167 cm; Width 140 cm
Unearthed From Imperial Concubine Yan's Tomb, which was an Attendant Tomb of Zhaoling Mausoleum, at Dongpingcun of Yanxia in Liquan, Shaanxi, in 1990. Preserved on the original site.

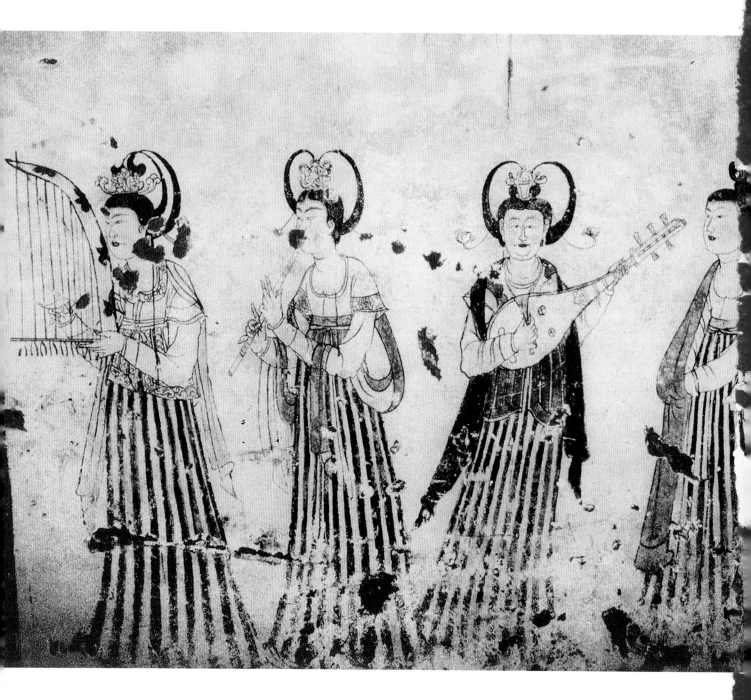

214.奏乐图

唐咸亨三年（672年）

高175、宽210厘米

1990年陕西省礼泉县烟霞镇东坪村昭陵陪葬墓燕妃墓出土。原址保存。

位于墓室东壁南幅。共四人，人物高140厘米。右起第一个人梳锥髻，未持乐器，操手而立。第二、三、四人梳双环髻，分别持五弦琵琶、竖箫、箜篌。四人均着赭色条纹裙。除右起第二人为正立外，余均侧立。

<div style="text-align: right">（撰文：李浪涛　摄影：张展望）</div>

Music Performance

3rd Year of Xianheng Era, Tang (672 CE)

Height 175 cm; Width 210 cm

Unearthed From Imperial Concubine Yan's Tomb, which was an Attendant Tomb of Zhaoling Mausoleum, at Dongpingcun of Yanxia in Liquan, Shaanxi, in 1990. Preserved on the original site.